The Ethnic Avant-Garde

Modernist Latitudes

Jessica Berman and Paul Saint-Amour, Editors

Modernist Latitudes

JESSICA BERMAN AND PAUL SAINT-AMOUR, EDITORS

Modernist Latitudes aims to capture the energy and ferment of modernist studies by continuing to open up the range of forms, locations, temporalities, and theoretical approaches encompassed by the field. The series celebrates the growing latitude ("scope for freedom of action or thought") that this broadening affords scholars of modernism, whether they are investigating little-known works or revisiting canonical ones. Modernist Latitudes will pay particular attention to the texts and contexts of those latitudes (Africa, Latin America, Australia, Asia, Southern Europe, and even the rural United States) that have long been misrecognized as ancillary to the canonical modernisms of the global North.

The Ethnic Avant-Garde

Minority Cultures and
World Revolution

STEVEN S. LEE

Columbia
University
Press

New York

Columbia University Press
Publishers Since 1893
New York Chichester, West Sussex
cup.columbia.edu

Library of Congress Cataloging-in-Publication Data
Lee, Steven S. (Steven Sunwoo), 1978–
 The ethnic avant-garde : minority cultures and world revolution / Steven S. Lee
 pages cm. (Modernist latitudes)
 Includes bibliographical references and index.
 ISBN 978-0-231-17352-0 (cloth : alk. paper) — ISBN 978-0-231-54011-7 (ebook)
 1. American literature—Minority authors—History and criticism. 2. Avant-garde
(Aesthetics)—United States—History—20th century. 3. Avant-garde (Aesthetics)—
Soviet Union—History—20th century. 4. American literature—Russian influences.
5. Intercultural communication—United States—History—20th century. 6. Inter-
cultural communication—Soviet Union—History—20th century. 7. United States—
Race relations—History—20th century. 8. Soviet Union—Race relations—History—
20th century. 9. United States—Intellectual life—20th century 10. Soviet Union—
Intellectual life—1917–1970. I. Title.

 PS153.M56L465 2015
 810.9'920693—dc23
 2015017334

Columbia University Press books are printed on permanent and durable
 acid-free paper.
This book is printed on paper with recycled content.
Printed in the United States of America

c 10 9 8 7 6 5 4 3 2 1

COVER DESIGN: Mary Ann Smith
PHOTO CREDIT: Getty Images

References to websites (URLs) were accurate at the time of writing.
Neither the author nor Columbia University Press is responsible for URLs
 that may have expired or changed since the manuscript was prepared.

For my parents

Contents

List of Illustrations

A Note on Transliteration

In transliterating Russian quotes and citations, I have adhered to the U.S. Library of Congress transliteration system. I have transliterated proper nouns in keeping with this system except in cases where the name has been standardized in English (for example, Mayakovsky rather than Maiakovskii).

The Ethnic
Avant-Garde

Introduction

This is a book about minorities drawn to Soviet communism and the avant-garde. The initial focus is the 1920s and early 1930s and the allure of Moscow for the world's downtrodden and oppressed. The Bolsheviks, it seemed, had eliminated racism in the USSR while supporting anti-imperial struggles around the world. At roughly the same time, a loose grouping of artists and writers sympathetic to the revolution—retrospectively labeled the Soviet avant-garde—emerged at the forefront of modernist experimentation. Through such distinct but overlapping movements as futurism and constructivism, they enacted an unprecedented alignment of political and artistic vanguards—the artist as bona fide revolutionary.

I am linking here two phenomena that have each been thoroughly studied but rarely in tandem: the Soviet Union of the interwar years as a site of cultural innovation and the Soviet Union as a beacon of racial, ethnic, and national equality. These two sources of allure help to explain what, in hindsight, might seem strange: that the USSR of the 1920s and early 1930s had a magical, even religious significance for many minority and non-Western artists and writers. For reasons discussed in the following, my focus is primarily (though not exclusively) on those from the United States. The Jamaican American poet Claude McKay described his 1922 journey to Moscow as a "magic pilgrimage." Likewise, the Jewish American poet

Moishe Nadir called his 1926 visit a "pilgrimage" to the "holy land of the Soviets," and in 1932 Langston Hughes wired the organizer of an African American delegation to the USSR, about to set sail from New York, "YOU HOLD THAT BOAT CAUSE ITS AN ARK TO ME."[1]

As indicated by Jacques Derrida after his own 1990 visit, such descriptions can be seen as part of a "rich, brief, intense, and dense tradition" of Western travelogues casting the USSR as a "mythic (ahistoric, *in illo tempore*) and eschatological (mosaic or messianic) space."[2] My task is to connect this tradition to questions of race and ethnicity—something that makes little sense in our postsocialist present, accustomed as we are to dismissing the Soviet Union as a monolith that failed to accommodate difference. Moscow's attempts to do so can be summarized by the official prescription that culture be "national in form, socialist in content," which blandly meant that Bolshevik decrees were to be published in multiple languages and propaganda posters were to feature minority costumes. Thus, one basic aim of this book is to recapture the magic behind the "magic pilgrimage," more specifically, to explain how, via the Soviet Union of the 1920s and early 1930s, marginalized minorities could suddenly envision themselves at the forefront of both modernism and revolution. As a growing number of scholars have shown, these pilgrims and would-be pilgrims were certainly looking for Moscow's brand of multiculturalism and Leninist critiques of imperialism.[3] However, they were also seeking the creative possibilities opened by the likes of Sergei Eisenstein, Vladimir Mayakovsky, and Vsevolod Meyerhold—this lionized branch of the international avant-garde that, as Slavists well know, had itself long been fascinated by minority and non-Western cultures. From the alignment of art and revolution emerged many striking, eccentric ways of expressing cultural difference—visions of political and artistic vanguardism that deepened rather than erased ethnic particularism; visions of world revolution in which the ethnic Other took the lead. These visions, I argue, enable us to unlock the suppressed utopian potential of minority and avant-garde cultures alike—the former as revolutionary and experimental; the latter as inclusive and decolonizing.

To be sure, this is a counterintuitive pairing. Ethnic, minority cultures connote tradition and descent—one's inheritance from the past. Avant-garde, on the other hand, is a military term (the vanguard of a unit) with political and aesthetic connotations—the revolutionary vanguard

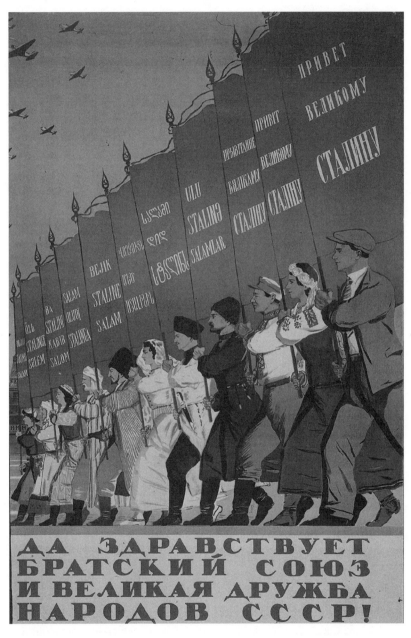

FIGURE I.1 "Long Live the Fraternal Union and Great Friendship of Peoples of the USSR!" Soviet poster illustrating "national form, socialist content" (1936).

Courtesy of Hoover Institution Library & Archives, Stanford University.

and artistic avant-garde each progressing toward a liberated future.⁴
Suffice it to say for now, the historical avant-garde employed montage
for the sake of creating new meanings, and this book employs precisely
this technique, beginning with the pairing of ethnic and avant-garde—
the goal being to estrange and renew both terms. I do so through a new
grouping that I call the ethnic avant-garde, which on one level refers
simply to the many diverse artists and writers—figures like McKay, Na-
dir, and Hughes—who were drawn to and often visited interwar Moscow.
Through the variety of translations and cultural productions emerging
from these encounters, they became active participants in Soviet efforts
to transform perception and to decenter the West—in experiments with
art and equality that opened radical, forgotten horizons for American
ethnic minorities. The ethnic avant-garde encompasses, for instance,
Mayakovsky's "Afro-Cuban" poems and Hughes's translations of them;
Nadir's accounts of the USSR as a "red-haired bride"; and a Soviet futur-
ist play about China that became Broadway's first major production with
a predominantly Asian American cast.

However, beyond these concrete cultural encounters, I also present the
ethnic avant-garde as a largely unrealized utopian aspiration, one that ul-
timately exceeds the Soviet Union of the interwar years. It is the dream of
advancing simultaneously ethnic particularism, political radicalism, and ar-
tistic experimentation, debunking the notion that particularism yields pro-
vincialism. More to the point, though, the ethnic avant-garde foregrounds a
distinct way of seeing—a "transnational optic" that, for the contemporary
reader, makes it possible to discern unexpected connections among radi-
cal artists and writers from many different countries.⁵ The figures covered
here themselves cultivated such an optic, motivated by the similar poten-
tial of avant-garde and minority cultures to level hierarchies and bring art
into life—that is, to shatter or open exclusive canons and to dismantle the di-
vide between high and low. Techniques like cinematic montage enabled not
only these ends but also alliances across racial, ethnic, and national lines.
Blacks, Jews, Asians, Latinos, and Russians could see themselves as part of
a collaborative effort to harness both perceptual estrangement and minor-
ity cultures for a Soviet-centered world revolution. Of course, such utopian
aspirations were arguably doomed to be suppressed and forgotten—crushed
by Stalinist terror and overshadowed by socialist realism—but remnants of
this interwar ethnic avant-garde nonetheless survive into the present day.

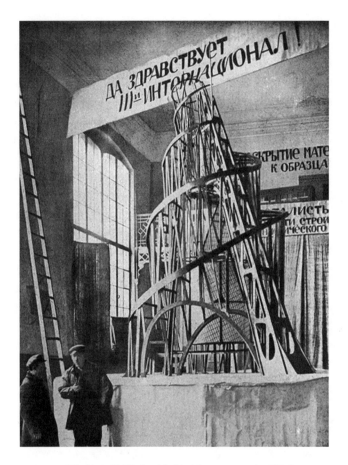

FIGURE I.2 Vladimir Tatlin beside his *Monument to the Third International* (1920).

Courtesy of HIP/Art Resource, New York.

To lay this grouping's historical and conceptual foundation, this introduction begins with an overview of the Soviet Union's political and artistic allure for minorities and non-Westerners around the world. I illustrate this through various interpretations of Vladimir Tatlin's *Monument to the Third International*—the famous protoconstructivist icon now best known as Tatlin's Tower, first displayed in Petrograd in 1920. Consisting of two intertwined iron spirals that cut through the heavens like a telescope or a cannon, the never-built tower positions the Soviet Union of the interwar

years at the forefront of both world revolution and global modernism, of both the Third Communist International (Comintern) and the international avant-garde. In the first part of this introduction I make use of the tower to rethink notions of both revolution and avant-gardism—to impart to them a variegated temporality that encompasses past as well as future. The task here is to articulate that distinct way of seeing that is central to the ethnic avant-garde—more specifically, an ability to see both the political vanguard and artistic avant-garde as compatible with the past and descent. In the second part of this introduction I apply this way of seeing to notions of race, ethnicity, and nationality. Here I will juxtapose American and Soviet efforts to overcome biological racism and to come to terms with the two countries' respective, exceptionally diverse populations. This will take us on an excursion to Soviet nationalities policy, linguistics, and ethnography, which will lead us back, in a roundabout fashion, to Tatlin's Tower. Its telescope design opens an estranging lens on avant-gardism, world revolution, and minority cultures alike. Its spirals provide the scaffolding for the ethnic avant-garde.

Moscow—Capital of Now-Time

This book builds on recent efforts by both Americanists and Slavists to center Moscow in the study of global and ethnic modernisms. Katerina Clark's *Moscow, the Fourth Rome* reveals that, even amid the Stalinist 1930s, Moscow remained a cosmopolitan city in dialogue with cultural figures and developments around the world. Likewise, Kate Baldwin's *Beyond the Color Line and the Iron Curtain* shows how journeys to the Soviet Union enabled African American activists and intellectuals to rethink race, class, and gender. In both works, one explicit aim is to decenter Western Europe—in the case of Clark, to open Pascale Casanova's "world republic of letters" to Stalinist culture; in the case of Baldwin, to open an affirmative, Marxist horizon for the Black Atlantic.[6]

More specifically, the aim has been to decenter Paris, which even during the interwar years could be considered passé. Walter Benjamin named it, in 1935, the capital of the nineteenth century, the city's revolutionary ambitions having long given way to urban redevelopment and "monuments of the bourgeoisie."[7] He hinted that the twentieth century demand-

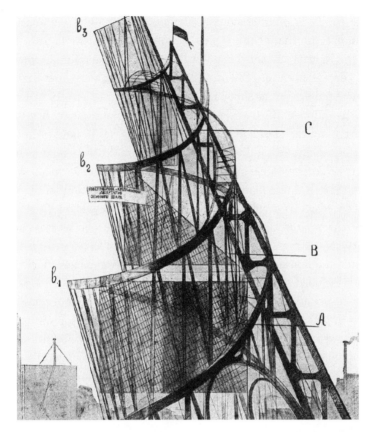

FIGURE I.3 Sketch included in Nikolai Punin, *Pamiatnik III Internatsionala*
(Petrograd: Otdel izobrazitel'nykh iskusstv NKP, 1920).

ed new, radical alternatives to build on the ruins of the Paris Commune, and as Clark has shown, he himself felt Moscow's pull as a new potential center. And so we turn from the nineteenth century to the twentieth, from Paris to Moscow, from the iron and glass of shopping arcades to the iron and glass of Tatlin's Tower. Indeed, the tower's 400 meters were explicitly intended to overshadow Paris (the Eiffel's mere 324). This was Tatlin's shot across the bow of Western Europe—his assertion of Russia, not France, as the center of cutting-edge modernism. The key ingredient was revolution—the Soviet avant-garde's union of artistic and political rupture, its ill-fated embrace of the Bolshevik vanguard.[8]

The tower, again, marked the alignment of two internationals—the Communist International and international avant-garde. In 1920 these were still in brief harmony: many still hoped that the avant-garde's project of perceptual estrangement could serve the revolution, and the tower was intended not just as a monument to but also headquarters for the Comintern—founded in 1919 by Vladimir Lenin to coordinate radical movements around the world. Accordingly, the tower was to have been a machine for making revolution, with communist radio emanating from the top and agitational slogans projected onto the surrounding clouds. Within the iron spirals, Tatlin planned three glass structures, each spinning at different speeds. A large cube at the base was to have rotated once a year and hosted the organization's polyglot congresses, with representatives from all corners and races. A pyramid in the middle was to have rotated once a month and housed the Comintern's executive committee. In the early 1920s it included M. N. Roy, the Indian anti-imperialist who helped found the Mexican Communist Party, and Sen Katayama, a founder of communist parties in Japan and the United States. A cylinder at the top was to have rotated once a day and housed the editorial offices for the organization's many publications, published in multiple languages.[9] In short, the scores of seemingly random trusses gathered into a coherent movement would have reflected the Comintern's diverse yet coordinated activists. This monument to artistic experimentation and world revolution was to have tripled as multicultural center.

Understanding this requires stripping the tower to its two constituent spirals, which chase each other but never touch, starting and ending at different points. One spiral, call it the vanguard spiral, evokes the tensions of forging world revolution: its balance of centripetal and centrifugal movements evokes the push and pull between Soviet center and non-Soviet peripheries, as well as between different societies caught in different stages of development. The other spiral, call it the avant-garde spiral, also twists time and space, but for more formal ends—for "the creation of a new world of sensations," as Viktor Shklovskii put it in a review of Tatlin.[10] These sensations opened the way for ever more varied understandings of revolution. Nikolai Punin described the spiral as the "classical form of dynamics," promising liberation from "all animal, earthly, and reptile [presmykaiushchikhsia] interests"—the tower as escaping the bounds of time and space and leaping into a socialist future. However, the

tower also gestured to the distant past: Punin noted too Tatlin's use of iron and glass, the "two most primitive [*prosteishikh*] materials, for which fire was, to the same degree, the giver of life"—materials that concealed a "severe and red-hot simplicity" evoking the "birth of an ocean." From this perspective, the two spirals evoked not simply a socialist future but also a sleeping giant from time immemorial. The result, according to Punin, was "an ideal, live, and classic expression . . . of the international union of the workers of the globe."[11]

All this points to a vision of revolution sweeping back and forth between future and past and becoming ever more inclusive as a result. On the one hand, the tower anticipated a liberated, unified humanity. Unlike traditional monuments, it eschewed a single heroic type and, in line with Soviet constructivism, advanced a world free of hierarchy and superfluity. Trotsky praised its exclusion of "national styles," its transcendence of past division and prejudices.[12] However, as indicated by Punin, the "classic" tower also gestured to the distant past and, from the moment of its unveiling, was seen as a vestige of premodernity. Several have noted its likeness to the Great Mosque of Samarra (ca. 846–861) in present-day Iraq, which Tatlin may have visited during his youth as a sailor. He certainly visited Syria, Turkey, and Egypt, and some have seen the tower as a composite of ruins from those places.[13] The suprematist painter El Lissitzky called it a reworking of ancient Assyria's Sargon Pyramid. In turn, as Svetlana Boym has emphasized, "the Sargon monument was considered an inspiration for the Tower of Babel, which was in itself an unfinished utopian monument turned mythical ruin." Accordingly, just as Nimrod's tower glorified a united humanity speaking a single divine tongue, Tatlin's was to have joined all peoples in a shared, liberated society; and arguably the result of both failed enterprises was the scattering of nations.[14]

The tower was thus read as advancing a universal form, but one with vaguely Middle Eastern forebears; it evoked a single world civilization, but one drawing from every people and culture. This flight of fancy enables us to broaden revolution beyond modern bounds to its original, astronomical connotations—revolution as, in Hannah Arendt's words, the "recurring, cyclical movement" of stars. This makes the notion of the tower as telescope all the more apt, with the different rotation speeds (day, month, year) corresponding to the "celestial rhythms" of earth and moon.[15] Reinhart Koselleck similarly expands revolution by linking it to premodern

eschatology—both marked by expectations of salvation and efforts to accelerate time.[16] In short, while revolution is typically understood as a distinctly modern leap into the new, it can also refer to a perspective outside time and history. Indeed, many Russians viewed the 1917 Revolution as "an apocalyptic moment, as a time not of forward linear progress but of a sacred break in temporality."[17]

It is understandable, even predictable that an avant-gardist like Tatlin would evoke such iconoclastic views of revolution, opening the term to a Pandora's box of myths and legends. Remarkably, though, at least in the early 1920s, the political vanguard found it necessary to do something similar, that is, to articulate a vision of revolution able to accommodate all the world's peoples. If the tower referenced both a liberated future and ancient civilization, under Lenin's guidance, the Comintern finessed the stagism (i.e., from feudalism to capitalism to socialism) typically associated with Marx. That is, at least in its earliest years, the Comintern evinced a flexible, open-ended approach to history and revolution—similar to but to a lesser degree than its planned monument. According to Lenin and Leon Trotsky, democratic revolution could immediately give way to socialist revolution (Trotsky's theory of permanent revolution); "backward" nations could combine and leap over historical stages (Trotsky's theory of combined and uneven development); and countries where capitalism was not fully developed (e.g., Russia itself) offered the best opportunities for undermining the global capitalist system (Lenin's "weakest link" theory).[18] In short, the last could become first. A "backward" nation could serve as the vanguard of world revolution without having to advance through capitalism—Russia providing the key case in point. For Trotsky, the fact that the country had been "backward" (i.e., predominantly agrarian) on the eve of revolution was a virtue; Russia's "amalgam of archaic with more contemporary forms" made possible the Bolsheviks' success.[19] Accordingly, in advance of the Comintern's Second Congress in 1920, Lenin famously called for communists to support "revolutionary movements among the dependent and underprivileged nations (for example, Ireland, the American Negroes, etc.) and in the colonies." This meant that the Comintern would organize not only the "advanced" Western proletariat but also "backward" minority and colonized groups around the world—what Lenin called "oppressed nations," suffering under the rule of developed, imperialist "oppressor nations."[20]

My detour from artistic avant-garde to political vanguard points once again to a basic congruence between the two, and indeed, Tatlin took pride in combining "purely artistic forms with utilitarian goals."[21] This is not to say that Tatlin's design was a crude reflection of Leninist policy, but rather that this policy enables a better appreciation of the design. It enables us to see Tatlin's interweaving of the modern and premodern not simply as an instance of abstract, universal form but also as an expression of the way and how of world revolution—of the need to attract revolutionaries of all stripes, colors, and stages of development. More to the point, already at the time of its November 1920 unveiling, the *Monument to the Third International* was a monument to a world revolutionary movement increasingly oriented toward Asia and Africa. That August, the Red Cavalry's assault of Poland—monitored throughout the Second Congress and later immortalized by Isaac Babel—had been narrowly repelled, shattering hopes of a European revolution.[22] This prompted the Bolsheviks to turn their attention elsewhere: in September 1920, the Comintern convened the "First Congress of the Peoples of the East" in Baku, Azerbaijan, drawing thousands of predominantly Muslim delegates from a broad swath of land, from Turkey to India to Korea. There Comintern chairman Grigory Zinoviev pledged Soviet support for all the world's "oppressed peoples" in a "holy war" against Western imperialism[23]—one that was, again, to have emanated from a recast Tower of Babel. The political vanguard (Zinoviev) and artistic avant-garde (Tatlin) here close in on each other, both expressing similarly expansive, indeed premodern visions of revolution.

Admittedly, my interweaving of vanguard and avant-garde has been a bit heavy-handed, especially considering that Tatlin likely envisioned his tower for Petrograd, not Moscow, and originally as a commemoration of the Bolshevik Revolution, not the Communist International.[24] Indeed, it may be for the best that his design was never realized given the Comintern's much-maligned subservience to Soviet state interests, the frequent accusations of world revolution betrayed.[25] Functioning as that organization's administrative center would likely have diminished the tower's nostalgic appeal, and I do not care to crush the monument under the Third International's weight. Rather, having noted the momentary, complementary congruence of vanguard and avant-garde, I will now separate them again, or keep them separate à la Tatlin's two spirals—again, chasing each other but never quite touching. I will use the tower as a springboard to

yet more eccentric, inclusive visions of world revolution, related but not bound to the Bolshevik vanguard.

This formulation—related but not bound, encircling but not touching—allows us to see the vanguard and avant-garde neither as synonymous nor as completely at odds. More specifically, it enables us to salvage the avant-garde's "utopian surplus" from the abortive histories of the Bolshevik Revolution and the Communist International. At the same time, it enables us to draw from these histories a revolutionary political horizon that bolstered the Soviet avant-garde's long-standing interest in other peoples and cultures. The avant-garde was obviously tied to the catastrophic history of the Bolshevik vanguard. However, as evinced by Tatlin's Tower, the avant-garde also "side shadows" alternative possible histories—indeed, alternative ways of imagining the flow of history.[26]

My contention is that through works like the tower, Soviet avant-gardists unseated the Hegelian notion of historical development, which had long posed Western Europeans at the lead of "World Spirit," Russians lagging, and Africans excluded altogether.[27] Again, the Bolshevik vanguard had complicated this stagist view just by sparking socialist revolution in Russia, but the avant-garde went much further. Wedding perceptual estrangement and romantic anticapitalism, it articulated visions of revolution in which even lost civilizations and ancient religions could play a role.[28] The writings of one of Tatlin's close friends, the futurist Velimir Khlebnikov—now most famous for his *zaum* (transrational) poetry—are here exemplary. Many have discussed Khlebnikov's eccentric approach to time, namely, his effort to predict the future by measuring the intervals between past historic events, as well as to find through *zaum* the common origin of all languages. However, as Harsha Ram has shown, such efforts also led him to embrace non-Western cultures and, specifically, to imagine the Bolshevik Revolution as an Asian revolution. "We know that the bell that sounds for Russia's freedom will not touch European ears," Khlebnikov declares in his 1918 manifesto, "An Indo-Russian Union." As a result, Russia must embrace its Asianness: "We, the citizens of the new world, liberated and united by Asia, parade triumphantly before you. . . . Our path leads from the unity of Asia to the unity of the Stars, and through the freedom of the continent to the freedom of the entire planet." For Khlebnikov, Asia serves as the key to making the revolution global as well as timeless: the manifesto credits "the will of Fate" for the union's creation and proclaims the unity of "three worlds—the

Aryan, the Indian, and the Caspian, the triangle of Christ, the Buddha and Muhammad. . . . We have plunged into the depths of past ages and collected the signatures of the Buddha, Confucius and Tolstoi." Imparting to the revolution an eternal, religious quality, this call for an "Indo-Russian Union" exceeds what Ram describes as the Bolsheviks' "gestural solidarity" toward Asia, for instance, Zinoviev's "holy war" at the Congress of the Peoples of the East. Unlike Zinoviev, Khlebnikov actually identifies with Asia, which opens the way for a more inclusive vision of revolution—resonant with, but not limited to, Comintern outreach.[29]

This is to distinguish once again the Soviet avant-garde from the Bolshevik vanguard but also to distinguish the Soviets from their Western counterparts and competitors, many of whom also happened to be drawn to minority and non-Western cultures. Khlebnikov's manifesto seems to anticipate Ezra Pound's *Cantos LII-LXXI* (1940), which connected Confucian China to the American Revolution and, in turn, fascist Italy. Of course, such efforts to harness non-Western cultures for modernist innovation often bore a racism and Eurocentrism that ultimately kept these cultures at a distance—a distance that Khlebnikov sought to overcome.[30] Indeed, the anti-imperialist underpinnings of his Indo-Russian Union seem to align him more closely to James Clifford's Paris-based "ethnographic surrealists," who in the 1920s used "cultural impurities and disturbing syncretisms" to destabilize received notions of the "real," "normal," and "beautiful." Drawing inspiration from works like Pablo Picasso's *Les demoiselles d'Avignon* (1907), this group sought to unlock "the full human potential for cultural expression" through the sense that "something new was occurring in the presence of something exotic." Such experimentation—this taste for the exotic—of course helped make interwar Paris a vibrant cultural hub, including for many artists and writers of color.[31] However, in contrast to Tatlin and Khlebnikov, the ethnographic surrealists lacked the Comintern's revolutionary politics, directed against the very forces that made African artifacts so readily available in Paris. As Clifford writes, the ethnographic surrealists sought to decenter Europe and offered "resistance to oppression and a necessary counsel of tolerance, comprehension, and mercy" (145). But this group stopped short of both world revolution and of identifying with (rather than just embracing) the Other.[32]

Khlebnikov, in contrast, was part of a long Russian tradition of identifying with the Other—a tradition that bears elaboration given the handle

it provides on the Soviet avant-garde's relation to minority and non-Western cultures. That is, we must follow Khlebnikov down the rabbit hole of Russian modernists and avant-gardists identifying in particular with Asia. This will take us to the prerevolutionary years, then to the alignment of this tradition with the Bolshevik Revolution, followed by its resonance with pilgrims like Claude McKay. My starting point for this brief excursion is an influential group of painters from the second decade of the twentieth century who called themselves the neoprimitivists and who counted Khlebnikov and Tatlin among their many allies. At first glance, this group's works and writings seem to mimic Western chinoiserie in claiming "the beautiful East" as the key to disrupting perception and continuity: "We are striving to seek new paths for our art, but we do not reject the old completely, and of its previous forms we rec-

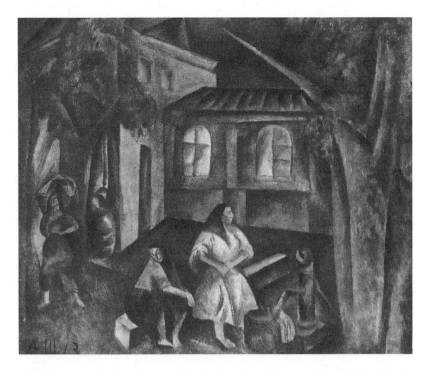

FIGURE I.4 Russian neoprimitivism and "the Beautiful East," Aleksandr Shevchenko, *Laundresses* (1913).

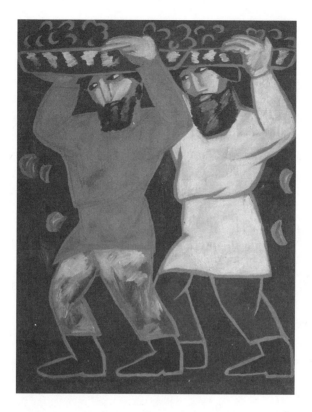

FIGURE I.5 Natal'ia Goncharova, *Peasants* (1911).

© 2014, State Russian Museum, Saint Petersburg.

ognize above all—the primitive, the magic fable of the old East," wrote the painter Aleksandr Shevchenko in 1913.[33] Accordingly, the Asian faces in his painting *Laundresses* from the same year evoke the angled African masks of Picasso's *Les demoiselles*. However, as art historian Jane Sharp has emphasized, the "neo" of this primitivism lay in its avowedly anti-Western stance. In the words of another of its leaders, Natal'ia Goncharova, "I turn away from the West because for me personally it has dried up and because my sympathies lie with the East. The West has shown me one thing: everything it has is from the East." Thus, if the West had long cast Russia as laggard in world historical development—Russia as "Byzantine" and "semi-Oriental" in the Enlightenment imagination—

the neoprimitivists (akin to the nineteenth-century Slavophiles) turned this into a source of defiance and pride.[34] "We are daily in the most direct contact with Asia," Shevchenko boasted. "We are called barbarians, Asians. Yes, we are Asia, and are proud of this, because 'Asia is the cradle of nations,' a good half of our blood is Tatar, and we hail the East to come, the source and cradle of all culture, of all arts."[35] In short, just as with Khlebnikov, the neoprimitivists not only drew from but also identified with the premodern and non-Western. They claimed to regard *themselves* as Other and Asian—Russia as, in the words of one member, "the avant-garde country of the East."[36] By this view, Russia itself was, according to Sharp, "colonized by the West, economically and culturally dependent on the prior 'civilizing' accomplishments" of England, Germany, Italy, and France. This means that in contrast to Western chinoiserie, neoprimitivism can be seen as something of an anticolonial discourse, with a "devotion, even subordination" to Asia that hinders any conflation with Saidian "Orientalism."[37]

However, though Russian artists and writers may have considered themselves "Asian" vis-à-vis Western Europe, they were most certainly European vis-à-vis the empire's non-Russian peoples. This is to say that Russians could be just as distant and condescending toward the czar's non-Russian subjects as Westerners could be toward African peoples and cultures.[38] Here again, though, the key distinction was revolution, with 1917 imparting an anti-imperialist edge to Russian identifications with Asia. That is, after the Bolshevik Revolution, Russian-turned-Soviet artists and writers came not only to identify with but also to mobilize the Other: Asia became a rallying point for revolution. Perhaps the most striking and famous example of this is the symbolist Aleksandr Blok's 1918 poem "Scythians"—a 1920 edition of which Goncharova illustrated in Paris. It cast the Bolsheviks as the eponymous nomadic tribe from the Black Sea steppes, reigniting an age-old battle between Asia and Europe:

Mil'ony—vas. Nas—t'my, i t'my, i t'my.	You are mere millions. While we are hordes, and hordes, and hordes.
Poprobuite, srazites' s nami!	Try and fight with us!
Da, skify—my! Da, aziaty—my,	Yes, we are Scythians! Yes, we are Asians,
S raskosymi i zhadnymi ochami!	With slanted and greedy eyes!

Though far more crude and violent than Khlebnikov's manifesto, these lines once again cast the Bolshevik Revolution as an Asian revolution. Here the Bolsheviks-as-Scythians leap from premodern tribe to revolutionary vanguard, intent on decentering the West through force and terror:

My liubim plot'—i vkus ee, i tsvet,	We love the flesh—its taste, and color,
I dushnyi, smertnyi ploti zapakh . . .	And the sultry, deathly scent of flesh . . .
Vinovny l' my, kol' khrustnet vash skelet	Are we to blame if we crush your skeleton
V tiazhelykh, nezhnykh nashikh lapakh?	In our heavy, tender paws?[39]

As Ram notes, in the often empire-inflected tradition of Russian writing about Asia, this poem marks the inward collapse of East and West—"no longer dichotomies but perspectival thresholds through which Russia could contemplate the crisis of her imperial destiny." Indeed, by casting the revolutionary masses as Asians, Blok came not only to contemplate this crisis—namely, a revolution proclaiming the Russian Empire's end—but also to endorse it, to self-identify as "Scythian."[40] This is despite the poem's prophetic anticipation that efforts to forge world revolution, to bridge East and West, would yield orgiastic bloodshed—the devouring of partisans and enemies alike. As the poem ends, Europe can escape certain doom only by uniting with this cannibal tribe: in a flip side rendition of the hymn "The International" (". . . unites the human race"), Blok invites "the old world" to heed "the barbarian lyre" and join "the brotherly feast of labor and peace."[41]

Again, these lines—along with the works by Khlebnikov, Shevchenko, and Goncharova—emerged from a long tradition in Russian art and letters of using Asia as a means of self-definition. Russian symbolists like Blok had a particular predilection for looking eastward for apocalyptic renewal.[42] The distinctness of this tradition makes all the more remarkable the fact that outsiders latched on to it as well, for instance, Claude McKay. Though he apparently had limited prior exposure to Russian literature, he writes in his memoir that during his 1922 visit to address the Comintern's Fourth Congress his "senses were stirred by the semi-oriental splendor and movement of Moscow even before my intellect was touched by the forces of revolution." While there, he composed a sonnet titled "Moscow" to try to capture this splendor. It can be read as an affirmative, though

probably unintended, response to Blok's "barbarian lyre"—a reading rein-
forced by the regular use of rhymes and iambs found in both "Scythians"
and the sonnet:

> Moscow for many loving her was dead . . .
> And yet I saw a bright Byzantine fair,
> Of jewelled buildings, pillars, domes and spires
> Of hues prismatic dazzling to the sight;
> A glory painted on the Eastern air,
> Of amorous sounding tones like passionate lyres;
> All colours laughing richly their delight
> And reigning over all the colour red.
>
> My memory bears engraved the high-walled Kremlin,
> Of halls symbolic of the tiger will,
> Of Czarist instruments of mindless law . . .
> And often now my nerves throb with the thrill
> When, in that gilded place, I felt and saw
> The presence and the simple voice of Lenin.[43]

Blok's "barbarian lyre" here harmonizes into McKay's "amorous
sounding tones": once again the Bolshevik Revolution is cast as an Asian
revolution, with the Soviet capital here becoming something from *Arabian
Nights*—dazzling colors mixing with communist red, and Lenin holding
court in a golden fortress. To be sure, just as "Scythians" emerges from a
distinctly Russian literary tradition, "Moscow" evokes Western romantic
Orientalism, and accordingly, McKay's rhymes and iambs as well as (char-
acteristic) choice of the sonnet form impart to his poem a lulling, retro-
grade quality. But not just Orientalism: "Moscow" also exemplifies what
Bill Mullen has termed Afro-Orientalism—black appropriations of Asia
that serve to sidestep the "crushing oppositional hierarchies" of Ameri-
can racism.[44]

Taking a step back, we can say that Khlebnikov, Blok, and McKay wrote
from quite different contexts and yet arrived at similarly strange, counter-
intuitive visions of the Bolshevik Revolution. Each cast it as an expression
of archaic desires and passions, and about the clash of cultures (East versus
West) rather than classes. Though not necessarily bound to the party or

Comintern, these estranging views, I would like to suggest, served to extend the revolution's reach—to make it more appealing to non-Europeans, McKay here providing a case in point. Again, he was in Moscow to address the Comintern, specifically on the plight of African Americans, and as others have shown, he helped shape the organization's views on the so-called Negro question. However, far more poignant than his participation in the Fourth Congress is McKay's very enchantment with Moscow. As he recalls in his memoir,

> Never in my life did I feel prouder of being an African, a black, and no mistake about it. Unforgettable that first occasion upon which I was physically uplifted. . . . As I tried to get through along the Tverskaya I was suddenly surrounded by a crowd, tossed into the air, and caught a number of times and carried a block on their friendly shoulders. The civilians started it. The soldiers imitated them. And the sailors followed the soldiers, tossing me higher than ever.
>
> From Moscow to Petrograd and from Petrograd to Moscow I went triumphantly from surprise to surprise, extravagantly fêted on every side. I was carried along on a crest of sweet excitement. I was like a black ikon in the flesh. The famine had ended, the Nep was flourishing, the people were simply happy. I was the first Negro to arrive in Russia since the revolution, and perhaps I was generally regarded as an omen of good luck! Yes, that was exactly what it was. I was like a black ikon. (168)

As others have noted, this passage combines racial pride on the one hand and a willingness to become an "ikon"—that is, to accept the Comintern's latent essentialism, the role of "stand-in African" assigned to him.[45] But I would also like to emphasize a more subtle allure operating here: his spelling of "ikon" (as opposed to "icon") suggests that, as he was being foisted above Moscow's streets, he imagined himself as a religious icon (*ikona*) and, hence, "omen of good luck"—Jamaican American poet as Russian Orthodox saint, painted on wood, kissed by parishioners.[46] In other words, not only did McKay admire the "Byzantine" qualities of Moscow's "jewelled buildings, pillars, domes and spires," that is, Orthodox churches, but also, in a sense, he himself became "Byzantine," identifying with Russia just as Khlebnikov and Blok identified with Asia.[47] McKay was not alone

in doing so: the Soviet Union's perceived exoticness also impressed Lovett Fort-Whiteman, who in 1924 became the first African American to receive Comintern training in Moscow. Upon his return to Chicago as a communist organizer, he "affected a Russian style of dress, sporting a *robochka* (a man's long belted shirt) which came almost to his knees, ornamental belt, high boots and a fur hat." By one account he resembled a "Buddhist monk"; by another, a "veritable Black Cossack" whose "high cheekbones gave him somewhat of an Oriental look."[48]

All this is to present Moscow and the revolution as uncannily inclusive, as promoting not only class-based equality but also unexpected cross-cultural encounters. These encounters had the power to transform perception, giving rise to these feverish visions of the Bolsheviks as Asian and blackness blurring with Russianness. (Indeed, to boost recruitment in the early 1930s, black communists in New York distributed busts of Aleksandr Pushkin and flaunted his Ethiopian ancestry.[49]) To be sure, not all minority visitors to interwar Moscow found the city so welcoming: incidents of racism were reported to and punished by Soviet authorities.[50] However, the point here is not to gauge the extent to which such visions corresponded with reality but to pursue the imaginative possibilities that they opened. These visions are particularly useful in undercutting received notions of the Soviet Union as "cold, stern, rational"—as a gray place where utopian dreams went to die.[51] Tatlin, Khlebnikov, Blok, and McKay highlight instead the colorful allure of revolution, the "magic" behind the "magic pilgrimage."

Such visions were widespread enough—both in the USSR and beyond—that at least one prominent Soviet official felt compelled to weigh in. Clearly these artists and writers had gone too far: in 1926 Commissar of Enlightenment Anatoly Lunacharsky asserted, "Yes, we shall rise at the head of Asia. We shall even arm Asia with European thought, but not for the purpose of 'crushing her skeleton' with our Scythian embrace." Contra Blok, Lunacharsky insisted that the Bolsheviks were "by no means opposed to European civilization" and that the world revolution would fulfill, not destroy this civilization. According to him, too many Western communists—disenchanted with modernity after World War I—had given in to "decadent mysticisms and passivities." This led them to place "much less hope in their own proletariat than in those phantom hordes which their imaginations invoke out of Asia." In addition to being anti-Marxist,

the problem with such fantasies was that they were stifling revolution in Europe, strengthening the resolve of the Bolsheviks' opponents. Thus, Lunacharsky declared, "we must absolutely establish our position in this question and destroy the myth that we are the banner-bearers of a new religion."[52] In short, visions of the Bolshevik Revolution as premodern and Asian were to cease, but this was far from the final word on the matter. Just two years later, the director Vsevolod Pudovkin released his own "phantom hordes" to the world in his stunning film *The Heir of Genghis Khan* (1928, released in English as *Storm Over Asia*). Set in Mongolia during the Russian Civil War, it shows British expeditionary forces capturing what they believe to be Genghis Khan's heir, but their efforts to turn this modest hunter into a puppet ruler end with him tearing down their headquarters with his bare hands, riding on horseback with sword raised, and leading a horde that literally blows the British across the steppe. "O, my people, rise in your ancient strength and free yourselves!" read the film's final intertitles. Lunacharsky's declaration notwithstanding, notions of the Bolshevik Revolution as an Asian revolution persisted.[53]

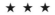

Nonetheless, Lunacharsky raised an important objection. While they clearly exceeded party politics and pragmatism—that is, the Kremlin's "gestural solidarity" to oppressed nations—what political function did these iconoclastic visions serve? Were they progressive or regressive—innovative harbingers of a liberated culture that would unite the human race, or violent echoes of a Western primitivism that had long reinforced racial hierarchies? We can respond to these questions and situate these visions within a legibly Marxist tradition with the aid of Walter Benjamin—and, in particular, his own impressions of the Soviet Union during his 1926–1927 visit to Moscow. His goals there were to witness Russia firsthand and explore future writing collaborations, but primarily to pursue a fruitless romance with his Latvian communist muse, Asja Lacis. Unlike McKay, he was not there in an official capacity and interacted mostly with fringe, predominantly Jewish cultural figures. (McKay, in contrast, met the cream of Moscow's political and cultural elite—Trotsky, Zinoviev, Lunacharsky, Mayakovsky.[54]) Nonetheless, Benjamin's experience was similar to McKay's in that he found a city filled with strange and unexpected enchantments, which he also linked to its supposed Asianness. Benjamin's writings add to such descriptions a

theoretical framework that helps us to see them as both radical and portable, that is, not exclusive to the distinct traditions of Russian modernism, Afro-Orientalism, and the West's relegation of Russia. More to the point, Benjamin enables us to impart both revolutionary and avant-gardist credentials to the seemingly retrograde notion of the Bolsheviks as Asian.

He does so through his description of the "new optics" that he gained in Moscow, which informed his subsequent theories of both revolution and avant-gardism. Moscow bombarded him with "vivid perceptions" that resulted in part from the astounding "degree to which the exotic surges forth from the city."[55] He later came to associate these perceptions with surrealism, recalling near the start of his 1929 essay on the group surrounding André Breton,

> In Moscow I lived in a hotel in which almost all the rooms were occupied by Tibetan lamas who had come to Moscow for a congress of Buddhist churches. I was struck by the number of doors in the corridors that were always left ajar. What had at first seemed accidental began to be disturbing. I found out that in these rooms lived members of a sect who had sworn never to occupy closed rooms.[56]

Tibetan lamas housed together with German Jewish cultural critic: this is the very kind of juxtaposition that Breton prized. He endorsed the bridging of distant realities to enable new forms of expression, and accordingly, Benjamin likens this Moscow encounter to the shock of reading Breton's Nadja—both providing "an intoxication, a moral exhibitionism, that we badly need." Of course, it was Benjamin's project to harness such intoxication and exhibitionism for socialism, to show how the avant-garde's "magical experiments with words" could help spark revolution. The key was to see beyond veneers and get at "the true face of a city," "where ghostly signals flash from the traffic, and inconceivable analogies and connections between events are the order of the day." Benjamin here had Paris in mind, but it seems he found the "inconceivable" more readily present in Moscow. He appreciated the city as a place that was (and remains) spatially disorienting, with labyrinthine streets, shoving crowds, as well as map names and borders shifting without warning. He described it as a city on guard against the visitor: Moscow "masks itself, flees, intrigues, lures him to wander its circles to the point of exhaustion."[57] It was

also disorienting in the broader sense that this was the furthest he would ever venture from Western Europe. As he wrote to a friend soon after his arrival, "you never lose consciousness of just how remote from everything this metropolis (two and a half to three million inhabitants) is." However, just over two weeks later, he saw how such remoteness could be put to good use. He reports in his diary the popularity of a map "on which the West is a complex system of small Russian peninsulas." Used in Vsevolod Meyerhold's experimental production *Give Us Europe* (*Daesh' Evropu*, 1924), it seems to have anticipated by several years the famous "Surrealist Map of the World," published in the Belgian magazine *Variétés* in 1929, with the Pacific in the center, the continental United States absent, and Europe as a tiny appendage to an outsized Russia.[58]

What I am suggesting here is that Benjamin's Soviet stay informed his subsequent views on surrealism—a visit to Moscow in 1926 as akin to reading Breton or smoking hashish. These experiences opened dreamlike, unexpected ways of seeing, though Moscow was unique in that the source of this disorientation was the city itself. This becomes more evident by turning from Benjamin's experience of space there to his experience of time. According to him, his Moscow writings concentrate "less on visual than on rhythmic experience, an experience in which an archaic Russian tempo blends into a whole with the new rhythms of the Revolution."[59] He elaborates on this blend in his essay "Moscow," where for the locals "minutes are a cheap liquor of which they can never get enough . . . they are tipsy with time." In the face of nothing turning out as planned, he concludes that, in his use of time, "the Russian will remain 'Asiatic' longest of all."[60] Thus, here again we find an association between Russia and Asia, though at first glance this is merely a Westerner's complaint about Slavic "backwardness"—bafflement that the revolution could have unfolded here.

Similar to Trotsky, though, Benjamin was able to transform this seeming deficiency into a virtue. In Moscow he was able to rethink the movement of time, to stretch and imbibe minutes so that time itself became an intoxicant. The resulting uncertainty—for instance, whether the hotel would deliver his morning wake-up knock (presumably he kept his door closed)—became a source of possibility:

The real unit of time is the *seichas*. This means "at once." You can hear it ten, twenty, thirty times, and wait hours, days, or weeks until the promise

is carried out. By the same token, you seldom hear the answer no. Negative replies are left to time. Time catastrophes, time collisions are therefore as much the order of the day as *remonte* [building renovation]. They make each hour superabundant, each day exhausting, each life a moment.

Through this distinctly Russian emphasis on the *seichas*, Benjamin identifies an unruly temporality marked by density—the collision and accumulation of distinct moments of time. For instance, he describes the public transport system as evincing the "complete interpenetration of technological and primitive modes of life," with conductresses standing "fur-wrapped at their places like Samoyed women on a sleigh." He encounters similar collisions of time in the everyday consumer goods being sold on Moscow's streets—for example, a traditional black lacquer box with a cigarette girl painted on it (dubbed by him "Soviet 'Madonna with the Cigarettes'"), Orthodox icons and Lenin portraits displayed side by side, and handmade wooden folk toys that captured the diverse styles of Russia's "hundreds of nationalities" and that he feared would disappear in the face of progress.[61] As art historian Christina Kiaer has emphasized, more than political meetings or official decrees on art and literature, what attracted Benjamin in Moscow was this ubiquitous intermingling of old and new.[62] Historical possibilities came in the form of that strangely "Asiatic" temporality—the ability to rethink and disrupt the flow of time.

Here we find more echoes of Tatlin, Khlebnikov, Blok, and McKay, but with this difference: Benjamin uses such descriptions explicitly to articulate new understandings of both revolution and the avant-garde. The key is this use of *seichas*, which, as he indicates, when spoken can be translated as "at once," though the literal breakdown of this common word—typically translated simply as "now"—is "this-hour" or "this-moment" (*seichas*). What I would like to suggest is that the Russian *seichas* anticipates what Benjamin would call now-time (*Jetztzeit*) in his 1940 "Theses on the Philosophy of History." As others have elaborated, now-time is precisely that sense of time not functioning as expected—"a random time, open at any moment to the unforeseeable irruption of the new." This erratic time (an eccentric cousin to "combined and uneven development") interrupts chronology through "a mediation between different temporalities within the present." More specifically, "through the prism of the historical pres-

ent" now-time seeks to capture "the presence of history as a whole"—a history awaiting revolutionary redemption.[63]

In his 1940 theses, Benjamin illustrates now-time through Robespierre's embrace of ancient Rome, the fact that "the French Revolution viewed itself as Rome incarnate."[64] We can add to this his accounts of Asiatic Russians and Samoyed conductresses—these instances of *seichas* that take on revolutionary significance when recast as *Jetztzeit*. Through this Benjaminian lens, they become constellations of past and present that serve to shatter the continuum of history, or as he famously calls it, "homogeneous, empty time."[65]

Benjamin's 1929 "Surrealism" piece similarly decouples the avant-garde from progress. In Peter Osborne's words, one of the essay's achievements is its "reintroduction of historical time into the conceptualization of Surrealist experience"—its emphasis on temporal as well as spatial estrangement.[66] Specifically, Benjamin praises Breton as "the first to perceive the revolutionary energies that appear in the 'outmoded,' in the first iron constructions, the first factory buildings, the earliest photos, the objects that have begun to be extinct, grand pianos, the dresses of five years ago, fashionable restaurants when the vogue has begun to ebb from them." According to Benjamin, embedded in such relics are destitution, thwarted desires, and, thus, revolutionary nihilism. In short, he praises surrealism for its disruptive invocations of the past—more specifically, its ability to substitute "a political for a historical view of the past"—which for him is what makes this branch of the avant-garde revolutionary.[67] However, Benjamin elaborates on this only much later (in the 1940 theses as well as in "Paris—Capital of the Nineteenth Century") through his notion of the "dialectical image," which he defines as "images in the collective consciousness in which the new and the old are intermingled," and more cryptically as "the involuntary memory of redeemed humanity." While we can label as surreal any image that bridges distant realities, Benjamin's dialectical image is more ambitious, running across "the whole horizon of the past" like "ball lightning" in order to arrest historical progress, in order to capture "now-time":

> In the dream in which every epoch sees in images the epoch which is to succeed it, the latter appears coupled with elements of prehistory—that is to say of a classless society. The experiences of this society, which have

their store-place in the collective unconscious, interact with the new to give birth to the utopias which leave their traces in a thousand configurations of life, from permanent buildings to ephemeral fashions.[68]

One vivid illustration of this coupling is Benjamin's juxtaposition of the modern bomber plane with Leonardo da Vinci's dream of airplanes that would deliver mountain snow onto sweltering cities in the summer. That is, the dialectical image refers not to an actual image but to a particular way of seeing or reading—one able to detect past, thwarted utopias in "a thousand configurations" of present-day life, from Parisian arcades to Samoyed conductresses to wooden toys. The dialectical image reveals in these fragments of the everyday traces of a "communistic society at the dawn of history." It captures history's disappointments but also the unfulfilled hopes that persist alongside them—dreams, in Michael Löwy's words, of a "lost prehistoric paradise."[69]

Several have noted the avant-gardist underpinnings of Benjamin's dialectical image—its montagelike juxtaposition of present and past, its reliance on "discontinuous multiplicity," its experimental effort to uncover "what is 'truly new' in the present."[70] At this point, though, it is necessary to present a more precise definition of avant-garde vis-à-vis Jetztzeit and the dialectical image. Of course, the most prominent definitions of this term turn on the alienation of artists (as Renato Poggioli has it), the tearing down of art institutions (Peter Bürger), and the dismantling of high-low divides (Andreas Huyssen). However, in his discussion of Benjamin, Osborne adds another definition that complements rather than replaces those that went before and that here proves useful: the avant-garde as "that which, in the flash of the dialectical image, disrupts the linear time-consciousness of progress in such a way as to enable us, like the child, to 'discover the new anew' and, along with it, the possibility of a better future."[71] In short, Osborne defines avant-gardism as the abandonment of empirical history, that is, of the chronological succession from old to new. In its place, this avant-gardism reimagines the movement of time, indeed, imagines the cessation of time—or, at the very least, keeps alive memories of those past, thwarted utopias for the sake of future redemption. This requires opening notions of the avant-garde to both new and old, specifically to premodern, nonlinear understandings of time—as Susan Buck-Morss puts it, the "ur-old theological myth of worldly utopia as the origin and goal of history."

Thus, Osborne's connection of dialectical image and avant-garde enables us to reconcile the latter to the archaic and traditional.[72]

Bringing this back to Moscow, Benjamin's encounter with the Tibetan lamas now assumes added significance. Not only is this a surreal encounter, but with the lamas' refusal of closed doors, it also hints at that "communistic society at the dawn of history" later referenced by him. Here we find a constellation of past and present—older forms of communism in the heart of twentieth-century communism. (Indeed, Benjamin notes in his diary the lamas' "red and yellow coats," the same colors as the Soviet flag.[73]) We can apply a similar reading to McKay's "Moscow." Even though its sonnet form is not discernibly experimental, it can still be considered avant-gardist in Osborne's sense of the term. Blurring Byzantine hues with communist red, the poem has the effect of undercutting empirical history; and indeed, from this perspective, McKay's traditional use of form only accentuates the poem's combination of archaic legend and socialist revolution. Similar readings can be applied to Blok's "Scythians," Khlebnikov's "Indo-Russian Union," and of course Tatlin's Tower. Though hailing from distinct artistic traditions (Russian symbolism, futurism, and constructivism, respectively), each of these examples constellate past and present so as to estrange but also advance the project of world revolution. In short, Benjamin's dialectical image enables us (with Osborne's help) to group these very different figures into a shared avant-garde. Oriented toward both future and past, this was an avant-garde that was open to cultural difference—indeed, one in which "Asiatic" Russians and Tibetan lamas could play leading roles.

American Ethnicity, Soviet Nationality

It would be premature to call this shared avant-garde the ethnic avant-garde. Rather, the point so far has been to lay out the notions of revolution and avant-gardism undergirding this grouping. The task now is to unpack the accompanying notion of the ethnic, which up to this point I have vaguely associated with "oppressed nations" and premodern cultures. The challenge now is to arrive at a more precise understanding of this term so as to better fuse it with the avant-garde. More specifically, I would like to suggest that, just as it is possible to rethink notions of avant-gardism via the Soviet Union, the same can be done for ethnicity.

As noted, a growing number of scholars—predominantly American-
ists—have shown how Moscow's promises of equality appealed to a veri-
table who's who of black activists and intellectuals, including McKay,
Hughes, Paul Robeson, and W. E. B. Du Bois. Largely missing from this work,
however, has been an emphasis on the jarring and, I think, productive gaps
between American and Soviet conceptualizations of difference. In this sec-
ond part of the introduction, I highlight these gaps in order to arrive at a
new, defamiliarized understanding of ethnicity—one also oriented toward
both past and future and therefore well suited to the avant-gardism spelled
out in the preceding. Making this claim requires a detour from avant-gard-
ist discourses to those of race, ethnicity, and nationality. To be sure, there
is historical overlap among these discourses, beginning with the fact that
the now ubiquitous term "ethnic" and the "ethnicity paradigm" came into
formation in the early decades of the twentieth century, that is, at roughly
the same time that the likes of Tatlin and Benjamin sought new ways of
seeing. However, the ethnicity paradigm emerged in a very different place,
namely, the United States, which explains this book's pairing of the U.S.
and the USSR. Through much of the twentieth century, these vast, diverse
countries laid competing claims to global preeminence by touting domes-
tic inclusion and assailed each other's failures to live up to stated ideals.[74]
From the perspective of the post–Cold War present, American civil rights
and "multiculturalism" apparently prevailed over Soviet nationalities
policy and "multinationalness" (*mnogonatsional'nost'*). Nonetheless, Soviet
approaches to countering racism still provide useful, estranging counter-
points to the now-globalized discourse of American ethnicity.

Simply because it does seem so familiar today, my starting point is eth-
nicity. During the interwar years, it remained a malleable and open-ended
concept, emerging from the efforts of social scientists to unseat the no-
tion that biological racial divides were intractable and that races could
be ranked as superior or inferior. Ethnicity instead emphasized cultural
differences that were socially rather than biologically acquired. Beyond
this antiracialist stance, however, there was much room for variance. The
anthropologist Franz Boas, for instance, valorized distinct cultures and
sought to appreciate them on their own terms. Against the linear evolu-
tionist notion that some were "advanced" and others "backward," he in-
stead dispersed different groups spatially in a simultaneous present that
allowed for cultural intermixture. However, several have noted a latent

assimilationism in his work, with Johannes Fabian charging Boas's synchronic, culturalist emphasis with simply ignoring rather than remedying the problem of Western anthropology's "denial of coevalness."[75] The sociologist Robert Park, on the other hand, emphasized the ability of cultures to adapt and transform, especially in urban settings, and viewed assimilation as a means of social progress. His assimilationism, in contrast to Boas's, was overt, though several have noted a latent nostalgia for cultures lost in the process.[76] Thus, as Michael Omi and Howard Winant have noted, from its earliest articulations in the 1920s and 1930s, the American ethnicity paradigm has been marked by tensions between pluralism and assimilationism, or what Rey Chow has more recently called particularistic practices and universalist aspirations. Chow describes this tension in terms of time: even today, in the eyes of the dominant society, the ethnic Other is confined to "an earlier (temporally arcane) condition of humanity" but also cast as "politically avant-garde" and "future-oriented, always looking ahead to the time when the United States will have fully realized its universal ideals."[77]

Chow's use of "avant-garde" emphasizes the term's typical, forward-looking connotation, something I have complicated through the dialectical image and Benjamin in Moscow. However, she also underscores the different temporalities of ethnicity, which here gestures toward both descent-based identities and forward-looking politics, to both past and future. This suggests that one way to link ethnicity and avant-gardism (as framed in the preceding) would be to emphasize their similarly variegated temporalities. However, for Chow this aspect of ethnicity is not something to celebrate but an expression of its contradictory, irrational nature. Her project is to correct this by situating ethnicity vis-à-vis class in a globalized present. Thus, in order to link ethnicity and avant-gardism during the interwar years, I find it necessary to follow a different route, to turn away from American discourses of ethnicity and to channel this term through Moscow, just as I did with the avant-garde. More specifically, in the following I juxtapose the American ethnicity paradigm with its Soviet analogue—Soviet nationalities policy.

If American ethnicity was wrought by tensions between pluralism and assimilationism, the particular and universal, the past and future, what I would like to suggest is that the Soviet concept of nationality allowed for, if not resolved, these tensions. For American minorities drawn to the USSR,

this concept made it possible to look both backward and forward—to embrace descent-based particularism in a way that advanced universal equality. This is evident, for instance, in Richard Wright's much-cited encounter with the writings of Joseph Stalin, himself a minority (Georgian) who served as the Bolsheviks' first commissar for nationalities affairs. In Chicago of the early 1930s, Stalin's essays on the national and colonial question prompted Wright's conversion to communism, but also, in William Maxwell's words, his "movement from fear to relative faith on the subject of African-American folk culture."[78] That is, whereas Wright—under Park's influence—had previously disdained both this culture and his own southern roots, Stalin's writings prompted a reconsideration. As he recalls in a 1944 essay,

> I had read with awe how the Communists had sent phonetic experts into the vast regions of Russia to listen to the stammering dialects of people oppressed for centuries by the tsars. I had made the first total emotional commitment of my life when I read how the phonetic experts had given these tongueless people a language, newspapers, institutions. I had read how these forgotten folk had been encouraged to keep their old cultures, to see in their ancient customs meaning and satisfactions as deep as those contained in supposedly superior ways of living. And I had exclaimed to myself how different this was from the way in which Negroes were sneered at in America.[79]

To be sure, Wright never made the "magic pilgrimage," meaning his grasp of Soviet nationalities policy was limited largely to Stalin's word; he was far from an authority on the topic. However, Moscow did indeed deploy teams of linguists and ethnographers to make sense of the diverse peoples it had inherited from the Russian Empire, as well as to bolster the cultural development of its minorities. Particularly in the 1920s, the Soviet state promoted a remarkable degree of cultural diversity—in historian Yuri Slezkine's words, "a feast of ethnic fertility, an exuberant national carnival." This was done partly to convince the world of the Bolsheviks' anti-imperialist credentials but also to rush their own "backward" minorities through historical stages—from feudal tribes to capitalist nations, which would pave the way for socialist unity.[80] That is, in contrast to Boas's synchronic emphasis, Soviet nationalities policy was diachronic and, indeed, unabashedly evolutionist. Its long-term aim was assimilation into a Soviet

whole, but it also claimed to preserve national particularities and to erase cultural hierarchies. Just as the Comintern worked to enfold distinct liberation movements into a unified world revolution, the Soviet state sought to embrace both particularism and communism, both "old cultures" and a liberated future.

I subsequently highlight the shortcomings of Soviet nationalities policy, but the point for now is that, in the 1920s and 1930s, it seemed to provide an alternative to American approaches to difference—and, in particular, to Boas's latent and Park's overt assimilationism. This becomes more evident by turning to another of the architects of the ethnicity paradigm, the philosopher Horace Kallen, who in 1927 did make the "magic pilgrimage" to the Soviet Union, named it one of two "frontiers of hope" for all Jewish people (the other being Palestine), and today is regarded as a forefather of late twentieth-century liberal multiculturalism.[81] Hailing from a German Jewish immigrant family, Kallen is now best known for coining the term "cultural pluralism," which has come to be associated with the antiassimilationist strand of the ethnicity paradigm. What I would like to suggest is that the Soviet concept of nationalities was quite compatible with this strand, that is, compatible with Kallen's notion of pluralism. This becomes evident by juxtaposing two seminal texts that were written just two years apart but have not yet been discussed together: Kallen's "Democracy Versus the Melting-Pot" (1915) and Joseph Stalin's "Marxism and the National Question" (1913). The point here is not influence but defamiliarization. Placing into dialogue the fathers of American cultural pluralism and Soviet nationalities policy reopens a historical moment in which concepts of race, ethnicity, and nationality remained unformed and contingent.

Accordingly, the thrust of both essays is their common effort to work through terms that, in the second decade of the twentieth century, were still up for grabs. Pronouncing the failure of Anglo-Saxon "Americanization" in the face of "primary ethnic differences," the Kallen essay claimed that what appeared to be assimilation was actually the first step toward "dissimilation": new immigrants learned English in order to attain economic independence, but once this was achieved, the "solitary spiritual unit" of each "ethnic group" expressed itself through "arts, life, and ideals":

Ethnic and national differences change in status from disadvantages to distinctions. All the while the immigrant has been using the English

language and behaving like an American in matters economic and political, and continues to do so. The institutions of the Republic have become the liberating cause and the background for the rise of the cultural consciousness and social autonomy of the immigrant Irishman, German, Scandinavian, Jew, Pole, or Bohemian. On the whole, Americanization has not repressed nationality. Americanization has liberated nationality.[82]

In short, one could become both more American and more ethnic, though as many commentators have noted, this vision relied on a latent racialist logic that willfully ignored blacks. Put differently, Kallen failed to disentangle his vision of culture from race,[83] a failure that is reflected in his inconsistent use of terms. As seen in this passage, he presented "ethnic" and "national" as synonyms, and elsewhere used "national group" in place of "ethnic group" (218). He also evidently linked "nation" to a combination of blood and culture, and in the same essay coined the term "natio" to identify each group's irreducible kernel—the result, he wrote, of "biological processes" and man's "psychophysical inheritance" (219, 220). According to Kallen, "external" factors, such as economic and political ties, only masked the "internal" constant of the "natio," expressed in "inevitable aesthetic and intellectual forms," that is, particular cultures and languages. In response, America should strive to be a "symphony of civilization" that combined "harmony and dissonances and discords" into "an orchestration of mankind" (220).

More than his pseudoscientific essentialism, Kallen's wavering between "ethnic" and "national" would have irked Stalin, whose 1913 essay sought precisely to distinguish and champion the latter term. Published when the Bolsheviks were just a branch of the larger European left and directed against an Austrian social democrat's endorsement of "cultural-national autonomy," the essay defined the nation as a stable, historically constituted community of people with a shared (1) language, (2) territory, (3) economic life, and (4) "psychical disposition, manifested in a community of culture."[84] According to him, neither a "tribe" nor a "race" (which he regarded as premodern groupings) could fulfill all four criteria, the most important being territory. Each nation (a modern grouping) was to be granted its own fixed territory, although he added that various nations should be required to coexist within larger autonomous regions—that is, "such crystallized units as Poland, Lithuania, the Ukraine, the Caucasus, etc.," each with its own "national minorities." Coexistence within a single

region would spur the gradual displacement of national by class divisions. However, Stalin's emphasis on territory did not mean a complete dismissal of culture and "psychical disposition": when laying out this part of his definition, he noted that while "national character" changed with the "conditions of life," nonetheless "it exists at every given moment, it leaves its impress on the physiognomy of the nation" (6). Thus, Stalin imparted to each nation a fixed inner essence—or "ethnos," as Soviet ethnographers later called it.[85]

In short, Kallen and Stalin both allowed for the fixedness of descent-based identities ("natio" and "ethnos," respectively), and both stressed the persistence of language. On the other hand, as noted, Kallen downplayed the importance of "economic life," though interestingly, in a 1924 republication of "Democracy Versus the Melting-Pot," he subtly revised his earlier dismissal of class vis-à-vis "natio."[86] This leaves the fourth and most important part of Stalin's definition, territory, which anticipated the Soviet Union's division (and ultimate dissolution) into national republics (e.g., Russia, Uzbekistan, Armenia) and, within each republic, smaller "national minority" regions (e.g., Chechnya, Tatarstan). Within these territories, members of the titular nationality (e.g., the Uzbeks in Uzbekistan) were given preferential treatment in government hiring and university admissions—a policy known as nativization (korenizatsiia) and described by one historian as a precursor to U.S. affirmative action.[87] Stalin's emphasis on territory also anticipated the Comintern's 1928 and 1930 calls for an autonomous African American republic stretching from Maryland to Arkansas—the so-called Black Belt, eerily similar in shape to Uzbekistan.[88] Remembered today mostly as a historical oddity, this assertion that African Americans constituted a Stalinist "nationality" might seem to emphasize the gulf separating American and Soviet conceptualizations of difference. However, Kallen's pluralist vision also emphasized territory, situating different groups geographically—the Irish in Massachusetts and New York, the Germans in Wisconsin, the Scandinavians in Minnesota. According to him, each group settled not in small, diverse units but in "a series of stripes or layers," which made it possible to delineate discrete ethnic territories in both rural and urban settings (192).

To be sure, Kallen did not then conclude that each American ethnicity should be granted its own region or republic. Nonetheless, when he visited the USSR in 1927, he immediately seized on the importance of territory,

particularly for Soviet Jews. According to him, an autonomous region would enable them to cease being "an alien minority among suspicious neighbors" and to instead become farmers—or as Slezkine has since put it, to transform from rootless Mercurians to rooted Apollonians.[89] In Kallen's words, the granting of territory would mark the emergence of a Soviet "Promised Land" marrying communism and Zionism:

> The homeland of Israel, say the Russian Jewish Communists, is where collective Israel can hold land and build itself homes. This also is to be, like Palestine, an agricultural homeland. . . . To make farmers of Israel was not merely the aspiration of Jews who inherited this aspiration from their fathers and their fathers' fathers, to whom it had been an article of religion since nomad days in the Arabian desert; to make farmers of the Jews was a program of Lenin's and a plan of the Central Executive Committee of the Communist Party early in the development of revolutionary Russia. (396–97)

The promise of this new homeland is what prompted Kallen to declare the Soviet Union a Jewish "frontier of hope." At the time of his visit, its location had not yet been established, but Kallen visited a few new agricultural settlements in Ukraine established with the aid of a Jewish American philanthropic organization. Here he witnessed the emergence of "a new kind of Jew," one who combined "revolutionary ideology" and "the natural scene":

> In the young it seemed liberating. They impressed me with a charming eagerness. They had something of that healthiness and buoyancy of tone that one could observe in the chalutzim in Palestine. . . . I felt in the presence of the children and the young Jews on the farms of the new settlements, as I had had occasion to feel again and again in Russia: the Jews are being transformed more radically, more completely than any of the other subjects of the Communist Party. For them more truly than for any people under the Soviets a new life is beginning. (430)

However, even amid this transformation, Kallen insisted that Soviet Jews would maintain their distinctness, their "natio," thanks to "the wise nationalist policy of the Soviet Republic" (393):

Each nationality is encouraged to develop its own language and litera-
ture, its own arts and crafts and to conduct its affairs in its own medium.
Even primitive folk who as yet have no written language are provided
with a congruous alphabet and solicited to create a literature and to keep
records of their public affairs. The whole enterprise is expensive and
inconvenient, but it is regarded as a valuable investment, for it releases
great complexes and repressed interests and ideals and satisfies long-
standing aspirations and heals many of the wounds of the past. (388–89)

Thus, according to Kallen, the Bolsheviks had achieved his vision of cul-
tural pluralism. Soviet Jews were poised to become one more unique con-
tributor to Moscow's own "symphony of civilization" (451), which he him-
self seemed to envy. Kallen anticipated that the "new Russo-Jewish world"
would be "far more Jewish than the Jewry of America and to be the matrix
of culturally far more significant Jewish values than the Jewry of America."
Jewish religion, though prohibited, would remain a part of this world's
"moral and intellectual climate," traditions would continue through "sec-
ularized memories of the past," and the predominant language would be
Yiddish (432).

The rather sensational conclusion to be drawn from Kallen's travelogue
is that the founder of American cultural pluralism himself looked to Stalin-
ist nationalities policy as a positive model. With their four-part defini-
tion of the nation and emphasis on territorial autonomy, the Bolsheviks
seemed to him well suited to the task of reconciling universalism and par-
ticularism—of making Soviet Jews both more Soviet and more Jewish. (The
fact that Jews were proportionally overrepresented among the Bolshe-
viks' ranks, unmentioned by Kallen, may have lent credence to this con-
clusion.[90]) Accordingly, historian Francine Hirsch has helpfully described
Soviet nationalities policy as promoting "double assimilation": "the as-
similation of a diverse population into nationality categories and, simul-
taneously, the assimilation of those nationally categorized groups into the
Soviet state and society."[91] Thus, the Soviets could have their cake and eat
it too: maintain fixed national identities within a melting-pot-style whole.

As noted, the official cultural expression of this balance was "nation-
al in form, socialist in culture." This was the rigid prescription that, for
instance, plays staged in Moscow be translated into Uzbek and adorned
with "Asiatic colouring"—as a disappointed Langston Hughes encountered

during his 1932 stay in Tashkent. The state delineated and enshrined lo-
cal languages, folk styles, and literary forebears, but in a programmatic,
top-down manner that paralyzed them in time.[92] More pressingly, howev-
er, Wright, Kallen, and the many other foreigners drawn to Soviet nation-
alities policy missed (at least initially) the fact that "double assimilation"
could be both "high-minded and vicious"—could advance both minority
uplift and state terror. Indeed, as Hirsch has shown, the efforts of Soviet
linguists, ethnographers, and census takers to demarcate local identities
came to assist the state in the management and punishment of peoples—
for example, in the late 1930s, the mass deportations of entire nationalities
deemed enemy or "unreliable."[93] This suggests that Wright and Kallen were
quite simply wrong about the Soviet Union. Indeed, when Moscow finally
did establish a Jewish Autonomous Region in 1934 (with considerable Jew-
ish American backing), it literally chose a frontier: a remote stretch of land
in the Russian Far East that failed to draw many permanent settlers. As an
aside, those who did make the trek eastward met a group that would soon
be sent westward—Korean farmers who had migrated to the same region
from the late nineteenth century onward, had benefited from Soviet-spon-
sored cultural institutions, and had championed the Comintern's stance
against Japanese imperialism. In 1937 Stalin deported them en masse to
Central Asia, fearing they might serve as Japanese spies.[94]

Any effort to revisit Soviet nationalities policy—including its relevance
for American ethnicity—must confront such contradictions head-on.
While "double assimilation" might have provided an alternative to the
ethnicity paradigm's universalism-particularism tension, this came at the
cost of a new, more troubling set of tensions—between, on the one hand,
minority uplift and world revolution and, on the other, state terror and
Stalinist autarchy. However, just as it was possible both to connect and dis-
tinguish the Comintern and avant-garde, the same can be done with Mos-
cow's nationalities policy vis-à-vis a distinctly Russian and Soviet way of
seeing the Other. More specifically, despite the betrayals and disappoint-
ments of this policy, it is possible to distill from it a certain practice of Sovi-
et ethnography that is fascinating if not quite redeemable, that highlights
anew a productive gap between the USSR and the West, and that brings
this all back to Tatlin's Tower and the avant-garde.

The key here is, in Slezkine's words, a "linguist, archaeologist, histo-
rian, folklorist, and ethnographer" named Nikolai Marr—one of the most

prominent and powerful Soviet academics of the 1920s and 1930s.[95] This is despite the fact that his eccentric theories have long been discredited, and indeed, as Slezkine, Clark, and others have shown, it might be best to characterize Marr more as a poet or fantasist than a scholar. Hailing from Georgia and dismayed by the dearth of linguistic research on the Georgian language, he claimed to discover a new, ancient family of languages that happened to originate in Georgia and that found its purest contemporary manifestations in Georgian and Armenian. This "Japhetic" language—named after the biblical Noah's third son (according to legend, the ancestor of Georgian kings)—was meant to unseat Western linguistics and its emphasis on Indo-European languages. Over time, the scope of the theory grew bolder and broader: Marr proceeded to discover Japhetic traces in all the languages of the world, from Native American tongues to Chinese, and asserted the existence of a previously unknown Japhetic civilization that, in ancient times, spanned from the Iberian Peninsula to the Caucasus to Asia Minor. As Marr himself suggested in 1923, this unified civilization, which superseded racial, ethnic, and national divides, was comparable to that which culminated in the Tower of Babel. The biblical tale was, in his words, "the tale of Japhetic reality," though according to him, the Japhetic civilization was scattered not by the hand of God but by Indo-European invaders—the forebears of contemporary Western Europeans, whom he never failed to condemn as oppressors and imperialists.[96] This was "provincializing Europe" par excellence: in response to the perceived slighting of Georgia by the West, Marr claimed the Caucasus as the seat of a world civilization that preceded Indo-European "barbarism."[97]

If Marr had what we would now call a subaltern perspective, one of its distinguishing features was the expectation that Soviet power would restore this lost civilization—would restore the Babel legend's single divine language. Already a respected senior academic by 1917, after the revolution his views received official endorsement and weighed heavily on all scholarly efforts to think about minority languages and cultures. His monumental success resulted from his ability to align his theories with the new political landscape: in the 1920s he wedded his Japhetic theory to a crude Marxist evolutionism positing that languages were mere superstructure, which meant that class and economic base determined language more than race, ethnicity, or nationality. By this logic, it was because of economic development that the earliest sounds enunciated by primitive man—which Marr

identified in 1926 as *sal*, *ber*, *yon*, and *rosh*—had evolved into more compli-
cated languages and would continue evolving through intermixture. Thus,
languages did not belong to discrete families but followed a set path deter-
mined by economic stages, though with each intermixture, the original
sounds as well as elements from every language would remain intact. This
evolutionary process would continue until the final economic stage, social-
ism, was achieved, and the result would be a new world language based, in
his words, "on the final accomplishments of manual and sound languages—
a new and unified language wherein supreme beauty will merge with the
highest development of mind."[98] Nationalities and "ethnic cultures"—also
mere superstructure according to Marr—would likewise give rise to a uni-
fied humanity, akin to the lost civilization posited by his Japhetic theory (re-
branded in the late 1920s as his "New Theory of Language"), which in turn
evoked the Book of Genesis.[99]

For my purposes, the most salient aspect of "Marrism" is its align-
ment with the Tower of Babel legend, which provides an unexpected
link between Marr and Tatlin. Both can be seen as updating the legend;
both incorporated it into their eccentric visions of the socialist world
to come. However, Marr underscored more explicitly than Tatlin—and
more vividly than his fellow Georgian Stalin—the notion that even in
this future world, each language and culture from the past would be pre-
served. Here was a diachronism that posited the existence of "backward"
and "advanced" peoples (against Boas's synchronic emphasis) but vehe-
mently rejected placing them in any hierarchical relationship (against
the biological racism often associated with such evolutionist schemes).[100]
Indeed, in his pursuit of both socialist unity and Japhetic forebears, Marr
insisted that one could be both "backward" and "advanced" simultane-
ously: a single people could encompass within it "every epoch of the
cultural history of mankind, including even our own modernity."[101] In
line with Benjamin's constellations of past and future, Marr advanced
a class-based evolutionism built on premodern ruins. That is, he situ-
ated all peoples in a class-based evolutionary track that paradoxically
remained distinct from notions of linear progress—an evolutionism at
odds with homogeneous, empty time. Accordingly, Marr was a leading
promoter of one of the more bizarre (and enduring) practices of Soviet
nationalities policy—the systematic assignment of ancient cultural fore-
bears to each people.[102]

To be sure, this counterintuitive, contradictory evolutionism may have been pure fantasy, dreamed up by Marr to serve various professional and political needs. And while Marr and Tatlin may have conveyed similarly iconoclastic takes on time and history, it is important to note that while Tatlin's Tower never got off the ground, Marr's theories enjoyed official state sanction from the 1920s through the 1940s. Until his death in 1934, Marr himself prominently served on several key commissions and institutions that both informed and were informed by Soviet nationalities policy. His close association with the regime, coupled with the professional and physical harm that befell his detractors, has cast a long shadow on his legacy.[103] However, his (again, roundly discredited) theories did bear some salvageable fruit in the form of an ethnographic practice that emphasized empathy and close collaboration—a stripping away of the divide between scholar and subject. Marr's goal was to serve the periphery, to show, in Vera Tolz's words, that minorities "were not peoples outside history but central to understanding the origins of European civilization and key players in its development."[104] As Tolz has shown in her recent study of Russian-turned-Soviet Orientologists (including Marr), the result was a commitment to valorizing and preserving minority cultures as well as to treating local informants as equals. This group of scholars criticized their Western colleagues' complicity with imperialism and view of Asian religions as text-bound and static. In a departure from Western anthropology's "denial of coevalness," these Soviet scholars "denied altogether the essential differences between the traditions of Europe and the 'East' "—for instance, asserting Buddhism and Islam's compatibility with Marxism and modernity. They embraced the Asian Other but in ways that avoided the pitfalls of Western Orientalism; and indeed, Tolz has suggested that Edward Said's very notion of Orientalism owes an indirect intellectual debt to Soviet Orientology.[105]

Through this turn to Soviet nationalities policy and then to Marr and his colleagues, we have ventured a long way from American ethnicity. As outlined here, in contrast to the then still-emergent ethnicity paradigm, Soviet approaches to difference in the 1920s and 1930s made it hypothetically possible for all nationalities to evolve into a single socialist people but remain both spatially and temporally dispersed. Through Moscow's nationalities policy, one could be rooted on a clearly defined plot of land (e.g., Uzbekistan, the Black Belt) and simultaneously reconcile past and

future, tradition and socialism. The writings of Nikolai Marr pushed this further, imagining difference in such a way that shattered received notions of time and history, combining visions of ancient past and liberated future. This expansive approach to time should ring a familiar bell given its resonance with the modernists and avant-gardists discussed earlier in this introduction—for example, the neoprimitivists' identification with Asia and the notion of the Bolshevik Revolution as Asian. What this points to is a convergence of avant-gardism and ethnography—bound by estranging yet empathetic views of the Other and the sundering of homogeneous, empty time. Indeed, Benjamin himself was drawn to what he called Marr's "generally rather strange ideas," which he saw as invalidating "the concept of race, and indeed of peoples, in favor of a history of language based on the movements of classes"—but always with an eye toward the past: Benjamin sought to use Marr and other leftist linguists to unlock the "ancient truth" of language's "inherently expressive character, its physiognomic powers," the goal being to articulate a new, noncapitalist conviviality.[106] Accordingly, in the late 1920s, Marr was in a study group with Sergei Eisenstein and others, pursuing such questions as "the survival of primitive expressive forms in our languages of today." Likewise, as Clark points out, Marr himself frequently foregrounded the Scythians in his work at "a time when Scythianism was a dominant literary movement in the Soviet Union"—a movement that included, of course, Aleksandr Blok, who was an avid reader of Russian Orientology. And, as one more instance of Marrism converging with the avant-garde, there are clear affinities between his theories of a unified language and futurist *zaum* poetry.[107] Marr's four original, prelogical sounds (*sal, ber, yon, rosh*) themselves seem to echo *zaum* (e.g., Alexei Kruchenykh's famous "Dyr bul shchyl" from 1913).

While the first part of this introduction tied the ethnic avant-garde both to the Comintern and to the Soviet avant-garde's outreach to the non-Western Other, this second part has emphasized how Soviet policy and science conceptualized "national," linguistic, and cultural difference. I have complemented Vladimir Tatlin's Tower of Babel iteration with Nikolai Marr's version of it; or, put differently, turned from my reading of Tatlin's spirals as avant-garde vis-à-vis vanguard to the spirals as avant-garde vis-à-vis ethnography. In any case, the goal here has been to articulate new ways of seeing both the

avant-garde and the ethnic: the former as embracing ancient cultures to bolster artistic innovation and political revolution (itself recast as historical arrest), the latter as pressing "national" homelands for the sake of socialist unity and joining romantic millenarianism to Marxist evolutionism. Taken together, these alternative understandings of ethnicity and avant-gardism provide the conceptual scaffolding for the ethnic avant-garde. They allow us to group together the transnational, cross-ethnic encounters covered in this book—encounters highlighting the ability of minority cultures to collapse past and future, modern and premodern, East and West.

Arguably, these iconoclastic ways of seeing simply could not hold. As Buck-Morss has suggested, the Bolshevik regime ultimately had little use for the avant-garde's irruptive temporality—useful for revolution, but less so for state building—and in 1934 enshrined socialist realism as official dogma.[108] Through the 1930s, linguists and ethnographers allied to Marr suffered a similar fall from state-sanctioned grace, and in 1950 Stalin himself explicitly rejected Marr's "Promethean linguistics" in favor of more conventional understandings of language and identity.[109] It thus seems fitting to look to Tatlin's Tower not just as the conceptual scaffolding but also as an emblem for the ethnic avant-garde. Because the tower was never realized, it today evokes the fleeting aspiration that artistic experimentation could advance in harmony with revolutionary politics. Indeed, there were some who claimed that the tower could never have been built, that it—like Marr's theories—was unsound. Likewise the ethnic avant-garde as a historical formation was momentary and stunted, but as will be seen, it persisted (and persists) as a utopian aspiration long after the interwar years.

To varying extents, each of the chapters draws from the tower in order to illustrate different aspects of the ethnic avant-garde. Chapter 1 takes as a starting point the tower's likeness to the Tower of Babel—the ethnic avant-garde as the joining of languages. The case in point here is the futurist Vladimir Mayakovsky's distinctive poetic form: Soviet critics believed that his fragmented, staircase lines (visually reminiscent of Tatlin's Tower) and irregular rhymes and rhythms could incorporate minority voices without sacrificing their particularities. The chapter tests this potential by following Mayakovsky on his 1925 visit to the United States via Cuba and Mexico, during which he wrote two Russian-language poems depicting Havana's Afro-Cuban community. Langston Hughes later translated these poems in Moscow in 1933, discarding Mayakovsky's signature form and,

in doing so, throwing into question the futurist's ability to speak for the Other. However, by highlighting the gaps separating Russian and English, English and Spanish, Hughes can also be seen as realizing Mayakovsky's efforts to cross yet maintain linguistic distinctions. Drawing from various theories of translation, I argue that the two poets are best seen as collaborators in what Walter Benjamin called the task of the translator—namely, the integration of "many tongues into one true language" without sacrificing "the freedom of linguistic flux."

Chapter 2 turns from language and translation to a futurist technique known as factography, another binding agent for the ethnic avant-garde. In line with Tatlin's Tower, this technique sought to bring art into life, but it did so by turning from iconoclasm to the "precise fixation of facts." However, factography understood facts as the result of process rather than reflection, and this left room for experimentation and estrangement—facts as emerging from fragments, lost details, and limited points of view. This self-critical open-endedness allowed for innovative representations of workers, peasants, and Chinese people—the subjects of choice for lead factographer Sergei Tret'iakov. The case study here is Tret'iakov's play *Roar China*, an indictment of Western imperialism and exoticism in 1920s China. Drawing from actual events, it was one of the most successful and well-traveled works of its time—leaving a lasting imprint on international Popular Front culture and, in 1930, becoming the first major Broadway production to feature a predominantly Asian American cast. I argue that a close examination of the play, however, reveals factography's contradictions: for example, despite Tret'iakov's intent to free China from "backwardness," when writing the script he prescribed an antiquated, naturalistic style for the actors in Chinese roles. In New York, however, the Asian American actors refused this instruction. Through a combination of lack of experience and (South Brooklyn) accented English, these actors exceeded the roles assigned to them, proving the most vivid and alienating aspect of the performance—and thus achieving the disruptive aims of factography.

While chapters 1 and 2 foreground the utopian promise of the ethnic avant-garde, chapters 3 and 4 reveal how and why we have come to forget this grouping—comprising never-completed projects like Tatlin's Tower and leaving many bodies in its wake. However, both chapters also emphasize how ethnic avant-gardism carried over into the Cold War years, embedded in dominant discourses on literature and identity. Chapter 3

tracks the ethnic avant-garde's recalibration into the language of cultural authenticity and inauthenticity. Authenticity typically points to the policing of cultural boundaries, the notion that understanding a community requires membership in that community. As such it undergirded a postwar turn away from the boundary-flouting ethnic avant-garde, but only at first glance. The chapter reveals that, in fact, the language of authenticity was perfectly legible to the interwar ethnic avant-garde—though this group embraced a very specific kind of authenticity, premised on anticapitalism rather than descent. One could be authentically black by resisting mass culture or, more precisely, the commercialization of black culture.

Chapter 3 traces these competing authenticities by trying to solve a puzzle: in 1956 Langston Hughes famously used his autobiography to dismiss a planned Soviet film about African American struggles titled *Black and White*, after one of Mayakovsky's "Afro-Cuban" poems. Hughes had traveled to the Soviet Union in 1932 to serve as a script consultant, but according to his autobiography, the film was ultimately canceled owing to the Russian screenwriter's "pathetic hodgepodge of good intentions and faulty facts." In other words, the script was fatally inauthentic—an account I dispute through a discussion of the actual 1932 Russian-language script, which bore none of the wild inaccuracies described by Hughes. In a nod to factography, the Russian screenwriter insisted that it was based entirely on "real facts, borrowed from literary and newspaper sources," and I show how this emphasis buttressed that other, anticapitalist authenticity. I then account for Hughes's 1956 dismissal by arguing that his deployment of cultural authenticity enabled him to satisfy American anticommunism (i.e., by throwing into question Soviet outreach to blacks) while concealing the actual, cynical reason for the film's cancellation (Moscow's 1930s bid for U.S. diplomatic recognition). That is, he convinced the West that he was authentically black, and the East that he was authentically black *and* socialist—the latter proven by his steadfast refusal to condemn Moscow.

If chapter 3 shows Hughes masterfully navigating dueling authenticities, chapter 4 shows how notions of the authentic came to heighten the Cold War divide between the United States and the Soviet Union. The chapter marks the weaponizing of cultural authenticity: in the United States, the USSR came to be seen as hostile to both particularism and experimentation—the USSR as an inauthentic place, dominated by uniformity and didacticism; versus the United States as a place where authenticity could

flourish, in the form of ethnic diversity and artistic innovation. In short, this final chapter traces how the ethnic avant-garde came to be overshadowed by familiar Cold War binaries. The focus here is on the New York Intellectuals' articulation of a Jewish cultural authenticity that advanced liberal pluralism and opposed socialist internationalism. I show how this was partly in response to the emergence of Stalinist anti-Semitism after World War II, which was especially disillusioning given the leading roles that Jewish artists, writers, and thinkers played in interwar leftist culture. However, amid this turn, I find traces of a messianic Soviet Jewish avant-garde from the 1910s and 1920s—for instance, in Irving Howe's embrace of the author Sholem Aleichem as someone able to bridge Jewish identity and revolutionary socialism. I argue that Howe used Sholem Aleichem to revive one fragment of the ethnic avant-garde, here again smuggled into postwar America.

The closing image of chapter 4 is Paul Robeson in Moscow in 1949 meeting with his close friend, the Soviet Jewish writer Itzik Feffer at the height of Stalinist anti-Semitism. Soviet officials tried to conceal Feffer's imprisonment by sending him to Robeson's bugged hotel room, but through notes and gestures, Feffer made clear that he would soon be executed. Such tragedies, present throughout the book, highlight the bloodstained passing of the ethnic avant-garde—bound, ultimately, not only by multiple temporalities and languages, the desire to bring art into life, and notions of the authentic versus inauthentic, but also by a shared confrontation with terror and disillusion. This final point binds the ethnic avant-garde to the rise-and-fall narratives typically applied to the Soviet avant-garde and the Soviet project as a whole—narratives that tend to culminate in oppression, collapse, and the triumph of global capital. The afterword unseats such schemes by tracing renewed, postwar iterations of the ethnic avant-garde, in particular the emergence of China as a new revolutionary center. Maoism expanded European Marxist discourse through its focus on local contexts and "the conscious transformation of everyday life"—the personal as political—which proved conducive to "identity politics" and to radical rearticulations of "cultural authenticity." However, under Mao there was no Chinese equivalent to the Soviet avant-garde, and Beijing lacked the creative allure of interwar Moscow. What, then, became of the ethnic avant-garde? As I show through a discussion of Karen Tei Yamashita's 2010 novel *I Hotel*, traces of it can still be found in contemporary minority writ-

ing. Focusing on cross-ethnic activism in the Bay Area of the 1970s, *I Hotel* traverses revolutionary circuits from Moscow to Beijing, Cuba to Vietnam, and also joins the postwar New Left to the interwar Old Left. While taking into account revolutionary failures and defeats, it resuscitates many of the features of the interwar ethnic avant-garde, adding to it a host of formal innovations as well as heightened emphases on local resistance and gender equality.

In short, this is no nostalgic celebration. While mining the ethnic avant-garde for new constellations of identity, art, and politics, the book provides a clear sense of its limitations and decline. Ultimately, though, I show how the group exceeds this rise-and-fall narrative—through fragments that survived the transition, and also through an enduring sense of hope coupled with failure, of revolutionary pathos, that still resonates around the world. What it all adds up to is a minority and Soviet-centered remapping of global modernism, one that advances the avant-gardist project of seeing the world anew. More immediately, it also provides the basis for new scholarly and creative communities in the present day—a reforged avant-gardism and internationalism bound by and learning from the ruins of the past.

1

Translating the Ethnic Avant-Garde

Da bud' ia And if I
 i negrom preklonnykh godov, were a Negro of withered years,
i to, even then,
 bez unyn'ia i leni, without pause or idleness,
ia russkii by vyuchil I would learn Russian
 tol'ko za to, only because
chto im Lenin conversed
 razgovarival Lenin. in it.

—*Vladimir Mayakovsky (from "To Our Youth"* [Nashemu iunoshestvu], *1927)*

The introduction presented two visions of the Tower of Babel rising from the Soviet Union of the 1920s, Vladimir Tatlin's *Monument to the Third International* and Nikolai Marr's "New Theory of Language." Together they pointed to the restoration of a unified humanity through socialist revolution, a revolution linking ancient past to liberated future, and in doing so appealing to every people at every stage of historical development. This chapter focuses on the place of language and translation in creating this unity.

Babel evokes both "Babylon" and the Hebrew word for "confusion." In Dante's elaboration of the legend, Nimrod's hubris prompted the replacement of a single divine language with a multiplicity of tongues that corresponded to the different skills of the tower's builders. God had the architects speak one language, stone carriers another, "and so on for all the different operations. . . . As many as were the types of work involved in the enterprise, so many were the languages by which the human race was fragmented; and the more skill required for the type of work, the more rudimentary and barbaric the language they now spoke."[1] Dante thus imparted to the legend a class dimension: languages were doled out according to division of labor, and those who were first became last, a proto-socialist redistribution of expressive eloquence. However, what I find more

tantalizing about the Tower of Babel—what makes it relevant for the Soviet-centered ethnic avant-garde—is that it captures language as a source of both unity and fragmentation. The legend points to a single language transcending human divisions but also to the origins of linguistic confusion and miscomprehension. As a writer, Dante himself sought to reclaim this lost single language, and the introduction noted Marr's similar effort to theorize a new, socialist language of "supreme beauty" that would unite all peoples. This chapter brings such efforts down to earth by focusing on a specific poetic form that seemed able to cross national and ethnic boundaries and, indeed, serve as a model for minority writing. This was the futurist form developed by Vladimir Mayakovsky, another towering icon of the Soviet avant-garde, whose stature and voice elicited rapt admiration from around the world.

This chapter unearths not only Mayakovsky's imprint on minority and non-Western cultures but also how he sought to incorporate them into his own work. That is, it examines how Mayakovsky inspired artists and writers of color, but also how his encounters with these figures and their cultures affected his own writing. The key here is his 1925 journey to the United States via Cuba and Mexico and his accounts of these places in both a travelogue—published in 1926 as *My Discovery of America*—and poetry. During the trip he wrote poems in an "Afro-Cuban" voice, admired the murals of Diego Rivera, and found that his most dedicated American fans happened to be Russian and Jewish émigrés—all unexpected developments for the futurist author, who made the trip primarily to witness the world's most advanced industrial society. That is, he had expected to bask in American technology and industry, but as I show, Mayakovsky's journey prompted him to question his prior, headlong rush into the future, to reconcile his voice and vision with the diversity of the Americas. His "Afro-Cuban" poems in particular lay open the possibility that his distinctive poetic form—fragmented, staircase lines marked by irregular rhyme and rhythm—could incorporate minority voices without sacrificing their specificities.

What I suggest is that Mayakovsky presents us with yet another iteration of the Tower of Babel, namely, with an avant-gardist form capable of joining multiple languages, cultures, and peoples within a Soviet orbit. However, in keeping with the Babel legend, he also presents us with the confusion and miscomprehension that accompanied this effort. The

first part of this chapter provides an overview of Mayakovsky as a model for minority writing. The main task here is to align him with the visions of avant-gardism and difference spelled out in the introduction, visions oriented toward both future and past. I do so by discussing his 1927 poem "To Our Youth," which in addition to exhorting elderly blacks to learn Russian incorporates some of the many cultures and languages of the USSR. I then use Mayakovsky's 1925 journey to apply such efforts to non-Soviet peoples. My focus is on the gaze that he applied in particular to Cuba and Mexico, where, I argue, he articulated a new, progressive kind of exoticism—one undergirded by Comintern anti-imperialism and that in turn undergirded the Soviet-centered ethnic avant-garde. The chapter's second part then tests Mayakovsky's ability to transcend racial, ethnic, and national divides by discussing Langston Hughes's translations of his "Afro-Cuban" poems. Hughes produced these during his 1932–1933 visit to the Soviet Union, where he was advised to look to Mayakovsky as a model for balancing "proletarian internationalism" with a distinct "national [i.e., black] atmosphere." However, Hughes departs drastically from the originals and in doing so highlights the limits of Mayakovsky's voice and form. I explain this by emphasizing the inevitable gaps that emerge from translation, which, as will be seen, ultimately opened a space for the ethnic avant-garde to balance multiple languages and cultures.

A brief overview of futurism is first necessary, for more than any other grouping within the historical avant-garde, its connection to the past, descent, and the "ethnic" seems counterintuitive. F. T. Marinetti's founding futurist manifesto (1909) drove away the "smelly gangrene of professors, archaeologists, *ciceroni* and antiquarians" via speeding automobiles and art as violence, art as the Oedipal overthrow of all previous generations. Likewise, the Russian futurist manifesto "A Slap in the Face of Public Taste" (1912) threw "Pushkin, Dostoevsky, Tolstoy, etc., etc. overboard from the Ship of Modernity," thus enabling poets to achieve the "Summer Lightning of the New Coming Beauty of the Self-sufficient (self-centered) Word."[2] The aesthetic and political distinctions between Italian and Russian futurism— one now associated with fascism, the other with socialism—are beyond this chapter's scope. Taken together, though, they point to a common "futurist moment," which Marjorie Perloff has defined as rejecting the past in favor

of chaos, motion, and simultaneity, the larger goal being to tear down canons and institutions and to address the masses directly.[3] The futurists, of course, embraced the machine and industry—not the prehistoric paradises deployed by Walter Benjamin, as discussed in the introduction.

And yet Perloff adds that the "future" of the futurist moment was the result not of linear sequence but the incorporation of the past (albeit often through negation) into "the seamless web of the present."[4] Thus, in Perloff's futurist exemplar—Blaise Cendrars and Sonia Delaunay's verbal-visual *La prose du Transsibérien et de la petite Jehanne de France* (1913)—train travel through space (from Moscow to Siberia to Paris) becomes a journey through time: Moscow, with its "one thousand and three bell towers," evokes *Arabian Nights*; Siberia menaces with Mongol hordes; and the North Pole is cast as the home of prehistoric ancestors. In line with Benjamin's revolution as messianic arrest, Cendrars explicitly anticipates "the coming of the great red Christ of the Russian Revolution."[5] The indication here is that the futurist moment, which found its most powerful expressions in the economically "backward" countries of Italy and Russia, actively incorporated exotic, seemingly retrograde cultures. As Perloff puts it, locomotive technology could paradoxically go hand in hand with an "insistence on *difference*."[6] Thus, even while warding off "Mythology and the Mystic Ideal," Marinetti also pushed poets to "swell the enthusiastic fervor of the primordial elements." Likewise, the signers of "Slap"—David Burliuk, Alexei Kruchenykh, Vladimir Mayakovsky, Velimir Khlebnikov—called their futurist group Hylaea, which, as Anna Lawton writes, referred to "the ancient land of the Scythians where in mythical times Hercules performed his tasks. It was a name pregnant with poetic suggestion to the initiators of a trend in art and literature who looked back to prehistory in order to build the future."[7] Indeed, in place of the foreign term "futurist," Khlebnikov himself coined and preferred the Russian *budetliane* (people of the future), which one critic described as distinct from futurism in its embrace of the past, its "creation of new things, grown on the magnificent traditions of Russian antiquity."[8] This was in line with Khlebnikov's stated goal of enabling the human brain to grasp the ever-elusive fourth dimension, that is, "the axis of time." He envisioned artists and writers retreating to an "independent nation of *time*," free from everyday life and consumerism.[9]

Such eccentric understandings of time made it possible for Soviet futurists to embrace far-flung traditions and cultures. However, they did so in

ways that countered the hierarchies of race and empire lurking in Western futurism—for instance, in Marinetti's 1909 manifesto, where he associates his memory of the "blessed black breast of my Sudanese nurse" with the "nourishing sludge" of a factory drain.[10] Against this repellent mixture of primitivism, misogyny, and industry, the Soviet futurists concocted a way of embracing the non-Western Other without relegating her or him. Again, the key figure here is Mayakovsky, who at first glance would seem an unlikely candidate for any backward-looking futurism. Among the Hylaeans, Khlebnikov was the one most interested in prehistory and Russia's connection to Asia. Mayakovsky, in contrast, was the group's urbanist, who even before the revolution pressed the abolition of "national differences" in his search for the language of the future. In Vladimir Markov's words, he "had little use" for the "Hylaean primitivism" of Khlebnikov and Kruchenykh.[11] On the other hand, Mayakovsky was born in Georgia and occasionally interspersed his dramatic readings with Georgian—a coincidental echo of Marr's own "Japhetic"-inflected language of the future. And despite his urbanist, cosmopolitan stance, Mayakovsky was also able to advance toward the future with an eye trained on the past. For example, as Christina Kiaer notes, Mayakovsky's 1923 poem "About This" (Pro eto) briefly mentions "curly-headed Negroes" in order to imply a connection between the Bolshevik Revolution and "unspoiled African culture."[12] The suggestion here is that, like Benjamin, Mayakovsky grasped revolution as the cessation of time, and according to his friend Roman Jakobson, he looked to poetry as a means of overtaking both time and death, poetry as springing from "some primordial, mysterious force."[13] Thus, in 1918 he wrote and performed in a play in verse titled *Mystery-Bouffe*, which reimagined the Bolshevik Revolution as a Noah's ark journey from a flooded, broken world through an innocuous hell, then an insipid heaven, and finally to a redeemed world—the heroes inspired by the brief appearance of a new Messiah walking on water and played by Mayakovsky himself.

This messianic futurism becomes clearer when turning to the actual voice of Mayakovsky, which projects both his ability and inability to transcend cultural and linguistic divides. Two accounts of this famously powerful, resonant voice prove instructive. The first comes from Diego Rivera, one of Mayakovsky's hosts in Mexico City (though the poet stayed at the Soviet embassy). He recalled that when guns were drawn in a meeting of Mexican artists, writers, and political types, Mayakovsky

shouted "Listen!" in Russian in a voice which subdued the commotion. Everyone stopped in their tracks and looked at him. He began reciting [his poem "Left March"], which got louder and louder. The Mexicans remained quiet and, when the poet had finished, burst into a large round of applause. Everyone fell to embrace him and each other. . . . Our respectable Soviet friends, who had been flabbergasted by the scene (which seemed more like the actions of madmen than the sane), slowly opened the door, surely satisfied that Vladimir had the power of Orpheus and that they could now allow these wild beasts out on the street."[14]

The second account comes from the recollections of William Carlos Williams, who attended an apartment reading that Mayakovsky gave soon after his arrival in New York from Mexico. According to Williams's biographer, "the Russian's performance was unforgettable, as Mayakovsky, foot on coffee table in that small, crowded apartment, half read, half chanted his poems in his native Russian, until they sounded to Williams as if the *Odyssey* itself were being delivered by some 'impassioned Greek.'"[15] Thus, even for audiences that did not understand Russian—though Rivera himself did command some—Mayakovsky's voice carried force. To hear him speak was to hear echoes of Greek mythology as well as, perhaps, Babel's lost civilization and Marr's intermixed language to come. More to the point, these accounts of Mayakovsky's voice underscore Russian futurism's commitment to (as the eponymous 1913 *zaum* pamphlet put it) "the word as such"—language freed from any fixed referent and catering more to intuition than rationality.[16] Based on Rivera's and Williams's impressions, Mayakovsky's voice conveyed precisely this promise—of words that could be felt, if not understood, and that could thus cross cultural and linguistic divides. However, these accounts also underscore the difficulty presented by such divides. Mayakovsky commanded only Russian and a bit of Georgian, while those who lacked Russian likely failed to process the revolutionary content of "Left March" or "Black and White." The latter was one of the poems that Williams heard and was in fact about an Afro-Cuban worker rather than Odysseus.[17]

Turning from his voice to his writing, we find a similar tension between understanding and misunderstanding, namely, in his famously fragmented form, which accommodated multiple, often contradictory

positions. This was true of Mayakovsky's works from both before and af-
ter 1917, when the revolution prompted a utilitarian turn to agitational
verses, advertising slogans, newspaper reporting—but never the loss of
his pursuit of the new.[18] Again, the case in point here is "To Our Youth"
(1927), in which Mayakovsky uses this form to join various Soviet na-
tionalities. The sprawling 178-line poem recounts his journeys by train
around the USSR to deliver lectures and readings—as his autobiography
puts it, continuing "the interrupted tradition of troubadours and min-
strels."[19] His signature step-ladder lines prove well suited to capturing
movement from Moscow to Ukraine and then the Caucasus, as well as the
vast country's diversity.

Lechu	I fly
ushchel'iami, svist priglushiv.	by the canyons, the whistle muffled.
Snegov i papakh sedíny,	Gray streaks of snows and *papakhas*,
Szhimaia kinzhaly, stoiat ingushi,	Ingushes stand, gripping daggers,
slediat	watching
iz sedla	from saddles—
osetiny.	Ossetians.[20]

A *papakha* is a Caucasian fur hat, and elsewhere in the poem Maya-
kovsky likens the silvery Don River to another kind of traditional head-
gear (*kubanki*) and also references colorful, straw-roofed Ukrainian huts
(*mazanki*). However, these obvious efforts at inclusion are countered by
an overarching sense of distance between poet and his surroundings.
Mayakovsky's speeding-train vantage affords him only a fleeting glance
at these peoples, and his lines seem poised to scatter amid the move-
ment and irregular rhythms. As in almost all his poetry, the placement
of accents is flexible (e.g., "SnegOv i papAkh sedIny"), and the number of
accents alternates line by line. This enhances the poem's sense of frag-
mentation and of a world come undone, with different places and cultural
markers blurring together. However, Mayakovsky's own overriding pres-
ence—his Whitman-influenced "I"[21]—as well as his use of rhyme serve
to keep this world intact. My literal translations do not capture this, but
these lines in particular use rhyme specifically to harmonize the named
Caucasian minorities with standard Russian words: "priglushiv / ingushi,"
"sedíny / osetiny."

This is all to highlight the poem's tension between order and disorder—the Soviet mélange of peoples as a source of both harmony and confusion. Accordingly, the poem later focuses on language as a distinguishing marker through the insertion of non-Russian tongues. We are told that everyone learns the alphabet "in their own way" (*po-svoemu*), and the poet declares that he himself bears "Three / different sources / in me / as to speech." He recalls this encounter from Ukraine:

Odnazhdy,	Once,
zabrosiv v gostinitsu khlam,	having dumped my stuff in a hotel,
zabyl,	I forgot,
gde ia nochuiu.	where I was spending the night.
Ia	I asked
adres	the address
po-russki	in Russian
sprosil u khokhla,	to the *khokhol*,
khokhol otvechal:	*khokhol* answered:
—Ne chuiu.—	"*Ne chuiu.*"
Kogda zh perekhodiat	Turning now
k nauchnoi teme,	to scholarly themes,
im	the frame of Russian
ramki russkogo	is narrow
úzki;	for
s Tiflisskoi	the academies of Kazan
Kazanskaia akademiia	and Tbilisi,
perepisyvaetsia po-frantsuzski.	corresponding in French.[22]

Visually evoking the spirals of Tatlin's *Monument to the Third International*, these lines on linguistic confusion, I would like to suggest, illustrate the contours of Mayakovsky's own Tower of Babel. The difference is that the building material here is language itself, as opposed to Tatlin's iron and glass. The scattered words combine into a structure that houses a mix of Russian, Ukrainian, and French, a mix marked by mutual incomprehension and perhaps even intolerance: the obstreperous *khokhol* is a crude Russian term for a Ukrainian person, while "Ne chuiu" is Ukrainian for "I don't hear." However, Mayakovsky once again creates a sense of order through his own presence, as well as through rhymes that enfold Ukrai-

nian and French into Russian ("khlam / khokhla," "Ne chuiu / nauchnoi," "úzki / frantsuzski"). These lines thus convey a contradictory push and pull—linguistic confusion but also cohesion—which in turn anticipates the Janus-faced conclusion of "To Our Youth": that all Soviet peoples (and, indeed, elderly blacks) should learn Russian, but at the same time, those previously without alphabets should use "the freedom of Soviet power" to "Find your root / and your verb, / enter the depths of philology." Thus, Mayakovsky presents to us a fast-paced, futurist form that emphasizes the differences between languages even while enfolding them into a Russocentric whole.

Having provided a brief overview of this form, my goal now is to focus on its resonance with non-Soviet peoples, including, as it happens, blacks in Cuba and a black poet and translator from the United States. Before proceeding, however, I should note that the utilitarian advice in "To Our Youth" rather unfortunately fell in line with the Soviet policy of "double assimilation," that is, assimilating into both national units and a Soviet whole. This advice also anticipates Moscow's emphasis, beginning in the early 1930s, on Russification and on Russia itself as the "first among equals." In the decades after Mayakovsky's 1930 suicide, such apparent alignments with official policy led Soviet critics to enshrine him as a standard-bearer for the state's "friendship of peoples," his wide-ranging influence as providing "indubitable evidence of Soviet Russian culture's leading, enormous role in the development of the socialist-in-content, national-in-form cultures of the peoples of the USSR."[23] In other words, there is a dubious precedent for reading Mayakovsky as a model for minority writers, one bearing the heavy-handed imprint of Soviet officialdom. However, the poet's iconoclastic form and perspective cannot be so easily pinned down. Ultimately, he was transformed by his American travels, as well as by encounters with the likes of Rivera and Hughes—encounters that expanded the inclusive, cross-cultural potential of the futurist poet's writing.

Mayakovsky Discovers America

He anticipated his 1925 journey six years prior, with the writing of his extended agitational poem "150,000,000." It cast the poet himself as a folktale giant named Ivan who encompassed the entire Soviet population and

journeyed to Chicago to wreck global capitalism. Lenin denounced the work as "double-dyed stupidity and pretentiousness," though the fortunes of Soviet futurism only worsened after the leader's death in 1924. After the revolution the futurists had reorganized as the Moscow-centered Left Front of the Arts (LEF, which published a journal by the same name) with Mayakovsky as one of its leaders, but in June 1925—the same month that he set sail for the Americas—the state stripped LEF of support in favor of a rival, more accessible group of "proletarian writers."[24] Thus, he was ambassador of an avant-garde movement that was increasingly embattled, something his overseas audiences tended to miss.

If his American audiences had little sense of what was happening in the Soviet Union, he likewise had difficulty apprehending the Americas. This difficulty—related to his limited command of languages—defines his writings from Cuba, Mexico, and (in defamiliarizing Soviet parlance) the "North American United States." His American poems and travelogue heighten the sense of distance between himself and his surroundings that we previously encountered. "America I only saw from the windows of a train," he concedes in the travelogue, which is filled with inaccuracies, as well as several wonderfully bizarre observations—for instance, "There is iron in celery. Iron is good for Americans. Americans love celery." The travelogue also claims that Americans are so dollar obsessed that a common greeting is "Make money?" or as Mayakovsky hears it, "Mek monei?" (Мек моней?)—perhaps a misconstrual of "Mac."[25] This is an outsider's perspective, grasping at outlandish claims absent intimate knowledge, and accordingly, a sense of bemused estrangement pervades *My Discovery of America*, particularly the sections on Cuba and Mexico. "I had never seen such a land, and didn't think there were such lands," he writes of the Mexican desert (15), which he also observes by train. Likewise, upon stepping off the boat in Havana, he abruptly interjects,

> What is rain?
> It's air with a film of water.
> Tropical rain—that's sheer water with a film of air. (8)

For Mayakovsky, these are exotic places filled with an "incomprehensible, idiosyncratic and amazing way of life" (12), places that prompted for him new ways of seeing and an uncharacteristic loss for words.

What I would like to suggest is that during these earlier legs of his journey, Mayakovsky developed an exoticist interest in preserving traditional cultures

FIGURE 1.1 Mayakovsky's travel sketches of Mexico and Cuba, published with his poem "Tropics" in *KRASNAIA NIVA*, No. 35 (1926): 11.

but also in pairing exoticism with anti-imperialism—in harnessing the exotic for revolution. In other (namely, Stephen Greenblatt's) words, Mayakovsky's rendition of the New World encounter is marked by an open-ended wonder that—in a departure from the explorer and adventure genres—refuses to give way to apprehension and possession.[26] For example, his poem "Mexico" (1925) notes his boyhood fantasies about Native Americans as he encountered them in the pages of James Fenimore Cooper and Thomas Mayne Reid, both enduring favorites among Russian readers. As he disembarks in Vera Cruz, he imagines that it is "Montihomo Hawk's Claw" who assists him with his suitcase stuffed with copies of Lef—an allusion to a young Chekhov character who, himself having read Reid's adventure novels, assumes this "Indian" nickname. However, Mayakovsky's misinformed excitement soon passes:

Glaz toropitsia slezoi nalit'sia.
Kak? chemu ia rad?—
—Iastrebinyi Kogot'!
 Ia zh
 tvoi "Blednolitsyi
Brat."
Gde tovarishchi?
 chego taish'sia?
Pomnish',
 iz-za klumby
strelami
 otravlennymi
 v Kutaise
bili
 my
 po korabliam Kolumba?—
Tsedit
 zlobno
 Kogot' Iastrebinyi,
medlenno,
 kak tresnuvshaia krynka:
—Netu krasnokozhikh—istrebili
gachupíny s gríngo.

The eye quickly fills with tears.
How? Why am I happy?
"Hawk's Claw!
 I'm
 your 'Pale-Faced
Brother.'
Where are the comrades?
 why are you hiding?
Remember how
 from behind the flowerbed
with poisoned
 arrows
 in Kutais
we
 beat
 against Columbus's ships?"
Hawk's Claw
 strained out
 darkly,
slowly,
 like a cracked decanter:
"No more redskins. Wiped out by
gachupins and gringos.[27]

In light of the unhesitating flight in "To Our Youth" across linguistic and national boundaries, this rebuke of the poet, this admission of ignorance is striking. Just as in that poem, here he blurs together different places—conflating indigenous peoples in the United States (i.e., the tales of Fenimore Cooper and Reid) with those in Mexico, and connecting his boyhood home of Kutais, Georgia, to the Americas. With "Hawk's Claw's" derogatory terms for Spaniards and Americans, Mayakovsky likewise brings in a foreign tongue—though otherwise it is unclear which language the porter speaks. (It could be Mayakovsky's own: at one point the travelogue describes Cuban pineapple vendors cursing to one another in Russian.) However, immediately after these lines, the porter proceeds to rebuff the poet's fantasies by relating how those not killed were ravaged by alcoholism and exploitation. Instead of slinging arrows, they are lugging suitcases, including Mayakovsky's own.

Thus, in his encounter with this indigenous figure, the futurist poet concedes the limits of his perspective, but as the poem proceeds, he is able to recalibrate how he sees the Other. He does so by delving into Mexican history, in contrast to the only cursory glance at Ingushes and Ossetians in "To Our Youth." "Mexico" describes the glories of Tenochtitlán, Cortés's arrival in Veracruz, the shortcomings of Montezuma, and the subsequent conquest. To be sure, Mayakovsky was not the only one to explore this subject. His dive into a past "so long ago / as though it never was" brings to mind not only *Mystery-Bouffe* and Khlebnikov but also William Carlos Williams's 1925 account of "The Destruction of Tenochtitlan"—portrayed as the battle of primal forces—which in turn evokes Williams's account of Mayakovsky as Greek orator.[28] However, amid these perhaps predictably modernist turns to the ancient past, what distinguishes the Soviet futurist is his choice to identify with the defeated Aztecs after he describes the death of one of their leaders: "I vot stoim, / indeets da ia, / tovarishch / dalekogo detstva." (And here we stand, / the Indian and myself, / a comrade / from long-ago childhood.)[29] After thus reaffirming this youthful bond, Mayakovsky then casts the Aztecs as revolutionaries in the present day: the poem concludes with his juxtaposing their history with the Mexico he finds, leading him to bemoan the passing of heroism, the rise of a Mexican bourgeois society hardly distinguishable from others, and the fact that "Montezuma became a beer brand." However, amid capitalist homogenization, Mayakovsky envisions a revolution made up of "Aztec / Mestizo / Creole," that is, of the country's

impoverished indigenous peoples. All this points to the flexibility of Maya-kovsky's perspective—his ability, within a single poem, to disidentify with, then reidentify with, then radicalize these peoples.[30]

This flexibility enabled Mayakovsky to reject an uninformed embrace of the future and to instead seek new, revolutionary configurations of the modern and premodern. This becomes clearer when delving deeper into his travelogue, particularly his observations from his two-day stay in Cuba and three weeks in Mexico. Mayakovsky's disorientation there brings to mind McKay's and Benjamin's impressions of "Byzantine" Moscow, also from the 1920s. "Everything seemed the wrong way round," he recounts from his train journey from Veracruz to Mexico City:

> In a completely blue, ultramarine night, the black silhouettes of the palms looked absolutely like long-haired bohemian artists.
>
> The sky and the land merge. Both on high and low down there are stars. Two arrays. Above—are the motionless, accessible heavenly bodies; and below—the darting and flitting sparkle of fireflies. (14)

Such dazzled responses were, again, unexpected given that Mayakovsky made the trip to witness American industry, with Cuba and Mexico intend-ed as mere way stations. In Paris, he had been warned that "Mexican art is an outgrowth from the ancient, variegated, primitive, folkloric Indian art," that is, ostensibly not of much interest to a futurist (16). However, he found himself taken by Diego Rivera and his famous Ministry of Education pieces (then in progress), which he deemed the "world's first Communist mural" (16). More specifically, he praised Rivera's murals for their harmonious marriage of a "primordial paradise" with "the construction of the world of the future" (16)—a combination that resonates well with Benjamin's vi-sions of revolution and avant-gardism. That is, Mayakovsky found in Mex-ico and Rivera's revolutionary history the same intermingling of the old and new that Benjamin saw as ripe with irruptive possibility.[31]

However, Mayakovsky was not simply applying a Soviet or European vision to Mexico but was transformed by what he saw. More specifically, the travelogue shows him learning to distinguish between imperialist and anti-imperialist varieties of exoticism. He excoriates the kind practiced by American tourists, who condemn Mexicans to the "exotica of starva-tion" while purchasing souvenirs—"jumping beans, glaringly bright sera-

pes which all the donkeys of Guadalajara would shy away from, handbags with printed Aztec calendars, postcards of parrots from real parrot feathers" (24, 26). This is the exotic as kitsch, bound to U.S. exploitation, which Mayakovsky rejects in favor of another kind of exoticism—that found in Rivera's premodern utopias, as well as in instances of Cuban and Mexican culture untainted by American tourists:

> Everything to do with traditional exoticism is colourfully poetic and non-profitable. An example is the very beautiful cemetery of the multitudinous Gomez and Lopez breeds, with its dark alleys, even in daytime, of some sort of interwoven tropical and bewhiskered trees. (9)

Mayakovsky juxtaposes the "traditional exoticism" of this Havana cemetery with the stultifying, unthinking orderliness of an American-organized telegraph office, as well as with the tall buildings representing American firms—"the first tangible signs of the sway held by the United States over all three Americas: North, South and Central" (9). What emerges from this contrast between old and new is a notion of the former that exists beyond U.S. imperialism and, indeed, potentially enables a critique of imperialism. The futurist poet thus gained from his time in Cuba and Mexico an ability to specify a "traditional exoticism" that was preferable to American industry and could bolster progressive ends.[32]

During his three months in the United States, this nuanced perspective served him in good stead. His account of Havana's telegraph office anticipates the fact that in New York he found himself ambivalent about innovations like the automobile ("stinking out the streets") and skyscraper ("in which you can't live, though people do"). His travelogue dismisses them as instances of "primitive futurism," a (for him) repellent combination of a "backwoods psyche [*derevnie psikhiki*]" and naked technology (102–3), a noisome, haphazard technology with little concern for human needs and comforts. He expresses hope that the USSR will avoid "primitive futurism" by, for instance, fitting silencers on trains so that poets can converse, as well as by achieving "motorless flight" and a "wireless telegraph" (103). In short, just as his travels brought him to a variegated understanding of exoticism, the same can be said of futurism. Mayakovsky's resulting desire for quieter, more humane technologies evokes Charles Fourier's utopias and Benjamin's dialectical image (e.g., modern bombers juxtaposed with

Da Vinci's airplanes dropping snow in the summertime). The din of American cities prompts him to cast the "deliberate age-old clinging" of the countryside in a favorable light (105–6) and to arrive at new combinations of future and past. For example, his paean to the Brooklyn Bridge, which he links to his own struggle "for constructions / in place of style," examines the steel structure from the perspective of geologists unearthing it long after the passing of this civilization. However, the poet also describes himself staring at it "as an Eskimo looks at a train"—the futurist poet once again adopting a premodern, indigenous vantage.[33]

This layered perspective—this ability to inhabit multiple points of time at once—provides the bridge between Mayakovsky and minority writing in the United States. For this perspective undergirded his encounters with American ethnics, helping him to make sense of the country's astounding diversity. As his travelogue puts it, "Negroes, Chinese, Germans, Jews, Russians—they all live in their own districts, with their own customs and language, preserving these through the decades in unadulterated purity. . . . An enigmatic picture: who then, essentially, are the Americans, and how many of them are hundred per cent American?" (55). Mayakovsky concludes that "it's the white man who calls himself 'an American'. He considers even the Jew to be black, and will not shake hands with the Negro" (83). To be American, in short, means to cling to biological racism, which Mayakovsky excoriates. Moreover, just as he identifies Americans as buying kitsch souvenirs in Mexico, in New York he describes well-off "idiots" who board "a car adorned with fancy lights to Chinatown, where they will be shown perfectly ordinary blocks and houses, in which absolutely ordinary tea is drunk—only not by Americans, but by the Chinese" (60). "Americans" also venture into the city's Russian quarter in order "to buy an exotic samovar" (82). Thus, to be American also means to practice a false, commodified exoticism that assigned a kitsch past to the ethnic Other—both abroad and at home.

In contrast, Mayakovsky embarked on more intimate encounters with different kinds of Americans, namely, ethnic Americans. Along with his ambivalence toward industry, this was the other unexpected aspect of his trip—the fact that he was surrounded by mostly immigrants and minorities, again, mainly Russian and Jewish émigrés. He entered Laredo, Texas, from Mexico with the help of that city's Russian Jewish community, one member of which translated for him at border control. In New York his

visit proved a sensation and "moral boost" for the vibrant writing circles of the Russian and Jewish left, which, aspiring to generate "American Mayakovskys," sponsored his lectures and ran newspaper "reports on his daily peregrinations."[34] The interest he drew from left-leaning Jewish immigrants seems particularly relevant here. The pro-Soviet Yiddish newspaper *Frayhayt* published an interview in which Mayakovsky—oddly described as resembling a "Mexican cowboy"—proclaimed the USSR more vibrant than the United States despite its relative backwardness. To escape New York's "primitive futurism," he thrice visited a *Frayhayt*-sponsored summer camp, where he "indefatigably read his poems before an attentive workers' auditorium, his lion's voice often resounding over the mountains, over the Hudson River." These visits resulted in the poem "Camp 'Nit Gedaige'" (Yiddish for "Don't Be Down"), which features Mayakovsky in a tent at night hearing sirens howling over the Hudson and imagining eternity as a flying creature unfurling its tail—time as weaving "not hours / but canvas," so that all can be clothed. That is, he situates his Jewish American hosts outside time and space: ultimately he is awakened by the call of young communist campers pledging to fight for Soviet power. The poem concludes, "Through song / they make / the Hudson flow to Moscow."[35]

Here we find the leading Soviet futurist bending time and space at Jewish summer camp, and in fact, upon his return to the USSR, he suddenly became involved in Jewish cultural projects there.[36] However, more interesting (and less limited to any single group) is the way he engaged questions of Otherness—indeed, his own marginality in New York—through language. Again, he spoke only Russian and Georgian, and his efforts to pick up English were foiled by his mostly Russian-speaking hosts. Despite Rivera's and Williams's triumphant accounts, this was a source of great personal frustration for Mayakovsky whenever he confronted non-Russian speakers—his booming voice reduced to repeating stock lines like "Gif me pliz sam tee."[37] However, he managed to make good use of the linguistic mix he encountered. He contributed to and possibly coedited the first issue of the "American revolutionary" trilingual journal *Spartak/Spartacus* (1925), published that October by a group of young Jewish émigré authors and intended as a conduit between the United States and USSR.[38] Divided into three sections (the first and largest in Russian, the second in English, and the third in Yiddish), it featured a wide range of pieces on American

СПАРТАК

SPARTACUS

THIRTY UNION SQUARE

New York City

INTERNATIONAL MAGAZINE

published by the

NEW WORLD PUBLISHING COMPANY

Subscription Rate:

$3.00 per year in U. S. A. and Canada

$2.00 per year in other countries

ИЗДАНИЕ ГРУППЫ ПРОЛЕТАРСКИХ ПИСАТЕЛЕЙ «РЕЗЕЦ»

VOL. I · OCTOBER, 1925 · No. 1

Editorial Committee:

M. BOYKANSKY, E. WINOGRADOV, LAZAREV

SAMUEL BLISS, Manager

СОДЕРЖАНИЕ НОМЕРА

FIGURE 1.2 *SPARTAK/SPARTACUS*, "Publication of the 'Rezets' group of proletarian writers" (1925).

and Soviet life and culture, including Mayakovsky's never-before-published poem "The Six" (Shesterka) and a Russian translation of Langston Hughes's "Drama for Winter Night." These juxtaposed languages evidently inspired the futurist poet. At a celebration for the journal shortly before his departure, he read another new poem, "American Russians," which tries to capture the mixed vernacular of his immigrant hosts.[39] The poem centers around a fictional, presumably Jewish character named Kaplan trying to arrange a meeting with a fellow émigré via a hybrid of Russian and English, the Russian intermixed with phonetic Cyrillic renderings of "appointment" (apointman), "good-bye" (gud bai), "job" (dzhab), and "bootlegger" (butleger). Alongside these English words, the poem includes new Russian acronyms emerging from the bourgeoning Soviet bureaucracy (TsUP and TsUS), and at least one Russian word spoken by Kaplan is rendered with a Yiddish accent—"tudoi, an adaptation of the standard tuda (thither), which Mayakovsky performed aloud in an exaggerated, perhaps stereotyped manner.[40] In short, the poem shows the Russian language creolizing in both the United States and the USSR—the language absorbing Americanisms, Sovietisms, and different accents—and becoming increasingly incomprehensible to the poet. The result, he concludes, is a new, all-devouring language that, like Spartak/Spartacus, combines Russian, English, and Yiddish:

Gorlanit	Across this very America
po etoi Amerike samoi	yells
stoiazykii	a hundred-tongued
narod-ogoltets.	people-frenzier.
Uzh esli	If already
Odessa—Odessa-mama,	Odessa is the Odessa-mama
to N'iu-Iork—	then New York is
Odessa-otets.	the Odessa-father.[41]

These lines further substantiate the notion of a Mayakovskian Tower of Babel, here assuming a monstrous form. Swallowing multiple peoples and tongues, it joins Odessa (a center of Eastern European Jewish culture) and New York (the center of Russian and Jewish American immigration). Indeed, Mayakovsky came to imagine the United States precisely as a Tower of Babel: his travelogue describes the "language of America" as "the imaginary language of the pandemonium of Babel, with just one difference—

that there the languages were mixed so that no one understood them, whereas here they are mixed so that everyone understands them" (82). America thus enables Mayakovsky to imagine a new iteration of the legend and, in turn, a new means of crossing linguistic divides. If originally Babel referenced a unified language followed by mutual misunderstanding, misunderstanding here gives way to an intermixture that yields comprehension. To put this differently, Mayakovsky seems to register William Carlos Williams's avowed ability to make sense of the Russian poet. According to the travelogue, Americans are not at all fazed by—indeed, thrive on—a multiplicity of languages.

But Mayakovsky himself *was* fazed. He returned to the USSR eager to be surrounded only by Russian speakers again, after which he immediately embarked on the speaking tour that resulted in "To Our Youth." However, as he describes in an essay about his return, relief soon gave way to confusion: an inability to relate with fellow train passengers, and a hotel attendant suspecting him of making sexual advances.[42] His limited communication abilities in the Americas, it seems, somehow followed him home, a development he anticipated in a poem that he wrote while crossing back over the Atlantic. Called "Homeward!" it originally concluded,

Ia khochu byt' poniat moei stranoi,	I want to be understood by my country,
A ne budu poniat—	But if I'm not understood—
chto zh.	what of it.
Po rodnoi strane	Through my native country
proidu storonoi,	I'll pass to the side,
Kak prokhodit	As passes
kosoi dozhd'.	the slanting rain.[43]

At first glance, these lines seem to convey Mayakovsky's awareness about the embattled position of LEF, something he could momentarily forget while in the Americas. What I would like to suggest, though, is that they also signal Mayakovsky's adoption of an outsider's perspective—the perspective of a Russian-speaking émigré in New York, doubtful about his ability to make himself understood. That is, in the Americas he came to question not only his previous embrace of the future but also the capacity of his language and poetry to overcome his sense of distance and alienation. Perhaps nostalgic for his Russian Jewish hosts in New York, as part

of his return tour he visited Odessa, but here too he was unable to shake this sense of alienation. One of the poems he read there was "American Russians," but strangely, his efforts to mimic Jewish vernacular fell on deaf ears. By one first-person account, while "the poem provoked laughter everywhere," in Odessa this was not the case. There it "did not have success," suggesting that this particular largely Jewish audience—if not the one in New York—was not at all flattered by Mayakovsky's attempts at imitation.[44]

As we saw, "To Our Youth" addresses precisely such thwarted efforts to cross linguistic boundaries, which in turn evoke Mayakovsky's often frustrating encounters with the American Babel. However, in a departure from his earlier, American writings, "To Our Youth" ends with his confident assertion of Russian as the Soviet lingua franca, an assertion that, again, anticipated the Soviet state's own pending turn to Russification. Mayakovsky in the Americas was not so confident, and in fact there are indications that after 1925 he sought to develop a more tendentious style of writing. As he wrote to a young poet in a letter, this is precisely why he chose, sometime between his return and 1928, to excise "Homeward's" quoted conclusion—in his words, a "paradisiacal tail [*raiskii khvostik*]" that was too facilely "plaintive [*noiushchii*]."[45] Prior to this turn, however, Mayakovsky's American writings accentuated the Soviet futurist's tentativeness, his acceptance of confusion and misunderstanding—in short, that which enabled him to embrace but not quite encroach upon the different cultures that he encountered. As I show below, Hughes's translations further accentuated these qualities, revealing in the process that the ethnic avant-garde was not simply about emulating figures like Mayakovsky but rather was a two-way street.

"Blek end Uait" / "Black and White": Hughes Translates Mayakovsky

In 1927 Diego Rivera himself made what Claude McKay called the magic pilgrimage to the Soviet Union. Upon his arrival he was surprised to find that "almost everyone within Moscow's intellectual and cultural community, it appeared, as well as many ordinary citizens, had heard of him and his work because of Mayakovsky." While there, he participated actively in debates about the role of old techniques and traditions in new, revolutionary art

forms, but he left in May 1928 disillusioned by the state's growing control of the arts, as well as the increasing prominence of what would become socialist realism.[46] Indeed, LEF found itself ever more embattled through the late 1920s. As previously alluded to, its journal lost state support and ceased publication in 1925, and though it was relaunched two years later, at that point the group declared an end to its past iconoclasm in favor of journalistic writing and factography—a turn covered in chapter 2. Mayakovsky committed suicide in 1930, perhaps because of the increased cultural constraints, though his final note pointed more to thwarted love. This, however, did not mark the end of the Soviet avant-garde, nor its engagement with minority and non-Western cultures. During his Moscow stay, Rivera—in addition to reuniting with Mayakovsky—met the film director Sergei Eisenstein, of *Battleship Potemkin* fame, another member of LEF. Their meeting resulted in Eisenstein's own, prolonged visit to Mexico from 1930 to 1932 to shoot his never-completed *¡Que viva México!* which I discuss at the end of this chapter. The year 1932 was also the year that Hughes made his own "magic pilgrimage" to Moscow. There he assisted with the production of another never-completed film, *Black and White*, a Soviet dramatization of African American struggles and the focus of chapter 3.

Suffice it to say for now, "Black and White"—or, more precisely, "Blek end uait" (Блек энд уайт), the phonetic Cyrillic rendering of these words—was also the title of one of Mayakovsky's two "Afro-Cuban" poems, which Hughes translated during his visit. My goal in the remainder of this chapter is to juxtapose the originals and translations in order to test Mayakovsky as a model for minority writing. In the preceding, the key to this model was a fragmented, irregular form that incorporated transliterated foreign words as well as a flexible perspective discerning different varieties of the exotic. However, I paired this potential with Mayakovsky's distance from his surroundings and audiences—an enduring iconoclasm that might seem contrary to his appeal across racial, ethnic, and national lines. Accordingly, by turning to Mayakovsky's "Afro-Cuban" poems and Hughes's translations of them, we get a stronger sense of the difficulty of crossing such boundaries, in particular, of the racial and linguistic barriers between Mayakovsky and persons of African descent. Nonetheless, by juxtaposing "Blek end uait" and Hughes's "Black and White," we can ultimately read this poem as a collaborative, cross-racial, Soviet-American effort. In the gaps between the two, we

are able to hear hints of that transcendent, unifying voice described by Rivera and Williams.

Of course, all translations operate within the interstices between languages, and as several scholars have shown, it is in these interstices that questions of nationalism and internationalism come to the fore. According to Lawrence Venuti, even seemingly transparent translations highlight national differences, since both languages involved in the process bear their own histories, contradictions, and struggles. This means that in order to make a foreign text legible, the translator must impart to it a "domestic remainder," which Venuti defines as "an inscription of values, beliefs, and representations linked to historical moments and social positions in the domestic culture." In turn, a self-critical awareness of these inherent asymmetries makes it possible to discern translation's utopian undercurrent, namely, the dream of "a future reconciliation of linguistic and cultural differences."[47] That is, translation highlights the gaps between languages and cultures but also the desire to overcome them—translation as a concrete step toward new Towers of Babel and Marr's unified language, or what Walter Benjamin calls in his essay "The Task of the Translator" (1923) the integration of "many tongues into one true language."[48] From this perspective, translation can serve as the basis of new communities and groupings, and, indeed, in discussing Hughes vis-à-vis Mayakovsky, I seek to use translation as a tool for binding together the internationalist, interwar ethnic avant-garde.

Venuti suggests that such utopian aims are best realized by translations that do not aim for transparency but that self-consciously add elements to convey some of the understandings available to the original text's readers. That is, such translations use domestic remainders to convey the original text's foreignness, and as a result, they override the notion that cultural differences are fixed or essential; they open the possibility of defamiliarizing and reinventing the domestic culture and language.[49] My literal translations of Mayakovsky have not attempted to do this, though I have resisted transparency by juxtaposing my renderings with the original lines, as well as by reverting to the Russian to illustrate accents and rhymes. My goal has been to convey the poet's bare meaning and layout, but also to maintain a sense of the gaps between the Russian originals and my English renderings. In contrast, Hughes's more ambitious undertakings accentuate precisely the gaps between cultures and languages, and at first glance,

they thus throw into question Mayakovsky's applicability to the black diaspora. However, I present Hughes's translations as not only diverging from but also supplementing Mayakovsky. Examining the translations vis-à-vis the originals makes it possible to imagine the two authors as part of a shared effort to realize Benjamin's one true language.[50]

Let's begin with the two Mayakovsky poems. "Blek end uait" (1925) follows Willie, a black sweeper at an American cigar company in Havana as he slowly gains awareness of racial inequity. However, when he demands to know from his employer, Mr. Bragg, why blacks perform all the labor for whites, Bragg beats him unconscious. "Syphilis" (1926) describes a black itinerant named Tom, a third-class boat passenger who is quarantined in Havana's harbor, while a wealthy white American from first class, Swift, the syphilitic "pig king," disembarks. Encountering Tom's starving, beautiful wife, Swift propositions her, and thinking she has been abandoned by her husband, she agrees to prostitute herself. The anti-imperial content—the plight of Afro-Cubans—is obvious in both poems. More interesting is the way in which Mayakovsky conveys this message, namely, through his characteristically fragmented lines. For instance, "Blek end uait" begins,

Esli	If
Gavanu	at Havana
okinut' migom—	you flash a glance—
rai-strana,	paradise-country,
strana chto nado.	the best country there is.
Pod pal'moi	Under a palm
na nozhke	on thin leg
stoiat flamingo.	stand flamingos.
Tsvetet	Callario
kolario	blooms
po vsei Vedado.	over all Vedado.[51]

These lines convey a now familiar push and pull between past and present—the futurist poet once again basking in a premodern, exotic setting. They also convey an equally familiar push and pull between order and disorder: on the one hand scattered details and fragmented lines, on the other, frequent rhymes ("migom / flamingo"; "nado / Vedado") and alliteration ("Pod pal'moi," "na nozhke").

Remarkably, this ability to reconcile extremes was explicitly presented to Hughes as something to emulate. In an article published in the Moscow-based journal *International Literature* while he was still in the USSR, Lydia Filatova, a young Soviet critic of African American literature, applauded Hughes's adoption of a revolutionary voice and "working class themes." However, she followed this praise with a fascinating caveat:

> Yet there is danger here of lacking proportion, of falling into schematism and rhetorics. A synthesis based on living, concrete reality is always more convincing than abstract symbols. The ability to give generalisations while retaining the concrete individual substance may be seen in the work of the great poet of the October Revolution, Vladimir Mayakovsky.
>
> Revolutionary art is international in character. Hughes's verses are impregnated with the spirit of proletarian internationalism, which ought to be welcomed in every way. Yet the poem goes to extremes by obliterating national boundaries and to some extent destroys the specific national atmosphere of his poetry; in this sense it is a step backward in comparison with his earlier works. We are for an art that is national in form and socialist in content. Hughes first of all is a poet of the Negro proletariat. . . . The force of Hughe's [*sic*] poems will be stronger, the influence deeper, if he will draw closer to the Negro masses and talk their language.[52]

According to Filatova, Hughes has abandoned blackness for revolution, which to her is cause for alarm. In effect, she anticipates the frequent dismissals of his communist-influenced poetry as stunted and whitewashed. Ostensibly, her solution for balancing a distinctly black "atmosphere" and "proletarian internationalism" can be summed up with the slogan "national in form and socialist in content"—basically, poems that portray working-class struggle but using black dialect. Filatova here seems to subscribe to the crude essentialism of Soviet nationalities policy.[53] However, her invocation of Mayakovsky points to a more subtle solution—a poetic form that can balance "individual substance" and "generalization," which Filatova here implicitly analogizes to the particular and universal, black identity and world revolution.

We can test this solution, first by exploring what distinguishes these two poems within Mayakovsky's oeuvre, namely, their depictions of black

bodies and voices; and, second, by seeing how Hughes responded to these depictions in his translations, which he produced with Filatova's assistance. Most notably, the fragmented quality of Mayakovsky's writings allows the poems to be simultaneously exoticist and antiexoticist. For instance, he distances and objectifies the wife's body in "Syphilis," likening it to a glossy consumer good: she has hair "dense like oil" and skin "black and rich" like "the wax / 'Black Lion.'" Here Mayakovsky seems to partake in a fetish for black, female bodies, but then provides a detailed, repellent account of this fetishism's outcome, namely, the "pig king's" arousal:

A misteru Sviftu	And Mister Swift's
posledniuiu strast'	last passion
razdula	was swelled by
eta ekzotika.	this exotica.
Potelo	His body
telo	sweated
pod bel'etsom	under his briefs
ot chernen'kogo miastsa.	from the little piece of black flesh.

Thus, for Mayakovsky, the "exotic" serves as a source of both allure and disgust, and by the end of the poem, the spell of the fetish is broken. Tom returns, contracts syphilis himself, and he, his wife, and future children become street beggars:

I slazilo	And the rot
chernogo miasa gnil'e	of black flesh fell
s gnilykh	from rotting
negritianskikh kostei.[54]	Negro bones.[54]

The earlier, fetishized "little piece of black flesh" (conveyed through the diminutive *chernen'kogo miastsa*) here becomes neutral "black flesh" (conveyed through the nondiminutive *chernogo miasa*). The outcome of colonial and capitalist exoticism—operating under the guise of "civilization"—is the unadorned decay of black bodies. And Hughes apparently agreed: though he does not translate nuances like diminutive versus nondiminutive suffixes, he diligently provides each of Mayakovsky's details.[55] He voices no objection to the "socialist content" of the original poems.

While "Syphilis" shows Mayakovsky depicting black bodies, in "Blek end uait," he presents a black voice. It is here—and on the level of form rather than content—that gaps arise. The climax is the question Willie asks his American employer, the white "sugar king":

"Ai beg yor pardon, mister Bregg!	"I beg your pardon, Mister Bragg!
Pochemu i sakhar,	Why should sugar,
belyi-belyi,	white-white,
dolzhen delat'	need to be made
chernyi negr?	by a black Negro?
Chernaia sigara	A black cigar
ne idet v usakh vam—	doesn't suit your moustache—
ona dlia negra	it's for a Negro
s chernymi usami.	with black moustache.
A esli vy	And if you
liubite	love
kofii s sakharom,	coffee with sugar,
to sakhar	then sugar
izvol'te	please
delat' sami".	make yourself."[56]

Just as in "To Our Youth," "Mexico," and "American Russians," Mayakovsky here inserts a foreign language—the transliterated English of "I beg your pardon, Mr. Bragg." It is unclear in what language Willie proceeds to ask his question: he could either be continuing in English, or else the turn from transliterated English to Russian could mark Willie's own switch from English to Spanish. In either case, Mayakovsky translates him into Russian. There are two problems here. The first is that it makes little sense for Willie to be addressing Bragg in English rather than Spanish. While Willie may simply be greeting Bragg in Bragg's own language before switching to Spanish, "I beg your pardon" (as opposed to, say, "Hello") seems too formal for this. My sense is that Mayakovsky is presenting Afro-Cubans as English speakers, which in turn suggests an erroneous conflation of this group and African Americans. However, the more pressing problem is that, whether Willie proceeds in Spanish or English, his voice is indistinguishable from Mayakovsky's own. The sweeper's spoken lines maintain the poet's use of rhyme, alliteration, and fragment

("belyi-belyi," "dolzhen delat,'" "usakh vam / usami / sami"). The only possible distinction between Willie's voice and Mayakovsky's own is that the sweeper's question consists of mostly short, simple words, indicating his lack of education. Earlier in the poem, his brain is described as having "few convolutions / few sprouts / few sown seeds."[57]

Mayakovsky's effort to transcend cultural and linguistic divides here seems questionable, seems too sheer. To put this differently, his effort to *translate* from either English or Spanish into Russian is too transparent. Aside from the ambiguous insertion of transliterated English, the poet fails to capture the linguistic and cultural distinctions between Soviet poet and Afro-Cuban worker. All we know of Willie is that his speech and perspective are severely limited. As a result, Mayakovsky's form here seems constraining and, indeed, infantalizing, a problem borne by the poem's content as well. In response to Willie's question, Bragg turns from white to yellow and punches him in the face, leaving the poet to conclude,

Otkuda znat' emu,	How could he know
chto s takim voprosom	that with such a question
nado obrashchat'sia	you need to turn
v Komintern,	to the Comintern
v Moskvu?	to Moscow?[58]

Thus, Willie's only recourse is to look to Moscow and follow the Comintern's lead, though he purportedly has no way of knowing this. Not only does Mayakovsky deny his character a distinctive voice and a developed mind, but he also denies Willie any means of local resistance. This is all to reveal the limits of Mayakovsky's fragmented form and, in turn, political content—to question the notion that he could provide a model for preserving "individual substance" and black particularity. Likewise, despite its anti-imperial orientation, the exoticist gaze that the poem applies to Willie here seems retrograde and disempowering, asserting a clear hierarchy between Soviet center and Cuban periphery.

Enter Langston Hughes. If Mayakovsky's figurative translations of this character lose the cultural and linguistic specificity separating the Soviet Union and Cuba, Hughes's own translations add precisely this specificity. That is, his translations work to keep Mayakovsky in check—to rework the form and language of the poems, if not the content. For both "Black and

White" and "Syphilis," Hughes presents blocks of text in place of scattered fragments. There is no rhyme, little alliteration, and a much more sober tone. Note, for instance, Hughes's opening for "Black and White":

> Havana in a glance—
> Paradise land, all it ought to be.
> Under a palm, on one leg, a flamingo stands.
> Calero blossoms all over Vedado.[59]

If Mayakovsky's lines bear some resemblance to Tatlin's Tower, Hughes renders the poem into a more conventional structure—the original's spirals here compressed into a block. These lines mostly match my literal translation, but compare them with another, more transparent translation from 1933, which better captures the original's tone:

> When over Havana
> > You cast your glance . . .
> Paradise country—
> > Luxurious land!
> Under palm
> > stands flamingo
> > > in a one-legged trance
> Over all Vedado
> > Blooms callario
> > > Grand![60]

In short, Hughes excludes from his translation Mayakovsky's expansive, playful persona. The poem's original content is present, but the form—that unique combination of individual voice and revolutionary sweep—is missing.

Of course, one might attribute Hughes's translation to a limited command of Russian—though, as mentioned, he was assisted by Filatova. Another explanation might lie in his general method of translation. Ryan James Kernan writes that for much of his career, Hughes embraced "collaborative literal translations as the best way to avoid limiting the poetic potential of the source text in translation and the ethical pitfalls of speaking for the Other."[61] Thus, as John Patrick Leary has shown, his effort to translate the

Afro-Cuban poet Nicolás Guillén for a 1948 volume emphasized literal fidel-
ity over "musicality and colloquial cadences." For Leary, the resulting loss of
the original poem's "locality" points to the gaps, contradictions, and strug-
gles inherent to diasporic internationalisms, and accordingly, when Hughes
himself visited Cuba in 1927, 1930, and 1931, he fetishized Afro-Cuban cul-
ture "like a hungry tourist seeking some local dish." These accounts affirm
what Brent Hayes Edwards calls the *décalage* and difference within unity of
diasporic and internationalist formations—in the case of "Black and White,"
the distance between both Hughes and Mayakovsky and Hughes and Cuba.[62]
Just as with Mayakovsky, Cuba was for Hughes an exotic place; the connec-
tion between the African American poet and his Afro-Cuban colleagues was
far from seamless. Indeed, in a coincidental echo of Mayakovsky's juxtapo-
sition of Havana cemetery and telegraph office, Hughes's 1931 poem "To
the Little Fort of San Lazaro on the Ocean Front, Havana" begins with the
romantic past of the eponymous stone fortress repelling pirates and ends
with the unromantic present of U.S. banks ensconced in the city. In short,
both poets could present Cuba only from the outside, and both applied to
the island a similarly exoticist gaze.[63]

Given their limited perspectives on Cuba, what I would like to suggest
is that Hughes supplemented Mayakovsky's efforts to represent this place
that both had only visited. Returning to Hughes's "Black and White" and,
in particular, his rendering of Willie's question, here we find an English
translation of a Russian translation of either English or Spanish speech.
While the first translation at hand (Mayakovsky's) provides a minimal
sense of the distance between the Soviet Union and Cuba, the second
translation (Hughes's) emphasizes this precisely by departing from Maya-
kovsky's distinctive voice and fragmented form:

> "Excuse me, Mr. Bragg,
> But why's your white, white sugar ground by black, black Negroes?
> A black cigar don't go with your moustach— [*sic*]
> That's for a Negro with a black moustach!
> And since you like coffee with sugar,
> Why don't you grind the sugar yourself?"[64]

It would be absurd to say that Hughes here presents what an Afro-Cuban
laborer might actually say, for of course an actual Afro-Cuban would use

Spanish. Rather, Hughes seems to confer upon Willie an African American voice ("A black cigar don't go")—despite the fact that he himself resisted using such dialect when subsequently translating Guillén.[65] Dialect here functions as an English domestic remainder deployed by Hughes to achieve two ends: first, to accentuate the gap between his language and Mayakovsky's, and second, to highlight Willie's own distinctness, which the original poem downplays. Again, this distinctness has more of an African American than Afro-Cuban inflection, which raises the possibility that Hughes, like Mayakovsky, is simply imparting his own voice to Willie. However, the crucial difference is that Hughes's version grants Willie a potency, an agency that is lacking in the original. In place of Mayakovsky's bouncing playfulness, Hughes imparts to him a simmering reserve. The original's manic, transliterated "Ai beg yor pardon, mister Bregg!" becomes a terse "Excuse me, Mr. Bragg." Willie's closing line—"then sugar / please / make yourself"—becomes more pointed and defiant: "Why don't you grind the sugar yourself?" While Hughes still advises this character to turn to the Comintern and Moscow, and portrays his brain as housing "few furrows: / Little sown, little harvest," his voice gains a forthrightness and, I think, a sophistication lacking in the original.

Much, of course, is lost in Hughes's translation—Mayakovsky's incorporation of transliterated English, for example. Indeed, Hughes's domestic remainders do not seem geared toward capturing the foreignness (as Venuti would have it) of "Blek end uait" but rather toward improving the Soviet poet's efforts to speak for the Other. This is not to say that Hughes refused Mayakovsky's voice and form: in Willie's speech, Hughes not only maintains the original's bubbly repetition ("white, white") but also adds some of his own—the new, second "black" in "black, black." In other words, Hughes builds upon rather than counters Mayakovsky. He enables the Soviet poet to realize the potential identified by Filatova, namely, by enhancing, in "Blek end uait," the balance of "generalizations" and "individual substance," world revolution and ethnic particularities.[66] We can thus see "Blek end uait" / "Black and White" as a shared effort between Hughes and Mayakovsky to render (in Russian and English) an Afro-Cuban voice (presumably Spanish)—a collaboration that occurred via translation, three years after Mayakovsky's suicide. In this posthumous literary encounter, translation provides a means of connecting cultures and languages without obliterating their differences.[67]

Accordingly, using Walter Benjamin's famous account of it, we can see translation as a tangent touching a circle, the original, and, by this light touch, the translation proceeding into infinity, following "its own course according to the laws of fidelity in the freedom of linguistic flux."[68] One language does not impose on the other, but the two remain discrete, supplementing and estranging each other by this touch but still pursuing their own courses. Seen from the perspective of the Mayakovsky-Hughes encounter, Benjamin here provides a model for balancing cultural unity and difference, but of course he also presents translation in a more utopian light. For him translation reveals the "innermost kinship of languages" (255) and thus serves to regain "pure language fully formed in the linguistic flux" (261):

> In translation the original rises into a higher and purer linguistic air, as it were. It cannot live there permanently, to be sure; neither can it reach that level in every aspect of the work. Yet in a singularly impressive manner, it at least points the way to this region: the predestined, hitherto inaccessible realm of reconciliation and fulfillment of languages. (257)

This is all to heighten the significance of Hughes's Mayakovsky translations—his translations as not simply an instance of intercultural, internationalist collaboration but also a means of forging new Towers of Babel. Benjamin almost but does not quite reference that tower here—tangent and circle giving rise to something in the air, however so briefly. In turn, we can imagine that this particular tangent (Hughes's "Black and White") and circle (Mayakovsky's "Blek end uait") approximate some of the component spirals and trusses of Tatlin's Tower.

To put this in less fanciful terms, what I am suggesting is that Hughes takes Mayakovsky's iconoclastic form and perspective as a starting point and then extends them—the tangent touching the circle to chart a new course. Perhaps the clearest, most concrete indication of this can be found in Hughes's 1934 poem "Cubes," published in the *New Masses* soon after his return from the USSR via East Asia. Linking "the broken cubes of Picasso" to the presence of Africans in Paris, it explicitly pillories the Western avant-garde's interest in blackness:

God
Knows why the French

Amuse themselves bringing to Paris
Negroes from Senegal.

It's the old game of the boss and the bossed,
 boss and the bossed,
 amused
 and
 amusing,
 worked and working,
Behind the cubes of black and white,
 black and white,
 black and white

Here Hughes emphasizes the exploitation underlying cubist renderings of African masks, the imperialism that undergirds Western modernist primitivism.[69] Perhaps, too, we find here disapproval of Mayakovsky, with the blatant references to "Black and White" hinting that the Soviet poem also contains this familiar interplay of "amused / and / amusing." But Moscow is not Paris, and "Cubes" is clearly not just a criticism of but homage to Mayakovsky, a synthesis of "Black and White" and "Syphilis." The Afro-Cuban Willie is replaced by a Senegalese man (the bossed), the American Mr. Bragg is replaced by the French (the boss), and Hughes uses the sex trade to illustrate the relationship between the two: the Senegalese wanders the boulevards of Paris, contracts venereal disease from three French prostitutes (named Liberty, Equality, Fraternity), and then transmits the disease to Africa, "To spread among the black girls in the palm huts." In line with Mayakovsky, here we find an exoticist vision of Africa, but one geared toward a critique of imperialism, the disease transmitted "From light to darkness," "From the boss to the bossed."

Beyond these obvious readings, I would like to suggest that "Cubes" shows the aftereffects of Hughes's encounter with Mayakovsky, but with a difference—again, the tangent touching the circle but proceeding on its own course. Hughes's multiple repetitions and fragmented, scattered lines gesture to Mayakovsky's form, but the tone remains reserved—almost as though Hughes's Willie himself were the one speaking. As in Mayakovsky's poems, Hughes's layout highlights the shape of each line, the materiality of each word, though if Mayakovsky's lines seem to approximate Tatlin's

Tower, here we find an arguably more complicated, less-regular structure. And yet "Cubes" does conclude with a one-word spiral of sorts:

d

 i

s

 e

 a

 s

 e

Though it is unclear whether Hughes ever encountered Tatlin's design, this parting word works well with the *Monument to the Third International*— both serving as springboards for attacking Western dominance, artistic and political. In this evocation of Tatlin and, in turn, Babel, we find the now-familiar yearning for a unified language that might cross the boundaries of race, ethnicity, and nation. Gesturing to Soviet avant-gardist form, the poem adopts Mayakovsky's combination of exoticism and anti-imperialism, and applies its critical gaze elsewhere.

Hughes in Central Asia, Eisenstein in Mexico

This gaze redirects our attention from language to a way of seeing that connected these two poets—a similar way of understanding different cultures. "Read Mayakovsky's poem *Black and White*, or *Syphilis*, if you don't know what life is like in Cuba," Hughes advises in a slim travelogue that he wrote in Moscow, around the same time that he translated these works.[70] Titled *A Negro Looks at Soviet Central Asia* (1934), it contrasted the American South and the Soviet "East" and, specifically, the treatment of minorities in both places. As noted, Hughes had arrived in Moscow in the summer of 1932 to assist with a Soviet film on African American struggles. After this project fell through, he spent several months traveling the steppes of Kazakhstan, Uzbekistan, and Turkmenistan in order to see how the USSR treated its own "dark races."[71] He was not the first to make such a trip: he spent Christmas of 1932 in a remote *kolkhoz* in Uzbekistan settled by a group of African Americans helping the Soviets to cultivate cotton.[72]

The travelogue resulting from this journey is similar to Mayakovsky's writings in that it pairs the exotic with revolution. In Uzbekistan, wandering the Silk Road city of Bukhara, he is just as enchanted as Mayakovsky is by Cuba and Mexico:

> I walk through the streets of Bukhara, eastern city of song and story, place of legend. I walk through the crumbling walls of sun-dried brick, beneath the empty towers and minarets, past the palaces and mosques. I remember how, as a boy in far-away Kansas, I dreamed of seeing this fabulous city of Bukhara—as distant then as a fantasy of the *Thousand and One Nights*. And now, in 1932, here I am (dreams come true) travelling through the courtesy of a Soviet newspaper throughout Central Asia, and seeing for myself all the dusty and wonderful horrors that feudalism and religion created in the dark past, and that have now been taken over by socialism. (28)

These lines echo Claude McKay's "Afro-Orientalist" poem on Moscow (discussed in the introduction), as well as Mayakovsky's criticism but also embrace of the exotic—here taking the form of the feudal and religious past, seen by Hughes as both wonderful and horrible. Indeed, even as he praises Soviet nationalities policy—in particular, Moscow's elimination of czarist segregation as well as its campaign to unveil Uzbek women—he yearns for instances of the exotic in harmony with revolution, beyond the limits of "national form, socialist content." And ultimately, Hughes finds this merging in the dances of Tamara Khanum, "the first woman in the history of the peoples of Uzbekistan to perform on a public stage" (41–42). Before the revolution, he explains, women were forbidden to dance, and several unveiled theater performers were murdered in the early days after the revolution. Instead, young boys played the roles of women, and as Kate Baldwin has elaborated, Khanum's performances thus enabled Hughes to recast the "veil of race" in terms of female agency and sexuality.[73] In the travelogue Khanum enables him to trouble the boundaries between new and old, Soviet power and Uzbek tradition, male and female: "She has taken over the best of the old dances of the former boy-dancers, and has created new patterns of her own" (47).

This synthesis of new and old is precisely what Mayakovsky found in the murals of Diego Rivera, as did Sergei Eisenstein, who went to Mexico in 1930 to shoot a film based on these same murals. Unfortunately,

the Kremlin ordered Eisenstein back to the USSR in early 1932 before he could finish shooting, just as later that year it ordered the cancellation of Hughes's Soviet film project. That is, the same year that Langston Hughes wandered the Central Asian steppe Eisenstein was in the Mexican desert, enchanted by its flatness—in his words, "the geographic coexistence of different stages of cultures, something that makes Mexico so surprising."[74] The film itself (partly reconstructed and released by Mosfil'm in 1979) was to present all of Mexico's history—from a premodern, matriarchal utopia to the Spanish conquest to the revolution of 1910–1920—and conclude with dancing skeletons from a Day of the Dead celebration. As Eisenstein elaborated, "This is a remarkable Mexican day, when Mexicans recall the past and show their contempt of death. . . . With victory of life over death, the film ends. Life brims from under the cardboard skeletons, life gushes forth, and death retreats, fades away." In short, just as Hughes found hints of a new Uzbekistan in traditional Uzbek dance, Eisenstein sought to harness this vestige of pre-Columbian culture to usher in a "new growing Mexico."[75] Also like Hughes, Eisenstein used his travels to trouble gender roles—in his case, to explore fully his own bisexuality—thus subverting the heteronormative masculinism frequently associated with the historical avant-garde.[76] Thus, in their mirror-image journeys to the opposite ends of the earth, Hughes and Eisenstein, Hughes and Mayakovsky were looking for something quite similar—exotic cultures that could point to a liberated, boundary-crossing future.

Hughes in the Central Asian steppe, Eisenstein in the Mexican desert, Mayakovsky at Camp "Nit Gedaige"—the threads connecting these fragments are common efforts to pair artistic innovation with revolutionary politics; ethnic identity with socialist internationalism; exoticism with anti-imperialism. There were certainly challenges facing these efforts, namely, the constant dilemma of mutual misunderstanding and misrepresentation—a dilemma that LEF's turn to factography sought to remedy, as discussed in the next chapter. Nonetheless, rearticulating such fragments makes it possible to at least begin to discern the visions and languages of this polyglot ethnic avant-garde.

2

The Avant-Garde's Asia

Factography and *Roar China*

You are an Asiatic. So am I.

—Joseph Stalin to Japanese foreign minister Matsuoka Yōsuke, April 13, 1941

The preceding chapter followed Vladimir Mayakovsky on his 1925 American travels. This one begins with another Soviet futurist, Sergei Tret'iakov, traveling to China in 1924. A poet, playwright, and photographer, he had weathered the Russian Civil War in Vladivostok, there cofounding the Far Eastern futurist group Tvorchestvo (Creation), and then in 1922 had settled in Moscow, joining Mayakovsky's Left Front of the Arts (LEF).[1] He spent two years in China, where he taught Russian literature at Peking University and wrote several works based on his observations there. One of them, a play called *Roar China*, is the focus of this chapter. Though little remembered now, this indictment of Western imperialism in 1920s China was one of the most successful, internationally performed works of its time. After debuting at Moscow's Meyerhold Theater in 1926, where it ran for four years, it was part of that theater's 1930 European tour and also appeared around the world—including in New York, where it was produced by the respected Theatre Guild company in 1930.

Staged at the behemoth Martin Beck (now Al Hirschfeld) Theatre, this Soviet play—and not, as is usually claimed, Rodgers and Hammerstein's 1959 musical *Flower Drum Song*—was the first major Broadway production to feature a predominantly Asian American cast. Thus, we can use *Roar China* to extend the Moscow-centered ethnic avant-garde to Asian Americans, a group not typically associated with interwar socialist culture.[2]

More broadly, though, *Roar China* reveals an ethnic avant-garde that, in tandem with the Soviet avant-garde, was forced to adapt to the increasingly restrictive political climate of the late 1920s and early 1930s. In the case of Tret'iakov and his fellow futurists at LEF, adaptation came in the form of a quixotic and contradictory technique called factography—the transformation of both art and reality through the "precise fixation of facts."[3] This technique and its literary component, "the literature of fact," marked the Soviet avant-garde's gradual turn from iconoclasm, that is, from eccentric works like Tatlin's Tower and Mayakovsky's American writings. From this perspective, the chapter marks the beginning of the end of both the ethnic and Soviet avant-gardes. However, in line with the various Towers of Babel that we encountered in the previous chapter, factography still cast the non-European Other in a radical, experimental light. Indeed, this technique can be seen as offering a positive alternative to the ethnic avant-garde of Mayakovsky and McKay, Hughes and Eisenstein, in that it explicitly eschewed exoticism in favor of ethnographic precision. To be sure, the lens opened by this turn from iconoclasm to factography is not as estranging as those offered by the likes of Tatlin or Mayakovsky. Still, *Roar China* presents another avant-gardist path not taken, one that reveals Asian America's forgotten Soviet legacy.

The chapter begins by describing the emergence of factography within Soviet avant-garde circles of the mid to late 1920s, using the various manifestations of *Roar China* to illustrate this technique. Just as in the introduction and chapter 1, I draw both contrasts and connections between the avant-garde and vanguard, in particular, between *Roar China* and the Comintern's disastrous policy toward China. The chapter then focuses on how factography translated abroad, comparing the 1930 New York production to the Moscow original. As will become apparent, both the play and factography benefited from the inclusion of Asian American actors, mostly Chinese and Korean immigrants living in New York. However, in the move to New York, key factographic elements were dropped, and the technique began to fade from memory. After discussing additional echoes of *Roar China* through the 1930s, I use Langston Hughes's 1937 poem by the same name to mark the abandonment of factography in the face of socialist realism and Stalinist terror.

However, beyond this predictable arc from avant-gardism to socialist realism, the main goal here is to salvage something positive from this

suppressed, forgotten technique. Specifically, *Roar China* presents an anti-exoticist iteration of the Moscow-centered ethnic avant-garde, here bearing a clearer political vision than in the previous chapter. Again, this can be attributed to growing political and aesthetic constraints in the Soviet Union, but just as in the previous chapter's discussion of Mayakovsky and Hughes, we will find non-Soviet artists claiming and adapting Soviet culture. Through their many reworkings of *Roar China* and factography, these artists were able to smuggle the ethnic avant-garde out of the USSR and into the postwar years.

The Facts of *Roar China*

Tret'iakov arrived in China soon after Sun Yat-sen announced that his fledgling republic would look to the Soviet Union for assistance against Western imperialism. In response, the Comintern sent financial and military aid to bolster Sun's project of national consolidation. It also sent a wave of military and political advisers, and though not a formal Comintern agent, Tret'iakov can be regarded as part of this Soviet outreach to China.[4] After the prospects for European revolution dimmed, Moscow and the Comintern increasingly looked eastward, and given its precarious, semicolonized status, China seemed particularly ripe for upheaval. However, the Comintern—increasingly beholden to Stalinist realpolitik from the mid-1920s—deemed that the country still had to pass through a bourgeois nationalist stage before advancing to socialism. That is, even though the Bolsheviks had justified the outbreak of revolution in their own "backward" country, they came to apply a more conservative line to others—a reflection of the Comintern's increasingly rigid, evolutionist take on history, as well as Trotsky's declining authority. Thus, Moscow instructed the Chinese Communist Party (CCP) to ally itself with Sun's Nationalist Party, or Guomindang, and to maintain this alliance with Sun's vehemently anticommunist successor, Chiang Kai-shek. The result was the near liquidation of the CCP in 1927, when Chiang abandoned the alliance and massacred thousands of communists in Shanghai—the topic of André Malraux's 1933 novel *La condition humaine*.[5]

As spelled out in the introduction, the Soviet avant-garde can be seen as connected to but apart from the Comintern—Tret'iakov as the former's

representative to China. He was not the only avant-gardist drawn there. His close friend Sergei Eisenstein was as well, and in 1925–1926 he and Tret'iakov planned a never-realized sprawling film epic on Chinese history, similar in concept to ¡Que viva México![6] As might be expected in light of the Mexican project, Eisenstein was drawn to the "exoticness" of China: from the 1920s through the 1940s, he wrote essays embracing what he viewed as the visual and nonrational bases of the Chinese and Japanese cultures. For instance, he celebrated how Chinese ideograms created meaning through the collision of images—the product of a "primitive thought process" that, he claimed, anticipated his own views on montage. As Katerina Clark has shown, for him Chinese ideograms also pointed to the overcoming of linguistic divides demanded by a Moscow-centered world order. In his words, ideograms provided "a unique model for how, through emotional images filled with proletarian wisdom and humanity, the great ideas of our great land must be poured into the hearts and emotions of the millions of nations speaking different languages."[7] Of course, this exoticist embrace of the Chinese language is now legible to us: Eisenstein here brings to mind both Ezra Pound's own embrace of Chinese as well as the ethnic avant-garde's search for a unified language via past-present constellations.

Tret'iakov, however, was a different kind of avant-gardist, rejecting Eisenstein's exoticism, that is, Eisenstein's emphasis on Chinese "backwardness." In his writings on China, Tret'iakov's goal was to present China "as it really was," eschewing the exotic and revealing the most pressing issue facing the country—according to him, Western imperialism. In short, Tret'iakov offered an alternative model for the Soviet-centered ethnic avant-garde, one that broke from fanciful, mythological notions of revolutionary history and non-Western cultures. Instead, his emphasis was on contemporary China, and accordingly, *Roar China* was based on actual events that occurred in Wanxian, a small town on the Yangtze River, in June 1924: an American businessman named Ashlay got into a scuffle with Chinese boatmen and ended up dead in the river. In response, the captain of the British gunboat HMS *Cockchafer* ordered that the guilty man be found and put to death—or else that two random members of the boatmen's union be put to death. Failure to comply would result in the annihilation of the town. After two days, according to Tret'iakov, "two boatmen were executed, sacrificed to the red-headed god of British ruthlessness. These are the facts: I have hardly had to change anything."[8]

Despite this seeming transparency, Tret'iakov endeavored, in Devin Fore's words, "not simply to depict life, but to create it anew in the process." That is, he was a steadfast avant-gardist in Peter Bürger's sense of the word, committed to bringing art into life—a definition that Bürger substantiates through, for example, cubism's incorporation of newspapers into painting. Accordingly, Tret'iakov described *Roar China* as an "article, only it reaches the audience's consciousness not from the pages of a newspaper but from theatrical stageboards"—in short, the incorporation of newspapers into theater. For Bürger, the works of the historical avant-garde abandoned organicity in favor of fragments, the aim being to highlight the "principles of construction that determine the constitution of the work." Accordingly, Tret'iakov opposed art and literature as passive reflection and maintained an open-ended, dynamic understanding of "facts"—for him, the result of action, process, and operation.[9] It is this self-critical open-endedness that keeps factography interesting amid its muted iconoclasm, allowing for innovative presentations of workers, peasants, and Chinese people—Tret'iakov's subjects of choice.

To understand this iteration of the Soviet avant-garde, Walter Benjamin again comes in handy. In a 1934 Paris lecture titled "The Author as Producer," he singled out Tret'iakov as exemplifying the ability to overcome the seeming opposition between political tendency and artistic quality, namely, by being not just an author but also a producer. Benjamin was referring to Tret'iakov's 1928 stint at a *kolkhoz*, where he called mass meetings, collected funds for tractors, and edited a small newspaper. But Tret'iakov's writings from the mid-1920s also comply with Benjamin's more formal prescriptions for overcoming this opposition: combining different media such as writing and photographs, turning readers and spectators into collaborators, and, in the case of theater, employing montage and interruption. (Benjamin uses Brecht here as an example, and Tret'iakov happened to be Brecht's Russian translator and collaborator.[10]) In short, Benjamin viewed such techniques as dissolving the conventional separation of tendency and quality, as granting art an organizing function without reducing it to propaganda. Maria Gough nicely sums up his stance: "In order to formulate an efficacious concept of tendency, Benjamin dissolves its conventional opposition to quality by redefining quality itself as a matter of literary tendency, and the latter, in turn, as a matter of progressive or regressive literary technique."[11]

However, Benjamin's embrace of Tret'iakov was a bit too generous—perhaps reflecting his awareness that, in 1934, Moscow had enshrined socialist realism, consummating the Soviet avant-garde's decline.[12] Indeed, factography is best understood as a defensive measure that had sought to prevent this outcome. By the mid-1920s, efforts to fuse avant-garde and vanguard had apparently fallen flat: LEF had failed to make its art and writing an integral part of postrevolutionary society. As a case in point, art historian Benjamin Buchloh notes the painter El Lissitzky's outreach to factory workers in the early 1920s:

> The paradox and historical irony of Lissitzky's work was, of course, that it had introduced a revolution of the perceptual apparatus into an otherwise totally unchanged social institution, one that constantly reaffirms both the contemplative behavior and the sanctity of historically rooted works of art.
>
> This paradox complemented the contradiction that had become apparent several years earlier when Lissitzky had placed a suprematist painting, enlarged to the size of an agitational billboard, in front of a factory entrance in Vitebsk. This utopian radicalism in the formal sphere—what the conservative Soviet critics later would pejoratively allude to as formalism—in its failure to communicate with and address the new audiences of industrialized urban society in the Soviet Union, became increasingly problematic in the eyes of the very groups that had developed constructivist strategies to expand the framework of modernism.[13]

Thus, avant-gardists like Lissitzky—encountered in the introduction praising Tatlin's Tower as a new Sargon Pyramid—had grown troubled by a perceived gulf between them and the masses. Their formal innovations seemed increasingly at odds with Soviet audiences and realities. In response, techniques like factography were aimed at accessibility and the transformation of social institutions. At the same time, however, the LEF group remained opposed, in Tret'iakov's words, to "art in its aesthetic-stupefying function."[14] That is, the factographers were still intent on defamiliarization, on creating works that would change how the masses perceived a postrevolutionary world. They were particularly against art as mere representation, or as Leah Dickerman puts it, "the reflection model of realism . . . presupposing a stable and transhistorical concept of truth," which

in turn pointed to an "emergent model of socialist realism."[15] Tret'iakov and his circle sought a middle ground of sorts, art that was legible to workers, but that also destabilized perception and undercut received notions of the real.

Factography was intended to serve these ends. For the visual arts, its emphasis on precise facts translated to a shift from painting to photography, more specifically, from nonrepresentational works that highlighted their own constructedness to iconic photos that seemed to render "aspects of reality visible without interference or mediation."[16] For writing, the literature of fact spelled a rejection of fiction in favor of reportage. Thus, in 1928 Tret'iakov proclaimed,

> Now the maximum of the left movement has transferred over to the line of the assertion of documentary literature. The problem of the fixation of fact; raising the interest of the activists in reality; the assertion of the primacy of realness over fiction, the publicist over the belletrist—this is what in Lef is now most burning and immediate.
>
> The memoir, travel notes, the sketch, articles, feuilletons, reportage, investigations, documentary montage—opposed to the belletristic forms of novels, novellas, and short stories.
>
> The fight for fact against fiction divides today's futurists from the passéists.[17]

We see here the broad generic range of the literature of fact, which Tret'iakov envisioned not as a new genre itself but as a "method of utilitarian publicistic work on present-day socialist problems." That is, the literature of fact was to capture the "reality" of socialist life in as objective a manner as possible, not reality as it was supposed to be—the prerogative, in the near future, of socialist realism. Tret'iakov called for reportage on such tasks as "raising literacy, doubling the harvest, collectivization of agriculture, raising the productivity of labor, and other everyday matters."[18] Likewise, he pressed for new books with titles like *Forest, Bread, Coal, Iron, Flax, Cotton, Paper, Locomotive, Factory*, eschewing hagiographies of revolutionary heroes.[19]

Factography was to enable art and literature to catch up to "enormously developing reality," namely the massive transformations brought by Soviet industrialization.[20] It was to allow the viewer or the reader to "experience the extended massiveness of reality, its authentic meaning."[21] Again,

. ТРЕТЬЯКОВ

РЫЧИ, КИТАЙ!

■ ■ ■
БИБЛИОТЕКА „ОГОНЕК"
№ 160
АКЦ. ИЗД. О-во „ОГОНЕК"
МОСКВА—1926

FIGURE 2.1 1926 cover of the poem "Roar, China!"

Courtesy of Widener Library, Harvard University.

though, this meaning was not to be achieved through passive reflection but rather the disruptive combination of facts that themselves were understood as emerging from action and process. Quoting Viktor Shklovskii, Dickerman notes that "the role of the factographic author was to return to a state of first sight—'to see things as they have not been described.' "[22] Accordingly, this technique privileged the fragment, lost details, and limited points of views—thus Tret'iakov's earlier-noted preference for incomplete writings (e.g., the travel note and sketch). In addition, this technique combined various forms, styles, and genres; for instance, the literature of fact was to be "an explicitly photographic mode of writing," and Tret'iakov presented himself as both a writer and photographer. However, the factographic photograph was often provisional, partial, or blurred.[23]

To help illustrate these claims and intents, let us now turn to *Roar China*, which appropriately assumed multiple forms. The 1926 play was preceded by a 1924 futurist poem called "Roar, China!" which Tret'iakov describes in his introduction to it as "a first encounter with China—or more accurately with a Peking street. . . . The basis of the poem's songs is 'a sound signboard' of the vagrant artisans and sellers of Peking, that is, either hawker calls or the sounds of different instruments."[24] He then provides a partial index of these sounds, as well as images and terms:

The knife grinder makes himself known with a long, thin pipe, the sound of which is like a battle signal.

The axle of a water-carrier's wheelbarrow is rubbed with rosin and emits a distinctive creak. . . .

In the rickshaw—a two-wheeled carriage—the passenger is suspended. If the driver releases the shaft, there's a blow to the back of the head on the ground.

Manure collectors with particular ladles on long handles gather every grain of manure from the Peking streets and khutings (alleys), which is deftly thrown over the shoulder into tubs or baskets carried on the back.

Blue is the basic color of Chinese clothing.

Loess—yellow earth—forms the Chinese soil, and also is carried by winds from Mongolia to East Turkestan.

Palanquins—sedans—are the means of movement of rich Chinese.

Copper and kesh—Chinese coins. A copper is 1/3 a kopeck. A kesh is 1/10 a copper.

"Tsuba"—down! Scram!
"Red devils"—nickname given by Chinese to Europeans.
"Kaki"—fruits akin to sweet tomatoes.[25]

Here we find a montage of seemingly random details, presented in both short sentences and sentence fragments, the aim being to capture the experience of walking down a Beijing street. In keeping with Benjamin's "Author as Producer," Tret'iakov inserts himself into the world he depicts, and to emphasize objectivity, he keeps embellishments to a minimum. We find just one use of simile—"like a battle signal"—and no clear agitational content aside from that reference to "red devils."

The poem itself bears similar features, though with more emphasis on fragment. Note, for example, part one, "Walls":

U Kitaia mnogo tiazhelykh sten.	China has many heavy walls.
Tsapaiut nebo zubami za kozhu.	They snatch the sky by the skin with teeth.
Kitai ustal	China is tired.
Kitaiu postel'—	A bed for China—
Mezh sten pustynia postlala lozhe.	Between the walls the desert laid a bed.
Zheltyi less—	Yellow loess—
Zemlianoe salo,	Earthen fat,
Chtoby koles	So that the rumble of wheels
Grokhotal' ne briatsala.	Doesn't cease to jangle.
Zhirnyi less	The rich loess
Rodit ris.	Bears rice.
Vodoemnykh koles	The reservoir wheels'
Vzmakh vverkh,	Upward stroke,
Vzmakh vniz,—	Downward stroke—
I zelenyi risovyi mekh	And the green rice fur
Rastet.	Grows.
Ris, pitai	Rice, feed
Kitai.	China.
Arba, katai	Oxcart, drive
Kitai.[26]	China.

The poem begins with a journey past the Great Wall of China, desert, and fields—the outsider making his way to the city. The crenellations of the

wall become snatching teeth, but Tret'iakov quickly abandons this meta-phor—namely, the Great Wall as a forbidding dragon intent on keeping out foreigners. In response to this exoticist trope, he presents mundane agri-cultural scenes—the movement of reservoir wheels and oxcarts, the slow growth of rice.

These examples point to the promise of the literature of fact. Tret'iakov's effort to return to a "state of first sight" is evident in the open-ing index's unconnected details and sounds, as well as in the poem's short lines, evocative of Mayakovsky's American writings taken up in the previ-ous chapter. Once again, fragments are used to capture arrival in a new place, but Tret'iakov eschews Mayakovsky's all-encompassing poetic voice. What we find here instead is the author's own sense of disorientation as he tries to remove the barrier between self and reader, relaying his immediate impressions of arriving by cart and walking down the street. Unlike with Mayakovsky's Cuba and Mexico, there are no traces of a premodern uto-pia. The countryside is exhausted rather than alluring; promise lies in the future rather than the past. Though Tret'iakov, like Mayakovsky, presents a place that is distant and estranging, for him it becomes comprehensible through this assemblage of facts.[27]

However, these examples also point to the contradictions inherent to factography, namely, its claim but inability to overcome artistic media-tion. Of course, the index's selection of details to signify China is itself an instance of literary embellishment, that is, metonymy. Likewise, the poem makes consistent use of rhyme and alliteration—for instance, "pitai / Kitai" and "katai / Kitai" in the preceding excerpt. As he further developed fac-tography and the literature of fact through the mid to late 1920s, Tret'iakov came to disavow such poetic flourishes and, indeed, poetry entirely in fa-vor of photography, newspaper reportage, and kolkhoz sojourns. In a 1928 manifesto, he noted "a sharp decline in the readers' appetite for verse" and recounted the following episode involving Vladimir Mayakovsky:

As Mayakovsky was reading in the Red Hall of the Moscow Komsomol, the young organization members knowing him by heart and loving him, called out: "Down with Mayakovsky-the-poet, long live Mayakovsky-the-journalist!" And Mayakovsky applauded this outburst. Or, giving an order about how and what to write from abroad, they said: "Write us a lot about what is abroad, only write it in prose."[28]

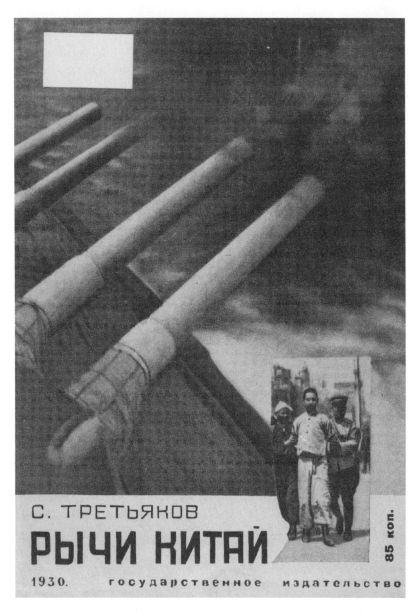

С. ТРЕТЬЯКОВ
РЫЧИ КИТАЙ
1930. государственное издательство
85 коп.

FIGURE 2.2 1930 cover of the play *Roar China*.

Courtesy of Widener Library, Harvard University.

Thus, in the peak years of the literature of fact, we find poets sublating themselves into journalists, verse giving way to prose. Accordingly, by this time Tret'iakov had already reworked "Roar, China!" the poem into *Roar China* the play, which, again, he envisioned as a newspaper article on stage. However, in its transformation from poem to play, *Roar China* maintained its sense of both promise and contradiction—a tension between estranging and reflecting reality. This was particularly the case in its depictions of non-Western peoples and cultures.

The Moscow and New York Productions

The play consists of nine scenes, with action alternating between the British ship and Wanxian's wharf, the Chinese and Westerners kept largely separate until the final execution scene. The plot follows the sequence of events as laid out above, though the death of the businessman Ashlay is rendered an accident: he falls into the river after haggling with a boatman over fifteen coppers. This prompts the town's Western colony—including a French merchant family, camera-wielding tourists, and a journalist with a taste for child prostitutes—to seek refuge on the *Cockchafer* until the captain carries out his ultimatum. In the meantime, as a way of protest, the ship's Chinese servant boy commits suicide above the captain's bridge, a gruesome figure that a character named Cordelia, the young daughter of a businessman, states "would make a marvelous photograph" (76). Back on the shore, the man involved in Ashlay's death is nowhere to be found, forcing members of the boatmen's union to draw straws to determine who among them will be hanged. Immediately after the execution, which occurs onshore, the journalist attempts to photograph the two corpses ("It'll be quite a scoop," he says), sparking a protest among the Chinese (85). The wife of one of the executed boatmen tells her young son to look at the captain and to "grow up quickly to kill him" (88). Another Chinese character, called Stoker (i.e., the furnace stoker at the local radio station), who earlier urges the boatmen to draw hope from the Russian Revolution, reveals himself as a member of the Canton Workers' Militia, with his blue uniform and red ribbon. Suddenly it seems that the Chinese crowd is filled with these uniforms, and the Westerners flee back to their ship. Stoker brandishes a gun and calls after them, "Count your hours. Your end is near. China is

roaring. Oh, you can see me at last" (89). In short, via factography and the Comintern, this is a play about making China visible, explicitly rejecting the fetishistic efforts of Westerners to capture this place on film.[29]

Tret'iakov's staged newspaper story reports the 1924 incident as the basis for imminent revolution—the facts of the incident presented so as to bolster the transformation of reality. Indeed, in 1926, the same year that the play debuted at Meyerhold, art and life seemed to merge: two British gunboats (including the *Cockchafer*) destroyed the town of Wanxian, killing hundreds of civilians. "The direct cause of the incident was the British attempt to retrieve forcibly two merchant ships that, blamed for crushing two sampans carrying Chinese soldiers across the Yangtze, had been commandeered by the Chinese in late August."[30] *Roar China* thus assumed a prophetic quality, which bolstered its success both at home and abroad. It was particularly popular among foreigners in the Soviet Union, with one Englishman calling it "the leading show piece of Moscow to which every visitor who devoutedly believed in the principle of the New Russia went to pay homage."[31] As Konstantin Rudnitsky recounts, Tret'iakov's "aim was achieved":

> Instead of exotic "chinoiserie" the audience saw unusually lifelike tableaux. The crowd scenes recalled those of the early [Moscow Art Theater] and in the reviews the word "naturalism" cropped up accompanied by the epithets "ethnographic," "dismal," "earth-bound," and so on. The scene of the execution of the two Chinese, "shown in all its repugnant details," shocked the critics. . . . The Chinese "sections" created a more striking impression than the sharply caricatured European episodes.[32]

Rudnitsky here touches on the play's tension between naturalism (associated with Stanislavsky and the Moscow Art Theater) and caricature (for which the experimental Meyerhold Theater was famous), more specifically, between journalistic depictions of the Chinese and stylized depictions of the Europeans. I delve into this tension below, but suffice it to say for now, one of the play's innovations was indeed its nonexoticist depictions of the Chinese characters. Although all the roles were played by non-Asian actors, the production incorporated such "ethnographic" details as musical instruments, costumes, rickshaws, and fan vendors. According to Rudnitsky, "a great variety of genuine objects was brought from China. Chinese students in Moscow were invited to rehearsals and asked to check

that there were no blunders in the details of everyday life and behavior." At the same time, Tret'iakov sought to avoid chinoiserie by insisting that "the stage must not be decorated with pretentious curved roofs, screens, dragons or lanterns." The Moscow production began with a full ten minutes of the Chinese characters loading bales of tea onto boats.³³

This brings us to *Roar China* as a departure from the avant-gardist representations of the Other presented in chapter 1. Again, the key here is Tret'iakov's abandonment of exoticism, something he lays out in the play's introduction:

> Barefooted workmen, in grey and blue clothes, at first sight apathetic, working slowly; dignified officials dotted among them rustling in their black silk jackets; portly merchants; young intellectuals with glasses and Western hats—this is the true China which must be opposed to the old false and exotic ideas about China, with its wonderful vases, embroidered kimonos, phoenixes, dragons, pagodas, princesses, refined courtesans, cruel mandarins, dancers (who, by the way, do not exist in China, as China is not acquainted with the art of dancing); opposed, in a word, to all the harmful tomfoolery which is still believed in the West.³⁴

Particularly interesting here is the absurd notion that dancing did not exist in China. This is a far cry from Eisenstein's subsequent embrace of Mexican dance, as well as Hughes's embrace of Uzbek dance. As we saw, both sought to harness these "exotic" traditions for socialist revolution, and arguably Tret'iakov pushes too hard here against exoticism and any ensuing "denial of coevalness." For instance, the play includes a monk who tries to sell to the boatmen "holy silk," promising that the prayer written on it will protect them from bullets (66–67). While McKay, Mayakovsky, Eisenstein, and Hughes might have accentuated this scrap of premodern utopianism—this potential alignment of exotic past and revolutionary present—Tret'iakov has Stoker drive the monk away by daring him to wear the clothes of a boatman.

However, what appears at first glance to be an abandonment of Benjaminian now-time in favor of linear modernization is in fact a more nuanced version of it. As indicated in the preceding passage, Tret'iakov's China is indeed marked by multiple temporalities—plain workers' clothing interspersed with traditional silk jackets, as well as intellectuals wearing glasses and Western hats. Accordingly, the play features a student who

wears a traditional gray gown "on top of European trousers and shoes, horn-rimmed glasses and a Trilby hat" (51), details indicating that what drew Tret'iakov's attention were precisely intermixtures of modern and premodern, East and West. He used such intermixture to disrupt the exoticism of his contemporaries—Western writers who, in his words, used "China as a piquant exotic spice for fiction" so as "to fend off the stench of poverty, illness, hatred, and human flesh ground in colonial millstones"; but also the exoticism of his avant-garde compatriots.[35] That is, Tret'iakov's syncretism was distinct from Mayakovsky's: through factography, one could be an ethnic avant-gardist without harking back to some exotic, mysterious past. In addition to its jumble of clothing styles, *Roar China*'s sudden leaps between British warship and Chinese wharf, Westerners and Chinese, point to a volatile mix of cultures and temporalities—anticipating postmodernist pastiche, but also echoing Trotsky's notion of "combined and uneven stages of development."

The play's resonance with this theory of revolution indicates its propagandistic thrust, raising the possibility that political tendency here overshadowed artistic quality. Indeed, in a retrospective essay, Tret'iakov makes clear *Roar China*'s alignment with Comintern policy or, as he refers to it, "the Soviet point of view" on China—again, that the country's primary problem was imperialism. As he explains, this view—the basis of Moscow's insistence on the ill-fated CCP-Guomindang alliance—led to the play's emphasis on "the theme of how foreigners foster Chinese hatred towards them" and not on the other major problems he noticed in China: "Revolutionary nationalists and generals fattened by foreigners. Labor and capital. Fathers and children." That is, he consciously chose to eliminate "stratification among the Chinese masses, and China (from the loader to the governor) is placed in opposition to imperial guns as a unified lump. This was dictated by design."[36] To be sure, this conscious design can be read as indicating the failure or duplicity behind factography and the literature of fact—ultimately beholden to a political program and providing only the illusion of unmediated reality. And yet, as indicated earlier, factographers were never so naive as to believe in unmediated facts but always viewed them as aesthetic phenomena. For them facts were never fixed or objective but open to manipulation. As indicated by Tret'iakov's deliberate occlusions and emphases, facts could be construed so as to serve clear political ends.[37]

But not just political ends: this flexible approach to facts also opened aesthetic possibilities. Strikingly, *Roar China*, particularly as it was staged in Moscow, fulfilled Benjamin's prescriptions for a technique overriding the art-politics divide—namely, by turning spectators into collaborators and by employing montage and interruption. As Natasha Kolchevska points out, rather than offer a straightforward sequence, *Roar China* relies instead on "discontinuities, including retardation, reverse chronology, overlapping, and echoing."[38] For instance, Ashlay's drowning is presented in two separate scenes, from the perspective of both wharf and ship—an instance of theatrical montage. Indeed, several factographers had been trained in cinematic montage, and Tret'iakov himself had worked closely with Eisenstein on *Battleship Potemkin*, the pioneering exemplar of this technique. In turn, Eisenstein, who had directed three of Tret'iakov's earlier plays, was originally slated to direct *Roar China*'s Moscow production.[39]

The script's montage effect was heightened by its staging at Meyerhold, which, as an experimental space, famously lacked a proscenium and eschewed realism. As one American critic described it,

Now there was the battleship, fiercely stylized, that stood on Meyerhold's stage as a symbol of imperialism, and the scene itself was divided into three distinct units, which were used separately. When the story moved from the ship to the pier and occasionally into a tank of water, blackouts gave the single episodes a greater emphasis; the settings stood bare upon the stage, and the performance was directed, like a polemic, at the audience.[40]

Clearly this was no passive presentation of "facts" but an effort to shock and disorient the audience. The transitions between ship and wharf emphasized interruption, thus furthering the contrast between Westerners and Chinese. In addition, writes Kolchevska, Tret'iakov called for acting that was "hyperbolic, stylized, and 'alienating' for the foreigners"—something easily accomplished at Meyerhold given the director's innovation of a "bio-mechanical" acting style that, in Alaina Lemon's words, "aimed to deactivate those forms of realism that stimulated sympathy too habitually, to allow new ways to see social reality." In contrast and as alluded to earlier, Tret'iakov suggested that the Chinese characters be presented using a "naturalistic, sober, and poignant" acting style—in short, a more "sympathetic" style, not at all associated with Meyerhold or avant-gardism.[41]

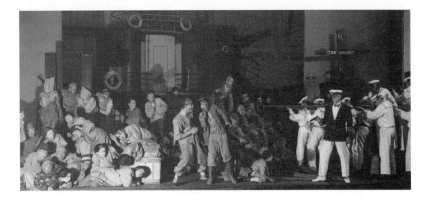

FIGURE 2.3 "Naturalistic" Chinese: final scene from the Moscow production of *Roar China* (1926).

© Federal State Budget Institution of Culture "A. A. Bakhrushin State Central Theatre Museum," Moscow.

Tret'iakov's acting instruction should thus give us pause. As we have seen, factography offered a technique that served both revolutionary politics and artistic innovation. It also sought to present the Other in a way that eschewed exoticism and "the denial of coevalness," namely, by allowing for cultural intermixture and impurity. And yet Tret'iakov's acting directions suggest that the Chinese could be portrayed only in a dated style. For all their nonexoticness, these characters were, in a sense, kept in the past—just as the Comintern deemed China itself still too "backward" for a Soviet-style revolution.[42] This problem is compounded by the mentioned fact that the Chinese roles were performed by non-Asian actors, which raises the possibility that the play was an instance of white modernist minstrelsy. My sense, however, is that such judgments of *Roar China* would be too hasty, and that Tret'iakov was not interested in the spectacle of whites performing in blackface or yellowface. Rather, the use of Asian actors was likely not a possibility in Moscow, and the naturalistic acting may have served precisely to downplay racial crossing.[43] Also, in context this acting style was not merely retrograde but, again, heightened the montage effect of the performance as a whole. In any case, in subsequent productions, the play would feature not just portrayals *of* Asians but also *by* Asians—that is, the Chinese and Korean American actors who performed in *Roar China*'s New York production, as well as the Chinese actors who staged the play in China, both before and

after the 1949 Revolution. At least in New York, the Chinese characters were also intended to have a naturalistic effect, which is additionally problematic given the strained historical relationship between Asian Americans and literary (if not dramatic) naturalism.[44] However, the use of Asian actors there proved "avant-gardist" in ways that neither the play's American director nor Tret'iakov himself could have anticipated.

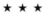

Roar China opened in New York on October 27, 1930, amid all the fanfare and reviews befitting a large Broadway production. Sergei Eisenstein, who would be in Mexico by year's end, was in the audience, and Langston Hughes apparently attended the November 3 performance.[45] On stage, the budding playwright Clifford Odets was among the actors. The director was Herbert Biberman, who had seen the Moscow production multiple times in 1927–1928 and who would go on to lead a successful film career. He is best known now as a leader of the "Hollywood Ten"—a group of industry leftists who were blacklisted and briefly imprisoned after refusing to answer questions before the House Un-American Activities Committee in 1947. In short, *Roar China* was very much part of the "Cultural Front" that emerged in 1930s America—the New York production anticipating the "laboring of American culture" that arose during the Popular Front years and then declined under McCarthyism. Indeed, as one might expect, Tret'iakov was a writer for the "living newspapers" staged by Moscow's Blue Blouse troupe from the early 1920s, a theater form that made its way from the Soviet Union to the United States in the early 1930s and that became central to the New Deal's Federal Theatre Project of 1935–1939.[46] Biberman, in turn, served as a conduit between Soviet and American theater. He was one of the many Jewish Americans who made the "magic pilgrimage" to the Soviet Union in the 1920s and 1930s, and as Theatre Guild founder Lawrence Langer recounts, he "came into the Guild replete with such words as 'Dynamic,' 'Agitprop,' and some other resounding new words."[47] "Factography" and "literature of fact" were likely among them.

However, what was most innovative about *Roar China* in New York was its use of predominantly Asian American actors—sixty-eight out of a total of ninety-two. As Walter J. and Ruth I. Meserve write, the 1930 production was "the first time in the American theatre that Chinese were removed from portraying traditional, stereotyped roles"—though, again, several Koreans

FIGURE 2.4 *Roar China* in New York (1930).

Photo by Vandamm Studio © Billy Rose Theatre Division, The New York Public Library for the Performing Arts.

were also present.[48] For the most part, these actors were nonprofession-als, selected by Biberman with the assistance of the Chinese Dramatic and Benevolent Association. Among them was H. T. Tsiang, who launched his long acting career with the play and would go on to write the pioneering Asian American proletarian novel *And China Has Hands* (1937). Other actors included restaurant and laundry workers, shopkeepers, and journalists. According to the *New York Times*, ten of the actors did not understand English, forcing Biberman to deliver instructions through an interpreter.[49]

The use of amateur actors blurred the boundary between art and life, turning potential spectators into collaborators (à la Benjamin), and for sympathetic reviewers from the left press, this made the play all the more compelling. *New Masses* called the acting "superb," asserting that "every mispronounced English word only carries added conviction." Myra Page, writing for the *Daily Worker*, praised "the sincerity and in-tense earnestness" of the Asian actors: "To them [the play] is evidently a living embodiment of the wrongs and struggles of the four hundred millions of Chinese toilers who are today fighting on to victory."[50] Ac-cordingly, in a 1962 letter to Tret'iakov's widow about the production, Biberman recalls,

> The Chinese and Koreans felt the meaning and significance of the play not only as actors, but as an oppressed people, and this faithfulness to the theme and orientation of the play created such a solidity, such a group cohesion, which made any member of this group much higher than any of the white actors, and the professional cohesion of the group of Euro-pean actors could not oppose the mastery borne from the depths of pas-sion and humiliation.[51]

To be sure, there is a hint of well-meaning condescension here—the Asian actors were passionate, not necessarily talented, and certainly rough around the edges. Less-partisan publications were not nearly as glowing. *Time*, which praised the New York staging but expressed skepticism about Tret'iakov's claim to factuality, recognized Biberman for capably managing his "mob" of mostly Asian actors. The *New York Times* was more skeptical still, calling the play a failure as an expression of drama, and the Asian ac-tors "the most unwieldly [sic] element in the production, throttling down China's roar to a murmur."[52]

Still, there are clear indications that, thanks to the Asian actors, the production was able to fulfill some of the disorienting, interruptive aims of factography. Indeed, it seems that the actors' performances were intended to be "unwieldly" for mainstream audiences, with the New York script rendering, for instance, "very" as "velly" in scenes featuring the Chinese characters using English with the Westerners.[53] That is, though certainly many of the actors were nonnative English speakers, the script sought to accentuate rather than hide this—a gesture, arguably, to Tret'iakov's ethnographic precision, and likewise, the Moscow production used grammatically incorrect Russian to simulate the Chinese characters' broken English.[54] However, in light of Tret'iakov's interest in intermixture, it seems more fitting that, according to the New York American's reviewer, the Asian actors were difficult to understand because of "their grievous South Brooklyn sort of English speech"—Brooklyn, not Chinese accents.[55] This wonderful, stereotype-defying detail provides a perfect distillation of factography's aim—to present facts that undermined rather than affirmed received notions of art and reality. As another reviewer noted, the play gave the Asian actors an opportunity to belie "traditions concerning the stolid Oriental," and indeed, after the lights went up at the premiere, several of the Asian actors stepped across the proscenium crying, "Roar, China!" to heightened applause—a marked departure from other, typically straitened examples of early Asian American performance.[56]

This crossing of the proscenium—again, something lacking at Meyerhold—points to the New York production's partial fidelity to factography. Accordingly, just as in Moscow, the Broadway production featured the everyday tasks of a Chinese port. During the intermission, several of the actors remained on the proscenium to perform these tasks, and curious audience members were allowed to climb up and speak with them.[57] Here again we see the divide between stage and world breached. More notable about Biberman's production, however, were the flagrant departures from factography—beginning with those everyday port scenes, which were significantly abridged. The New York production ran just two hours, compared with three and a half in Moscow, and the redactions were primarily those "interludes of local color" that Biberman regarded as "stunning and rich" but ultimately distracting. In a further break from factography, the name of the British ship, HMS *Cockchafer*, was changed to HMS *Europa*, in effect deemphasizing the factual basis of the play. Formally, the New York pro-

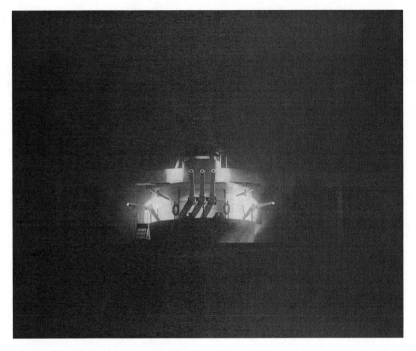

FIGURE 2.5 Lighting for the *Europa* (1930).

Photo by Vandamm Studio © Billy Rose Theatre Division, The New York Public Library for the Performing Arts.

duction privileged dramatic seamlessness over the factographic fragment. In contrast to the Moscow production's use of montagelike interruption to separate ship and wharf, in New York the "movement between the dock, the deck and the water is inter-related and continuous."[58] Biberman was aided here by an elaborate stage design in which the British ship moved forward and backward atop a large pool of water, looming over the play's action. The Chinese wharf, meanwhile, was set on the proscenium, and lighting effects were used to establish the two locations. For scenes on the ship, the proscenium could be submerged in darkness. For scenes on the wharf, the *Europa* could be likewise submerged, with sampans floated in front to conceal the ship's presence. For the final scene, the ship moved forward, its cannons pointed down toward the proscenium. The two settings thus merged into one, setting the stage for the concluding execution and protest.

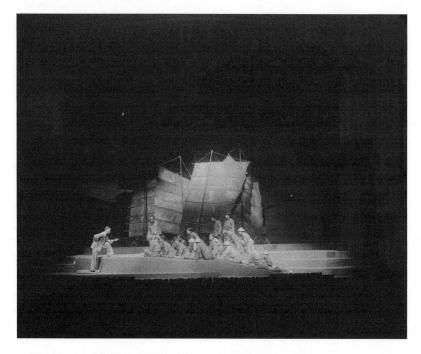

FIGURE 2.6 Lighting for the wharf; *Europa* concealed (1930).

Photo by Vandamm Studio © Billy Rose Theatre Division, The New York Public Library for the Performing Arts.

The seamlessness of the New York production would have struck Tret'iakov as heightening rather than dismantling aesthetic illusion—the play as a self-contained work, cut off from the world. The very presence of a proscenium in New York points to this disconnect: Biberman's *Roar China* could be and often was appreciated as a clash between two merely theatrical spaces—upper (*Europa*) versus lower (wharf)—with technical wizardry enabling their final confrontation. The factographers' suspicions would have been fanned by the fact that Lee Simonson's fluid and multilevel design garnered praise even among those wary of the play's anti-imperialist script: J. Brooks Atkinson called it "a triumph of representational scenery," while *Time*'s reviewer conceded, "Any spectator will probably be moved by the scenic grandeur, the bold theatrics of the production."[59] Thus, the New York production could be enjoyed for its spectacle independently from its politics. Biberman, in fact, toned down the latter: he removed Stoker's final battle cry and replaced the Moscow produc-

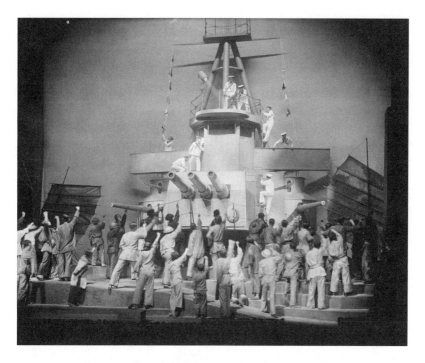

FIGURE 2.7 Final scene, New York (1930).

Photo by Vandamm Studio © Billy Rose Theatre Division, The New York Public Library for the Performing Arts.

tion's "hyperbolic, stylized, and 'alienating'" acting styles for the foreigners with "a broad irony which . . . emerges from the characters themselves."[60]

Thus, Biberman removed many of the estranging touches that were the hallmarks of the Meyerhold production—for example, the contrasting acting styles (alienating versus naturalistic) used in the original. He explicitly did this to deflect charges that *Roar China* was mere propaganda, which as he later explained to Tret'iakov's widow was also why he originally chose to work with Asian actors:

It occurred to me that in order for this play to touch [New York] viewers, on the whole representatives of the ruling class, it was necessary to make the performance as naturalistic as possible. I figured that to fill the Chinese roles with Europeans wearing wigs and speaking with accents would be an unforgivable mistake.[61]

Interestingly, this concession to local taste gels with Tret'iakov's sugges-
tion that the Chinese roles be acted in a naturalistic way—though again,
Tret'iakov's use of naturalism served to heighten the original production's
montage effect and, perhaps, to minimize the spectacle of Russians playing
Chinese roles. In contrast, the New York production apparently prescribed
naturalistic acting for both the Chinese and Western roles. Naturalism
here had a flattening effect—geared toward making the play easier to di-
gest—and as George Lipsitz has noted, this was one of Biberman's faults
throughout his career: his view of mass art was limited "to that which
[spoke] to great numbers of people, not what involve[d] them in changing
their own worlds."[62] In short, by following the play from Moscow to New
York, we are able to trace the partial passing of factography. Just as with
the LEF group, Biberman was concerned about accessibility—but in his
case, for "ruling-class" theatergoers rather than Soviet workers. He thus
kept some of Tret'iakov's factographic touches but dropped or downplayed
others, and the result was a production that lost much of the original's ex-
perimental edge. However, the use of Asian American actors went against
Biberman's concessions to accessibility, at least as indicated by the impres-
sion they left on the New York reviewers. Through a combination of lack of
experience, (South Brooklyn) accented English, and passion about the sub-
ject matter, they escaped the bounds of naturalism and sobriety reserved
for them, becoming the most memorable, unusual aspect of what was, at
best, a moderately successful three-month run. Reminiscent of Hughes
reworking Mayakovsky, these actors exceeded the roles assigned to them
and thereby fulfilled the disruptive aims of factography, the prescriptions
of Benjamin—despite the fact that they were not intended to do so.

Roar New Mexico

As noted, Tret'iakov's interest in ethnographic precision—China as it ac-
tually was, with all its syncretism and intermixture—anticipated post-
modern celebrations of impurity and pastiche. He also anticipated what
Hal Foster has identified as the postmodern artist's related turn to eth-
nography—the "artist as ethnographer"—which the critic describes as
"structurally similar" to Benjamin's notion of the author as producer.
Whereas before the author (e.g., Tret'iakov at the *kolkhoz*) sought to iden-

tify with the worker, Foster writes that the postmodern artist seeks to identify with the "cultural and/or ethnic other." Foster then links these two efforts by noting their shared and problematic "realist assumption: that the other, here postcolonial, there proletarian, is somehow in reality, in truth, not in ideology, because he or she is socially oppressed, politically transformative, and/or materially productive."[63] It would be simple to apply this poststructuralist critique to Tret'iakov—who unbeknownst to Foster aspired to be both producer *and* ethnographer—and conclude that he was beholden to this realist assumption; that he fetishized (if not exoticized) both *kolkhozniki* and Chinese, which perhaps explains his acting instructions for the Chinese roles. However, this critique would occlude the strange afterlife of *Roar China*, which ultimately transcended any single context, form, or set of instructions. As indicated by the Asian American actors in New York, the ethnic avant-garde was able to advance beyond Tret'iakov's original designs.

This last section of the chapter proceeds as a factographic experiment of sorts. It juxtaposes additional echoes and fragments of *Roar China* so as to enable us to see anew both minority, non-Western cultures and the Soviet avant-garde—to draw additional unexpected links between the two. We are helped here by how mutable and well traveled the play proved to be. After New York, in the 1930s it was staged in Japan, Estonia (where one critic called it "the greatest event in the theatrical world"), England, Poland, and Canada. In 1942 it was produced in India, where it was adapted to expose "the persecution of the peaceful Chinese by the Japanese and the subsequent growth of revolutionary anti-Japanese attitudes in China."[64] During World War II, the play appeared again in Poland, this time "in Yiddish at Tzchenstochov concentration camp, primarily a labor camp for the German war machine." According to Meserve and Meserve,

> The commandant of this camp permitted a drama club and a theatre in a small bunker. Since the prisoners worked only during the daytime, they could hold rehearsals in the evenings. Despite the inexplicable liberalness of the camp commandant, *Roar China* was a play of protest. When the German SS took over the camp, all theatrical activities were stopped.[65]

Here we find reinforcement of the play's power and versatility, its ability to serve multiple functions in multiple places.

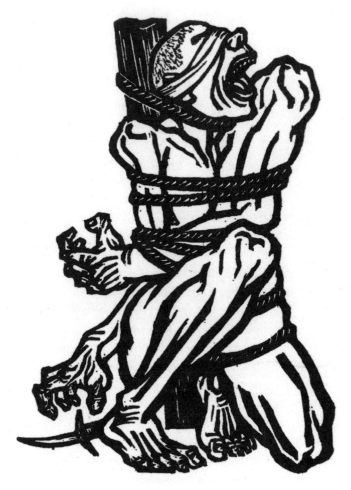

FIGURE 2.8 Li Hua, *Roar, China!* (1935). Reprinted from *Anthology of Lu Xun's Collection of Modern Chinese Woodcarvings, 1931–1936* (Beijing: People's Fine Arts Publishing House, 1963).

Courtesy of Beijing Lu Xun Museum.

The play first appeared in China just prior to the New York production—in Guangzhou in the summer of 1930, with over a hundred students filling in as extras. It was then staged in Shanghai in September 1933, "on the eve of the second anniversary of the Mukden Incident" (which led to Japan's seizure of Manchuria). One newspaper article about the Shanghai

production proclaimed, "With the approach of a second world war that aimed to partition China . . . should members of the nation not all cry 'Roar, China!'?"[66] In an apparent reply to this call, it was around this time that the work assumed a new form, namely, black-and-white woodblock prints. As art historian Xiaobing Tang traces, throughout the 1930s "Roar, China!" served as the title for several newspaper and journal images that mixed populist appeal and representational realism. Tang describes these prints as attempts "to visually render a voice, to project it, and then to elicit an expressive response from the viewer." They imaginatively transgress "the boundary between the visual and the aural" for the sake of turning the viewer into an agent.[67] We find here clear echoes of Soviet factography: the artists consciously cross the boundaries of genre and form—from play to image—in order to transform woodblock prints into rallying cries.

However, the Chinese iterations of *Roar China* depart from factography in one key way. Despite Tret'iakov's ethnographic emphasis, many of the woodblock prints lack "markers and representational details of social, cultural, or national particularities," even as they press for national action against Western and Japanese imperialism.[68] To follow Foster's line of reasoning, this apparent "post-ethnic" turn eschews Tret'iakov's reliance on Asianness as a source of agency, and perhaps this is why *Roar China* assumed a potency in China that it lacked elsewhere. Whereas even in Moscow the play kept the Chinese characters in check—again, through Tret'iakov's instruction that they be presented in a "naturalistic, sober, and poignant" manner—this was evidently not the case in China, where the prints and stagings repeatedly urged immediate action amid the tumult of the 1930s. And of course, action was taken. Despite the Soviet Union's persistently ineffectual policies toward China, the CCP completed its own revolution in 1949. As Meserve and Meserve point out, in the fall of that year,

> *Roar China* was again staged, this time in the Canidrome of Shanghai in a large open-air set with rapid scene changes made possible by lighting techniques. . . . With this production, *Roar China* perhaps found its ultimate appeal among the people whose sad plight originally stimulated Sergei Tret'iakov while he was in Peking.[69]

By this account, the Shanghai production restored some of the original's sense of interruption, namely, through its unorthodox setting and

rapid scene changes. Meserve and Meserve thus present one possible way to end our own journey—with Tret'iakov and factography, despite their flaws and contradictions, prevailing beyond Soviet borders. From this perspective, *Roar China* ushers in a new chapter in the ethnic avant-garde: its postwar turn from Moscow to Beijing, which I discuss in the afterword.

However, we can unseat this teleological narrative—1949 as end point—with another, more disillusioning one, pieced together through a different set of fragments. While covering the antifascist movement as a newspaper correspondent in Spain, Langston Hughes published a poem titled "Roar, China!" in the *Volunteer for Liberty*, the English-language organ of the International Brigades. It was written on August 29, 1937, the same summer that Japan invaded China, and opens with the following lines:

> Roar, China!
> Roar, old lion of the East!
> Snort fire, yellow dragon of the Orient,
> Tired at last of being bothered.
> Since when did you ever steal anything
> From anybody.
> Sleepy wise old beast
> Known as the porcelain-maker,
> Known as the poem-maker,
> Known as maker of firecrackers?
> A long time since you cared
> About taking other people's lands
> Away from them.[70]

As mentioned, Hughes attended the New York production in 1930. During his 1932–1933 Soviet visit, he in fact met with Tret'iakov, who made him "a present of an enormous poster, showing a gigantic Chinese coolie breaking his chains, and he gave me a copy of *Roar China* inscribed in English. When I left for the Far East, he and his wife came to see me off at the station."[71] It is unclear whether Hughes received Tret'iakov's poem or play, though Hughes's 1937 piece bears a few allusions to the latter, for instance, "Open your mouth, old dragon of the East, / To swallow up the gunboats in the Yantgse! [*sic*]"[72]

ROAR, CHINA!

Roar, China!
Roar, old lion of the East!
Snort fire, yellow dragon of the Orient,
Tired at last of being bothered.
Since when did you ever steal anything
From anybody.
Sleepy wise old beast
Known as the porcelain-maker,
Known as the poem-maker,
Known as maker of firecrackers?
A long time since you cared
About taking other people's lands
Away from them.
THEY must've thought you didn't care
About your own land either—
So THEY came with gunboats,
Set up Concessions,
Zones of influence,
International Settlements,
Missionary houses,
Banks,
And Jim Crow Y. M. C. A.'s.
THEY beat you with malacca canes
And dared you to raise your head—
Except to cut it off.
Even the yellow men came
To take what the white men
Hadn't already taken.
The yellow men dropped bombs on Chapei.
The yellow men called you the same names
The white men did:
 DOG! DOG! DOG!
 COOLIE DOG!
 RED! LOUSY RED!
 RED COOLIE DOG!
And in the end you had no place
To make your porcelain,
Write your poems,
Or shoot your firecrackers on holidays.
In the end you had no peace
Or calm left at all.
PRESIDENT, KING, MIKADO
Thought you really were a dog.
THEY kicked your ass daily
Via radiophone, via cablegram, via gunboats

by

LANGSTON HUGHES

MADRID

AUGUST 29

1937

In the harbor, via malacca canes.
THEY thought you were a tame lion,
Sleepy, easy, tame old lion!
 Ha! Ha!
 Ha-aaa-aa-a!... Ha!
Laugh, little coolie boy on the docks of Shanghai, laugh!
You're no tame lion.
Laugh, child slaves in the factories of the foreigners!
You're no tame lion.
Laugh—and roar, China!
Time to spit fire!
Open your mouth, old dragon of the East,
To swallow up the gunboats in the Yangtse!
Swallow up the foreign planes in your sky!
Eat bullets, old maker of firecrackers—
And spit out freedom in the face of your enemies.
Break the chains of the East, little coolie boy!
Break the chains of the East, red generals!
Break the chains of the East, child slave in the facto-
 ries!
Smash the iron gates of the Concessions!
Smash the pious doors of the missionary houses!
Smash the revolving doors of the Jim Crow Y.M.C.A.'s.
Crush the enemies of land and bread and freedom!
 Stand up and roar, China!
You know what you want!
The only way to get it
Is to take it!
Roar, China!

FIGURE 2.9 *The Volunteer for Liberty* (1937).

Courtesy of Hoover Institution Library & Archives, Stanford University.

At least visually, Hughes's "Roar, China!" resembles Tret'iakov's original poem, as well as his 1934 homage to Mayakovsky, "Cubes." Each of these works consists of short lines and isolated details, and at first glance, this suggests Hughes's ongoing engagement with Soviet futurism. Accordingly, in an apparent gesture to factography's frequent combinations of word and image, the *Volunteer for Liberty* placed Hughes's photo alongside the poem. Upon closer examination, though, we find that the poem marks an abandonment of factography's key aims. Unlike Tret'iakov, Hughes makes no lofty claims to present China as it really is, despite his travels there after his stay in the USSR. Indeed, he reverts to the very exoticist tropes scorned

by the Soviet author—"old lion," "yellow dragon," "wise old beast," "porce-
lain-maker," "maker of firecrackers." In place of open-ended facts, Hughes
uses such ready-made tropes to form agitational slogans, which follow
the "correct" political tendency but mark a decline in artistic quality. Of
course, we can read these tropes as reverting to another iteration of Soviet
futurism, covered in chapter 1, in which the "exotic" referenced premod-
ern utopias and forwarded an anti-imperial politics. Missing from these
lines, however, is the estranging enchantment of Mayakovsky's American
writings, as well as that poet's subversion of tropes like "Black Lion" (in his
poem "Syphilis") used to depict the Other. That is, while Hughes's "Roar,
China!" shares Mayakovsky's and Tret'iakov's anti-imperialist politics, its
noncritical reversion to hackneyed stereotypes—e.g., China as "the old
dragon of the East"—would have repelled both futurists. Thus, the 1937
poem usefully points to another possible end point for our journey: the
passing of the Soviet avant-garde, both figuratively (i.e., a shift from an
avant-gardist to a more received notion of reality) and literally. Hughes
could not have known this, but just four days after the publication of his
"Roar, China!" in Madrid, Tret'iakov was executed in Moscow as an alleged
Japanese spy.[73] The year 1937 was, of course, the height of Stalinist terror.
In 1940 Meyerhold was also executed.

Contra either of these extreme end points (the revolution of 1949, the
terror of 1937), I would like to suggest a more subtle route for factography
vis-à-vis the Other—namely, the American film *Salt of the Earth* (1954), di-
rected by none other than Herbert Biberman. The harrowing story behind
the film's production is well known. After being shunned by the major stu-
dios as a communist, Biberman formed an independent company made up
of other blacklisted Hollywood types and a multiracial crew—including Af-
rican Americans, who had long been excluded by the industry's discrimina-
tory practices. In 1953 they shot *Salt of the Earth* in Silver City, New Mexico,
despite sometimes violent harassment by local red-baiters; edited it at vari-
ous secret locations in Southern California against studio and union efforts;
but the combined forces of Washington and Hollywood, which deemed the
film pro-Soviet propaganda, stymied widespread distribution.[74]

What I would like to suggest is that *Salt of the Earth* offers a more auspi-
cious—but nonetheless fraught—echo of *Roar China* than Hughes's rendi-
tion of it. The film was based on a recent, prolonged strike that had in-
volved predominantly Mexican American workers at a zinc mine near

Silver City, and many of the strikers served as both script consultants and actors, with some playing themselves. That is, like *Roar China*, the film was torn from newspaper headlines and featured predominantly amateur, minority actors. Accordingly, just as with Tret'iakov, Biberman sought a dynamic presentation of the facts, explicitly eschewing both "hackneyed melodramatics" and naturalism's "mere surface record of actual events."[75] These preoccupations, of course, point to the film's long-acknowledged resonance with Italian neorealism, which, as Masha Salazkina has shown, itself drew from Soviet avant-gardist discourses.[76] However, Biberman's aim for a radical configuration of facts rather than passive representation also points to his factographic credentials, which are most evident in his depictions of Chicana/o culture and gender roles. Like Tret'iakov with China, he presents this community in a respectful but nonpatronizing way and, indeed, granted the workers and their families veto power over the script.[77] The result is a remarkably subtle depiction of the culture that eschews exoticism. As Deborah Silverton Rosenfelt writes,

> The Spanish language is woven into the texture of the film. References to the *floricanto*—flower and song—add a poetry to the screenplay while evoking the Latino background of the people. Similarly, Sol Kaplan's musical score conveys the Mexican heritage by using variations of "la Adelita," a song of women in the Mexican Revolution.[78]

In other words, the film tries to capture Chicana/o culture but never reduces it to an exotic spectacle, just as with Tret'iakov's treatment of Chinese culture. Instead, local language and culture serve to distinguish the strikers from the white owners; the "fact" of ethnic difference (most pervasively, the main characters' lightly accented English) bolsters class mobilization and, therefore, the transformation of reality. The film likewise focuses on the leading role of Mexican American women in the struggle: after an injunction bars the exclusively male workers from striking, their wives maintain the line while the men do domestic tasks—a role reversal that overcomes the workers' tradition-bound chauvinism. Thus, just as with ethnicity, *Salt of the Earth* presents gender as dynamic and transformative. The film's respectful depictions of difference serve to resolve "the conflicting claims of feminist, ethnic, and class consciousness" in order to alter—not simply reflect—reality.[79]

Again, compared with the 1949 or 1937 iterations of *Roar China*, *Salt of the Earth* presents a more nuanced echo of factography. Whereas the Shanghai production and Hughes's poem point to familiar revolutionary and "totalitarian" teleologies, the film does not lend itself to such ready-made narratives. On the one hand, its depictions of the Other have made it an enduring touchstone of Chicana/o and feminist film, meaning that we can potentially use *Salt* as a Trojan horse of sorts, smuggling factography into postwar U.S. discourses of the Other. However, if the film gestures to factography, it also departs from it, albeit not to the extent of Hughes's poem. That is, though its depictions of New Mexico evoke Tret'iakov's treatment of China, it would be difficult to describe the film as a whole as factographic or, more broadly, avant-gardist. The fault here lies once more in Biberman's emphasis on accessibility, in line with his efforts to mitigate *Roar China*'s experimental touches. As Rosenfelt notes, the film never uses the medium—"camera and editing room, sound track and visual images"—to complicate rather than emphasize its underlying themes. It is, ultimately, a "well made story" with a "tightly, carefully organized plot that leads to too tidy a denouement"—namely, a foiled home eviction, which prompts the lead male to thank the lead female for her perseverance.[80] That is, *Salt of the Earth* is marked by a seamlessness similar to that in Biberman's *Roar China*. And though that production's claim to factography was saved by the disruptive use of Asian American amateur actors, and although Biberman again used amateur actors based on his favorable *Roar China* experience, the *Salt* actors, in contrast, were remarkable for just how polished and professional they seemed.[81] This was likely because they were playing themselves, as opposed to Chinese and Korean Americans playing coolies in China; a less-pronounced language barrier may have been another factor. In any case, this resulted in more plausible acting, but a complete absence of *Roar China*'s (unintended) subversion of naturalism. This is to emphasize once again the passing of factography. Fragments of this futurist technique are certainly present in *Salt of the Earth*—for example, in its nonexoticist, politically radical depictions of the Other. However, the film loses the blurred open-endedness of the factographic fact, which, as has been noted, is the key to this technique's claim to formal innovation. Nonetheless, *Salt* does a better job than Hughes's "Roar, China!" of carrying forward factography's promise for minority, non-Western cultures, which explains the film's embrace by Chicana/o and feminist audiences

from the late 1960s onward. Biberman thus presents to us a third possible end point for our journey—the emergence of postwar U.S. identity politics.

However, rather than choosing among these three possible end points—1949, 1937, 1954—it seems more in keeping with factography to hold the various iterations and echoes of *Roar China* in juxtaposition, and to see what new narratives might emerge. That is, as part of my own exercise in factography, I would like to suggest that we look at each of these iterations as discrete facts that, taken together, can be seen as undergirding a new, unexpected grouping of artists and writers. Crossing multiple places, times, and backgrounds, this grouping is made up of all those who performed in, translated, or adapted *Roar China*—a grouping bound by Tret'iakov's multifaceted work as well as by varying degrees of adherence to his fact-based futurist technique. However, this grouping is also bound by an underlying sense of tragedy and loss—the passing of factography and, more pressingly, the Soviet avant-garde's figurative and literal demise.

Factography's commitment to reporting the facts and combining disparate fragments—the more disorienting, the better—is well suited to the combination of allure and tragedy that I have in mind.[82] The juxtaposition of, on the one hand, the international circulation of Tret'iakov's *Roar China* and, on the other, the tragedy of his 1937 execution points to an artistic grouping bound by a particular work and technique, but also by a particular affect. We can call it revolutionary pathos or melancholy, a sense of loss but also endurance in the face of the failed utopias of the past—a willingness to try again. As Jonathan Flatley observes, it is precisely a sense of melancholy that motivates Walter Benjamin's views on revolution—the endlessly piling ruin of the past as the driving force behind his efforts to cease history.[83] Benjamin did not, but we must count the interwar avant-garde as part of this ruin. The question now is how to look to it in a way that avoids lapsing into either apologia or defeatism. I return to this question in the next two chapters, but as a preliminary answer, I conclude with one more excerpt from Biberman's 1962 letter to Tret'iakov's widow in Moscow. At this point, these were both broken people: Biberman's film never received wide distribution in his lifetime, and when he wrote this letter, he was in the middle of a ten-year lawsuit against the studios over their coordinated assault on *Salt*. He ultimately lost and made only one more film before dying in 1971.[84] Ol'ga Tret'iakova

had herself been imprisoned in the late 1930s but was subsequently freed. Like many persecuted during the terror, her husband was posthumously exonerated during the Khrushchev thaw. In short, here we find two people corresponding in the wake of, respectively, McCarthyism and Stalinism—to be sure, two incomparable instances of state repression. However, in the wake of *Roar China* and *Salt of the Earth*, Biberman's effort to link these two places is moving despite being characteristically accessible. In his closing words to Tret'iakova, we can discern an attempt to salvage past hope and camaraderie:

> Finally, dear Mrs. Tret'iakova, this letter gives me the possibility, in some measure, to pay a very old debt of gratitude, in fact, several debts, which I will now list. Most of all I wanted to express my gratitude to all of the people from Moscow theater of the 1920s, who everyday generously presented me with warmth and inspiration from that great richness and diversity for which the inspired theater of that time was famous. Secondly, I am deeply grateful to the colossal creative genius of Meyerhold, for the countless number of the brilliant theatrical achievements of our time, which are as fresh in my memory as they were thirty years ago. . . . Thirdly, I want to express my gratitude to Sergei Tret'iakov for his play, which awakened in me that dormant affection for humankind that was in me; and which united this affection with my desire to express myself in theater, and uniting these elements, laid the basis of my worldview, which has supported me over the course of thirty years in art and life.[85]

Biberman's ability to maintain that sense of affection and inspiration against terror and persecution strikes me as a model for reexamining the ruins of the Soviet-centered ethnic avant-garde; for carrying forward Sergei Tret'iakov's crossing of art and life, but without naïveté.

3

From Avant-Garde to Authentic

Revisiting Langston Hughes's "Moscow Movie"

We pick up where chapter 1 left off—Langston Hughes in Soviet Central Asia, autumn 1932. He and twenty-one other African Americans had arrived in the USSR that June to make a movie about Jim Crow, and after the project's cancellation, half the group toured Uzbekistan to witness Moscow's elimination of czarist-era discrimination. However, only Hughes elected to also see Turkmenistan and, after abandoning the others, ended up in Ashgabat, in a run-down official guesthouse. Just by chance, the Hungarian Jewish author Arthur Koestler happened to be staying there as well and knocked on his door. In his 1954 autobiography, Koestler claims he did so because he heard Sophie Tucker's "My Yiddishe Momma" playing on Hughes's Victrola. Hughes would later dispute this account, claiming he never owned the record.[1] They agreed, though, that they became travel companions in Central Asia and, along with a Turkmen poet and Ukrainian ex-sailor, formed an impromptu touring "International Proletarian Writers' Brigade."[2]

I begin with this uncanny episode because of the discrepancies between Koestler and Hughes's recollections—the different ways in which the Soviet-centered ethnic avant-garde of the early 1930s appears from the vantage of the 1950s. This applies not just to what record was playing that day. Koestler—now most famous for his anti-Stalinist novel *Darkness at Noon* (1941)—uses his autobiography to repudiate his days as a young

communist. Hughes's own autobiography, *I Wonder as I Wander* (1956), has a more conciliatory tone toward the Soviet Union, as discussed in the following. The more striking dissonance, however, is in how the two authors perceive each other—the fissures they express only in retrospect. Koestler remembers Hughes as "likeable and easy to get on with, but at the same time one felt an impenetrable, elusive remoteness which warded off all undue familiarity" (137). Hughes, in turn, explains this "remoteness" at length: it had everything to do with color. He describes how Koestler looked down on Russians and Central Asians as "unclean." In contrast, Hughes saw "Soviet Asia with *Negro eyes*," leading him, for instance, to partake in the Central Asian custom of sharing tea bowls, which the fastidious Koestler called "a bloody disgusting filthy habit!" (116, emphasis in original; 115). Hughes writes, "To Koestler, Turkmenistan was simply a *primitive* land moving into twentieth-century civilization. To me it was a *colored* land moving into orbits hitherto reserved for whites" (116, emphasis in original). Thus, Koestler lacked the insight provided by "Negro eyes," and Hughes suggests that this led to both his condescension toward Central Asia and his subsequent break from communism.[3]

This assertion of "impenetrable" racial boundaries—reinforced by Hughes's denial that he could have played this jazz song about a Jewish mother—is anathema to the cross-racial avant-garde I have been tracing. As such, both accounts from the 1950s can be read as explaining this group's dissolution. By then the Comintern had been disbanded (Moscow's concession to its World War II allies), Stalinism had long silenced the Soviet avant-garde, and McCarthyism had done the same for American radicals. But in the writings of Hughes and Koestler, we get a clear sense that, even by the early 1930s, the boundaries of race, ethnicity, and nation were proving insuperable. Accordingly, their accounts gel with what became an increasingly widespread notion after World War II—that the Old Left had failed to bridge the interests of white (often Jewish) and black radicals, a charge most prominently leveled in Harold Cruse's *The Crisis of the Negro Intellectual.*

This chapter unpacks the terms used to break from the Soviet-oriented left of the interwar years. In Hughes's critical description of Koestler, we find the now commonplace language of cultural authenticity—the notion that to understand a community requires membership in that community or, at the very least, that one must be a person of color to understand

people of color. However, this seeming replacement of avant-gardism with authenticity is better seen as a recalibration, for in fact the interwar ethnic avant-garde was conversant in cultural authenticity—albeit a notion of authenticity lacking the exclusivity Hughes here imparts to it. From a Soviet and avant-gardist perspective, to be "authentic" meant to reject mass culture and commercialization—one could be authentically black by being anticapitalist—leading to a very specific embrace of African American culture. The chapter brings back into focus this alternative authenticity, which, I argue, is still latent in Hughes's 1956 autobiography. As we will see, the terms of the ethnic avant-garde's replacement (by discrete, "authentic" cultures) were in fact the terms of its postwar survival—albeit in a severely diminished form.

I show this by trying to solve a puzzle, one that emerges from a part of Hughes's autobiography where he more clearly deploys the language of cultural authenticity. I refer to his account of the failed Soviet film project *Black and White* (*Chernye i belye*), which, again, was the reason why Hughes traveled to the USSR in 1932. It was quickly canceled that summer, ostensibly because of script difficulties, but it was only in *I Wonder as I Wander* that Hughes, who served as a script consultant, provided a detailed account of what these difficulties were. The puzzle is as follows: his account—for decades regarded as definitive—is almost a complete fabrication. Thus, much of this chapter is devoted to describing and contextualizing the "authentic" Russian-language script. The chapter then turns back to the 1956 account, arguing that it enabled Hughes to part with the Soviet-oriented left on his own terms. Remarkably, unlike many of his peers (e.g., Koestler), he was able to navigate the competing notions of authenticity traced in this chapter and to thereby satisfy both sides of the American-Soviet Cold War.

Nested within this argument is the more basic point that *Black and White*'s Russian-language script would have made for a fascinating film. To be sure, the script did suffer from inaccuracies and other problems, but it undoubtedly would have opened new ground for both African American communism and the cinematic portrayal of blacks. The script points to paths not taken, inviting us to reconsider established historical narratives—in this case, the one provided by Hughes. More specifically, this failed film project allows us to reopen the memory—but also the wounds—of the ethnic avant-garde amid its passing.

"Long Live Moscow. . . . Long Live Soviet America"

Set in the contemporary South, *Black and White* was to have been "the first authentic picture of Negro life in America," according to materials prepared by a New York fund-raising committee. It was to have broken from the "sentimentality" and "buffoonery" that typified Hollywood portrayals of blacks and instead "trace the development of the Negro people in America, their work, their play, their progress, their difficulties." At the time, such hopes did not seem so far-fetched. As these materials noted, Soviet filmmakers had garnered "world-wide acclaim for new technical and artistic developments" and thus were well equipped to render the "true character" of African Americans.[4] Indeed, Mezhrabpomfil'm (short for "International Workers Relief Film")—the studio producing *Black and White*—had already combined ethnographic precision and formal innovation in Vsevolod Pudovkin's Mongolia-set *Storm Over Asia* (1928). There was word that an even more prominent avant-gardist, Sergei Eisenstein, was slated to direct *Black and White*.[5] As described in chapter 1, he had just spent two years in Mexico shooting a film based on Diego Rivera's murals, underscoring the Russian avant-garde's long-standing interest in non-Western cultures.

While Eisenstein's Mexican film was canceled before shooting was completed, *Black and White* was canceled before shooting even began—only two months after the group arrived in the Soviet Union. Given the considerable newspaper coverage the project had drawn, the result was a public relations disaster. "Negroes Adrift in 'Uncle Tom's' Russian Cabin," proclaimed the *New York Herald Tribune*, which portrayed the travelers as duped by Soviet promises of equality and stardom. In a statement, four group members called the cancellation a "compromise with the racial prejudice of American Capitalism and World Imperialism." They suggested that Moscow's bid for U.S. diplomatic recognition was to blame. Another rumor had it that Colonel Hugh Cooper, the American engineer heading construction of a massive Soviet dam, had personally lobbied Stalin to kill the project.[6]

As noted, the official explanation (script problems and technical difficulties) was far less sensational, and a majority of the group—including Hughes, who had been commissioned to overhaul the film's dialogue—released a statement confirming the studio's line. When the project did not begin again as promised the following year, blame shifted squarely to the faulty script. In the fall of 1933, Hughes—newly returned from the USSR

via Asia—described it as "artistically weak and unsound," mired by "de-
fects of the plot and continuity" and thus failing to pass the muster of "the
best minds of the Soviet film industry."[7] But again, it was not until *I Won-
der as I Wander*—published three years after Hughes's disavowal of com-
munism before Senator Joseph McCarthy—that he provided an in-depth
account of these defects. In a much-cited excerpt from a chapter called
"Moscow Movie," he writes that the script first drove him to astonishment,
then to laugher, then to tears. Clearly the Russian scenarist *"had never
been to America,"* resulting in a "pathetic hodgepodge of good intentions
and faulty facts." "Its general outline"—a tale of southern blacks rescued
by white workers from the North—"was plausible enough, but almost *all*
of its details were wrong and its accents misplaced." He reports telling
Mezhrabpomfil'm, "It is just simply *not true* to American life," and then de-
tails for the reader a few key scenes defying "even plausible fantasy."[8] In
short, the Russian scenarist (and, by association, Moscow and the Comin-
tern) was simply unable to grasp African American realities.

The original Russian-language script, written by Georgii Eduardovich
Grebner (1892–1954) and located in the Russian State Archive of Literature
and Art, bears none of the glaring inaccuracies specified by Hughes. No-
where does a "hot-blooded white aristocrat" at an upscale party proposi-
tion a black servant with the words "Honey, put down your tray; come, let's
dance"; indeed, there is no such party. The closest that the Grebner script
comes to this is a drunken white man assaulting a black woman by a river at
night. There are no "Negro capitalists" who own radio studios and broad-
cast towers used to call to the North for help. Instead, black workers in a
boardinghouse have access to a shortwave radio and for a brief moment
receive Radio Moscow. According to Hughes, the film was to climax with
a race riot "in which the poor whites attack both rich and poor Negroes
alike." This attack was to have prompted an alliance across class lines. In
fact, black workers remain hostile to the black bourgeoisie throughout the
film, and the climax is a multiracial workers' demonstration protesting a
recent lynching. This is followed by the Ku Klux Klan's (KKK) retaliation
on a black neighborhood. White workers do rush to the rescue, but from a
local factory rather than the North. Nevertheless, and in stark contrast to
Hughes's "trade-union version of the Civil War all over again," the police
and Klansmen prevail, shooting dead a handful of main characters and ar-
resting most of the others.[9]

In response to this puzzle, one might argue that Hughes received some other version of the script, and indeed, there were four: two preliminary Russian-language drafts (one silent, the other sound) written by Grebner between August 1930 and February 1931; Grebner's final, 1932 sound version, which is the focus of this chapter; and an English-language sound version written by the film's German director, Carl Junghans, in consultation with Hughes.[10] One scene in the English version does resonate somewhat with Hughes's 1956 description: a circle of white men joke with and ask a black servant woman to dance with them, she complies, and one of these men is later seen emerging from her house at dawn.[11] However, this brief scene is not nearly as outlandish as what Hughes describes, and in any case, even this version of the script—a condensed, disjointed version of Grebner's—lacks the absurd climax and resolution described in *I Wonder as I Wander*.[12]

Another possibility is that, after more than twenty years, Hughes simply misremembered the script's content. However, this explanation does not account for why he remembered it as he did, with such vivid detail:

> It would have looked wonderful on the screen, so well do the Russians handle crowds in films. Imagine the white workers of the North clashing with the Southern mobs of Birmingham on the road outside the city, the red fire of the steel mills in the background, and the militant Negroes eventually emerging from slums and cabins to help with it all! But it just couldn't be true. It was not even plausible fantasy—being both ahead of and far behind the times. (79)

Hughes here seems to be describing an actual film, still visible to his mind's eye, rather than some vaguely remembered script. Moreover, the film he imagines is not dismissed offhand but granted a captivating energy, at least in these lines—a quickening crescendo of militant action. The words "But it just couldn't be true" seem tinged with regret, particularly following the climax of interracial uprising.

The momentary allure of the passage points to what I think is the correct explanation for the fabricated account: Hughes sought to distance himself from past leftist affinities, but in a way that preserved the USSR as a beacon of hope. Indeed, the passage can be read as a reflectively nostalgic glimpse of the interwar, Soviet-centered ethnic avant-garde.[13] The

montage of white workers and "militant Negroes" evokes the pioneer-ing film techniques of Sergei Eisenstein, and the opening jab at Soviet crowd fetish can likewise be read as a tribute to that director—to his much remarked upon ability to present crowds as living organisms. Even the closing dismissal of the script as both too forward and backward can be read as echoing the multiple temporalities of Tatlin's Tower, another never-completed project.

These readings become less far-fetched when we turn to the actual script, which explicitly references the Soviet avant-garde. At one point Grebner proposes a "montage" for the sake of "both visual and auditory defamiliarization [*ostraneniia*]"—evoking here Eisenstein and Viktor Shk-lovskii. This is for a scene in which we first see the main characters' living quarters: Each corner of the empty room is marked by distinct sounds and objects, the goal being to use montage and defamiliarization to capture the nuances of individual characters. In one corner stands print equipment for the production of Herbert Hoover portraits (a trial print hangs on the wall); stylish clothing and a banjo case hang in the second; a small portrait of Lenin hangs in the third; and a large radio receiver and technical books fill the final corner. Aside from, arguably, the banjo, none of these objects is recognizably "black," and the juxtaposition of Hoover and Lenin is an especially defamiliarizing touch. As the script explains, the point here is a "logical and intriguing revelation [*raskrytiia*]" of the main characters, sug-gesting that Grebner indeed sought to harness Soviet "technical and artis-tic developments" to break from past caricatures.[14]

Grebner's efforts to do so resonate with a specific iteration of the So-viet avant-garde, namely, Sergei Tret'iakov's futurist emphasis on facts (the focus of the previous chapter). That is, while *Roar China* was a facto-graphic rendering of China, *Black and White* can be seen, at least in part, as a factographic rendering of African Americans. The scenarist Grebner was not a member of LEF but was apparently just as committed to accu-racy as Tret'iakov. "All events . . . are based on real facts, borrowed from literary and newspaper sources," Grebner writes in his notes.[15] Countering Hughes's claim that the script was based on the "very few books about Ne-gro life in our country" that had been translated into Russian, the scenar-ist's papers mention at least two of these sources—the leftist *Harlem Libera-tor* and the *New Masses*, which in the 1930s devoted considerable attention to African American struggles. The film's opening titles, after establishing

the setting, tersely repeat this claim of accuracy ("The Material: Facts"), and the script itself is interspersed with several asides detailing African American culture and history—from the improvisational qualities of the music, to the tendency of black pastors to address God directly in their sermons, to the founding and rise of the KKK, to the number of lynchings in 1931 ("over a hundred") and the first two and a half months of 1932 ("47"). In short, Grebner did not take lightly his stated task of presenting "*for the first time*" in world cinema blacks "as people" rather than "tearful and sugary," or "the faithful servant," or "half idiots." In his instructions to the director, he insists on the integration of "statistical, historical, and other information" into the fictional plot—a factual emphasis that troubles not only Hughes's account but also commonplace dismissals of 1930s Soviet film as "socialist realist," that is, depicting reality not as it was but as it should be.[16]

This is all to say that Grebner viewed *Black and White* as a vehicle not only for political agitation but also for artistic innovation—namely, the combination of fact and fiction to yield new representations of African Americans. To be sure, Grebner understood facts differently from the factographers: unlike Tret'iakov, he did not seek to present a single, actual event, and he lacked Tret'iakov's interest in limited points of view. His scenario has a cohesion and seamlessness incongruous with the Soviet avant-garde. Nonetheless, just as with Tret'iakov, the project of presenting peoples of color as they really were was, at the time, radical in itself. On this score and despite Hughes's dismissal, Grebner does a respectable job. In order to acquaint Soviet viewers with African Americans, he proposes opening the film with three historical fragments: The film's first image is sunlight over an ocean straining to break through storm clouds, followed by a close-up of a black corpse flashing by on a crest. We are then transported to a slave ship—with the "live cargo" packed so tightly that no one can move, women and children begging for water, and corpses thrown overboard by white sailors. The second fragment is a New Orleans slave auction, where we see a father sold away from his crying family. We are then shown plantation labor, including overseers cracking whips, after which we are returned to the slave auction, where two "nearly white" sisters are up for sale. (Grebner here informs the director, "There is an entire gamma of shades from 'almost black' to 'almost white.'") He thus makes it clear that not all Soviets thought African Americans were literally black—an expectation that fre-

quently irked the *Black and White* group.[17]) The third fragment is a night-time uprising at a plantation. In the dim reflected light by an irrigation ditch, a pale-faced landowner is besieged by a "mass of dark people filled with hatred." Next, though, we hear the sounds of attacking horsemen, see the brief skip of a cavalry line, which is followed by daybreak—order restored through the image of a black corpse rotting in the sun. Grebner thus opens with an orgy of violence—a grotesque, even fetishistic focus on abject black bodies. This is his shot across the bow of Hollywood decorum, his awakening of Soviet-audience sympathies, his starting point for a new, more coordinated black uprising.[18]

Again, in contrast to *Roar China*, *Black and White* is not based on a single historical event but nonetheless has a plausible plot. The film centers around an aniline dye (not steel) factory in an unspecified southern city, with management plotting to pit black workers against their white counterparts. Accordingly, although the workers appear identically black beside the aniline boilers—their skin colors revealed only after they shower off the dye—there are divisions. The factory's trade union refuses to admit blacks. When an Irishman, O'Grady, accidentally pushes a black worker to his death, most whites pay no heed. However, through the efforts of the film's main characters—an interracial mix of communists—an alliance is eventually forged after the black workers refuse to cross a white picket line. Meanwhile, as a subplot, the main characters stumble upon Sidney Brooker, a teenager unjustly accused of "violating the honor" of a white woman. The factory management tries to use this charge to divide the workers again, but after Brooker is caught and lynched by the KKK, blacks and whites—joined along the way by Chinese laundry workers—demonstrate together, resembling what Grebner calls an "avant-garde column" as they wend their way through the streets. As mentioned, the film ends with the KKK's retaliatory assault of the black ghetto, and despite a valiant defense—with the climactic battle cry "Long live Moscow. . . . Long live Soviet America"—Grebner reserves victory for a future date. As the surviving black and white communists march to prison in mixed-race columns, they sing, "We will return for a new fight."[19]

Revisionist scholarship on African American radicalism—which tends to emphasize local agency and downplay top-down, center-periphery control—largely affirms this plot and Grebner's claims of accuracy. Rob-

in Kelley, for instance, has shown that the Communist Party of the USA (CPUSA) made significant gains among southern blacks in the 1930s. In 1929 the party established a regional headquarters in Birmingham, and though led by white northerners, it attracted black workers through calls for social and economic equality, as well as by trumpeting the Comintern's endorsement of Black Belt self-determination. By August 1930, "over five hundred working people populated the Party's mass organizations, of whom between 80 and 90 percent were black."[20] These numbers swelled further following the CPUSA's defense of the "Scottsboro Boys"—nine African American men wrongly convicted in 1931 of raping two white women aboard a train. In Black and White, the Brooker subplot, called "a second Scottsboro" at one point in the script, clearly evokes this case, which received considerable attention in the presses of both the American left and the Soviet Union.[21] To be sure, revisionist work also reveals the film's faulty optimism, seen particularly in its abruptly formed workers' alliance. In fact, the CPUSA's success with blacks largely alienated white workers, who occasionally accused the party of a "pro-black bias." In contrast to the script, black-white alliances were often reluctant and could even leave racist attitudes intact. Moreover, violent confrontations involving black communists were rare, far outweighed by "evasive, cunning forms of resistance."[22] Nevertheless, Grebner's depictions of blacks are far from the "ludicrousness" described by Hughes and mirror the journals and newspapers of the American left. Indeed, the scenarist writes that he "borrowed" the film's parting shot from the May 1931 cover of New Masses.[23]

In retrospect, radical journals published in New York might seem a skewed source on southern blacks, and the cover cited by Grebner, featuring two perfect lines of demonstrating workers, now conveys an unsettling uniformity. Except for their evenly alternating black and white heads, the workers are identical, with the same black pants, white shirts, and almost no facial details. Upon closer examination, though, we see that the foremost worker on Grebner's New Masses cover has a black face and black right forearm but a white left forearm. Though this may be a simple oversight, it is possible to read this incongruity as acknowledging what Ralph Ellison has called the "interrelatedness of blackness and whiteness"—the notion that the categories "black" and "white" do not exist objectively but have defined and redefined each other throughout

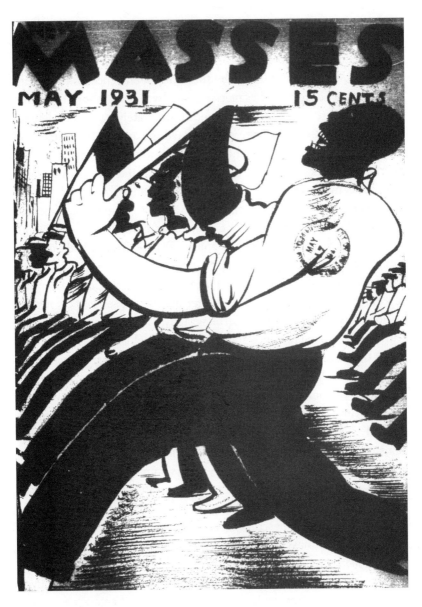

FIGURE 3.1 May 1931 cover of *New Masses*.

American history.[24] Accordingly, in a scene from Grebner reminiscent of the *New Masses* cover, the Irishman O'Grady, driven to hunger and desperation after being fired from the factory, appears on a cabaret stage in blackface. Afterward, infuriated by the drunken audience of Klan members, he responds to a dandy's mockery with two punches—one fist white, the other stained black with shoe polish. Ultimately he dies in defense of the ghetto.[25] Grebner, it seems, perceived the ambiguity of American race relations in the early twentieth century, which often cast Irish immigrants as black or semiwhite. Also included in the script is a budding romance between a black man and a Jewish woman.

This fact-checking is not meant just to disprove Hughes's account but also to bring back into focus the script's factographic traces. Though Grebner was, again, not a formal member of LEF, he clearly had exposure to its documentary innovations. His incorporation of American newspapers into the script evokes Tret'iakov's own blurring of theater and reportage. The emphasis on racial intermixture evokes Tret'iakov's rejection of exoticism in favor of ethnography. The two-toned fists, along with the interracial romance and triangulation of black, white, and Irish, assert the contingency and flexibility of racial formations. As such, these details—these disruptive facts—serve to unsettle received notions of race in a way similar to *Roar China*, with its emphasis on Chinese-Western intermixture. However, in addition to Grebner's gestures to factography, I would also like to highlight his ability to subvert the cultural conventions of his time, in this case, blackface minstrelsy and masquerade— the crossing of color lines that proved so seminal for the likes of D. W. Griffith and Ezra Pound but that also reinforced racial hierarchies.[26] In contrast, the *Black and White* script provides an instance of racial crossing that levels hierarchies, that serves as a vehicle not solely for modernist innovation or mass entertainment but also for cross-racial solidarity. Despite the limits of Grebner's script—discussed further in the following—it holds out the hope that a combination of revolutionary politics and artistic innovation could undo the deleterious effects of past representations. It also reopens the now counterintuitive possibility that an "authentic picture of Negro life in America" could be produced by a Russian writer, and before delving further into the script, it is necessary to unpack this possibility—more specifically, that Soviet and avant-gardist notion of authenticity.

Competing Authenticities

This alternative authenticity is meant as a counterpoint to Hughes's more familiar use of it in his 1956 autobiography, that is, an authenticity that guards cultural boundaries, that wards off outsiders trying to present or speak for a particular group. By the time of Hughes's Moscow trip, this familiar authenticity had been forcefully articulated by African American writers and scholars, particularly W. E. B. Du Bois. For example, Du Bois's 1926 "Criteria of Negro Art" noted how "racial prejudgement" had limited white writing on blacks, writing that tended to focus on "human degradation." Likewise, in *The Souls of Black Folk* (1903) he asserted that black sorrow songs descended from "primitive African music" and that "debasements and imitations" could "never find the real Negro melodies." In turn, just as Du Bois embraced sorrow songs, Hughes, in his 1926 essay "The Negro Artist and the Racial Mountain," established "Negro folksongs" and "the eternal tom-tom beating in the Negro soul" as the provenance of black modernism.[27] This is all to say that the 1956 account of *Black and White* must be situated within a long-running discourse of black authenticity, a discourse in which Du Bois loomed large. Indeed, Hughes's description of the script basically repeats Du Bois's claim about "debasement and imitations" and applies it to Grebner.

Robert Gooding-Williams has recently unpacked the contours of this discourse, noting how the sorrow songs chapter in *The Souls of Black Folk* emerged from Du Bois's own distance from the vast majority of blacks, how he presented the songs as the basis of a "racially distinctive spiritual identity" in order to legitimate his claims of connection to, and thus leadership over, African Americans as a whole. In short, *Souls* deploys notions of black authenticity for clear political ends—to override the problem of Talented Tenth elitism, and as Gooding-Williams goes on to explain, to press for black rights solely within the framework of American democracy (i.e., reciprocal recognition, formal equality). Out of frustration with this framework, Du Bois later renounced his U.S. citizenship and embraced communist programs for equality, even as Hughes renounced his own, past communist ties. The point for now, though, is that Du Bois's early articulation of black authenticity—again, echoed in Hughes's 1956 account—was designed to be compatible with American democratic ideals, thus excluding a priori broader criticisms of capitalist modernity.[28]

However, within African American discourses there existed another understanding of authenticity, one geared toward world revolution rather than elite leadership. Richard Wright's "Blueprint for Negro Writing" (1937) points to this by connecting black hopes and struggles with those "of minority peoples everywhere." Still a communist at this point, Wright adds that "a Negro writer must learn to view the life of a Negro living in New York's Harlem or Chicago's South Side with the consciousness that one-sixth of the earth surface belongs to the working class."[29] He refers here to the Soviet Union, which, as discussed in the introduction, he admired in large part for its valorization of minority cultures and languages. More specifically, against Du Bois's decrial of "debasements and imitations," Wright embraced a Soviet ethnographic practice that, as noted, stripped away the divide between scholar and subject. A, for instance, Russian or Jewish researcher could help collect Kazakh folk stories, bring them back to the state ethnography museum in Leningrad, and then demonstrate how different Soviet folklores borrowed from one another. In keeping with the state's nationalities policy, the task was to identify and preserve the distinct "character" that Stalin granted to each group. Of course, the USSR was not alone in dispatching ethnographers from center to periphery. However, even before 1917, Russian ethnography was distinct from its Western counterparts in claiming Asia as a marker of Russian distinction and denying "altogether the essential differences between the traditions of Europe and the 'East.' "[30]

What I would like to suggest is that, through a combination of Soviet ethnography, avant-gardism, and nationalities policy a distinctive brand of cultural authenticity emerged—one determined by anticapitalism rather than descent, "authentic" as shorthand for "untainted by capitalism." We encountered this authenticity in chapters 1 and 2: it appeared as Mayakovsky's rejection of Mexican souvenirs and the "exotica of starvation" and Tret'iakov's rejection of "old false and exotic ideas about China." To be sure, Mayakovsky proceeded to find authenticity in a "traditional exoticism" that was "colourfully poetic and non-profitable," while Tret'iakov rejected exoticism altogether in favor of a "true China" of street scenes and motley attire. Nonetheless, the two advanced a clear political and aesthetic prerequisite for culture to be considered "authentic," namely, an opposition to kitsch and commodification that many theorists (from Clement Greenberg to Renato Poggioli to Peter Bürger) have tied to avant-gardism.[31]

We have also seen this Soviet notion of authenticity applied specifical-
ly to African American culture: Lydia Filatova's advice to Hughes that he
"draw closer to the Negro masses and talk their language" and use Maya-
kovsky as a model for doing so. However, as I emphasized in my discussion
of Hughes's Mayakovsky translations, such applications were not a one-
way street, not simply a case of Stalinist policies or Soviet discourses play-
ing out in the United States. Indeed, anticapitalist, revolutionary notions
of black authenticity very much emerged in dialogue with African Ameri-
cans and the American left. James Smethurst offers useful contextualiza-
tion here, showing how this Soviet notion of authenticity gelled with long-
standing desires to free black vernacular from minstrelsy and "plantation
literature." Seeking to reclaim "their" culture, several African American
writers in the 1930s responded by deploying an "'authentic' construction
of the folk that could be posed against mass-culture appropriations." As
Smethurst writes,

> Left oppositions of bourgeois culture, including mass culture, to working-
> class and peasant cultures, however fragmentary and skeletal, could be used
> to reappropriate vernacular expressive forms, including "dialect," without
> the contamination of minstrelsy, popular "dialect" literature . . . and other
> forms of popular "misappropriation" of vernacular black culture.[32]

In other words, radicalism was to cleanse black folk of minstrelsy's "con-
tamination," the implication being that market influences were intrin-
sically corrupting. Through this lens, black vernacular appropriated by
the bourgeoisie was inauthentic, serving only to reinforce stereotypes,
while black vernacular that opposed mass culture was authentic. Anti-
capitalism was to rescue black culture from inauthenticity, a construc-
tion that Smethurst illustrates via Sterling Brown's poetry. Rejecting the
"high" diction of northern blacks and the white-sponsored jazz of New
York, Brown's *Southern Road* (1932) presents a distinct southern vernacu-
lar apparently untainted by markets and bent on resistance. Brown thus
romanticizes the Black Belt as the authentic, anticapitalist foundation of
African American culture.[33]

The yoking of vernacular to resistance yielded a clear criterion for
evaluating black authenticity, which led white radicals on both sides of
the Atlantic to assert their supposed authority on the matter. As we saw

in chapter 1, Filatova in Moscow believed herself qualified to define "the Negro masses" and "their language." Similarly, *New Masses* editor Mike Gold derided New York nightclubs for peddling a false black voice, spoiled by wealthy white patrons such as Carl Van Vechten: "The Harlem cabaret no more represents the Negro mass than a pawnshop represents the Jew, or an opium den the struggling Chinese nation."[34] On the other hand, Gold embraced spirituals as untouched by markets and, as such, promising a black art and literature "that will amaze the world when revealed." He later suggested, though, that in order for this to happen, religious lyrics would have to be replaced by revolutionary ones, with just the melodies and dialects preserved. For example, as Barbara Foley notes, in 1932 Gold praised black workers in Chicago for transforming "Gimme That Old Time Religion" into "Gimme That New Communist Spirit."[35]

Likewise, throughout the early 1930s *New Masses* published a series on "Negro Songs of Protest," in which their white compiler, Lawrence Gellert, emphasized southern black dialects as well as a shift from religious themes:

> These new songs of the Negro differ from the well-known spirituals. Whereas the latter as a group are prayer songs—a racial heritage, part of the old, dead past—grooved and set, and now sung practically without variation throughout the Black Belt, these new songs are secular—reflecting the contemporary racial environment—the peonage, poverty and degradation. . . . And they're still in process. Never sung twice quite in the same way. New verses constantly added. In these songs we catch the Negro for the first time with his mask off. The mask he has for generations been constrained to assume in order to pick up the crumbs from the white man's table in peace.

In short, according to Gellert, the religious content of spirituals rendered them static and false. However, once black music assumed radical content, it could provide direct access to the "true" black subject, unfettered by past constraints and that "mask," which, Gellert adds, is figured in a song "the Negro wood-chopper at Fort Mills, S.C. sang for me":

> Boss man call me nigger, ah jes' laugh
> He kick de seat ob mah pants, an' dat ain' half

You don' know, you don' know mah min'
When you see me laughin' jes' laughin' to keep f'om cryin'

One min' fo' de white folks to see
One min' dat say what nigger lak fo' to be
You don' know, you don' know mah min'
When you thinks you's way 'head o' me, jes' leavin' you behin'[36]

Gellert here makes the too hasty assumption that he himself has access to this woodchopper's mind, that the song is not being directed against him as well. Yet the song harmonizes with the racial "veil" and "double consciousness" identified by Du Bois in *The Souls of Black Folk*, "this sense of always looking at oneself through the eyes of others, of measuring one's soul by the tape of a world that looks on in amused contempt and pity."[37] According to Gellert and Gold, the key to shattering this duplicity (both inward and outward) was a turn from religion to radicalism, expressed in what they heard as a uniquely black inflection. This would make the African American subject whole, both in his own eyes and in those of white radicals.[38]

In hindsight, the problems with this understanding of the "authentic black subject" are clear. First and foremost is its singular definition of black culture—confined to the Black Belt, drawn almost exclusively from male singers and writers, and uncritically dismissive of religion. Gellert's delineation of black spirituals as static and "songs of protest" as fluid seems forced at best. Nevertheless, in southern black vernacular and music, U.S. communists (both black and white) believed that they had located authentic African American culture. In turn, the American left's embrace of black folk culture influenced Soviet views. In a 1934 entry on "Negro literature" for a Soviet literary encyclopedia, Filatova draws from *New Masses*, mentioning the articles and stories of Eugene Gordon and quoting from Gellert's "Negro Songs of Protest." Her bibliography includes a collection of these songs translated into Russian. Thus, Filatova's—like Grebner's—authority on African Americans was based, at least in part, on American communist writings that themselves drew inspiration from the Soviet Union.

The result was a similar understanding of black culture among American and Soviet communists. Citing Hughes, Filatova describes African American literature's most recent revolutionary examples as possessing

the following components: (1) content that highlights the racism con-
fronting blacks, in response tending toward class consciousness and
away from religious themes; (2) form that draws from black "national
[*narodnye*, which can also be translated as "people's" or "folk"] 'blues' and
'spirituals,'" as well as a distinct "Negro dialect."[39] Apparently Hughes
did not disagree: as noted in chapter 1, he met with Filatova during the
Black and White trip and, by all indications, highly valued her readings.
Arnold Rampersad suggests that her criticism of his religious "relapses"
prompted him to write from Moscow in March 1933, "Never must mysti-
cism or beauty be gotten into any religious motive when used as a prole-
tarian weapon."[40]

Filatova's remarkably clear definition of laudable, authentic black cul-
ture was the product of a transatlantic, cross-racial leftist exchange that,
in retrospect, belies Hughes's caricature of uninformed Soviets. This defi-
nition resonates well with *Black and White*. I take up later Grebner's own
rendering of *Negritianskii narodnyi bliuz* (Negro national blues), but suffice
it for now to note the script's antireligious thrust, enacted through a "Ne-
gro preacher" character who, "calling to mind a fox," speaks at a deceased
black worker's funeral but later evicts the man's widow and children. (The
coup de grace against religion comes near the film's climax, when the
antilynching demonstrators sing in unison Joe Hill's "Preacher and the
Slave"—the Wobbly hit also known as "Pie in the Sky.")[41] However, there
were certainly limits to Filatova's definition, most prominently an unwill-
ingness on her part to venture into black dialect—just as Mayakovsky ex-
hibited in his poem "Black and White." While she insisted that Hughes use
a distinctly black language, she herself opted not to do so: in her Russian
translations of the spiritual "Go Down, Moses" and one of Gellert's pro-
test songs, she inserts no indications of a nonstandard dialect, yielding
only literal meanings. Likewise, except for "one or two" songs, Grebner
specifies that his *Black and White* was to be in "clean [*chistom*] Russian lan-
guage," arguing that "Russian speech, distorted with an imagined 'Ameri-
can' accent," sounds "horrible."[42] Here we find an uncharacteristic inabil-
ity to overcome racial barriers, perhaps even an echo of Du Bois's notion
of authenticity, but also a welcome contrast to Western white modern-
ism's eager exploitations of black dialect. The point for now, though, is
that a shared understanding of black authenticity emerged across Soviet
and American leftist circles—one that combined vernacular culture with

radical anticapitalism, which in turn was to purge vernacular culture of minstrelsy and religion.

Grebner's "Blue River"

To help capture this alternative authentic culture, Mezhrabpomfil'm asked the group of twenty-two to bring plenty of records and had them rehearse spirituals during their idle time in Moscow. Indeed, the incorporation of African American music into the film is the script's most striking feature. Music here serves as a cross-lingual medium for joining different cultures, histories, and spaces, for broaching the boundaries between American and Soviet, black and Russian, as well as black and Jewish. For example, near the film's start, a "sad (or angry) Negro song" accompanies a black worker's funeral. While Grebner does not specify melody or lyrics, he states that "Negroes are beautiful improvisers, and quite often, their choruses are constructed in the form of *dialogue*. Therefore, the 'choir-leader' [*khoreg*] can speak not only about [the deceased] *Elias individually, but about all the colored people of America*." Regarding the choir's language, Grebner notes, "There are a great number of beautiful Negro songs never translated into Russian language, but even irrespective of this, a song can be specially written for this case."[43]

A second example finds the black main characters reworking a sad Jewish workers' song—this in a mournful scene following the capture of Sidney Brooker. The owner of the boardinghouse where these characters live happens to be an immigrant from czarist Russia, the Jewish tailor and would-be Bolshevik Isaak Vorbi; the small Lenin portrait hanging in the room is his. He sings to his daughter Lizzy in Russian:

Shei moia igla . . .	Sew, my needle . . .
Kak mnogo zla	How much evil
Prinosiat liudi.	People bear.
Bedniak portnoi	A poor tailor
V strane chuzhoi—	In a strange land
Chto on takoe?	What is he anyway?[44]

Overhearing this song, one of the black boarders, a professional musician named Robert Hayes, accompanies it on his banjo and sings along without

words. Two other boarders join in, one with a harmonica, and the tempo quickens, tears dry up, and dancing commences, to Lizzy's delight. Grebner explains, "This appears incredible from our point of view, but it's absolutely natural, if you keep in mind the unique joy-of-life [*zhizneradostnost'*] of Negroes."[45]

Third, while waiting for the KKK's assault near the end of the film, Hayes, again with his banjo, sings a song called "Blue River" in Vorbi's staircase. Grebner provides the lyrics but calls them only an "approximate text":

Khleshchet plet' i zveniat kandaly . . .	A whip lashes and shackles clang . . .
Skvoz' lesnoi burelom	Through forest of wind-fallen trees
Tianem, tianem stvoly . . .	We drag, we drag trunks . . .
Vse litso v krovi—bol'no noet ruka . . .	Whole face bloody, arm ringing in pain.
Poterpi,—vperedi,—uzh blizka	Hurry, ahead, it's already close
Golubaia reka . . .	Blue river . . .
go—lu—baia . . .	blue . . .
Byl korotok boi	The battle was short
I eshche ne odin vperedi . . .	And there's more than one ahead . . .
Nas neset golubaia volna	The blue wave carries us
V okean uvlekaia . . .	Away to the ocean . . .
Kogda vse kak odin—	When all are as one
Ne strashna nam bor'ba nikakaia	No struggle can scare us
Golubaia reka . . .	Blue river . . .
Golubaia reka . . .	Bluc river . . .
go—lu—baia . . .	blue . . . [46]

Grebner notes that his Russian-language rendering of a black sorrow song is "arrhythmic"—one might even say "syncopated" along the lines of the "drowsy syncopated tune" immortalized by Langston Hughes in "The Weary Blues" (1926).[47] Indeed, in appearance as well as its irregular rhythm and rhyme scheme (e.g., "ruka / blizka / reka"), "Blue River" resembles that poem more than any sorrow song, though the repetition of "Golubaia reka" seems to reference the repeated lines of the blues. However, Grebner modestly states that "by no means do I lay claim to a final version," adding that he would not object to having the song performed in English. He stipulates only that the words correspond to the following

visuals, to be displayed during Hayes's performance: chained slaves in the woods being beaten, their riverside revolt, and their escape to a floating barrel. They drag behind them fallen black bodies while an alligator devours their overseer's corpse.

This opens the way for the final song covered here, which commences just as "Blue River" ends. Hayes's banjo gives way to "new and unexpected sounds" from Vorbi's shortwave radio—Radio Moscow, playing the upbeat Red Army song "Amur Partisans," about the Russian Civil War:

I ostanutsia kak v skazke	And remaining as in a tale are
Nashi dal'nie ogni,	Our faraway fires,
Golubye nochi Spasska,	The blue nights of Spassk,
Karachaevskie dni . . .	And Karachai days . . .
I na Tikhom okeane	And on the Pacific Ocean
Svoi zakonchili pokhod . . .	They ended their campaign . . .[48]

Through this montage of languages and sounds, Grebner juxtaposes his song's slave revolt with Soviet victories—from the Karachai region of the Caucasus all the way to the town of Spassk in the Russian Far East. The "blue river" flows into the Amur River, and freedom's destination suddenly becomes the Pacific, not the Atlantic. In short, the United States blends into the USSR, and as the KKK attacks, Hayes, waiting in a window with a gun, quietly hums the Red Army refrain.[49]

Whether intentionally or not, Grebner here echoes Mayakovsky's poem "Camp 'Nit Gedaige' " (1925), in which the Hudson River flows into the Moscow River and young Jewish American communists pledge allegiance to Soviet power. That is, Grebner uses music not only to connect Jews to blacks, then blacks to Russians, but also to advance a new, Soviet-centered mapping of space and time: an American river leads to Moscow, while African American struggles are first juxtaposed with those of Russian Jews, then folded into the history of the Bolshevik Revolution.[50] Just as with Willie in Mayakovsky's own "Black and White" (1925), the solution for these workers is to address their concerns to Moscow and the Comintern. All the while, however, Grebner is careful to maintain the distinctness of these juxtaposed peoples, places, and histories. We see such an effort in the "black" adaptation of the Jewish tailor's song. Though Hayes takes his cue from Vorbi, his "unique joy-of-life" transforms the

original, and, presumably, his rendition of "Amur River" in the film's fi-
nal scene would have also showcased some perceived "black" nuance.
This likely would have resembled the use of music in the Dziga Vertov
documentary *Three Songs About Lenin*—built around montages of Central
Asia and Moscow that collapse the distance between center and periph-
ery. Produced by Mezhrabpomfil'm in 1934, its first extended "song"—on
the unveiling of women in Uzbekistan—includes children marching first
to a Soviet brass-and-flute sound track then to an Uzbek stylization of
the same.[51]

My aim here is to underscore Grebner's innovative use of music as
well as to place him in the good company of the Soviet avant-garde.
However, there are problems with his efforts to describe and, indeed,
author African American singing. Rather unfortunately, he states
that his "blue river" refers to the famously brown Mississippi, adding,
"There likely exist a few songs about 'the blue river' . . . I personally have
heard, I think, three, but I've thought of this myself."[52] To be sure, this
howler, as well as Grebner's essentialist descriptions of African Ameri-
cans as improvisational, musical, and happy-go-lucky are disconcerting.
In his defense, it is necessary to remember that while Grebner was not
the first nonblack writer to try his hand at black music, he was among
the few who did so with the explicit aim of leveling racial hierarchies.
However, a closer examination of Grebner's use of music reveals *Black
and White*'s more fatal shortcoming, one emerging not so much from
the script itself but from the context in which it was written. Grebner
provides for cultural diversity and an anticapitalist authenticity, but as
the film progresses, this diversity falls increasingly within a Soviet or-
bit, centering on a sacralized Moscow. Note the trajectory of the preced-
ing examples: described in the preceding: at first, the black characters
sing among themselves to mark the funeral of one of their own, then
their singing follows the lead of a Russian Jew, who establishes a link
between the United States and the USSR, and finally, the music of Ra-
dio Moscow magically folds the struggle for black freedom into a Soviet-
centered revolution. Of course, Mayakovsky's "Black and White" like-
wise instructs the Afro-Cuban Willie to look to Moscow, and Tret'iakov's
Roar China (1926) tells Chinese boatmen to draw hope from the Bolshe-
vik Revolution. However, with Grebner's 1932 *Black and White*, Moscow
has a far more active, controlling presence, with the African American

characters effectively drafted into the Red Army. This is not to criticize Grebner but simply to affirm that the Soviet 1930s was a time of Stalinist centralization. For artists and writers, this meant growing restrictions on creative possibility, and as we will see, the script itself fell victim to state interests. Meanwhile, as discussed in the introduction, Moscow's promotion of national cultures, territories, and elites streamlined the management of Soviet peoples, which meant that policies that at first appeared beneficent could also serve state terror—for instance, the deportations of entire peoples by the end of the decade.[53]

Perhaps this is what Langston Hughes had in mind when he wrote that *Black and White* was "simply *not true* to American life." Perhaps he meant to say that the scenario—like the Comintern's calls for Black Belt self-determination—presented a simplified, essentialized blackness, readily available to state co-option.[54] However, *I Wonder as I Wander* expresses no concerns about the domination enabled by Soviet essentialism, suggesting only that a fact-finding visit to the United States would have made this essentialism more plausible. This is not to fault Hughes for missing the looming terror of the 1930s. During his stay in the USSR, he was shown what he was meant to see, and upon his return to the United States, he had no way of checking or updating his facts. Nor is it my goal to demonstrate once again that the USSR committed betrayals, or that essentialism (even when "strategic") bears blinders and perils. Returning once more to Hughes's "Moscow Movie" account, we find more here than meets the eye—so typical for this author.

Cold War Authenticity

"All I can see to do for this film," I said, "is to start over and get a new one, based on reality, not imagination."
"Will you write it?" the Russian executives asked me.

—*Langston Hughes,* I Wonder as I Wander

With the Soviet Union's collapse, Moscow's archives have fully confirmed the conspiracy theories surrounding *Black and White*'s cancellation. Particularly following the Japanese advance into Manchuria, Moscow was eager

to secure its global position, and U.S. diplomatic recognition was a much-sought prize.[55] Archives have also confirmed that Hugh Cooper, chief engineer of the Dnieprostroi Dam, indeed threatened to delay the project's completion if the "un-American" film went into production. In a cruel, fitting twist, part of the *Black and White* group toured the finished dam before heading home.[56]

Thus, "scenario and technical difficulties" was nothing more than a diversion. The left-leaning members of the *Black and White* group, not fully sure what to make of the cancellation but convinced of the possible political repercussions for the CPUSA, had little choice but to toe the party line. However, this faction also prepared a private report critical of Mezhrabpomfil'm. "Members of this group have read the scenario," it declared. "They are unanimous in their belief that it is essentially true to Negro life in America and that in the hands of a competent director a powerful film can be made from it."[57] Addressing the Comintern, they urged immediate production. Instead, they received a written assurance from Mezhrabpomfil'm that the project would recommence in 1933. As noted, this promise went quietly unfulfilled.[58]

In effect, Langston Hughes's 1956 account buttresses Mezhrabpomfil'm's official reason for "postponement." We can see him as adopting and running with the "faulty scenario" line, playfully concealing one sacrifice to Soviet realpolitik and "socialism in one country." According to him, there was no sacrifice at all, only an inauthentic script—a perfectly acceptable criticism given the Soviet valorization of black authenticity. Indeed, Mezhrabpomfil'm was the first to forward this criticism, which was utterly preferable to "betrayal"; *I Wonder as I Wander* merely provided the details, in a sense fulfilling the Soviets' request that Hughes redo the script himself. Interestingly, however, Hughes recalls declining this request:

> "I couldn't," I said. "I've never lived in the South, never worked in a steel mill, and I know almost nothing about unions or labor relations. For this kind of film you need somebody who knows a great deal about what he is writing." (79)

It is in this statement that we can discern a crack in Hughes's account: he charges the Russian scenarist with ignorance even as he professes his own. That is, had Hughes written the scenario, it, too, would have fallen under

the shadow of inauthenticity. This concept's versatility is here made clear: a southerner or a unionist could have applied it against Hughes, just as Hughes applied it against Grebner.[59] However, Hughes's own deployment of the authentic versus the inauthentic bore a particular brilliance in that it killed two birds with one stone. His account upheld the party line and yet, by ridiculing Moscow's outreach to African Americans, it also gelled with U.S. anticommunism. As a result, even amid the heightening Cold War, Hughes managed to have it both ways—to be both black and communist, American and Soviet.

His deployments of authenticity were precisely what allowed for such crossings. By invoking black authenticity—the film as "not true" to African American realties—he drew a clear line between the United States and the USSR, thereby allaying anticommunist fears of a "Soviet America." With this line, this curtain, set in place, Hughes was then free to preserve the Soviet Union as an isolated bastion of equality. *I Wonder as I Wander*'s occasional complaints about the USSR regard mostly bureaucracy and shortages—like the inauthentic script, nothing that questions Moscow's good intentions and inspirational allure. The autobiography does include rumors of political prisoners, but Hughes adds, "I could not bring myself to believe . . . that life was not better for most people now than it had been in the days of the Volga boatmen, the Asiatic serfs, and the Jim Crow signs" (173). Of course, it was Hughes of 1932 who reached this conclusion, but Hughes of 1956 faithfully recounts it, despite professing a "complete reorientation of my thinking and emotional feelings" before Joseph McCarthy in 1953.[60]

Indeed, Hughes displayed remarkable consistency in his regard for the Soviet Union and, in his departure from the left, avoided serious charges against either the CPUSA or the USSR. It is instructive here to turn to his McCarthy testimony, which Rampersad describes as "a rhetorical *tour de force*," deftly avoiding unequivocal attacks on communism.[61] Note, for instance, this exchange with Roy Cohn, the Senate subcommittee's chief counsel:

COHN: Have you received any disillusionment recently, concerning the treatment of minorities by the Soviet Union?
HUGHES: Well, the evidence in the press—I have not been there, of course, myself—indicating persecution and terror against the Jewish people, has been very appalling to me.

Hughes here is appalled by "evidence in the press" rather than Soviet anti-Semitism—evidence, moreover, that he is unable to confirm. He does criticize the Nazi-Soviet Non-Aggression Pact of 1939, saying this "shook up a great many people"—though without specifying whether he was one of those people. He also notes a "lack of freedom of expression in the Soviet Union for writers," though in the context of McCarthyism, there is a certain irony to this charge. In any case, he frames these criticisms in layered vagueness, presenting them as "two interpretations of my feeling about my reorientation and change."[62]

Rampersad draws a helpful parallel between Hughes's McCarthy testimony and *I Wonder as I Wander*, noting that neither forum was used "to distort the facts of Soviet Russia as he saw them, or to slander or denounce the Soviet people." As a result, the testimony provoked only mild criticism from the American leftist press, and the *Daily Worker* called Hughes one of the country's "great talents" in its praise of *I Wonder as I Wander*.[63] Meanwhile, his poetry continued to be published and celebrated in the Soviet Union, with one critic noting there in 1981,

> American critics of a conservative persuasion try to present the final years of Hughes's life as a period of the poet's "pacification" [*umirotvoreniia*], his refusal of previous radical views, and passions for purely "cultural-uplift" [*kul'turtregerskoi*] activity. But this is not so. Hughes remained a poet-internationalist, faithful to his democratic beliefs. . . . Hughes invariably during every step of his path was in solidarity with leftist forces.[64]

Radicalism here is constant, while "cultural nationalism" is only skin-deep. According to this survey (titled *Contemporary Negro Writers of the U.S.A.*), Hughes's convictions remained intact but hidden, rendering him an authentic radical, as opposed to the likes of a Ralph Ellison or Richard Wright—both of whom were more pointed about their breaks from communism and neither of whom is included in the survey's bibliography.[65]

Such political delineations can be seen as analogous to this chapter's opening racial delineation between Hughes and Arthur Koestler. As mentioned, *I Wonder as I Wander* attributes Koestler's dissatisfaction with Soviet Central Asia—and, implicitly, the Soviet project as a whole—to his lack of "Negro eyes." However, in a gesture to the cross-racial ties of the

interwar years, Hughes proceeds to link the Jewish author's dissatisfaction to that which he perceives in Ellison, Wright, Wallace Thurman, and Myron Brinig. Notably, three of these four were African Americans with former communist connections, suggesting a link between lapsed leftism and, as Hughes puts it, emotional hypochondria—a tendency to be "unhappy when *not unhappy*" and wear one's sadness on one's sleeve (120, emphasis in original). The autobiography then suggests that this affliction emerges from racial and ethnic inauthenticity, manifested as black and Jewish self-loathing. After Hughes gives his last American pencil to a Bukharan Jew, Koestler is shown exploding: " 'He tricked you. That Jew!' Koestler said, 'I'm ashamed! Ashamed! Langston, I'll get your pencil back for you.' " For the embarrassed Hughes, who gets his pencil back a few hours later, this brings to mind both Jewish and African Americans who blanch at any behavior that they think "disgraces the race" (138). In contrast, the "Moscow Movie" caricature—a "signifyin(g)" satire?[66]—serves to cast Hughes as authentically black, meaning, in this instance, free from such neuroses (further explored in chapter 4), loyal to the United States, and yet still aligned with Soviet interests. By proving himself authentic on all fronts, Hughes managed to appease both sides of the Iron Curtain, deftly keeping himself above the Cold War's fray. Among the many people of color from around the world who once sought hope from Moscow, few fared so splendidly.

The loser of history to Hughes's winner was *Black and White*'s consultant, Lovett Fort-Whiteman—as noted in the introduction, among the first African Americans to join the CPUSA and, in 1924, the first African American to receive Comintern training in Moscow. During his eight-month stay, Fort-Whiteman marveled at the apparent elimination of racism, and after urging the Comintern to do more to organize blacks, he was placed at the head of a new recruiting organ called the American Negro Labor Congress (ANLC). Though a passionate orator, however, he was perhaps better suited for creative rather than political pursuits. Prior to becoming a communist, he had published theater reviews and short stories in the black socialist *Messenger* and played the title role in a touring production of *Othello*.[67] Accordingly, his leadership over the ANLC had a dramatic, iconoclastic quality, with the flair of performance art. On the streets of Chicago in 1925, he wore traditional Russian

clothing that gave him the appearance of a "Buddhist monk" and "veritable Black Cossack"—an instance of "Afro-Orientalism" akin to Claude McKay's 1922 poem "Moscow." However, there are indications that Fort-Whiteman sought something stranger and more alien than this. A fellow African American communist described him as "an unknown quantity," someone who "both repelled and fascinated" by rejecting familiar notions of blackness—clear markers of ethnic avant-gardism but unfortunate qualities for a community organizer. At the ANLC's opening festivities, he staged a Russian ballet and an *untranslated* play by Alexander Pushkin, whose African roots, once again, were widely touted by early black radicals. These programming choices may not have been "avant-gardist" in themselves, but in the context of 1920s black Chicago, they most certainly were.[68]

Unlike Hughes, Fort-Whiteman proved fatally inauthentic as both an African American and a leftist. In 1928, he was called back to Moscow because of the ANLC's "severe isolation" under his helm. That same year, he failed to support the Black Belt thesis, disputing the idea that African Americans constituted a "nation" and pressing class solidarity instead.[69] In the Soviet Union he married a Russian Jewish woman, worked for the Comintern, and kept in close contact with black radicals. Indeed, though he is never mentioned in *I Wonder as I Wander*, he greeted the *Black and White* delegation upon its arrival in Leningrad by train in June of 1932. The travelers could not have been surprised, well aware that he had been assisting with the script: for instance, in her invitation to Hughes to join the group, Louise Thompson notes, "The scenario is now in preparation, with Lovett Whiteman as consultant to see that it is true to Negro life." Grebner's script specifically cites him as a source on funeral songs.[70] Through his familiarity with the project, Fort-Whiteman likely took issue with the "faulty scenario" line and seems to have supported those who called the cancellation a political compromise. In her August 24 letter home, Thompson writes, "Whiteman turns out to be an awful person and such a person that one can only have contempt for. Instead of helping us, he encouraged Ted [Poston] and Thurston [McNairy Lewis] in their escapades."[71]

The noose tightens. In 1935 a Comintern committee noted "reported efforts of Lovett Whiteman to mislead some of the Negro comrades," though without specifying either these efforts or these comrades. However, it urged two prominent black communists—including William Patterson,

Louise Thompson's future husband—to take up the matter before returning to the United States. The following year at a Foreign Club meeting in Moscow, Fort-Whiteman reportedly offered adverse criticism of Langston Hughes's *The Ways of White Folks*. This action was deemed "counter-revolutionary" by "a black lawyer from the upper echelon" of the CPUSA, namely Patterson again. Meanwhile, official correspondence between American communists and the Comintern branded Fort-Whiteman a Trotskyist, sealing his fate. On July 1, 1937, the height of Stalin's purges, the People's Commissariat for Internal Affairs convicted him of "anti-Soviet agitation," a catchall charge at the time. At first he was exiled to Kazakhstan, where he worked as a teacher, but this sentence was changed to hard labor in May 1938. He died of "weakening of cardiac activity" in a Siberian prison camp on January 13, 1939.[72]

These tragic details affirm once more that Soviet dealings with African Americans were a collaborative effort, involving both blacks and whites, in both the United States and the USSR—a frequent emphasis in scholarly efforts to revisit the "black-red thread." Fort-Whiteman has long haunted this scholarship, which makes it all the more admirable that Glenda Gilmore's recent *Defying Dixie* places him at the forefront of African American communism. Though faulting him for not catching, in his capacity as *Black and White*'s consultant, Grebner's inaccuracies (Gilmore takes Hughes's account literally), she also eulogizes him: "No one knew of his eagerness, his recklessness, his abiding faith in poor working people. In the final, perfect equality of the gulag, it mattered not a whit that he was a black man, only that he was a broken man."[73] Gilmore here movingly joins Fort-Whiteman to all those shattered by Stalinism. The "black-red thread" unravels into the broader, troubled history of twentieth-century communism—though, as she concludes, the study of historical failures leaves open the possibility of "lost causes found."[74]

The *Black and White* film project was one of those lost causes, and as such, it is appropriate that Grebner's script concludes with a failed uprising and victory postponed to an undetermined future. For the likes of Grebner and Fort-Whiteman, victory here would mean something different from the very concrete gains of civil rights and liberal multiculturalism, including Hughes's canonization against the Cold War's backdrop. Victory would mean the reassemblage of the script's "avant-garde column"—of a cross-ethnic, international grouping that, under the rubric

of an alternative, anticapitalist authenticity, sought to fuse revolutionary politics and artistic innovation. However, this grouping was also bound by a shared encounter with Stalinist terror, which likewise cut across the boundaries of race, ethnicity, and nation—claiming, in the previous chapter, Tret'iakov; in this chapter, Fort-Whiteman; in the next chapter, Soviet Jewish writers. Although redemption would be but another lost cause, the ability to discern this ethnic avant-garde in the ruin of the past would, at the very least, make the many deaths like Fort-Whiteman's somewhat less lonely and futile.

4

Cold War Pluralism

The New York Intellectuals Respond to
Soviet Anti-Semitism

"The Sabbath is beginning," Gedali pronounced solemnly. "Jews must go to
the synagogue."

"*Pan* Comrade," he said, getting up, his top hat swaying on his head like a
little black tower. "Bring a few good men to Zhitomir. *Oy*, they are lacking in
our town, *oy*, how they are lacking! Bring good men and we shall give them all
our gramophones. We are not simpletons. The International, we know what
the International is. And I want the International of good people, I want every
soul to be accounted for and given first-class rations. Here, soul, eat, go ahead,
go and find happiness in your life. The International, *Pan* Comrade, you have
no idea how to swallow it!"

"With gunpowder," I tell the old man, "and seasoned with the best blood."
And then from the blue darkness young Sabbath climbed onto her throne.

—*Isaac Babel, "Gedali"*

Jewish artists, writers, and thinkers have been present in each of the
preceding chapters, serving as an implicit vanguard within the Sovi-
et-centered ethnic avant-garde. In the introduction, we saw Walter
Benjamin and Horace Kallen visiting the USSR, the latter declaring it a Jewish
"frontier of hope." Mayakovsky's American hosts were frequently Russian
Jewish émigrés sympathetic to the Soviet Union—and two such characters
figure prominently in Grebner's *Black and White* script. Herbert Biberman of
Roar China was one of the many Jewish American intellectuals who made the
"magic pilgrimage" to Moscow. Two other frequently discussed examples

are Mike Gold and Joseph Freeman, both fixtures of interwar New York's left literary scene.[1] I have yet to emphasize the central presence of Jews as ethnic avant-gardists partly because this is such well-trodden ground. Among Americanists, Slavists, and Jewish studies scholars alike, it is now widely accepted that Jews had a prominent place in the interwar left, and that Soviet Jewish culture drew the attention of Jews worldwide. In line with Kallen's conclusion from his 1927 visit that the "new Russo-Jewish world" would be "far more Jewish than the Jewry of America" and "be the matrix of culturally far more significant Jewish values than the Jewry of America," Moscow emerged as the center of what might be called a Yiddish world republic of letters, overshadowing New York and Warsaw.[2] In addition to English-language authors like Gold and Freeman, Moscow also drew Yiddish-language New Yorkers—for instance, the poet Moishe Nadir, who, during his 1926 visit, likened the USSR to a bride with red hair, "dearer to me with each passing day." Meanwhile, back in the United States, pro-Soviet publications like New York's *Frayhayt* (*Freedom*), which we encountered hosting Mayakovsky at Camp "Nit Gedaige," enabled Yiddish poets to explore both revolutionary politics and literary modernism.[3] Remarkably, these poets were then read in the USSR: a Moscow-based critic proclaimed one of them, Moishe Leib Halpern, the American Mayakovsky, able to merge literature with "real life" in the manner of the Soviet futurist poet.[4]

No other group better affirms the fact that, indeed, minorities were keenly interested in Soviet vanguardism and avant-gardism. However, this group's subsequent, widespread disillusion suggests that, ultimately, such interest was misguided. Existing studies on Jews and the Soviet-oriented left tend to have a tragic, entropic register: if, as noted in the introduction, the USSR seemed a "frontier of hope" for Jews worldwide, this promise soon proved illusory. According to Kenneth Moss, while there was a brief Soviet Jewish "renaissance" after the revolution, it faded in the early 1920s amid ever-heightening state control. In subsequent years, several of the Yiddish authors who shuttled between Moscow and New York suffered horrible fates: the turn from experimental to "proletarian" literature led to bitter infighting in Yiddish literary circles, followed by purges and executions for many of those caught in the USSR during the late-1930s terror.[5] Thus, the history of Jews and the Soviet Union tends to follow a well-trodden track from illusion to disillusion, one marked by several key dates for New York's leftist Jewish literary world: In 1922, Abraham Cahan's *Forward* came out

against the Bolsheviks' nondemocratic tendencies. Others lost faith in 1929, after the Kremlin blamed Zionists for an anti-Jewish riot in Palestine. And so on and so forth, with the first Stalinist show trials in 1936; the Hitler-Stalin Non-Aggression Pact in 1939; the 1940 assassination of Trotsky; and the emergence of Stalinist anti-Semitism after World War II. The venture of this chapter is that the ethnic avant-garde has granted us a new way of seeing, one that allows us to rethink—if not quite unseat—such linear trajectories.

Just as in the previous chapter, the key here is competing notions of authenticity. If Hughes's 1956 account of *Black and White* shows him navigating the authenticities of both ethnic identity and anticapitalism, in this chapter we will see how these came to heighten the Cold War divide between the United States and the Soviet Union. The chapter marks the weaponizing of cultural authenticity—how, through Jewish American responses to Stalinist anti-Semitism, an explicitly anti-Soviet authenticity emerged. Subsequently, in the United States, the USSR came to be seen as hostile to both particularism and experimentation, as a place where authentic cultural and ethnic expression had been quashed by totalitarianism. From this perspective, the United States was a place where authenticity could flourish via cultural experimentation and ethnic diversity. This distinction, I argue, opened one of the many fronts of the cultural Cold War—during which segregation in the American South remained a favorite topic for Soviet propaganda, to which American lawmakers could respond by highlighting anti-Semitism in the USSR. Thus, the Cold War was a struggle not just between the United States and the USSR but also between these countries' two competing models of equality, liberal pluralism versus socialist internationalism.[6] And in fact, much good emerged from this back-and-forth, namely, global scrutiny of Jim Crow and eased emigration for Soviet Jews.[7]

In short, this final chapter traces how ethnic avant-gardism came to be overshadowed by reified cultural boundaries and familiar Cold War binaries—the USSR versus the United States, socialist internationalism versus liberal pluralism, socialist realism versus high modernism. However, I then try to see beyond these binaries by identifying traces of the interwar ethnic avant-garde in postwar articulations of Jewish American authenticity. The chapter has three parts. The first backtracks to the interwar years in order to describe the attraction of the Soviet-oriented left for Jews in both the United States and the USSR. The focus in this part is on the Soviet Jewish avant-garde, which in the second and third decades of the twentieth century

created striking combinations of Jewish culture and revolutionary politics—the preceding Isaac Babel quote being a case in point. Part two crashes the utopian allure of this interwar moment against the rocks of postwar Stalinist anti-Semitism. After detailing this development, I examine Jewish American responses to it, focusing on the "middle generation" of the influential group now known alternately as the New York Intellectuals and the New York Jewish Intellectuals. I show how owing to both the Holocaust and Soviet anti-Semitism this group came to eschew class-based solutions to "the Jewish question"—a shift that can be discerned in two critiques of Jean-Paul Sartre's *Anti-Semite and Jew* (1946). The final part then confounds the Cold War binarism of the previous part: first by noting a similar shift regarding the "national question" within the USSR, and second by noting how at least one New York Intellectual, Irving Howe, sought a "third way" of sorts—a combination of Jewishness, socialism, and modernism. This balance, I argue, points to the ethnic avant-garde's postwar survival as well as to a shared experience of illusion, disillusion, and compromise that traversed but also reinforced descent-based divides.[8]

Socialism with a Messianic Face

Returning briefly to Hughes's March 1953 testimony before Joseph McCarthy, we find one clear instance of an American official—here McCarthy's chief counsel, Roy Cohn, himself Jewish American—using Soviet anti-Semitism to discredit Moscow's earlier allure:

COHN: Have you received any disillusionment recently, concerning the treatment of minorities by the Soviet Union?
HUGHES: Well, the evidence in the press—I have not been there, of course, myself—indicating persecution and terror against the Jewish people, has been very appalling to me.[9]

As noted in the previous chapter, Hughes tries his best here to avoid explicit critiques of the Soviet Union, expressing disillusion with unverified "evidence in the press" instead. Indeed, this evidence must have been difficult for him to accept given that, as a high school student, his first exposure to leftist politics came through his Jewish classmates. According

to Arnold Rampersad, though they were not all socialist, "some steered Hughes straight toward socialism" by lending him Max Eastman's *Liberator* magazine and John Reed's *Ten Days That Shook the World*. As Hughes recalled in 1946, the Bolshevik Revolution prompted "much jubilation" among these students, "because, they said, the Soviets did not believe in anti-Semitism, and that there were Jews high in the government now." His 1932 visit seemed to confirm this optimism: "In less than fifteen years, I found that Soviet Russia had gotten rid of the Jewish problem."[10]

Jews were indeed well represented in the Bolsheviks' ranks and were not merely persecuted by Moscow. As indicated by Grebner's *Black and White* and Mayakovsky's "Camp 'Nit Gedaige,'" during the interwar years, many Jewish Americans looked to the Soviet Union with zeal and longing; they envied their Soviet relatives' transformation from persecuted minority to revolutionary vanguard.[11] This is, of course, dangerous ground to tread, or at least once was. During the Cold War, the link between Jews and communism was a topic to be avoided, but more than twenty years after the Soviet collapse, worries about red-baiting and stereotyping have abated. In a 2004 article titled "Rich, Powerful, and Smart: Jewish Over-representation Should Be Explained Instead of Avoided or Mystified," David Hollinger writes, "The more we understand how the conditions of the Jewish Diaspora in Europe fostered Jewish participation in the Russian Revolution and the Soviet state, the less credible become suspicions that this participation was caused by something else, such as a peculiarly Jewish will to power."[12]

Two scholars—a Sovietist named Yuri Slezkine and an Americanist named Alan Wald—have independently answered this call for a nonessentialist, anti-anti-Semitic account of the Jewish left. Both affirm that Soviet and American Jews were disproportionately represented in communist circles. As Slezkine writes, while Jews constituted only about 4 percent of Russia's population at the turn of the century, it filled a large number of leadership roles during and after the revolution:

At the First All-Russian Congress of Soviets in June 1917, at least 31 percent of Bolshevik delegates (and 37 percent of the Unified Social Democrats) were Jews. At the Bolshevik Central Committee meeting of October 23, 1917, which voted to launch an armed insurrection, 5 out of the 12 members were Jews. Three out of seven Politbureau members charged with

leading the October uprising were Jews (Trotsky, Zinoviev, and Grigory Sokolnikov). The All-Russian Central Executive Committee (VtsIK) elected at the Second Congress of Soviets (which ratified the Bolshevik takeover, passed the decrees on land and peace, and formed the Council of People's Commissars with Lenin as chairman) included 62 Bolsheviks (out of 101 members). Among them were 23 Jews . . .[13]

Slezkine goes on to find disproportionate Jewish representation in the secret police, among the early Soviet state's leading artists and propagandists, and also in the ranks of European and American communists. In the United States of the 1930s, "Jews (most of them immigrants from Eastern Europe) accounted for about 40 to 50 percent of Communist Party membership and at least a comparable proportion of the Party's leaders, journalists, theorists, and organizers" (90). Alan Wald confirms this figure: "There was possibly a Jewish American presence of close to 50 percent of the total of those who published regularly in Party-affiliated venues and joined Party-led organizations such as the John Reed Club, the League of American Writers, and the National Council of Arts, Sciences, and Professions. This is a remarkable aggregate; only 2 or 3 percent of the population of the United States was Jewish in the mid-twentieth century."[14]

Both Slezkine and Wald concede that the majority of communists were not Jews, and that the majority of Jews were not communists—facts that confound any sheer equation of Jewishness and communism. Indeed, the authors also note that many Jews who were communists identified themselves as internationalists, seeking the elimination of all forms of inequality through world revolution, as well as an escape from the parochialism and persecution that they associated with Jewishness. More specifically, they both explain the Jewish-communist connection in Oedipal terms: according to both, young Jews in the United States and the USSR became communists in order to break from their upbringings. Slezkine argues that the 1917 Revolution was, in part, a "Jewish Revolution" against Jewishness, with Russian-speaking Jews in the cities rejecting their Yiddish-speaking parents back in the shtetl:

Wartime massacres and deportations accompanied by the militarization of apocalyptic millenarianism—anarchist, nationalist, and Marxist—

transformed the decades-old rebellion of Jewish children into a massive revolution. During Russia's Time of Troubles of 1914–21, most Jews hid, fled, or moved; tens of thousands were killed. But among those who took up arms, the majority did not stay to defend their parents' lives and property. They had universal brotherhood to fight for. (167)

This is world revolution as family drama—generational strife, not dialectical materialism, as the locomotive of history. Jewish Bolsheviks apparently took quite literally the claim of young Marx that the *"empirical* essence" of Judaism was "huckstering and its conditions"—to be abolished by revolution, leading to the "*social* [i.e., not just legal] emancipation of the Jew."[15] According to Slezkine, this goal led Jewish Bolsheviks to renounce their "class alien" parents and Jewish-sounding names, embracing instead military adventure and Russian spouses. In both Soviet and American literature of the 1920s and 1930s—for example, Isaac Babel's short stories and Henry Roth's *Call It Sleep*—he finds young secular Jews distancing themselves from their parents.[16] This dovetails well with Wald's account of the American scene:

> The Communist movement in the United States had a solid foundation in Eastern European Jewish immigrant families; they brought to their country not only an abhorrence of czarist autocracy but also working-class and socialist loyalties. Moreover, the Communist movement exhorted its members to adhere to a cultural pluralist and internationalist universalism, a stance that was attractive to young Jews emerging from families still shaped by the experience of shtetl and ghetto isolation. (180)

Similar to Slezkine, then, Wald uses family ties (coupled with an escape from family) to explain Jewish communism, in the process blurring together the United States and Eastern Europe, pluralism and internationalism.[17]

Slezkine's "Jewish Revolution" against Jewishness is useful in that it enables connections between the United States and the USSR, explaining how these two very different branches of the diaspora came to embrace communism and, as he goes on to show, came to see this as a mistake. And certainly we could go on and apply this model to other minorities drawn to communism, that is, to the Soviet-centered ethnic avant-garde as a whole—their common goal being to leap from parochial minorities to the

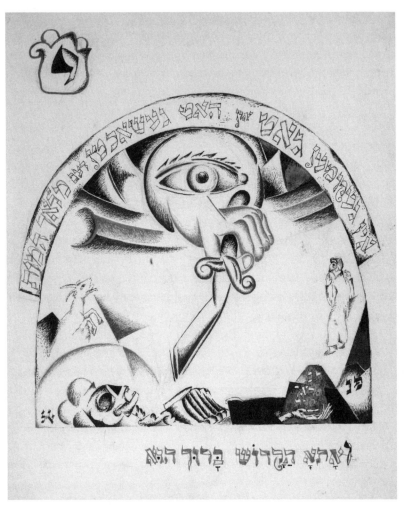

FIGURE 4.1 "And the Holy One, Blessed be He, came and smote the Angel of Death," scene 10 from El Lissitzky's illustrations for *Had Gadya* (1918–1919).

Collection of the Tel Aviv Museum of Art, donated by Israel Pollak, Tel Aviv, with assistance from the British Friends of the Art Museums in Israel, London, 1979.

"avant-garde of the world."[18] However, I am uneasy with the either-or re-
lation that Slezkine draws between ethnicity and communism, and here
again Wald comes in handy, telling us that, at least in the United States
during the interwar years, "a Jew entering the Communist movement had
a range of choices through which to express his or her identity. On one
hand, there were clubs and organizations immersed in *Yiddishkeit*; on the
other, one could also assume a non-Jewish 'party name' and a persona de-
void of any ethnic attachment" (181). In short, a devotion to leftism did not
necessarily entail a rejection of Jewishness.

Indeed, perhaps the most striking examples of the merging of the
two can be found in the Soviet Jewish avant-garde through the early
1920s. For instance, in 1918 El Lissitzky—the suprematist painter who
connected Tatlin's Tower to ancient Assyria—cofounded a support or-
ganization for Yiddish writers and artists in Moscow.[19] Around that time
he also produced several illustrations that aimed "to persuade the Jew-
ish public of the justice of the Communist cause by using a traditional
language, Yiddish, symbols, and characteristic Jewish values."[20] One was
"a boxed scroll resembling the traditional Scroll of Esther," with ornate
Hebrew calligraphy that Lissitzky described as "wonderful Assyrian
script."[21] Another included abstract shapes that anticipated his more fa-
mous suprematist works. It featured a "divine hand" striking down the
Angel of Death, upon which Lissitzky affixed a czarist crown. In these
illustrations, the Bolshevik Revolution merges with Jewish messianism,
the hand of Soviet power with the Book of Daniel's hand of God.[22] Here
there is no "Jewish Revolution" against Jewishness but rather a vision
of Jewishness that is alluring despite—or perhaps because of—the revo-
lutionary violence connected to it. A 1918 essay by the prominent So-
viet Jewish critic Abram Efros helps to explain this pairing of ethnicity
and revolution:

> The global crisis, the senseless cataclysm which is shaking the life of the
> world at the present time, cannot but see the simple reflection of what it
> has itself brought into being; for it is that crisis which has dislocated and
> shifted all the cultural strata so as to expose the most ancient layers of
> folk existence. Yet it is also the force which goes driving forwards, shap-
> ing the dynamic of history into completely novel "modernistic" "arch-
> left" nation-state and socio-economic alignments.

In short, war and revolution could benefit Jewish folk culture. Amid this apparently universal push and pull between ancient and modern, Efros expresses confidence that each group would be able to maintain its uniqueness, that "strange complexities" would emerge "through which sings the national blood and its artistic predilections." He anticipates that the Soviet Jewish avant-garde would be celebrated for "our 'modernism,' our leftishness, youth" as well as for "our 'populism,' our tradition, old age."[23]

Such visions and hopes should be perfectly legible to us—further instances of an avant-garde reimagining the movement of history and time. Lissitzky recasts revolution as a messianic event, evoking Vladimir Tatlin's protoconstructivist iteration of the Tower of Babel, that is, a vision of revolution oriented toward both future and past. In the introduction I brought to the fore precisely this notion of the avant-garde through Walter Benjamin's "now-time" and "dialectical image," and though I did not emphasize this there—not wishing to confine Benjamin to any single tradition—it seems relevant to discuss here the messianic undercurrent of his thought, which many have linked to his Jewish identity. Thus, for example, his "Theses on the Philosophy of History" describe revolution not just as arrest but also as "messianic arrest," and now-time as the secularized version of messianic time. Indeed, the theses assert messianism as the crucial ingredient for revolution's success. As Benjamin writes,

> A genuinely messianic face must be restored to the concept of classless society and, to be sure, in the interest of furthering the revolutionary politics of the proletariat itself.[24]

This is socialism with a "messianic face," drawing inspiration from pre-Marxist utopias and secularized religion, the goal being to reactivate the "conscious and unconscious memories, hopes, and longings" banished by history as progress.[25]

Again, Benjamin spelled out this vision of revolution in his 1940 theses, making all the more remarkable the fact that the Soviet Jewish avant-garde expressed the same vision, only twenty years earlier. This is evident in El Lissitzky's illustrations but also in a 1920 Yiddish play, *The End of the World*, which the Russian Jewish American anarchist Emma Goldman saw during a visit to Kiev:

The wrath of God rolls like thunder across the world, commanding man to prepare for the end. Yet man heeds not. Then all the elements are let loose, pursuing one another in wild fury; the storm rages and shrieks, and man's groans are drowned in the terrific hour of judgment. The world goes under, and all is dead.

Then something begins to move again. Black shadows symbolizing half beast, half man, with distorted faces and hesitating movements, crouch out of their caves. In awe and fear they stretch their trembling hands toward one another. Haltingly at first, then with growing confidence, man attempts in common effort with his fellows to lift himself out of the black void. Light begins to break. Again a thunderous voice rolls over the earth. It is the voice of fulfillment.

It was a stirring artistic achievement.[26]

The (apparently lost) play captures precisely Benjamin's revolutionary messianism and past-present constellation. The revolutionary subject is not the proletarian but these beast-man cave dwellers who somehow survive the Great Flood. The revolution itself is imagined as divine retribution for all past injustice, beginning and ending with that thunderous voice—perhaps spoken in the single divine tongue sought by Tatlin and Marr in their Tower of Babel renditions. And from the chaos of revolution, a new and unified people emerges, marked only by black shadows and shared encounters with the void of judgment day. In short, if in the introduction, we saw the Bolshevik Revolution as an Asian revolution (waged, for instance, by Blok's Scythian cannibals), here we see it as a Jewish revolution—not against Jewishness, as Slezkine would have it, but instead harnessing Jewish messianism to advance universal equality.

The point of this excursion back to the 1910s and 1920s has been to show how figures like Lissitzky articulated a Jewish culture in harmony with Benjamin's secular Jewish messianism. This is a version of Soviet Jewishness that disturbs the well-established rise-and-fall narrative alluded to earlier: that a brief Jewish "renaissance" gave way to growing state control through the 1920s and 1930s, followed by state-sanctioned anti-Semitism in the 1940s. Indeed, based on this narrative, one might say that *The End of the World* had it wrong: the moment of terror had not passed. However, the foregrounding of messianic arrest in Lissitzky's paintings and Benjamin's writings opens the possibility of using such works to derail the track to

Stalinist disillusion. True, the window for such visions proved quite narrow, but they present articulations of ethnicity and avant-gardism too striking to dismiss or forget. They generate a charge, an energy that, via the writings of the New York Intellectuals, I will now try to smuggle into the postwar years.

"Authentic" and "Inauthentic" Jews

In order to accomplish this, I must first discuss how, exactly, Jewish vanguardism and avant-gardism gave way to Stalinist anti-Semitism—or, as official organs put it, "anticosmopolitanism." Anticosmopolitanism is not quite synonymous with anti-Semitism but is the exact antithesis of ethnic avant-gardism. In Slezkine's account, Jewishness (in the form of hostility to Jewish stereotypes) initially went hand in hand with Soviet ideology (namely, the right to become more Soviet than Jewish), but all this changed during World War II. First, the Holocaust brought the "Jewish Revolution" against Jewishness to a close. In Dovid Katz's words, with six million gone, "there could be little appetite for pursuing the old 'anti-clericalist' line any longer."[27] Then, in 1948, the USSR became the first country to recognize the state of Israel (if only to drive the British out of the Middle East), inadvertently stripping Soviet Jews of their saving grace. During the Great Terror, they had largely escaped persecution as a group, for there had been no other state to divide their loyalties. In contrast, many other diaspora nationalities, such as the Koreans and the Poles, had suffered mass deportations in the late 1930s. With the establishment of Israel, however, Stalin suddenly came to see Soviet Jews as yet one more "ethnic Diaspora potentially loyal to a hostile foreign state," an "alien element" that had successfully infiltrated all strata of the Soviet elite.[28] This yielded predictable results already unleashed on those other "suspect" nationalities: the executions of top Jewish party members, the purges of many more, and the liquidation of state-sponsored cultural organs. Meanwhile, popular anti-Semitism, which the Soviet state had actively suppressed in the 1920s and 1930s, spiked after the war, with Jews targeted alternately as capitalists and communists.[29]

This background helps us to understand the March 1953 exchange between Roy Cohn and Langston Hughes on those troubling reports coming

from the USSR. Just two months earlier, *Pravda* had announced the arrest of nine doctors, mostly Jews, for assassinating two members of the Politburo: "They were recruited by a branch-office of American intelligence—the international Jewish bourgeois-nationalist organization called 'Joint.' The filthy face of this Zionist spy organization, covering up their vicious actions under the mask of kindness, is now completely revealed."[30] "Joint" refers to the American Joint Distribution Committee, a charitable organization with a long history of aiding Eastern European Jews. The alleged point men in this conspiracy were two members of the Jewish Anti-Fascist Committee (JAC), a group of prominent Soviet Jews who, at the Kremlin's behest, had solicited overseas funds for Moscow's war effort, particularly from Jewish Americans.[31] The following day this "Doctors' Plot," as it became known, made the front page of the *New York Times*, which in turn connected the arrests to the 1952 executions of prominent Jewish communists in Czechoslovakia.[32] *Commentary*'s lead article for February 1953 followed suit and drew two further connections—between this new crackdown and the 1930s terror, and between the Soviet Union and fascist Germany:

> World Communism's adoption of open and organized anti-Semitism and genocide as means of national and international policy has not only erased the last moral difference between the Nazi and Soviet rulers, it is also proof that totalitarian regimes, regardless of their ideological origins, find themselves driven along the same fatal course.[33]

There is indeed evidence that Stalin planned a "final solution" for Soviet Jews, namely, mass deportation to Central Asia and the Russian Far East.[34] With his death in March 1953, however, large-scale anti-Semitism came to a halt. The surviving doctors were released, their forced confessions withdrawn. Two had died in custody.

This explosion of anti-Semitism spelled the end of what Slezkine calls the special relationship between the Jews and the Soviet state, and not only for Jews in the USSR.[35] After all, the basis of the charges was the connections forged between Soviet Jews and Jewish Americans, in the form of the "Joint" and the JAC. The Doctors' Plot made it clear that, in the eyes of Moscow, Jewish American leftists were not to be trusted, that they were intelligence agents bent on sabotage through their Soviet Jewish contacts.[36] To be sure, by this point many Jewish Americans had already parted ways

with Moscow, and many had been anti-Bolshevik all along.[37] However, until the Doctors' Plot, most had agreed that, at the very least, Soviet power had improved the lot of (secular) Jews. Though information from Moscow was spotty and incomplete, it suddenly became clear that anti-Semitism was alive and well in the Soviet state. Indeed, the Doctors' Plot evoked the rumors of blood ritual that had fanned pogroms before the revolution. While no one in New York fully understood what had gone wrong, Horace Kallen's "frontier of hope" had most certainly proven a mirage. And gradually one mirage was replaced with another.[38]

The new line became that the Soviet Union was (and perhaps always had been) a false Jewish promised land—a line articulated most forcefully by the New York Intellectuals. Again, just as in the previous chapter, the key word here is "authenticity," usefully bearing ethnic, political, and aesthetic connotations. Represented by such influential postwar thinkers as Daniel Bell, Sidney Hook, and Irving Howe, almost all the New York Intellectuals covered here had Eastern European immigrant roots. However, they were distinct from other Jewish American writers in that they rejected *Yiddishkeit*, choosing instead "to declare themselves citizens of the world" and "to look upon social problems in terms extending beyond local or even national interests."[39] In doing so, they followed the lead of Trotsky, who, like them, was "both Jewish and Russian" and provided a model for combining a "life of action" with belief "in the power and purity of the word."[40] That is, in addition to a model for being discreetly Jewish, Trotsky provided political and aesthetic guidance, bolstering this group's commitment to both socialist revolution and high modernism. This led to the 1934 founding of the journal *Partisan Review*, envisioned as an alternative to Mike Gold's *New Masses* and its turn to socialist realism by the early 1930s. In a further departure from *New Masses*, *Partisan Review* was implicitly and, after the 1936 Moscow Trials, explicitly anti-Stalinist, thus helping to make 1930s New York "the most interesting part of the Soviet Union"—"the one part of that country in which the struggle between Stalin and Trotsky could be openly expressed."[41]

The New York Intellectuals can be regarded as outlier members of the interwar ethnic avant-garde. Unlike, for instance, the writers around *Frayhayt* and despite their focus on Moscow, they were never so enamored with Mayakovsky and LEF but instead shared Trotsky's belief that a truly socialist culture would be achieved only after the realization of a socialist so-

ciety. They also shared Trotsky's view of literature as intrinsically hostile to ideological control. From this perspective, Mayakovsky and his cohort were too hasty in their calls to merge art into life, too quick to denounce the art and literature of the past as passé.[42] Thus, though one New York Intellectual, Clement Greenberg, was an early American theorist of the avant-garde, he detached this term from revolutionary politics and the external world. He instead forwarded a rarefied avant-gardism that pursued art for art's sake, rejecting as "kitsch" mass art and socialist realism. Accordingly, this group remains known for its commitment to high modernism over revolutionary art and politics.[43]

In other words, one would be hard-pressed to describe this group as avant-gardist, at least as I have been using the term. But I focus on the New York Intellectuals because, after news of Stalinist anti-Semitism descended on "the most interesting part of the Soviet Union," this group won the debate. Far leftists who had embraced Moscow during the interwar years—the *Frayhayt* group, for example—never fully recovered from the Doctors' Plot and, later, Khrushchev's 1956 "Secret Speech" on Stalin's excesses.[44] In contrast, the standard narrative for the New York Intellectuals goes as follows: After World War II this group came to embrace their American and Jewish identities and to use them to reinforce their anti-Stalinist positions. This development was the result of the Holocaust but also of a perceived "failure of radicalism" that was hit home by the Doctors' Plot.[45] In short, this group helped to set the terms for a postwar turn from Soviet-centered internationalism to descent-based identity. They advanced the notion that socialism and ethnicity were incongruous with each other—just as Harold Cruse would go on to do in his *The Crisis of the Negro Intellectual*.[46]

Let us now unpack this (paradoxically cross-ethnic) turn from socialist internationalism to ethnic particularism. A good starting point is a 1946 essay by Howe, "The Lost Young Intellectual: A Marginal Man, Twice Alienated." At the age of twenty-six, Howe paints a portrait of a Jewish intellectual who feels no "sense of kinship with Jewish activities" but also "has not succeeded in finding a place for himself in the American scene." As a result, he feels "all of the restless, agonizing rootlessness that is the Jew's birthmark." He chafes at the observance of tradition, religious or otherwise, preferring radical politics instead but nonetheless cannot help longing for "a feeling of continuity."[47] Eight years later, Howe would assert this continuity by coediting *A Treasury of Yiddish Stories*, featuring English

translations of Sholem Aleichem, David Bergelson, and other Jewish writers from Eastern Europe. However, in "The Lost Young Intellectual," he concludes that the solution to his alienation rests not in Jewish introspection but in society at large:

> My personal opinion is that any conclusion which affirms the necessity of "returning home" to the ways of one's people is—like it or not—unrealistic and unlikely to be effected: the Jewish intellectual cannot, even if he wished to, return to a world no longer his. Possibly he can find some alleviation in individual psychotherapy, but even that can only ease individual problems without touching the cause. Ultimately the problem can only be solved if an American society appears in which both the Jewish intellectual and his people, along with everyone else, can find integration, security, and acceptance.[48]

While this is far from a call for revolution, the suggestion here is that American society is still rife with racism and anti-Semitism and that the solution to Jewish quandaries lies in structural changes benefiting all peoples. Meanwhile, Jewishness is portrayed only negatively, as something that might be abandoned if only society permitted. In short, at this point, Howe still fits Slezkine's Jewish revolutionary mold but has yet to accept "individual psychotherapy"—has yet to come to terms with Slezkine's Oedipus-complex diagnosis.

Indeed, earlier that same year, Jean-Paul Sartre had cast a similar mold, in an article most certainly read by Howe, "Réflexions sur la question juive," the first part of which appeared in the spring 1946 issue of *Partisan Review*.[49] Written in 1944, this controversial essay was remarkable in that it provided a socialist internationalist explanation of the Holocaust in a national (French) context, at a time when socialist internationalism was officially defunct—that is, one year after Stalin dissolved the Comintern to appease his World War II allies. As such, it presented a last stand of sorts for a class-based line on Jewishness. By critiquing Sartre—himself a staunch defender of the USSR until the late 1950s—the New York Intellectuals were able to articulate both a break from this line and a (skewed) framework for subsequently understanding Soviet anti-Semitism. In short, here we get an in-depth look at the supposed socialist-to-Jewish transition.

Sartre's essay is based on four economic and psychological profiles: the anti-Semite, the democrat, the "inauthentic" Jew, and the "authentic" Jew. At the root of anti-Semitism, he argues, is class: the anti-Semite belongs to the lower-middle class and denigrates Jews in order to feel less insecure; anti-Semitism is "a poor man's snobbery."[50] From this perspective, there is nothing distinctive about anti-Semitism; in other contexts, the anti-Semitic type "will make use of the Negro or the man of yellow skin" in order to persuade "himself that his place in the world has been marked out in advance, that it awaits him, and that tradition gives him the right to occupy it" (54). Sartre's second type, the "good democrat," tries to respond to this situation by proclaiming equal rights. However, by neglecting both class and race distinctions—"'There are no Jews,' he says, 'there is no Jewish question'"—he fails to comprehend the anti-Semite and the function of anti-Semitism (57). The response of Sartre's third type, the "inauthentic" Jew, is also inadequate. He reacts to anti-Semitism by trying to escape his Jewishness, though others still see him as Jewish. The "authentic" Jew, in contrast, understands the cause of anti-Semitism but chooses not to flee: he is "the one who asserts his claim in the face of the disdain shown toward him" (91). Ultimately, however, the solution to anti-Semitism is beyond the reach of Jews, even the brave "authentic" ones. Instead, the burden rests on all Frenchmen to forge a society without classes, united by "mutual bonds of solidarity" (150). In this circumstance, Sartre predicts, anti-Semitism would disappear, and Jews would cease being Jews; they would assimilate into Frenchmen.[51]

It is necessary to elaborate what Sartre means by "authentic," for it is on this axis that the New York Intellectuals articulated their rebuttals. "Authenticity," Sartre writes, "consists in having a true and lucid consciousness of the situation, in assuming the responsibilities and risks that it involves, in accepting it in pride or humiliation, sometimes in horror and hate" (90). By "situation" he refers to the structural causes of anti-Semitism, namely, class division. According to Sartre, this situation and its attendant persecution have destroyed Jewish history, culture, and tradition—obviating, as the young Howe puts it, a return to "the ways of one's people." Amid such destruction, the "inauthentic" Jew tries to flee Jewishness, but this leads only to self-loathing and hyperrationalism, traits the anti-Semite then associates with all Jewish people. Thus, the "inauthentic" Jew only reinforces anti-Semitic stereotypes, which in turn reinforce the boundaries of Jewishness.

In this light, both the young Howe and Slezkine's Jewish revolutionary can be seen as "inauthentic"—abandoning Jewishness for the "myth of the universal man" and, in the process, confirming the stereotype of the radical Jew who flees Jewishness (136). However, the two also possess the spirit of revolt that, for Sartre, is key to "authenticity." They understand their "situation" as one in which anti-Semitism is merely the displacement of class inequality, and they seek the equitable society that Sartre predicts will solve such troubles. Of course, until that society is forged through socialist revolution—forged by and liberating all peoples—the Jewish radical might seem "inauthentic," both to himself and to others. But there lies an implicit ray of hope from the world's first workers' state: no one fit Sartre's cramped "authenticity" better than the postwar Soviet Jewish communist—survivor, by then, of multiple messianic "Ends of the World" and still waiting for Moscow to grant a viable territory so that Jews could finally become just another Soviet nationality.[52]

It therefore seems fitting that the New York Intellectuals attacked Sartrean "authenticity" just as Soviet anti-Semitism was stepping up. In a January 1949 *Commentary* article titled "Does the Jew Exist?"—which Howe would later call a personal "turning point"—art critic Harold Rosenberg rejected Sartre's notion that Jewishness was a mere by-product of anti-Semitism.[53] Instead, he asserted a Jewish history not bound to external circumstance:

> The continuity of the modern Jew with the Jews of the Old Testament is established by those acts that arise from his internal cohesion with his ultimate beginnings, in which his future is contained as possible destiny— the acts of turning toward the Promised Land in his crises. And these acts, not deducible from his surroundings, *make* the Jew's situation and reveal who the Jew is.[54]

In contrast to Lissitzky's *Had Gadya* and *The End of the World*, this is a kinder, gentler Jewishness, one that emphasizes continuity rather than arrest. Here we find an uninterrupted connection between past and present, with future crises to be remedied via recourse to the nation, that is, the newly established Israel, itself rooted in the past. Rosenberg's notion of Jewishness exists independently of social relations, regardless of anti-Semitism and Sartre's "authentic" or "inauthentic" distinction. He goes on to expand the notion of "situation" to include not only social relations but also

"the fact of being alive as a unique individual" (16), and from this metaphysical perspective, Sartre's Jews—both "authentic" and "inauthentic"—become identical in their abnegation of selfhood:

> The Jew who wills to make himself nothing-but-a-Jew (and as a Jew nothing) does not thereby become more authentic than the Jew who wills not to be a Jew. Both have taken the way of despair, since they have willed to transform themselves from what they are, as given, into what they conceive the situation to demand them to be. (16)

To remedy such despair, Rosenberg concludes, the Jew can "rediscover" his "unique identity which springs from his origins and his story," an identity which includes, at times, assimilation (18). In effect, Rosenberg posits a singular (but implicitly secular) Jewish identity to override Sartre's blurry "authentic"-"inauthentic" distinction—an identity bent, again, on historical continuity rather than messianic arrest.

Four months later in the *Partisan Review*, philosopher Sidney Hook further critiqued Sartre's "authentic"-"inauthentic" distinction but without abandoning it as Rosenberg does. In his article "Reflections on the Jewish Question," Hook simply redefines "authentic" and "inauthentic," imparting to these terms their now common-sense meanings:

> In describing the psychology of what he calls the "inauthentic Jew" among Gentiles, Sartre does not distinguish between the psychology of what I call the "inauthentic" Jew—the Jew who desires, so to speak, to pass himself off as a Gentile, and the psychology of what I call "the authentic Jew" who accepts himself as a Jew for any reason whatsoever. . . . The "inauthentic Jew," in my sense, is afflicted with an additional dimension of self-consciousness. No matter how impeccable his conduct, he is always on guard in predominantly non-Jewish company, exquisitely conscious of the possibility that at any moment something he says or does will be regarded as a telltale sign. . . . There are very few inauthentic Jews of this kind. They are really inauthentic people. The main problem of the authentic Jews is to find some rational basis or ideal fulfillment of their authenticity. Sartre is no guide here.[55]

Thus, Hook refocuses attention from society to the individual. His "inauthentic Jew" is simply in need of psychological help. Meanwhile, the

tautological key to becoming an "authentic Jew" is to find some basis of authenticity. Hook himself is reluctant to define this basis, worried about essentializing Jewishness and thereby capitulating "to the muddy metaphysics of the antisemite" (480). He offers only this guideline:

> Far wiser, it seems to me, is to recognize the historic fact of Jewish existence, the plural sources of Jewish life, and its plural possibilities. No philosophy of Jewish life is required except one—identical with the democratic way of life—which enables Jews who for any reason at all accept their existence as Jews to lead a dignified and significant life, a life in which together with their fellowmen [sic] they strive collectively to improve the quality of democratic, secular cultures and thus encourage a maximum of cultural diversity, both Jewish and non-Jewish. (480)

In effect, Jewishness is to become synonymous with diversity for diversity's sake; the "authentic Jew" is to be Sartre's "good democrat," only with an added commitment to pluralism. As for Sartre's goal of "universal democratic socialism," Hook calls this a "dream" that "still has its uses as a guide in some ways but not as a home" (481). And despite past ties and travels, "home," of course, is the United States, where all can enjoy "the democratic way of life." To be an "authentic Jew" means to be a loyal American, which in turn means to embrace Jewish and non-Jewish cultures—assuming that these are democratic and secular.[56] In contrast, to be a Sartrean "authentic Jew," one must perceive the economic causes of anti-Semitism and continue to wait for socialist revolution, drawing meager hope from the French philosopher's qualified observation, "We find scarcely any anti-Semitism among workers."[57]

These competing understandings of "authenticity"—one aimed at structural equality, the other aimed at cultural diversity—reveal a fork in the road, a choice between Soviet socialist internationalism and American liberal pluralism. By the 1950s, Hook's embrace of the latter over the former seemed vindicated by all that was happening in the Soviet Union. Indeed, at one point in his article, he chides his opponent's ignorance of the USSR, and in fact, according to an American diplomat in Paris, Sartre was "crushed" by the Doctors' Plot and its blatant anti-Semitism.[58] This is not to pronounce winners and losers in this exchange, though certainly Hook's "authentic Jew" is much happier than Sartre's—allowed a "dignified and

significant life" without having to await revolution. Rather, the point is to recapture this moment in which two competing models of equality were still in dialogue—arguing over terms like "authenticity" and "situation"—right before history pulled them apart.

As disturbing reports continued to emerge from Moscow, particularly after Khrushchev's 1956 Secret Speech, the dialogue between liberal pluralism and socialist internationalism turned into an outright clash. This is evident in American responses to Soviet anti-Semitism, which was typically framed as an assault on Jewish culture and on cultural diversity in general. The elimination of Yiddish schools, publications, and theaters; the fact that no new books were being issued in Yiddish; and, most especially, the executions of thirteen Yiddish writers and JAC members on August 12, 1952—all this spelled "cultural genocide" analogous to Hitler's actual genocide. To be sure, the elimination of cultural figures and organs was indeed one aspect of Soviet anti-Semitism, and yet something did not quite fit: What about the fact that most of those executed were "Communist true believers who had dedicated most of their lives to promoting Stalin's 'socialist content' in Yiddish 'national form' "?[59] What of the countless literary works in Yiddish praising socialist internationalism, many penned outside the Soviet Union? And what about the Soviet Jewish avant-garde of the late 1910s and 1920s—artists like El Lissitzky and plays like The End of the World?

For left-leaning Jewish Americans, answering these difficult questions entailed revisionist takes on the interwar years. State-sponsored Yiddish schools and publications notwithstanding, the determination was that Soviet power had corrupted Jewish culture from the beginning. In their 1953 introduction to A Treasury of Yiddish Stories, Howe and Eliezer Greenberg wrote that from the end of 1924 onward, Soviet Yiddish literature had become "Neanderthal party literature," yielding "party propaganda in emasculated Yiddish."[60] A 1958 pamphlet distributed by the AFL-CIO's Jewish Labor Committee asserted, "Soviet-Yiddish literature was not and could not be independent. It was more a part of Soviet than of world Yiddish literature. It was under the absolute control of the Communist Party and the Communist dictatorship."[61] Isaac Bashevis Singer confirmed these accounts in a 1962 Commentary review:

> The inner dissolution of Yiddish in Russia began as early as the 1920's at the very time when Yiddish was supposed to be flourishing there. Writers

like David Bergelson and Moshe Kulbak, who were settled in Russia at that time and had harnessed themselves to the revolution, quickly lost their talent and their linguistic charms. It may sound mystical, but some of these writers were actually no longer able to construct a Yiddish sentence; their language had lost its soul.[62]

What we see here is Hook's notion of authenticity gaining legs: aside from that vaguely religious charm and soul, Jewish culture is defined in purely negative terms, as all that is non-Soviet and nonrevolutionary. Singer suggests that all loyal Soviet Jews had betrayed their Jewishness, including Bergelson (one of the twelve executed in August 1952) and Kulbak (executed in 1937). Accordingly, it is with a mixture of scorn and pity that Howe and Greenberg present these translated lines of Itzik Feffer—onetime visitor to the United States as cochair of the JAC, good friend of Paul Robeson, and, it turned out, a Soviet informant responsible for many Jewish deaths:

> When I mention Stalin—I mean beauty,
> I mean eternal happiness,
> I mean nevermore to know,
> Nevermore to know of pain.[63]

Feffer's writing career emerged during the heyday of the Soviet Jewish avant-garde; he was part of a literary group bound by "enthusiasm for Yiddish, modernism, and the revolution."[64] As indicated here, his work subsequently veered from innovation; however, this did not prevent him from being among those executed on August 12, 1952. In Jewish American accounts of that day, his name was sometimes excluded, meaning we have arrived at a belated comeuppance for Slezkine's Jewish revolutionaries—murdered in Moscow and excised in New York. Likewise, prominent Soviet Jews who escaped persecution were denounced as traitors and lackeys in Jewish communities around the world.[65]

There is something undeniably potent about this take on Soviet Jewry, which could only lead to the conclusion that Moscow-centered internationalism was a sham. This conclusion was supported not only by Stalinist anti-Semitism but also by the reduction of a figure like Feffer to a much-maligned informant, one who had abandoned avant-garde poetry for Stalinist paeans.[66] Accordingly, just as some New York Intellectuals were embracing

American liberal pluralism over Soviet socialist internationalism, another prominent member, Lionel Trilling, was arguing for the need to disaggregate culture from politics. The lead essay of his 1950 volume *The Liberal Imagination* asserted that "the form of [a culture's] existence is struggle, or at least debate—it is nothing if not a dialectic. And in any culture there are likely to be certain artists who contain a large part of the dialectic within themselves, their meaning and power lying in their contradictions; they contain within themselves, it may be said, the very essence of the culture, and the sign of this is that they do not submit to serve the ends of any one ideological group or tendency."[67] Trilling here separates the essence of culture—what one might call authentic culture—from ideological tendency, though as others have observed, his vision of culture was itself ensconced in postwar American liberalism.[68] This tendency is revealed more overtly by the writings and activities of Sidney Hook. In 1958 he echoed Trilling by proclaiming, "Where genuine cultural and political democracy are absent, where there is no recognition of the right to be different and to develop authentic and autonomous forms of culture, 'ethnic democracy' is a hoax, really a contradiction in terms."[69] And yet Hook's invocation of "authentic and autonomous" culture was a bit disingenuous. His ties to the U.S. government are now well known, with the State Department and CIA secretly funding his Congress for Cultural Freedom—an organization he cofounded to counter Soviet propaganda via scholarly exchange.[70] Meanwhile, Washington seized on the opportunity to expose the "false claims" of "Communist nondiscrimination against racial minorities."[71] In 1954, the House of Representatives' Select Committee on Communist Aggression held public hearings on the "Treatment of Jews Under Communism." It concluded that the "totalitarian Communist regimes oppress all national and religious minorities because in their drive for totalitarian 'gleichschaltung' [the Nazi term for "bringing into line"] and world expansion they cannot tolerate any expression of independent spiritual and communal life."[72] The committee's chair hinted that he would press the United Nations for further investigations, leading us back to the start of this chapter: the exchange between the USSR and the United States about minority rights—the Doctors' Plot versus Jim Crow. Also in 1954, the USSR proposed a UN resolution against "the propaganda of racial and national exclusiveness" in Western countries, which an American official denounced as "brazen effrontery" in light of Soviet anti-Semitism.[73]

However, another essay by Trilling complicates his earlier assertion about a dialectical essence of culture that could thrive only amid liberalism. In a 1955 introduction to Isaac Babel's short stories, he identifies in the Soviet Jewish author—who was published by LEF, served as a onetime Cheka agent, and was shot in 1940 as an alleged Trotskyite and foreign spy—a dialectic at odds with that permitted by the "liberal imagination." Particularly in the *Red Cavalry* cycle of stories—based on Babel's own participation in the 1920 assault against Poland and including the previously quoted "Gedali"—Trilling finds a "forbidden dialectic" between violent brutality and formal precision, Jewish spirituality and socialist revolution, bookish Jew and Cossack soldier. For Trilling (here echoing Efros), this vision of Jewishness has everything to do with the liberation of perception brought by revolutionary violence. That is, it bears no relation to Hook's "democratic way of life," and yet for Trilling, this vision still has the power to disturb and transfix, years after Babel's own execution and the emergence of Soviet anti-Semitism. Although, as Trilling concludes, the USSR ultimately refused the forbidden dialectic, Babel presents a path not taken—a violent, messianic vision in line with the Soviet Jewish avant-garde of El Lissitzky and *The End of the World*.[74] Of course, such estranging visions—incongruous with the New York Intellectuals' "authentic" liberal pluralist Jew—came to be overshadowed by Cold War binaries. As we will see, however, traces of this avant-gardist "third way" could still be found through the 1950s and 1960s.

The Battle for Sholem Aleichem

A wonderful man, Irving Howe. He's done so much for Yiddish literature and for me. But he's not a youngster anymore, and still, still with this socialist *meshugas*!

—*I. B. Singer*

To recap, as World War II was coming to a close, Sartre wrote a class-based explanation of anti-Semitism. Several New York Intellectuals criticized this explanation, countering Sartre's socialist internationalist notion of Jewishness (stripped of history and culture) with a liberal pluralist notion of Jewishness (secular culture plus American democracy).[75]

Against the backdrop of the Cold War, Soviet anti-Semitism seemed to affirm this binary, allowing us to see the heightening struggle between the USSR and the United States as a struggle between socialist internationalism and liberal pluralism. However, having raised it up, we can now pick apart this divide, first by noting that Sartre was no Soviet spokesman, despite his pro-Soviet leanings. Consequently, the framework used to understand Soviet anti-Semitism—one forged in criticisms of Sartre—was somewhat off target. As noted, Soviet Jews suffered because they constituted one more "diaspora nationality" with strong non-Soviet ties—indeed, ties that had been promoted by Moscow through the JAC. Once these ties no longer served Soviet interests, they became potential sources of disloyalty. In short, the dark years from 1948 to 1953 had little to do with "authentic and autonomous culture" and everything to do with Stalinist paranoia.

Indeed, Stalin would have disagreed with Sartre on exactly the same grounds as Rosenberg and Hook. In 1948, the year before they published their responses, Stalin declared before a Finnish delegation that

> every nation, whether large or small, has its own specific qualities and its own peculiarities, which are unique to it and which other nations do not have. These peculiarities form a contribution that each nation makes to the common treasury of world culture, adding to it and enriching it. In this sense all nations, both small and large, are in the same position, and each nation is equal to any other nation.[76]

Though at first glance simply affirming his 1913 statement on the fixed nature of "national character," these words marked a sea change in Soviet nationalities policy—unknown to Jewish American intellectuals given their limited sources on the USSR. In effect, Stalin declared that national identities were primary, trumping any class or ideology; nationhood provided the basis for individual identity and access to "world culture." On the ground, what this meant was that anyone who denied their national identity—that is, anyone who embraced assimilation—immediately became suspect. Such people were condemned as "rootless cosmopolitans," "cosmopolitan" here implying foreign contamination leading to disloyalty.[77] Jews could readily be targeted as such since their status as a Soviet nationality was questionable, especially given their lack of a substantial

national territory.[78] In short, the campaign against "cosmopolitanism" can be seen as part of Stalin's own rejection of interwar socialist internationalism. Soviet anti-Semitism targeted Jews not only for their ethnic particularity but also for being so active in defunct, "cosmopolitan" bodies like the Comintern.[79]

This leads us to the provocative conclusion that Sidney Hook and Joseph Stalin rejected socialist internationalism simultaneously, and that the New York Intellectuals opposed "anticosmopolitanism" without grasping or even disagreeing with one of its bases—a belief in discrete, eternal cultures. Indeed, amid de-Stalinization in 1956, Soviet Jewish culture became acceptable again: once-purged Jewish writers began reappearing in journals, and state publishing houses issued hundreds of thousands of copies of Sholem Aleichem's translated short stories. With the 1959 centennial of Sholem Aleichem's birth, he was honored with a forty-kopeck postage stamp, a commemorative "collected works" series in six tomes, plus a volume of his works in Yiddish, the first Soviet Yiddish publication since 1948.[80] Arguably these were half-hearted gestures done just for show, but they nonetheless demonstrate that a few years after the New York Intellectuals set about reclaiming Jewish culture, the Soviet state did the same.

However, it would be a mistake to link too closely the New York Intellectuals' turn to Jewishness and Stalin's embrace of national peculiarity. In the United States and the Soviet Union, Jewish culture assumed very different molds: most notably, Jewishness in the Soviet Union maintained a primary emphasis on class, as evident in a critical study of Sholem Aleichem by I. A. Serebrianyi. Published during the 1959 centennial and dedicated to Serebrianyi's family members who perished during the war, the book's opening pages chide American Yiddishists for their "aestheticist" approaches to the writer. Serebrianyi cites, for example, this passage from Maurice Samuel's The World of Sholom Aleichem (1943): "When Sholom Aleichem becomes the satirist, as in his descriptions of new Kasrielevky, he invites us to look down on others, and he is the less Sholom Aleichem. When he is the humorist, and identifies us with his characters, he is himself, and incomparable."[81] According to Serebrianyi, American Yiddishists thus deny Sholem Aleichem's social satire—namely his send-ups of the wealthy enclave in the fictional village of Kasrilevke. Serebrianyi goes on to credit Soviet literary scholars for

"discovering" Sholem Aleichem as one of the most democratic and best Jewish folk [narodnykh] writer-realists, as a defender of the interests of the working masses, as a writer whose work reflected the material sides of the general social and political life of Russia at the end of the nineteenth and beginning of the twentieth century.[82]

This echoes the Sartrean approach to Jewishness, here combined with an emphasis on realism—the author's satire as a precursor to socialist realism. The Soviet Sholem Aleichem emerges as a critic of class inequality, in contrast to the American Sholem Aleichem, a mere humorist.[83]

Indeed, a few years later, this second Sholem Aleichem debuted on Broadway, his *Tevye the Milkman* stories adapted into the hit musical *Fiddler on the Roof* (1964). According to Seth Wolitz, *Fiddler* "Americanizes" Tevye, transforming him from a patriarch resistant to but swept along by modern life into a "progressive grandfather figure" who accepts his wayward daughters' "individual rights" and "freedom of association." Meanwhile, "the class conflicts, which riddled the *shtetl* and which Sholem Aleykhem considered destructive of Jewish communal interests, are sidestepped in the musical. *Fiddler* posits, in fact, Jewish adaptability as the key to Jewish continuity."[84] In short, we find here further affirmation of Hook's understanding of secular Jewishness—"identical with the democratic way of life" and bearing no relation either to class or to the occasional criticisms of American society in Sholem Aleichem's *Tevye*.[85]

However, not every New York Intellectual accepted this adaptable, marketable Jewishness, helping us to confound further the socialist internationalist–liberal pluralist divide. I specifically have in mind that previously "lost young intellectual," Irving Howe. Note, for instance, his scathing 1964 review of *Fiddler on the Roof*: "Sholem Aleichem is deprived of his voice, his pace, his humane cleverness and boxed into the formula of a post-*Oklahoma* musical." Tevye's Anatevka—a predominantly Russian village in the original stories—is transformed into "the cutest *shtetl* we've never had":

Irresistible bait for the nostalgia-smitten audience, this charming little *shtetl* is first shown in the style of Chagall—itself a softened and sweetened version, sharply different from Sholem Aleichem—and then prettified still

more. It all bursts with quaintness and local color, and the condescension that usually goes along.[86]

Likewise, though intended as "touches of realism," the musical's Jewish elements—Sabbath candles, wedding dances, Tevye's talks with God—strike Howe as "sentimentalism and exploitativeness."[87]

Here we find vestiges of the Sartrean socialist authentic, expressed as a protest against Jewish culture as mass culture. Howe himself put forth another Sholem Aleichem—a "third way" of sorts between Moscow and Broadway. In an essay titled "Sholom Aleichem: Voice of Our Past," Howe figures the writer, who died in 1916, as standing on the cusp of revolution, serving as a bridge between Jewish identity and leftist ideology:

> Sholom Aleichem came at a major turning point in the history of east European Jews: between the unquestioned dominance of religious belief and the appearance of modern ideologies, between the past of traditional Judaism and the future of Jewish politics, between a totally integrated culture and a culture that by a leap of history would soon plunge into the midst of modern division and chaos.[88]

This passage reveals Howe's enduring socialist outlook—the notion of history as evolving from the religious and traditional (precapitalist) to the secular and modern (capitalist and postcapitalist). By this understanding, history progresses through stages but is also capable of leaping and plunging into chaos. He goes on to suggest that Jews are particularly suited to resolve this crisis through their distinct view of history, one we have encountered both in this and previous chapters:

> Sholom Aleichem believed in Jews as they embodied the virtues of powerlessness and healing resources of poverty, as they stood firm against the outrage of history, indeed, against the very idea of history itself. Whoever is unable to conceive of such an outlook as at least an extreme possibility, whoever cannot imagine the power of a messianism turned away from the apocalyptic future and inward toward a living people, cannot understand Sholom Aleichem or the moment in Jewish experience from which he stems.[89]

Though not conscious of it, Howe in effect presents Sholem Aleichem as prefiguring the Soviet Jewish avant-garde—specifically, its iconoclastic visions of Jewish messianism sparking socialist revolution, itself understood in the Benjaminian sense as the messianic arrest of history. Howe here uses Sholem Aleichem to carry forward the ambitions of the interwar ethnic avant-garde, albeit stripped of its cross-ethnic promise.

If he presented Sholem Aleichem as a precursor to this avant-garde, Howe himself advanced this group's aims by similarly trying to balance Jewishness and revolution. Even as many of the New York Intellectuals turned from Marxism to neoconservativism, he founded the left-liberal journal *Dissent*, anthologized Trotsky, and wrote critical histories of the American left. At the same time, he became a leading translator-anthologist of Yiddish literature and poetry and went on to win a National Book Award for *World of Our Fathers*, a study of Jewish American immigrants from Eastern Europe. Of course, he was also a prominent critic of modernist literature in the mold of Trotsky.[90]

Nonetheless, this balance of ideology, identity, and modernism was a tenuous one, which became evident when Howe tried to apply it to African American literature—leading us yet again to the black-Jewish opposition that began this chapter. In a 1963 essay, "Black Boys and Native Sons," he criticizes James Baldwin and Ralph Ellison for their criticisms of the black protest novel and, more specifically, of Richard Wright. According to Howe, African American literature is inextricably bound to injustice and oppression—"the violence gripping Negro life."[91] As a result, any attempt to move beyond the naturalistic protest novel—to seek shelter in high modernist literature—is wishful thinking. In response to Ellison's desire "to see America with an awareness of its rich diversity and its almost magical fluidity and freedom," Howe exclaims, "As if one could *decide* one's deepest and most authentic response to society!"[92]

Howe here evokes once more Sartrean authenticity—blacks as defined by external oppression. Several have since noted that he was projecting Jewish American anxieties onto Ellison and Baldwin, and Howe himself would later comment that

I found myself cast, to my own surprise, in a Sartre-like position. I had written an essay on the fiction of Richard Wright, James Baldwin, and Ellison, stressing the dominance—indeed, the inescapability—of the "protest"

theme in their work. Ellison objected that I had locked the black writers into an airless box—what Sartre would call their "situation." Ellison claimed for the blacks, as Rosenberg had for the Jews, an autonomous culture that could not be fully apprehended through the lens of "protest."[93]

Thus, in the space of just fifteen years, history was repeating itself, setting in place a dreary hierarchy: whites (Frenchmen) were to Jews as Jews were to blacks, all under a socialist banner. Or maybe this was already the second, farcical repetition: in the Soviet Union from the mid-1930s, the Russian people had been named "first among equals" given their role in the "Great Proletarian Revolution."[94] After the war, those who failed to acknowledge this hierarchy—this inequality integral to the Soviet "friendship of peoples"—were tagged "cosmopolitans."

I would like to conclude by suggesting that, had Howe himself been attuned to the existence of the interwar, Soviet-centered ethnic avant-garde, he would have been able to provide less-condescending advice to Baldwin and Ellison. That is, he would have been aware of earlier efforts to combine ethnic particularism, political radicalism, and artistic experimentation, which would have allowed him to see Jewish and black literature as part of an interrelated creative and political undertaking. During the interwar years, this undertaking was foreclosed by Stalinist terror and socialist realism, leading to similar experiences of illusion and disillusion that reverberated both around the world and across ethnic lines. As such, these similar experiences— this shared sense of failure and loss—point to another potential source for thinking across the boundaries of race, ethnicity, and nation. They offer a basis, I think, for new iterations of an internationalist, cross-ethnic avant-garde.

To be sure, there are important distinctions to be made between Jewish American and African American encounters with the Soviet Union and the Soviet-centered left. For instance, Langston Hughes was largely cooperative before Joseph McCarthy, even as Howe berated intellectual "conformity" to Washington. Meanwhile, the New York Intellectuals (Howe included) were far more willing than their African American counterparts to favor Washington over Moscow as the Cold War intensified.[95] This makes perfect sense in light of Soviet anti-Semitism, as well as the fact that the USSR remained a loud, though opportunistic, champion of African American equality. In the decades after World War II, it continued to host such luminaries as Paul Robeson, W. E. B. Du Bois, Angela Davis, and James Baldwin. However,

the very mention of Robeson allows us to confound anew the distinctions between black and Jew, American and Soviet. Robeson, who, like Hughes, had "discovered Russia, the Soviet Union, and socialism through the Jewish and Yiddish left," made one of several visits to Moscow in 1949, during the height of the anticosmopolitan campaign.[96] There, alarmed by rumors and indications of Soviet anti-Semitism, he demanded to see his good friend Itzik Feffer, already in prison at the time. Soviet officials tried to conceal this fact by cleaning him up and having him visit Robeson's bugged hotel room, but through notes and gestures, Feffer made it clear that he

> was in serious trouble, and many of the most outstanding Jewish cultural figures had already been arrested. They would come for the rest of them soon. There was little hope for any of them, including Feffer (here Feffer drew his finger across his throat). And there had just been a massive purge of the Party in Leningrad—like the awful days of 1937. . . . When Feffer rose to leave, he and Paul embraced like brothers; both of them had tears in their eyes, because they knew that they were probably seeing each other for the last time.[97]

In a bold show of solidarity with Feffer, Robeson included revolutionary Yiddish songs in a Leningrad concert soon after. However, upon his return to the United States, he denied the existence of Soviet anti-Semitism, maintaining the party line over all other considerations.[98] In 1959, soon after the U.S. State Department returned his passport (revoked in 1950 because of his communist ties) Robeson was in Moscow again. Most certainly relieved that the worst of Soviet anti-Semitism was over (though it would never disappear completely), he arrived just in time for the Sholem Aleichem centennial, stating at one celebration, "The life-span of Sholem Aleichem paralleled that of my father, and the lives and experiences of their peoples were also very parallel."[99]

In the Cold War's wake, it is now possible to discern a further parallel, encompassing Feffer, Robeson, and all those around the world who once looked to Moscow for inspiration. What I am pointing to here is a grouping, a community drawn from many different places and backgrounds, connected through the failed Towers of Babel of the interwar years. Amid the ruins of their efforts to enact historical cessation, this becomes a people connected through a shared revolutionary pathos—a phrase that I expand upon in the afterword, so as to push the ethnic avant-garde beyond a now-defunct Soviet center.

Afterword

Chinese Communism, Cultural Revolution, and American Multiculturalism

The USSR's collapse in 1991 marked the official defeat of socialist internationalism: the "sure bastion" of "the friendship of peoples" (as the Soviet anthem had it) gave way to fifteen sovereign republics, though in fact several of these had not actively sought independence. Meanwhile, a similar breakup in Yugoslavia erupted in civil war, which for many American commentators confirmed state socialism's failure to overcome age-old ethnic divides. In turn, the persistence of these divides led many to conclude that the Cold War rivalry between capitalism and socialism would be replaced by a "clash of civilizations."[1] However, such efforts to articulate a post–Cold War order missed the fact that the Soviet Union collapsed along the very lines demarcated by Moscow's nationalities policy and that Stalin himself had insisted on the persistence of age-old ethnic divides. In this light, the 1991 breakup actually spelled the triumph of Soviet "multinationalness"; it confirmed the veracity of Lenin's promise of national self-determination.[2]

Nonetheless, the collapse buried once and for all the notion of a Soviet "frontier of hope" for minority and non-Western peoples. Instead, the ex-USSR emerged as a negative model, as a cautionary tale about the hazards of racial, ethnic, and national division. For example, 1991 found columnist William Raspberry observing, "We look with some mixture of sadness and superiority at the breakup of the Soviet Union and Yugoslavia into ethnic

enclaves and fail to see how fragmented a society we in the United States are becoming. . . . We are not yet as ethnically riven as, say, Yugoslavia. But don't ever imagine that it couldn't happen here."[3] In short, several seized upon the Soviet and Yugoslavian collapses to bolster national unity over what, by the 1990s, had come to be known as multiculturalism.

The successor to liberal pluralism, multiculturalism has been influentially defined by the philosopher Charles Taylor as the recognition of subaltern identities by the universal and the resulting vacillation between the politics of equal dignity (the right to be included in the universal) and the politics of difference (the right to maintain unique identities).[4] More concretely, though, multiculturalism is just the latest in a "sequence of terms describing how American society should respond to its diversity"—"multiculturalism" of the 1990s as the descendant of "intercultural education" of the 1950s, in turn the descendant of Horace Kallen's "cultural pluralism" of the 1910s.[5] Indeed, in a flurry of center-right debates surrounding the term in the 1990s, scholars turned to the founding documents of Kallen as well as of his contemporary Randolph Bourne, author of the 1916 article "Trans-National America." In accordance with the parameters laid out by Taylor, Kallen's call for an American "symphony of civilization" was used to legitimate ethnic diversity for its own sake, while Bourne's call for a "beloved community" was used to legitimate a blend of ethnic diversity and civic nationalism. However, both authors focused on white immigrants as opposed to racial minorities, throwing into question their applicability to the "culture wars" of the late twentieth century.[6]

Beyond these debates, multiculturalism has changed into something new. Just as 1950s liberal pluralism buttressed America's standing amid the Cold War, 1990s multiculturalism has done the same in a post–Cold War world. More specifically, multiculturalism has emerged as something of a victor's ideology. In the former Soviet Union and Eastern Europe, governments, NGOs, and scholars have used Western rhetoric of tolerance and recognition to fill the void left by "multinationalness" and socialist internationalism. As Will Kymlicka notes, this sometimes has had the counterintuitive effect of actually worsening the plight of minorities in these countries.[7] More broadly, multiculturalism has become, in Pierre Bourdieu and Loïc Wacquant's words, part of a "great new global vulgate" undergirding U.S.-led globalization.[8] This points to a leftist criticism of multicul-

turalism (rounding out the dated, rightist criticism touched upon in the preceding)—multiculturalism as, according to Slavoj Žižek, "the cultural logic of multinational capitalism." From this perspective, multiculturalism has demarcated a new global elite that asserts superiority by claiming to respect multiple cultures; the multiculturalist possesses a "privileged universal position" over the Other, who in turn is confined to a "self-enclosed 'authentic' community."[9]

As American historian Nikhil Pal Singh points out, Bourdieu and Wacquant provide only a limited view of multiculturalism, a criticism that applies to Žižek as well. By emphasizing the term's capitalist, imperialist underbelly, these writers overlook "the ways in which different U.S. racial projects and racial imageries continue to play to different audiences."[10] That is, while in some contexts multiculturalism does indeed serve global elites, in others it can still provide a language for combating inequality. Nonetheless, one aim of this book has been to find a way beyond the perceived limits of multiculturalism. In response to center-right concerns about racial and ethnic "Balkanization," *The Ethnic Avant-Garde* has refuted the notion that "identity politics" somehow obviate larger affiliations. The book has delineated an avant-garde grouping that cuts across racial, ethnic, and national boundaries—a grouping bound by political and formal commitments and, as the book has proceeded, a shared revolutionary pathos. However, this blurring of boundaries does not signal an attempt to move beyond or against race, ethnicity, and nationality. Rather, my goal has been to reinvigorate categories like "African American," "Asian American," and "Jewish American" by revealing the common forms, politics, and tragedies that helped to constitute each. Connecting these groups via Moscow points to a new model for the comparative study of minority cultures, one that gets around the various binaries that have thus far dominated the field—for example, white-black, Afro-Jewish, Afro-Asian.

The notion that multiculturalism might replicate or bolster global capitalism is a particular concern for scholars pursuing the transnational and diasporic dimensions of race and ethnicity. The worry is that such research might also replicate or bolster the new, ever more inequitable world order that has emerged since the "end of history," that is, since the collapse of state socialism. In response, I have grounded my notion of ethnic avant-gardism on the anticapitalist alternatives once offered by the Comintern and socialist internationalism. Of course, in light of the abject failures of

these alternatives, members of the interwar, Soviet-centered ethnic avant-garde might seem joined, more than anything else, by poor decisions—motivated by unrealistic expectations about the merging of art and life and the erecting of new Towers of Babel. The only way to counter this conclusion is to prove that, in fact, the ethnic avant-garde survived its apparent demise. The preceding two chapters have argued precisely this through the postwar writings of Langston Hughes and Irving Howe.

The following reinforces both the endurance and mutability of this grouping by picking up where chapter 2 left off—the performance of *Roar China* in Shanghai, 1949. This signaled the emergence of Beijing as a new center of world revolution, raising the possibility that Red China would inspire further iterations of the ethnic avant-garde. Indeed, in the 1960s and 1970s, the next generation of American leftist minorities turned their attention to Chinese communism and Mao Tse-Tung's Cultural Revolution—his mobilization of students and workers against the party state with the aim of consolidating power and countering Soviet-style bureaucratism. These Americans were looking for a notion of world revolution attentive to peoples of color, the liberation of women, and the cause of decolonization—more attentive than the Soviet Union and its long-defunct Comintern. However, it remains unclear what to make of Mao's imprint on American race and ethnicity, whether those drawn to China in the 1960s and 1970s were not simply mimicking those once drawn to the USSR. Ultimately, in turning from a Moscow-centered to Beijing-centered ethnic avant-garde, it is difficult not to discern a now familiar arc from illusion to disillusion, an arc that would have us believe that revolution and avant-gardism are somehow preprogrammed to fail.

My goal here is to challenge this schematic view of history through a reading of the novel *I Hotel*, by Karen Tei Yamashita. The product of over a decade of research and a 2010 National Book Award finalist, *I Hotel* recovers the radical legacy of Asian American culture and activism, using as its base the old International Hotel in San Francisco's Manilatown. It is stunningly broad in scope, crossing the limits of race, class, gender, and geopolitics: the novel focuses on the Asian American movement from 1968 to 1977 but relates its emergence to black, Latino, and Native American activism. It centers on the San Francisco Bay Area but draws connections to the broader Third World movement, with sections set in China, the Philippines, and the Soviet Union. *I Hotel* also tests the boundaries of the novel form, in-

corporating documentary film transcripts, an R. Crumb–style comic, jazz performance, short stories, and philosophical analects.

My argument is that Yamashita's ambitious novel on revolutionary memory resuscitates the ethnic avant-garde, adding to it a host of formal innovations as well as heightened emphases on local resistance and gender equality. This afterword has two parts. The first provides an overview of the turn from Moscow to Beijing and Maoism's appeal to American minorities. I should emphasize that I do not address Maoism per se but its impact beyond Asia. The second part then turns to *I Hotel*, focusing on its pervasive revolutionary pathos—its sense of defeat and collapse as well as its tendency to connect political struggle with personal suffering. From this perspective, the novel reinforces the notion of an inevitable arc from illusion to disillusion. However, the novel also presents a way around this scheme through its innovative experiments with time: in accord with the interwar, Soviet-centered ethnic avant-garde, it disrupts linear understandings of history; it enables us to unseat the notion that state socialism's collapse brought history to an end.[11]

From Moscow to Beijing

To be sure, Maoism is just one aspect of this sprawling novel, which is more about the Bay Area than Red China, and a multiplicity of interests rather than a single ideology. Indeed, *I Hotel* and its characters quote not just Mao but also Fidel Castro, Angela Davis, Nelson Mandela, and many others. However, in the 1960s and 1970s, Beijing—unlike, say, Havana or Hanoi—actively promoted itself as a new center of world revolution, bolstering Maoism as, in Fredric Jameson's words, the "richest of all the great new ideologies." By several accounts, "Mao Tse-Tung Thought" became synonymous with "global revolutionary praxis," largely because the Little Red Book "read more or less like a handbook for guerrillas."[12] On a more theoretical level, though, Maoism expanded Marxist discourse through its criticism of "mechanical materialism" (with base determining superstructure) and its focus instead on local contexts and "the conscious transformation of everyday life."[13] According to Jameson, this emphasis on personal life over class or party affiliation—on being "revolutionary" over "proletarian"— opened the way for a "whole new political space" articulated by the slogan

"The Personal Is the Political." (Jameson links this slogan to the women's movement, and, accordingly, several Western visitors to China did report finding gender equality there.)[14] The seeds for this turn could already be seen in Mao's pre-1949 writings, for example, his seminal essay "On Contradiction," which forwarded a notion of contradiction present in all things and phenomena. According to this piece, the task of revolutionaries was to delineate between "principal" and "nonprincipal" contradictions, something that varied from context to context. What's more, in a given context, "superstructure (politics, culture, etc.)" could be seen as "principal and decisive"—an assertion that completely upended the classical Marxist focus on modes of production.[15] This was a flexible Marxism attendant to local, indeed individual conditions rather than Soviet directives; a Marxism that gained widespread appeal, with "On Contradiction" arguably inspiring Louis Althusser's 1962 essay "Contradiction and Overdetermination."[16] Expanding on early Bolshevik efforts to finesse historical stagism, Mao's writings were well suited to non-Western societies stymied by imperialism and tradition, societies lacking a proletarian vanguard.[17]

This helps us to understand Maoism's draw for peoples of color around the world, including American minorities—the topic of a growing body of scholarship, buoyed by interest in "Third Worldism" and the "Afro-Asian" analogy. In their seminal article "Black Like Mao," Robin Kelley and Betsy Esch contend that "China offered black radicals a 'colored,' or Third World, Marxist model that enabled them to challenge a white and Western vision of class struggle." Mao, along with other postcolonial thinkers like Fanon and Guevara, offered a means of connecting African American struggles to decolonization worldwide. The Black Panthers—who famously raised funds for weapons by selling the Little Red Book in Berkeley and who visited China in 1971—presented only the most visible example of this.[18] Kelley and Esch also note how the Cultural Revolution's emphasis on eliminating vestiges of the old contributed to the emergence of the Black Arts Movement of the 1960s and 1970s, which sought to purge "black culture of a 'slave mentality'" and create instead a new revolutionary art. Bill Mullen elaborates upon this connection, specifically the influence on the movement of Mao's 1942 "Talks at the Yenan Forum"—his call for "the unity of revolutionary political content and the highest possible perfection of artistic form." The "Yenan spirit" reverberated through Black Arts conferences, for instance, in participants' calls for an "art and literature

that can awaken and arouse the masses to unite and struggle to change their environment."[19]

Interestingly, Asian American radicals at the time—mostly U.S.-born Chinese and Japanese—absorbed Maoism largely through the cross-racial, revolutionary milieu of places like the Bay Area rather than through some direct connection to Asia. For instance, the so-called Red Guards of San Francisco's Chinatown were modeled more on the Black Panthers than on Mao's Red Guards; the very name "Red Guards" was suggested by the Panthers. Though there were Asian Americans independently sympathetic to Mao, in the 1950s these groups and individuals had been besieged by McCarthyism as well as by fear of being perceived as communist and therefore "un-American." The result was an entrenched anti-communism in the Chinatowns of New York and San Francisco.[20]

Movements like the Red Guards sought to reignite radicalism among Asian Americans and were bolstered by the "prestige and weight of socialist China and Mao."[21] However, the connections between Asian America in particular and Red China have still received limited scholarly attention, and perhaps for good reason. Ultimately, Maoism's imprint on Western discourses of difference is haunted not just by the Cultural Revolution's ghosts and China's adoption of capitalism but also by mutual misrecognition. As Lisa Lowe points out, the many French thinkers and artists drawn to China in the 1960s and 1970s practiced "postcolonial orientalism": they projected their progressive fantasies onto what they saw as a premodern, pre-Oedipal space—China as a matriarchal utopia that escaped signification and "occidental systems of meaning."[22] Lowe levels this charge specifically at Roland Barthes, Julia Kristeva and the *Tel quel* group. It can also be applied to at least some of the various American minority activists who toured China during the Cultural Revolution, those who sought "out of the East again" world salvation and the "triumph of the human spirit."[23] Despite such hopes and its own rhetoric, Beijing actually had limited interest in fostering revolutionary movements around the world: Mao regarded as "bourgeois" self-proclaimed European and American Maoists, while Western visitors had only a limited grasp of China and its various factions.[24]

This is all to emphasize the difficulty of making sense of Maoism's place vis-à-vis minority cultures, particularly among those well attuned to the hazards of Orientalism—for example, Asian Americans. In turn, this difficulty helps to explain the absence of and ambivalence toward Red China

in the most prominent works of Asian American literature from the 1970s. That is, even as Maoism left a conspicuous (if indirect) imprint on that decade's activism, pioneering literary figures like Frank Chin and Maxine Hong Kingston cast contemporary China in an understated light. For instance, the seminal 1974 anthology *Aiiieeeee!* drew a firm line between Chinese America and political events in China:

> The overview of the Manchus, the Sino-Japanese War, World War II, the success of the Communist Revolution, and the Cultural Revolution are five major events resulting in a China the Chinese of a hundred years ago, the ancestors of fourth-, fifth-, and sixth-generation Chinese-Americans, never saw and wouldn't understand.[25]

Here the editors of the volume establish a safe distance from China—Chinese Americans as completely removed from modern Chinese history.

Accordingly, in her 1980 novel *China Men*, Maxine Hong Kingston's narrator notes the gaping hole between her family in California and her relatives in China. While her parents, worrying about internment or deportation, fear any association between Chinese people and communism, China itself emerges as a shadowy place that does indeed escape signification—"a country I made up" (87), pieced together through relatives' pleas for money and their accounts of famine, killing, and torture.[26] Amid the Cultural Revolution's turmoil, these relatives are themselves unable to grasp what is happening:

> The Communists were not simply after property; they wanted the people to say certain things. They had to sing ugly Communist songs. "Stoop and scoop, stoop and scoop," they sang, and genuflected, swooping their red scarves from air to ground. The aunts waved the kerchiefs vigorously; they memorized fast and sang loud, but still they had to kneel on ground glass, and their thumbs were broken.... [The Communists] held court trials, which they thought were the same as entertainment and theater.... Communist schools, Communist books, Red art work, Red courts, theaters, customs were almost like real ones but off. (275–76)

Amid this macabre juxtaposition of dance and torture, Kingston captures one of Maoism's central goals, not simply the "vulgar economism" of prop-

erty redistribution but also the transformation of personal, everyday life. However, the culture that results from the merging of art and politics is "off" and blood-stained—Maoism and its aesthetic as things to be disclaimed and forgotten, independently of pressure by the U.S. state.[27]

Kingston's anticommunist account affirms dominant notions of Maoism and the Cultural Revolution as "madness"—perhaps analogous to Stalinist terror. And while it is possible to dispute this notion, it would be impossible to simply embrace Mao's influence among progressive activists and thinkers from the 1960s and 1970s. The interwar ethnic avant-garde has shown us that in order to study the radical, transnational roots of American race and ethnicity, we must confront head-on both the promise and failure of twentieth-century communism—both its "horror" and "glory" in novelist Richard Wright's words.[28] And this is precisely what we find in Yamashita's *I Hotel*.

I Hotel

Returning briefly to Kingston, we can say that, in *China Men*, Red China bears some relation to Freudian melancholia, that is, the failure to mourn a loss, resulting in the internalization of the lost person, object, place, or time. A mother dying of famine, presumably during Mao's Great Leap Forward, sends letters to her son in America, but he ignores her desperate pleas for him to return. After she dies, her ghost comes to haunt him, and his talking, yelling, and sobbing to the air earns him the name Mad Sao. His insanity passes only after he visits her grave in China, despite fears that "the FBI would use our interest in China to prove our un-Americanness and deport all of us" (178). As a result of this trip, a debilitating case of melancholia successfully gives way to healthy, functional mourning, which allows this uncle to resume his life in the United States. The same cannot be said for another of the narrator's uncles, Uncle Bun, who has a more troubling but also more interesting trajectory. He too seems to suffer from melancholia, but in this case born not from a deceased relative but from a lingering "unhappiness and strife" in the face of what he calls white demons:

> He told again about some fight he had had with the boss at one of his
> past jobs, his face red and his spit spraying. "How dare he treat me like

that? I'm a man and he's a man. In a fair system, the worker would be the more valuable man, and the supervisor serve him and make his job easier." (192)

In short, Bun is unable to let go of past hurts prompted by his white supervisor; his wounded masculinity suggests that he has suffered what David Eng has termed racial castration. More broadly, though, Uncle Bun seems to present an instance (one of many in Kingston's novels) of what Anne Cheng has termed racial melancholia. This refers to the "exclusion-yet-retention," the love yet resentment enacted by the U.S. racial regime, as well as to the raced subject's psychological responses to this ambivalence—in the case of Uncle Bun, an understandable grief and resentment, followed by a strange insistence on eating only wheat germ, followed by a fanatical embrace of communism.[29] However, this leads only to new psychoses: he justifies the torture of his relatives amid the Cultural Revolution, worries about being poisoned for his politics, then smuggles himself into Red China, never to be heard from again.

In short, for one uncle, melancholia gives way to mourning and a resumption of life in the United States. For Uncle Bun, however, a more specific, historically rooted melancholia—racial melancholia—gives way not to mourning but to revolutionary politics. Interestingly, this turn takes on a therapeutic quality when Kingston notes that Uncle Bun suddenly becomes more stable once he decides to return to China. However, his silence after departing—his apparent inability to communicate with his relatives in the United States—makes it difficult not to imagine the worst for him. The turn from melancholia to communism thus gives way to renewed loss, one emerging not from U.S. racial abjection but from a broader history of revolution and its attendant, haunting silences. What I am suggesting here is that Uncle Bun replaces racial melancholia with what I have been calling revolutionary pathos. "Melancholia" here refers to the intricate, often isolating process of internalizing loss. "Pathos," on the other hand, refers more simply to passion or suffering that evokes sympathy. This particular brand of pathos is born from the perceived excesses and failures of twentieth-century communism—a feeling that connects such former hotbeds of revolution as Moscow, Beijing, and San Francisco's International Hotel.[30]

This brings us to Yamashita's *I Hotel*, which picks up where Kingston leaves off—namely, by following others who are drawn to Chinese com-

munism, that is, by engaging a place and politics figured only obliquely in *China Men*. Interestingly, just as Uncle Bun suddenly becomes more stable once he decides to enter China, Yamashita's characters find an alternative to racial melancholia through the raucous Bay Area of the 1960s and 1970s. However, this alternative opens a whole host of disappointments, and the novel as a whole can be seen as an attempt to come to terms with the revolutionary, indeed Maoist undercurrents of the Asian American movement at its formation—undercurrents that, until recently, were long obscured in Asian American culture and scholarship.[31]

Again, Maoism is only one of many ideologies circulating through the novel, but it does seem to leave a longer shadow than the others.[32] In an early chapter, against the backdrop of the historic 1968 demonstrations for the establishment of ethnic studies at San Francisco State College, Yamashita presents a fictional literature professor, Wen-guang Chen, leading an off-campus class on Mao's "Talks at the Yenan Forum." A visiting scholar at the Sorbonne, the widower of an Austrian baroness, and friends with James Baldwin, Chen is the quintessential global modernist and, as such, a believer in both high art and "liberation by means of the pen." He teaches Mao's call for a cultural front alongside a military front, as well as for writers and artists to know "the language of the people." And yet at the same time, Chen recognizes that

> any war of words will ultimately be resolved in society's decision to define those words. Art and literature. Mao Tse-Tung and the Cultural Revolution defined those words in the service of a political agenda. Poetry for the Marxist-Leninist must be written for the proletariat. Everything that Chen loved about art and literature had to be destroyed or changed. He knew this, but he didn't tell his students.[33]

Chen here detects a fatal flaw in the intersection of modernist literature and revolutionary politics, with the latter dominating the former, the political vanguard crushing the artistic avant-garde. Indeed, during a 1972 visit to China with a group of Chinese American writers, he finds that an old teacher, once considered progressive, has been tortured and humiliated by Mao's Red Guards. The teacher has been displaced by writers who better represent the "spirit and the realization of the Yenan Forum in 1942, where Chairman Mao declares that there is no such thing as art for art's

sake—that all literature and art are for the masses of the people, for the workers, peasants, and soldiers" (71). In short, in contrast to most other Western visitors to China, this Chinese American delegation is able to discern the shortcomings of revolution. Accordingly, while passing through a model village, a group of "sister-comrades" from the delegation is surprised to learn that their Chinese counterparts still conduct household duties alone. "It is reactionary to think that women must be superwomen and do everything," says one of the visiting women (69)—in response to which their hosts, offended at being branded reactionaries, suddenly get up and leave. Another Chinese American woman almost incites a riot by photographing a street vendor. A local yells at her, "Why are you taking a picture? Did you ask for permission? Do you think we are monkeys, so you can steal our picture?"—a refusal of the outsider's utopianist gaze (76).

Though likely just by chance, this volatile street encounter evokes Sergei Tret'iakov's *Roar China*—its concluding riot sparked by a Western journalist photographing the executed boatmen. This unexpected echo of the Soviet-centered ethnic avant-garde conveys critical awareness about the limits of different media and, in doing so, enables us to connect the interwar and postwar periods, Tret'iakov's play and Yamashita's novel. We find more such echoes in *I Hotel*'s overriding pathos, the sense of revolution as alluring but destructive, as bearing the seeds of its own dissolution. The novel as a whole relates the rise and apparent fall of Asian American radicalism, culminating in the 1977 police seizure of the International Hotel—a low-income residence for mostly Chinese and Filipino elderly bachelors and a longtime hub of political mobilization.[34] To reinforce this defeat, one of the final chapters focuses on the young radicals at the novel's heart—all "avid readers and interpreters" of Lenin and Mao (599–600) who are schooled on the latter's insistence on the correct theoretical line and thus prone to the bitter factionalism that characterized the New Communist Movement.[35] As they try to organize a protest after the I-Hotel evictions, the various youth organizations (each with its own acronym) instead turn on one another:

> An alphabet soup of punching youth, kicking and pushing, beating out the long years, months, and days of our frustrations, strangling the deep disappointments of our failure, finally spilling the blood we could not in nonviolent civil disobedience. The police across the street who now

guarded our four doors pointed at our stupid battle and laughed. But we continued to fight, our humiliation pounding away, erasing our young years, our awakening minds, our innocent smiles. (601)

Note the tone here—retrospective, elegiac, like the parting words of a classic bildungsroman. This account of leftist impotence comes presumably from the perspective of the postradical present, recounting lost innocence and affirming past hubris. As such, it presents a eulogy of sorts for this confused revolutionary history, a sense of disillusion underscored by recent reports that Richard Aoki, the most prominent Asian American Black Panther, was likely an FBI informant.[36]

To reinforce this elegiac tone, Yamashita intertwines failed radical politics and fraught personal lives, in line with the movement's previously noted emphasis on transforming everyday life, the personal as political. Chen enters a romance with his student Paul, but this soon falls apart: Chen regards as parochial Paul's English-only compilation of Asian American literature (a clear reference to *Aiiieeeee!*); Paul learns that his mother was briefly married to Chen. In short, complicated lives mirror complicated politics. A more striking example of this is the relationship between Ben and Olivia, two young radicals who meet amid protests and Marxist study groups. Yamashita intersperses accounts of their budding romance with quotes from *The Communist Manifesto* and Lenin's *What Is to Be Done?*—the suggestion being that this romance is itself being enfolded into Marxist-Leninism, that Marxist-Leninism is being expanded to account for individual lives, à la Mao. (Accordingly, the novella on Ben and Olivia begins with a poem by Mao: "We were young, / sharp as flower wind, ripe, / candid with a scholar's bright blade / and unafraid. / We pointed our finger at China" [295].) The two consummate their relationship in 1968 while driving home from Montreal's Hemispheric Conference to End the Vietnam War, have a revolutionary wedding in the I-Hotel ("*By the power invested in the people, we pronounce you, Bienvenido San Pablo and Olivia Wang, partners in life. All power to the people!*" [350]), and name their son Malcolm. However, as their activism begins to devolve into infighting and drug abuse, Olivia abruptly dies of ovarian cancer, and the novella devoted to them ("1972: Inter-national Hotel") ends with Ben weeping into her hair.

Arguably, Yamashita here draws from a hackneyed Hollywood convention—"staging great historical events as the background to the formation

of a couple."[37] More specifically, the novel's pairing of romance and politics renders failed radicalism legible to broad audiences: joining a revolutionary cause is likened to starting a doomed relationship. From this perspective, I Hotel serves to sublimate revolutionary pathos into something more familiar and conventional, namely, mourning for lost love. The novel enables this now-grayed generation to accept and bury its radical past. But I Hotel is more interesting than this: it is no mere eulogy but points to a more flexible perspective on revolution. I refer to Yamashita's experiments with time and space, the novel's organization into ten separate novellas, or "hotels." Each begins with a diagram of a flattened box, its component surfaces listing a place, character, or event. The novellas' titles consist of a year followed by a variation of "International Hotel," for example, "Aiiieeeee! Hotel." Thus, on the ruins of the ultimately demolished International Hotel, Yamashita erects ten imagined hotels, which at first glance are organized chronologically: the first novella is titled 1968, and the last 1977—again, the year of the building's seizure. As Yamashita explains in her afterword, "Multiple novellas allowed me to tell parallel stories, to experiment with various resonant narrative voices, and to honor the complex architecture of a time, a movement, a hotel, and its people" (610).

What I would like to suggest is that Yamashita's architectural experiment is similar in spirit to Vladimir Tatlin's Monument to the Third International. Both seek to join multiple peoples and languages; both blend formal innovation and radical politics; and both challenge fixed understandings of time and history. Though proceeding in historical sequence, Yamashita's novellas are by no means discrete: most span multiple years, and characters from each reemerge in others. For instance, in the second novella ("1969: I Spy Hotel"), Yamashita presents a documentary film transcript with a scene from a 1975 antieviction protest in San Francisco's Japantown. A disabled protester, Harry Hama, is left behind by the police, despite his demand to be arrested:

HARRY HAMA: Hey! Hey! (Sound of commotion and chanting fading into quiet. No one answers. Harry Hama finally shrugs in frustration and wheels himself out.) (160)

This scene appears again in the eighth novella ("1975: Internationale Hotel"), but this time from Hama's perspective, in more traditional narrative

form: "Harry yells out the door from the office, 'The people united will never be defeated,' but the protest and struggle fade down the hallway. 'Hey!' he yells. 'Hey!' No one returns to make his arrest" (525).

The first impression left by this episode is again that sense of revolutionary pathos: the protest comes to an end, and while his fellow activists are dragged away, Hama is abandoned, barred from the climax by his disability. However, more interesting than this episode's defeat is the very fact of its recurrence: a protest from novella 2 can resume in novella 8. The former's documentary film leads to a dead end of sorts—from Hama's abandonment, it concludes with dissension among the protesters, anticipating the movement's collapse. In contrast, novella 8 proceeds with Hama participating in separate protests for disability rights and, several years later, taking pride in finally getting arrested. In short, his radicalism continues unabated, despite considerable personal tragedy and the abrupt conclusion of this scene's first iteration.

What this points to is a fragmented, nonlinear way of thinking about the 1960s and 1970s, one that belies any simple trajectory from illusion to disillusion, from 1968 to 1977. Yamashita clarifies this somewhat in the novella on Ben and Olivia, the first chapter encompassing their marriage and anticipating her death. At the chapter's outset, we hear from what seems to be a muse or patron saint of revolution, or perhaps Walter Benjamin's Angel of History:

> 1.1 She said: I am the indelible voice, returned to pay tribute to the lives of young revolutionaries. Who are these young men and women who sacrifice their youth for a new idea of the future? New idea of the future? In ten thousand years, what futures have blossomed and withered again and again, with generation after generation, each as hopeful as the former, each a whisper in time. I, too, was once so young. (296)

In one of *I Hotel*'s earlier novellas, this strange, "Orientalized" voice is said to belong to the empress dowager, imperial China's penultimate ruler, "called upon in modern times to weave a brocaded wisdom" (36). This vestige of premodernity works well with Benjamin's angel: the voice is directed not to the future but to the past, specifically to the countless lives sacrificed for some idea of the future—history as an endlessly piling ruin. Such visions of the past inform Benjamin's effort to separate revolution

from progress, to redefine revolution as historical arrest. In contrast, Yamashita's empress seems somewhat less ambitious, seeking a certain narrative flexibility. As Olivia lies dying, she closes the first chapter:

> 11.1 I have anticipated the end of the story without first imparting the beginning. Knowing the story's end does not necessarily imply completion or knowledge, for if many endings are possible, so also are many beginnings. History may proceed sequentially or, as they say, must proceed sequentially, but stories may turn and turn again—the knowing end kissing the innocent beginning, the innocent end kissing the knowing beginning. (301)

The turning and turning of stories here confounds historical progression, indeed the very notion of beginnings and endings. And this is crucial, for we know from the outset how this history ends: Olivia will die, the I-Hotel will be demolished, China will embrace capitalism, state socialism will collapse. However, this blurring of time does not simply affirm fiction's liberties relative to historiography. Rather, the challenge posed here is to rework temporality itself; as Christopher Connery puts it in his reperiodization of the 1960s, to approach "a temporality not structured by success and failure—though these kinds of judgments are necessary and productive—but perhaps with more humility about the historical process and the place of our present within it."[38] From the long perspective of Yamashita's empress or Benjamin's angel, the end of 1960s and 1970s radicalism, indeed the "end of history" need not be seen as final.

All this is to highlight *I Hotel*'s flexibility toward time and history, which countervails the novel's overriding pathos—its sense of defeat in revolution's wake. To be sure, this pathos is crucial, for it derails simple (and all too common) nostalgia for the Bay Area of that era. One risk of such a sprawling, comprehensive novel is that readers might find themselves trapped in the ten hotels and the ten-year span from 1968 to 1977. But Yamashita refuses this by foregrounding both illusion and disillusion, as captured in the novel's final words: "Sweet. Sour. Salty. Bitter."—a range of sensations existing side by side. One does not simply give way to another. This suggests an alternative mapping and periodization of 1960s and 1970s radicalism as a whole, underscoring the fact that *I Hotel* is not solely about the Asian American movement, nor, for that matter, about the Bay Area

left's multiple, interconnected struggles, which the novel scrupulously catalogues. There is something far more ambitious at work here: an attempt to revisit twentieth-century revolution as a whole—revolution as a singular phenomenon cutting across time and space.

We find a hint of this in that string of sensations meant to summarize the China-oriented, 1970s left, which evoke an earlier period—namely, the "horror" and "glory" perceived by Wright in 1930s Chicago. Both periods, it seems, gave rise to similarly contrasting, even contradictory sensations, pointing to a broader, shared history. This is seen more explicitly in the novel's emphasis on relationships across generations. There is the love affair between Chen (interwar global modernism) and Paul (the 1970s ethnic literary scene)—again, a fraught relationship, though by the end of the first novella, they seem to be back together. The Hama family provides a more politicized example, a bridging of Old Left and New Left. Harry's mother, Estelle, is a Russian émigré painter who marries a Japanese American Bolshevik, loosely based on the communist union organizer Karl Yoneda. They name Harry's brother Sen—after Sen Katayama, the Comintern luminary buried in the Kremlin wall; Harry, in turn, is named after Harry Bridges, founder of the International Longshore and Warehouse Union and fixture of the California left from the 1930s to the 1970s. While she and her sons have many disagreements—about her willed ignorance of Stalinist terror and her predilection for socialist realist art—they share a commitment to social justice and activism. Indeed, Sen and Harry stage an exhibit of her paintings from the Japanese internment camp where she and Sen spent World War II. Yamashita here transforms Asian American literature's (and Yuri Slezkine's) widely documented focus on intergenerational strife—immigrant parents versus assimilated children—into constellations between Old and New Lefts, interwar and postwar cultures. The result is a broader periodization, a focus not only on the 1960s and 1970s but on the 1930s as well. Estelle spots images of herself and her husband in San Francisco's famous Coit Tower murals, painted in 1933 and depicting "powerful working people" in the style of Diego Rivera (495). Meanwhile the novel connects the Bay Area to revolutionary circuits that cross the globe, from Cuba to Vietnam to Beijing to Moscow.

What is to be done with this expanded understanding of 1960s and 1970s radicalism, one that cuts across the notorious internecine feuds of the time? Slavoj Žižek offers one response: to imagine all revolutions—

France 1789, Moscow 1917, Beijing 1966—as part of an ongoing struggle for "the eternal Idea of egalitarian justice." From this perspective, as he writes in his discussion of Mao, "the ultimate factual result of the Cultural Revolution, its catastrophic failure and reversal into the recent capitalist transformation, does not exhaust the real of the Cultural Revolution: the eternal Idea of the Cultural Revolution survives its defeat in socio-historical reality, it continues to lead an underground spectral life of the ghosts of failed utopias which haunt the future generations, patiently awaiting their next resurrection."[39] In other words, by connecting 1960s and 1970s radicalism to this larger revolutionary trajectory, it becomes possible to see beyond defeats (for instance, the I-Hotel's demolition) and to anticipate new revolutions to come.

Against Žižek's implicit endorsement of future violence and terror, Yamashita offers a more measured response: a pathos that leads not to despair or defeatism but to an ability to connect different revolutionary moments and contexts—San Francisco, Beijing, Moscow—in an open-ended, nonlinear manner. This, in turn, points not to a revival of revolution per se but to something more modest: new ways of seeing across race, ethnicity, and nationality; new communities based on shared encounters with the vanguards and avant-gardes of the last century. *I Hotel* provides us with an expanded, reconstituted ethnic avant-garde, one advancing beyond the "end of history" by resisting nostalgia and cynicism alike.

Acknowledgments

A s noted in the introduction, in 1937 Joseph Stalin deported approximately 180,000 Koreans from the Russian Far East to Central Asia. This book began as an attempt to study this community, more specifically, to compare Korean American literature and its Soviet Korean counterpart—minority Korean writing with Russian soul. It was only near the end of my first stay in Kazakhstan and Uzbekistan that I learned about the long history of Americans drawn to Soviet national minorities. A friend informed me that Langston Hughes had frequented the bazaar just behind my apartment during his 1932 visit to Tashkent, and from there, the project began to grow broader in scope—from Soviet Koreans to Soviet "multinationalness" to the Soviet avant-garde. Every step of the way, the challenge has been to balance (to quote Richard Wright again) both the "horror" and the "glory" of twentieth-century communism—to draw hope from what might, at first glance, seem only a tragedy.

The most rewarding aspect of writing this book has been the far-flung friendships it has fostered. Barry O'Connell and Dale Peterson have served as steadfast mentors long since my time at Amherst College. In Central Asia, Aleksandr Kan, Valerii Khan, and German Kim continue to shatter my perceptions of Koreanness—as does my fellow Korean Virginian Y. David Chung, ever since we first met in Almaty. Nina Bagdasarova, Alexander

Diener, and Ryan Podolsky enabled me to test several of the book's ideas during wonderful stints in Kyrgyzstan.

As a graduate student in Stanford's Modern Thought and Literature program, I benefited tremendously from the advising of Shelley Fisher Fishkin, Gregory Freidin, and David Palumbo-Liu, while Gordon H. Chang, Maria Gough, and Arnold Rampersad provided additional invaluable feedback. I am also indebted to my fellow fellows at the Stanford Humanities Center, particularly Jeremy Braddock, James Clifford, Chris Rovee, Ema Vyroubalova, and prior fellow Steven Yao, for providing so much guidance and perspective. Thanks as well to Joon Nak Choi, Ebony Coletu, Dustin Condren, Irina Erman, Amelia Glaser, Kevin Kim, Peter Kim, Tomas Matza, Beth Piatote, Tom Roberts, Aaron Shaw, Nirvana Tanoukhi, and Brian Thompson for all the meals, conversations, and adventures.

The Department of English at the University of California, Berkeley, has been an ideal setting for revising and completing the book. I would like to thank in particular Stephen Best, Dan Blanton, Cecil Giscombe, Mark Goble, Marcial Gonzalez, Lyn Hejinian, Abdul JanMohamed, Donna Jones, Jeffrey Knapp, Kent Puckett, Scott Saul, Sue Schweik, Katie Snyder, Bryan Wagner, and especially Colleen Lye for generously taking the time to read my work and making it stronger in countless ways. All the while, the department's Junior Faculty Reading Group has been a continual source of insight and support. Thanks to Todd Carmody, Kathleen Donegan, Nadia Ellis, Eric Falci, Keith Feldman, Catherine Flynn, David Landreth, David Marno, Namwali Serpell, and Emily Thornbury for seeing me through multiple rewrites. I am also grateful to my colleagues from Berkeley's Slavic department, particularly Olga Matich, Anna Muza, Irina Paperno, and Harsha Ram, for inviting me to bridge the gap between Wheeler and Dwinelle, and for making possible the book's final framework.

One of the great privileges of being at Berkeley has been the opportunity to work with such brilliant and open-minded students. I am especially indebted to those from a spring 2013 graduate seminar on "Ethnic Avant-Gardes" for convincing me that such a concept might indeed provide a basis for new communities. Additional thanks go to Aristides Dimitriou and Irene Yoon for their assistance in preparing the manuscript.

My deep appreciation goes to Philip Leventhal at Columbia University Press for pushing forward with this project, Whitney Johnson and Roy Thomas for guiding it to completion, and Mike Ashby for his expert copy-

editing. I am also grateful for the advice and feedback I have received from Kate Baldwin, Choi Chatterjee, Rossen Djagalov, Jonathan Flatley, Christina Kiaer, Christina Klein, Alma Kunanbaeva, Aaron Lecklider, Julia Mickenberg, Bill Mullen, Paula Rabinowitz, James Smethurst, Julia Vaingurt, Karen Tei Yamashita, Izaly Zemtsovsky, and Bo Zheng. The book has further benefited from presentations at the Russian Academy of Sciences in Saint Petersburg, the Amherst Center for Russian Culture, New York University's Asian/Pacific/American Institute, the Long March Space in Beijing, Stanford's American Studies Program, and the Socialism in Contexts Working Group at the University of California, San Diego.

At Berkeley my research has been supported through a Humanities Research Fellowship, a Townsend Humanities Center Fellowship, and travel grants from the Committee on Research. I was also fortunate to spend a postdoctoral year at New York University's Center for the United States and the Cold War under the kind auspices of Marilyn Young and the late Michael Nash. Many thanks to Wen Jin, Ani Mukherji, Crystal Parikh, Ellen Schrecker, and Rich So for their camaraderie that year.

But of course it all begins with family. In 1946 my paternal grandfather disappeared in Manchuria while trying to assist the Korean community there during the Chinese Civil War. I remain in awe of my uncle, the political scientist Chong Sik Lee, and his ability to use scholarship to help make sense of such voids. He also led the family back from Manchuria to the Korean Peninsula (with the aid of a friendly Soviet soldier) and, several years later, on to the United States (with the aid of friendly Americans). In turn, my parents, Kwang Sik Lee and Young Sook Lee, overcame much immigrant hardship to build a wonderful, loving home for us in Virginia, while my sisters Suzy and Debra have provided so much joy through their own beautiful families. Thank you for always pushing me and always being there for me.

Last but not least, thanks to Makoto Tsunozaki, Zhanara Nauruzbayeva, Daniel Gallegos, Mun Young Cho, Dolly Kikon, Xonzoi Barbora, and Inessa Gelfenboym for making California another home—a center for our own, now scattered ethnic avant-garde.

Notes

Introduction

1. Claude McKay, *A Long Way from Home* (New York: Harcourt, 1970), 151. Moishe Nadir, *Moyde Ani* (New York: Narayev, 1944), 33, translated and quoted in a book in progress by Amelia Glaser. Arnold Rampersad, *The Life of Langston Hughes* (New York: Oxford University Press, 2002), 1:241.
2. Jacques Derrida, "Back from Moscow, in the USSR," in *Politics, Theory, and Contemporary Culture*, ed. Mark Poster (New York: Columbia University Press, 1993), 198, 219.
3. Recent scholarship on the "black-red thread" includes Kate Baldwin, *Beyond the Color Line and the Iron Curtain: Reading Encounters Between Black and Red, 1922–1963* (Durham: Duke University Press, 2002); Joy Gleason Carew, *Blacks, Reds, and Russians: Sojourners in Search of the Soviet Promise* (New Brunswick, N.J.: Rutgers University Press, 2008); Glenda Elizabeth Gilmore, *Defying Dixie: The Radical Roots of Civil Rights, 1919–1950* (New York: Norton, 2008); William Maxwell, *New Negro, Old Left: African-American Writing and Communism Between the Wars* (New York: Columbia University Press, 1999); David Chioni Moore, "Colored Dispatches from the Uzbek Border," *Callaloo* 25, no. 4 (fall 2002); Ani Mukherji, "The Anticolonial Imagination" (Ph.D. diss., Brown University, 2011); James Smethurst, *The New Red Negro: The Literary Left and African American Poetry, 1930–1946* (New York: Oxford University Press, 1999); and Mark Solomon, *The Cry Was Unity: Communists and African Americans, 1917–1936* (Jackson: University Press of Mississippi, 1998). See also Nikhil Pal Singh, "Retracing the Black-Red Thread," *American Literary History* 15, no. 4 (2003): 830–40.
4. This tension has been reinforced by one of the key theorists of the avant-garde, Renato Poggioli. According to him, the avant-garde emerged from the alienation brought by modernity, which broke "all the links between artisan and artist,

destroyed all the forms of folklore and ethnic culture." That is, Poggioli circum-
scribes "ethnic" to premodernity and precapitalism. It serves as the expression
of a historical moment in which art was still in harmony with the social. Amid
the alienating blows of modernity—in particular, the replacement of patrons
by markets—the artist might be tempted to re-create the ethnic, but Poggioli
dismisses such efforts as "unrealizable restorations" and "impossible palingen-
eses." Instead, the avant-gardist responds to his alienation by looking to the
future, by rebelling against all that has gone before (Renato Poggioli, *The Theory
of the Avant-Garde* [Cambridge, Mass.: Harvard University Press, 1968], 121). Re-
cently, Timothy Yu has used Poggioli's mention of the "ethnic" to posit a link
between American ethnic and avant-garde poetry; by Yu's account, both are ex-
pressions of alienation, both seek a "kind of community no longer imaginable
within bourgeois culture" (Timothy Yu, *Race and the Avant-Garde: Experimental
and Asian American Poetry Since 1965* [Stanford: Stanford University Press, 2009],
5). This useful connection, however, does not unseat Poggioli's reductive under-
standing of ethnicity as past-bound and, in a modern context, impossible.

5. Jessica Berman, *Modernist Commitments: Ethics, Politics, and Transnational Modernism*
(New York: Columbia University Press, 2011).

6. Katerina Clark, *Moscow, the Fourth Rome: Stalinism, Cosmopolitanism, and the Evolution
of Soviet Culture, 1931-1941* (Cambridge, Mass.: Harvard University Press, 2011), 141.
Baldwin, *Beyond the Color Line*, 8–11.

7. Walter Benjamin, "Paris—Capital of the Nineteenth Century," *New Left Review* 48
(March–April 1968): 88.

8. As the tower's accompanying pamphlet put it, "We assert that the present project is
the first revolutionary artistic work which we can—and do—send to Europe" (Niko-
lai Punin, *Pamiatnik III Internatsionala* [Petrograd: Otdel izobrazitel'nykh iskusstv
NKP, 1920], 3). Katerina Clark notes elsewhere that the revolution provided the So-
viet avant-garde with a "trump card" in their "campaign against Paris" (Katerina
Clark, *Petersburg: Crucible of Cultural Revolution* [Cambridge, Mass.: Harvard Univer-
sity Press, 1995], 36, 141). For more on the axes of Benjamin's world—Paris-Moscow-
Berlin-Naples—see Susan Buck-Morss, *The Dialectics of Seeing: Walter Benjamin and the
Arcades Project* (Cambridge, Mass.: MIT Press, 1991).

9. On the specific features of Tatlin's Tower, see Punin, *Pamiatnik III Internatsionala*, 1,
and Nikolai Punin, "O pamiatnikakh," in *O Tatline*, ed. I. N. Punina and V. I. Rakitin
(Moscow: RA, 1994), 16–17.

10. Viktor Shklovskii, "On *Faktura* and Counter Reliefs," in *Tatlin*, ed. Larissa Zhadova
(New York: Rizzoli, 1988), 342. I build here on Buck-Morss's discussion of the com-
peting temporalities of the avant-garde and vanguard: the former sought to "rup-
ture the continuity of time" by any means necessary, while the latter claimed "to
know the course of history in its totality" via a " 'science' of the future." By Buck-
Morss's account, the Soviet vanguard ultimately prevailed over the avant-garde,
but in response, she urges us to engage "in the historical task of surprising rather
than explaining the present—more avant-garde than vanguard in its temporality"

(Susan Buck-Morss, *Dreamworld and Catastrophe: The Passing of Mass Utopia in East and West* [Cambridge, Mass.: MIT Press, 2000], 42–60, 69).

11. Punin, *Pamiatnik III Internatsionala*, 3–4. See also Christina Kiaer, *Imagine No Possessions: The Socialist Objects of Russian Constructivism* (Cambridge, Mass.: MIT Press, 2005), 84–85.

12. Leon Trotsky, *Literature and Revolution*, ed. William Keach, trans. Rose Strunsky (Chicago: Haymarket, 2005), 200. Maria Gough, *The Artist as Producer: Russian Constructivism in Revolution* (Berkeley: University of California Press, 2005) 39, 69–71. This aim was not unique to the constructivists. In her groundbreaking work on Josephine Baker, Anne Cheng notes the proclivity of modernist architects like Le Corbusier for unadorned, "pure" surfaces, "set off against notions of excessive adornment, inarticulate sensuality, femininity, backwardness." Cheng proceeds to reveal the connections between modernist surface and racial skin, in part to arrive at a notion of race not confined to individual intent, fixed meanings, or commodification. Likewise I provide an "ethnic" reading of Tatlin's Tower, albeit with an emphasis not on surface but on time. See Anne Cheng, *Second Skin: Josephine Baker and the Modern Surface* (New York: Oxford University Press, 2011).

13. John Milner, *Vladimir Tatlin and the Russian Avant-Garde* (New Haven: Yale University Press, 1983), 156, 243n7. Vladimir Tatlin, "Autobiography," in *Tatlin*, ed. Larissa Zhadova (New York: Rizzoli, 1988), 264.

14. Svetlana Boym, *Another Freedom: The Alternative History of an Idea* (Chicago: University of Chicago Press, 2010), 211. For Babel as the loss of a single divine tongue, see Dante, *De vulgari eloquentia*, ed. and trans. Steven Botterill (Cambridge: Cambridge University Press, 1996), 10–17.

15. Hannah Arendt, *On Revolution* (New York: Viking, 1965), 35. Milner, *Vladimir Tatlin*, 164–65.

16. Reinhart Koselleck, *Futures Past: On the Semantics of Historical Time*, trans. Keith Tribe (New York: Columbia University Press, 2004), 17–25.

17. Mark Steinberg, *Proletarian Imagination: Self, Modernity, and the Sacred in Russia, 1910–1925* (Ithaca: Cornell University Press, 2002), 251.

18. As Perry Anderson points out, Marx himself subscribed to "a complex and differential temporality, in which episodes or eras were discontinuous from each other, and heterogeneous within themselves" (Perry Anderson, "Modernity and Revolution," *New Left Review* 144 [March–April 1984]: 101). See also Johannes Fabian, *Time and the Other: How Anthropology Makes Its Object* (New York: Columbia University Press, 2002), 158–59. Lenin and Trotsky built on this tradition: as Michael Löwy points out, Trotsky based the notion of "permanent revolution" on Marx's observations about Germany's "backwardness" (Michael Löwy, *The Politics of Combined and Uneven Development: The Theory of Permanent Revolution* [New York: Verso, 1981], 12). Of course, Russians were not the only ones seeking to nuance Marxist stagism. In his "Nonsynchronism and the Obligation to Its Dialectics" (1932), Ernst Bloch notes the urgent need (particularly in the face of fascism) to reconceptualize Marxist revolution to account for "unsurmounted remnants of older economic being and

consciousness." Echoing Trotsky's "uneven development," Bloch proposes liberating "the still possible future from the past only by putting both in the present" (Ernst Bloch, "Nonsynchronism and the Obligation to Its Dialectics," *New German Critique* 11 [spring 1977]: 33). Even the relatively orthodox Georg Lukács allowed that "primitive Utopianism" (lacking "authentic class consciousness") could be a "factor in the proletariat's struggle for freedom" (78–79), and that it was important to accept the proletariat's "diverse stages of consciousness" (80) (Georg Lukács, "Class Consciousness," in *History and Class Consciousness: Studies in Marxist Dialectics* [Cambridge, Mass.: MIT Press, 1971]).

19. Leon Trotsky, *History of the Russian Revolution*, trans. Max Eastman (Chicago: Haymarket, 2008), 5.

20. In other words, communists were to support antiracist and anti-imperialist struggles, even if this meant entering into a "temporary alliance" with nationalist movements little interested in Marxism. The aim here was to earn the trust of "oppressed nations" through sensitivity toward "the survivals of national sentiments," which would put the world's colonized and exploited on the side of the Comintern. This, in turn, would open additional fronts against global capitalism and, in particular, strip the West of the resources that it extracted from its colonies. See V. I. Lenin, "Draft Theses on National and Colonial Questions for the Second Congress of the Communist International," https://www.marxists.org/archive/lenin/works/1920/jun/05.htm (accessed July 4, 2014). See also Robert J. C. Young, *Postcolonialism: An Historical Introduction* (Oxford: Blackwell, 2001), 129–34.

21. Vladimir Tatlin et al., "The Work Ahead of Us," in *Tatlin*, ed. Larissa Zhadova (New York: Rizzoli, 1988), 239.

22. Victor Serge, *Memoirs of a Revolutionary*, ed. and trans. Peter Sedgwick (Oxford: Oxford University Press, 1980), 107–9.

23. John Riddell, ed., *To See the Dawn: Baku, 1920—First Congress of the Peoples of the East* (New York: Pathfinder, 1993), 78. See also Milan Hauner, *What Is Asia to Us? Russia's Asian Heartland Yesterday and Today* (Boston: Unwin Hyman, 1990), 24–28.

24. On Tatlin's strategic decision to rename his originally planned "Monument to the October Revolution," see Pamela Kachurin, "Working (for) the State: Vladimir Tatlin's Career in Early Soviet Russia and the Origins of the Monument to the Third International," *Modernism/modernity* 19, no. 1 (January 2012): 24–31.

25. Already by the Comintern's Third Congress in 1921, Robert Young detects an emphasis on the Soviets' need for diplomatic recognition from and trade deals with the West. Such emphases heightened after Stalin's 1924 assertion of "socialism in one country," which effectively made Soviet state interests synonymous with the world revolution. See Young, *Postcolonialism*, 144, 149–50.

26. The notion of "utopian surplus" comes from Buck-Morss, *Dreamworld and Catastrophe*, 64–65. Against efforts to disassociate the Soviet avant-garde from Stalinism, Boris Groys has argued that the avant-garde was never exactly innocent—not only in its eager embrace of the political vanguard but also in its dreams of "total," transformative art (Boris Groys, *The Total Art of Stalinism: Avant-Garde, Aesthetic Dic-*

tatorship, and Beyond, trans. Charles Rougle [Princeton: Princeton University Press, 1992]). Gary Saul Morson and Michael Bernstein's notion of "side shadows" allows for a more conciliatory approach to the avant-garde. Bernstein defines "side shadowing" against "back shadowing," the tendency of historians to depict events like the Holocaust (his focus) as inevitable. Side shadowing, in contrast, emphasizes the possibility that history could have turned out differently. Thus, rather than dismiss the Soviet avant-garde as doomed to failure or totalitarianism, it is possible to understand it on its own terms, in its own time, and to acknowledge the lost possibilities of paths not taken. See Michael André Bernstein, *Foregone Conclusions: Against Apocalyptic History* (Berkeley: University of California Press, 1994).

27. Dale Peterson, *Up from Bondage: The Literatures of Russian and African American Soul* (Durham: Duke University Press, 2000), 5–6.

28. Clark, *Petersburg*, 52–53.

29. Harsha Ram, "The Poetics of Eurasia: Velimir Khlebnikov between Empire and Revolution," in *Social Identities in Revolutionary Russia*, ed. Madhavan Palat (New York: Palgrave, 2001), 216, 227–28. Ram translates and presents in this piece the manifesto in full.

30. Pound and T. S. Eliot exemplify what Michael North calls the dialect of modernism. This refers to Anglo-American writers like T. S. Eliot and Ezra Pound using black dialect and racial masquerade to thwart convention, coupled with the ambivalent responses of African American writers who saw this embrace as both restricting and enabling. As many have shown, white modernist interest in blackness bolstered the Harlem Renaissance and New Negro Movement of the 1920s. Of course, the downside of this interest was stereotyping and pigeonholing—blacks cast as the bearers of virility, innocence, and regeneration—and North presents the "competing linguistic motives" of white and black modernisms as ultimately irreconcilable (Michael North, *The Dialect of Modernism: Race, Language, and Twentieth-Century Literature* [New York: Oxford University Press, 1998]); see also Alain Locke, "The Negro Poets of the United States," in *Anthology of Magazine Verse and Yearbook of American Poetry*, ed. William Stanley Braithwaite (Boston: Brimmer, 1926); George Hutchinson, *The Harlem Renaissance in Black and White* (Cambridge, Mass.: Harvard University Press, 1995); and David Levering Lewis, *When Harlem Was in Vogue* (New York: Penguin, 1997). On Pound and China, see Josephine Park, *Apparitions of Asia: Modernist Form and Asian American Poetics* (New York: Oxford University Press, 2008), 23–56, and Steven Yao, *Foreign Accents: Chinese American Verse from Exclusion to Postethnicity* (New York: Oxford University Press, 2010), 39–62.

31. James Clifford, *The Predicament of Culture: Twentieth-Century Ethnography, Literature, and Art* (Cambridge, Mass.: Harvard University Press, 1988), 129, 131, 147–48. On Paris as a center of the Black Atlantic, see Paul Gilroy, *The Black Atlantic: Modernity and Double-Consciousness* (Cambridge, Mass.: Harvard University Press, 1993), and Brent Hayes Edwards, *The Practice of Diaspora: Literature, Translation, and the Rise of Black Internationalism* (Cambridge, Mass.: Harvard University Press, 2003). On the violent underbelly of modernist primitivism, see Clifford, *The Predicament of Culture*,

189–214, and Donna V. Jones, "The Prison House of Modernism: Colonial Spaces and the Construction of the Primitive at the 1931 Paris Colonial Exposition," *Modernism/modernity* 14, no. 1 (January 2007): 55–69.

32. Of course, one could do a lot worse than forward "tolerance, comprehension, and mercy." As Clifford notes in *The Predicament of Culture*, this group was later active in the Nazi resistance as well as in postwar institutions like UNESCO (139–40). On the other hand, surrealism's tendency to keep the Other at a distance is discussed in Martine Antle, "Surrealism and the Orient," *Yale French Studies* 109 (July 2006): 4–16. For 1930s, Comintern-inspired efforts to remedy surrealism's complicity with imperialism, see Adam Jolles, "The Tactile Turn: Envisioning a Postcolonial Aesthetic in France," *Yale French Studies* 109 (July 2006): 17–38.

33. Aleksandr Shevchenko, "Neoprimitivism: Its Theory, Its Potentials, Its Achievements," in *Russian Art of the Avant-Garde: Theory and Criticism, 1902-1934*, ed. and trans. John E. Bowlt (New York: Viking, 1988), 45. On Tatlin's alliance with the neoprimitivists, see Kiaer, *Imagine No Possessions*, 47.

34. Natal'ia Goncharova, "Preface to Catalogue of One-Man Exhibition," in *Russian Art of the Avant-Garde: Theory and Criticism, 1902-1934*, ed. and trans. John E. Bowlt (New York: Viking, 1988), 58, 60. Likewise, the Slavophile movement sought to turn this relegated status into a source of strength: the "ahistoricity of Russian life" as allowing "Russia to maintain intact the purity of its inner being" (Boris Groys, "Russia and the West: The Quest for Russian National Identity," *Studies in Soviet Thought* 43 [1992]: 189, 193). See also Hauner, *What Is Asia to Us*, 21–24; Peterson, *Up from Bondage*, 57–58; Baldwin, *Beyond the Color Line*, 31–32. On Russia as "semi-Oriental" in the European imagination, see Larry Wolff, *Inventing Eastern Europe: The Map of Civilization on the Mind of the Enlightenment* (Stanford: Stanford University Press, 1994), and Martin Malia, *Russia under Western Eyes: From the Bronze Horseman to the Lenin Mausoleum* (Cambridge, Mass.: Harvard University Press, 1999).

35. Shevchenko, "Neoprimitivism," 49.

36. Jane Ashton Sharp, "Beyond Orientalism: Russian and Soviet Modernism on the Periphery of Empire," in *Russian Art and the West: A Century of Dialogue in Painting, Architecture, and the Decorative Arts*, ed. Rosalind Blakesley and Susan Reid (DeKalb: Northern Illinois University Press, 2007), 120. As Boris Groys colorfully puts it, "If Rousseau indulged in dreams about Native Americans [*indeitsakh*], German philosophy about Indians [*indiitsakh*], Gauguin about Polynesians, Picasso about Africans, etc., then the Russian intellectual proved to be a centaur composed of Rousseau and the Native American, Schopenhauer and the Indian, Picasso and the African (and this was the actual situation of the Russian avant-garde, with its interest in icons, masks, Russian broadsheets [*lubku*], etc.). In his own 'otherness' the Russian recognized the dream of European philosophy, in himself was the realization of this philosophy's ideal" (Boris Groys, "Rossiia kak podsoznanie zapada," in *Utopiia i obmen* [Moscow: Znak, 1993], 251).

37. Jane Ashton Sharp, *Russian Modernism between East and West* (New York: Cambridge University Press, 2006), 5–7, 32. On the applicability of Said's criticism to Russia,

see Adeeb Khalid, "Russian History and the Debate over Orientalism," *Kritika* 1, no. 4 (fall 2000): 691–99; Nathaniel Knight, "On Russian Orientalism: A Response to Adeeb Khalid," *Kritika* 1, no. 4 (fall 2000): 701–15; and Maria Todorova, "Does Russian Orientalism Have a Russian Soul?" *Kritika* 1, no. 4 (fall 2000): 717–27. For more on the Russian avant-garde's engagement with the Caucasus and Central Asia, see Michael Kunichika, "The Penchant for the Primitive: Archaeology, Ethnography, and the Aesthetics of Russian Modernism" (Ph.D. diss., University of California, Berkeley, 2007), and the documentary *The Desert of Forbidden Art*, DVD, directed by Amanda Pope and Tchavdar Georgiev (2010; Desert of Forbidden Art LLC, 2011).

38. Harsha Ram, for instance, notes the often ambivalent and hostile stance of Russian authors toward Asia—Asia as a source of both temptation and terror in the "imperial sublime" of Russian literature. See Harsha Ram, *The Imperial Sublime: A Russian Poetics of Empire* (Madison: University of Wisconsin Press, 2006). Likewise, as Dale Peterson makes clear, 1920s discourses of "Eurasianism"—articulated by Russian émigrés in Eastern Europe and increasingly prominent in Vladimir Putin's Russia—combined "cultural relativism and Russian hybridity" with "the heavy tread of a missionary nationalism." Though several Eurasianists embraced the Bolshevik Revolution from afar, they did so for nationalist rather than internationalist ends, anticipating, as Peterson suggests, Stalin's "socialism in one country" (Peterson, *Up from Bondage*, 144–51).

39. Aleksandr Blok, "Skify," in *Sobranie sochinenii v shesti tomakh*, ed. S. A. Nebol'sin (Moscow: Pravda, 1971), 3: 244–45. These literal translations are my own.

40. Ram, *The Imperial Sublime*, 230–32, 265n38. The limits of such proclamations and, in particular, of Soviet nationalities policy are discussed in the following. On Blok's endorsement of the revolution, see his January 1918 essay "The Intelligentsia and the Revolution," where he writes, *"Remake everything.* Build it so that everything will be new; so that our false, dirty, dull, deformed [*bezobraznaia*] life will be a just, clean, happy, and beautiful life" (Aleksandr Blok, *Rossiia i intelligentsia* [Berlin: Skify, 1920], 14; emphasis in original).

41. Blok, "Skify," 246. Though, interestingly, in "The International," it is the reactionaries who are portrayed as cannibals and (in the Russian version) vampires.

42. For more examples of Russian modernism's apocalyptic embrace of the East, see Ram, *The Imperial Sublime*, 221–30, and David M. Bethea, *The Shape of Apocalypse in Modern Russian Fiction* (Princeton: Princeton University Press, 1989). For more on the Scythian literary movement, see Clark, *Petersburg*, 52–53.

43. McKay, *A Long Way from Home*, 158.

44. Within this tradition, Asia often assumes an "exotic" and utopian quality, far removed from the spheres of Western power. See Bill Mullen, *Afro-Orientalism* (Minneapolis: University of Minnesota Press, 2004), xii.

45. Baldwin, *Beyond the Color Line*, 49–55; Maxwell, *New Negro, Old Left*, 73–74; Michelle Stephens, *Black Empire: The Masculine Global Imaginary of Caribbean Intellectuals in the United States, 1914-1962* (Durham: Duke University Press, 2005), 172–73.

However, these accounts also emphasize the benefit of McKay's Moscow visit to his literary output.

46. The *Oxford English Dictionary* defines "ikon" as a variant of "icon" but indicates its usage only in reference to religious depictions. Reinforcing his identification with Russia and Russians, McKay (like many other foreign visitors) adopted a Russian alias during his stay in Moscow—the sexually indeterminate "Sasha," which Gary Edward Holcomb uses to reread the author through the lens of queer black Marxism. For instance, after connecting McKay's "black iconography" in Russia to the "mystical aura" that his autobiography imparts to Lenin, Holcomb suggests that "in coming close to becoming a black Lenin, McKay forms a kind of ecstatic sexual union with the Communist leader" (Gary Edward Holcomb, *Claude McKay, Code Name Sasha: Queer Black Marxism and the Harlem Renaissance* [Gainesville: University Press of Florida, 2007], 42–43).

47. To be sure, Blok and Khlebnikov were more interested in "Asiatic Russia" than in Byzantine Orthodoxy. However, Orthodoxy did play a role in Russian avant-garde painting: Tatlin himself drew from icon traditions—for instance in his 1911 *Sailor (Self-Portrait)*—while Kazimir Malevich's famous *Black Square* was intended to be hung in room corners, just as icons were. See Kiaer, *Imagine No Possessions*, 47–49; Andrew Spira, *The Avant-Garde Icon: Russian Avant-Garde Art and the Icon Painting Tradition* (Hampshire, U.K.: Lund Humphries, 2008), 142–46. Interestingly, Groys provides a Freudian reading of *Black Square* as referencing the "blackness of some cosmic ur-vagina [*kosmicheskoi pra-vaginy*]" that serves to bridge East and West (Groys, "Rossiia," 247–48). This seems to buttress Holcomb's assertion of the McKay ikon's ecstatic, indeterminate sexuality in Moscow.

48. Harry Haywood, *Black Bolshevik: Autobiography of an Afro-American Communist* (Chicago: Liberator, 1978), 144–47; Homer Smith, *Black Man in Red Russia* (Chicago: Johnson, 1964), 78. Haywood probably means *rubashka*, the Russian word for "shirt."

49. For instance, an ad in the July 8, 1933, issue of the leftist *Harlem Liberator* proclaimed "A Pushkin Bust in Every Negro Home!" and described the poet as both a "famous revolutionary Negro" and "the Father of Russian literature." The newspaper offered discounted home-size busts ("shipped to *Harlem Liberator* from Moscow by Langston Hughes") as a subscription premium.

50. Woodford McClellan, "Africans and Black Americans in the Comintern Schools, 1925–1934," *International Journal of African Historical Studies* 26, no. 2 (1993): 371–90. For a broader survey of blacks in Russia—from postrevolutionary romance to perestroika-era bigotry—see Maxim Matusevich, "Journeys of Hope: African Diaspora and the Soviet Society," *African Diaspora* 1 (2008): 53–85.

51. Alaina Lemon, "Sympathy for the Weary State? Cold War Chronotopes and Moscow Others," *Comparative Studies in Society and History* 51, no. 4 (2009): 859.

52. Anatoly Lunacharsky, "The Eastern Bogey," trans. Bessie Weissmann, *New Masses*, November 1926, 13.

53. As another example, Andrei Platonov's *Dzhan*, written between 1933 and 1935, interweaves local legend with one man's effort to bring socialism to his Central Asian

tribe. As in many of Platonov's works, the novel presents a world that exists independently of humans and human knowledge, and revolutionaries whose grasp of language and socialism can be described as crude, rudimentary, and primitive. As Thomas Seifrid notes, "Like the primitivists, Platonov saw the precultural as fertile ground for new meanings, and both he and they canonized crudity as a source of aesthetic deformation" (Thomas Seifrid, "Platonov, Socialist Realism, and the Avant-Garde," in *Laboratory of Dreams: The Avant-Garde and Cultural Experiment*, ed. John E. Bowlt and Olga Matich [Stanford: Stanford University Press, 1996], 240).

54. Maxwell, *New Negro, Old Left*, 73. Both McKay and Benjamin also met Vsevolod Meyerhold briefly.

55. Walter Benjamin, "Moscow," in *Walter Benjamin: Selected Writings, Volume 2, Part 1, 1927-1930*, ed. Michael W. Jennings, Howard Eiland, and Gary Smith (Cambridge, Mass.: Belknap Press of Harvard University Press, 2005), 22–23; Walter Benjamin, *Moscow Diary*, ed. Gary Smith, trans. Richard Sieburth (Cambridge, Mass.: Harvard University Press, 1986), 104, 129.

56. Walter Benjamin, "Surrealism," in *Walter Benjamin: Selected Writings, Volume 2, Part 1, 1927-1930*, ed. Michael W. Jennings, Howard Eiland, and Gary Smith (Cambridge, Mass.: Belknap Press of Harvard University Press, 2005), 209.

57. Ibid., 209, 211–12, 217–18; Benjamin, "Moscow," 24.

58. Benjamin, *Moscow Diary*, 51, 126. On the "Surrealist Map of the World," see David R. Roediger, *Colored White: Transcending the Racial Past* (Berkeley: University of California Press, 2002), 169–76.

59. Benjamin, *Moscow Diary*, 134.

60. Benjamin, "Moscow," 31–32.

61. Ibid., 26, 32, 34; Benjamin, *Moscow Diary*, 123. For a discussion of the lacquer box as a merging of modern (consumer) and premodern fairy tales, see Kiaer, *Imagine No Possessions*, 223–24. For a more recent instance (set in a dystopian end-of-history future) of Lenin juxtaposed with icons, see the film *Children of Men*, DVD, directed by Alfonso Cuarón (2006; Universal City: Universal Studios Home Entertainment, 2007).

62. Kiaer, *Imagine No Possessions*, 222. Indeed, by the time of Benjamin's arrival, the political and artistic headiness of Moscow was already on the wane. "Socialism in one country" had been declared two years earlier, Stalin was consolidating power, and the Soviet avant-garde found itself increasingly embattled. On the roles of loss and affect in Benjamin's disruptive temporality, and for traces of Benjamin's Moscow in post-Soviet Moscow, see Jonathan Flatley, "Moscow and Melancholia," *Social Text* 19, no. 1 (spring 2001): 75–102.

63. Michael Löwy, *Fire Alarm: Reading Walter Benjamin's "On the Concept of History,"* trans. Chris Turner (New York: Verso, 2005), 102. Peter Osborne, *The Politics of Time: Modernity and Avant-Garde* (New York: Verso, 1995), 145, 229–30n116.

64. Walter Benjamin, "On the Concept of History," in *Walter Benjamin: Selected Writings, Volume 4, 1938-1940*, ed. Michael W. Jennings and Howard Eiland (Cambridge, Mass.: Belknap Press of Harvard University Press, 2006), 395.

65. Ibid., 397.

66. Osborne, *The Politics of Time*, 184.

67. Benjamin, "Surrealism," 210.

68. Benjamin, "Paris," 79; Benjamin, "On the Concept of History," 403.

69. Buck-Morss, *Dialectics of Seeing*, 225, 245; Walter Benjamin, "Johann Jakob Bachofen," in *Walter Benjamin: Selected Writings, Volume 3, 1935-1938*, ed. Michael W. Jennings and Howard Eiland (Cambridge, Mass.: Belknap Press of Harvard University Press, 2006), 12, quoted in Löwy, *Fire Alarm*, 63, 76. There is ongoing disagreement about what constitutes a dialectical image. Buck-Morss writes there can be innumerable dialectical images in the form of everyday commodified objects and profane texts, the critic's task being to reveal the suppressed ur-historical utopian content in each. Eli Friedlander, on the other hand, argues that there can be only one dialectical image, which is "a dimension of reality made recognizable," an alternative, unified, redeemed reality. From this perspective, everyday commodified objects are merely "elements which will go into the construction of the dialectical image." However, Friedlander adds that while identifying such elements are preconditions for the ultimate recognition of the dialectical image, such work "never has a direct relation to the emergence of the image," which he likens to Proust's involuntary memory. I prefer Buck-Morss's understanding, since from a methodological perspective, it is much more portable and seems not incompatible with the total, singular image that Friedlander describes. See Buck-Morss, *The Dialectics of Seeing*, 249–50; Eli Friedlander, "The Measure of the Contingent: Walter Benjamin's Dialectical Image," *boundary 2* 35, no. 3 (2008): 3, 4, 24.

70. Osborne, *The Politics of Time*, 150; Friedlander, "The Measure of the Contingent," 12. Likewise, Peter Bürger asserts that Benjamin's exposure to avant-garde works led to his concept of allegory, which also creates constellations of past and present. Indeed, in "Paris—Capital of the Nineteenth Century," Benjamin calls allegory the canon of dialectical imagery in the seventeenth century (replaced by nouveauté in the nineteenth). However, Bürger argues that, unlike allegory, which can produce an infinite number of meanings, the dialectical image's tie to redemption (specifically, socialist revolution) grounds it in objective meaning—in both the sociohistorical and "mystico-theological" senses (Peter Bürger, *Theory of the Avant-Garde*, trans. Michael Shaw [Minneapolis: University of Minnesota Press, 2002], 68–69; Benjamin, "Paris," 86). See also Buck-Morss, *Dialectics of Seeing*, 241.

71. Osborne, *The Politics of Time*, 150. To be sure, Osborne's disruption of progress does not necessarily gel with every branch of the historical avant-garde. Of course, the Italian futurist F. T. Marinetti sought to negate the past through progress, though as pointed out in chapter 1, he also sought to "swell the enthusiastic fervor of the primordial elements." Soviet constructivism likewise emphasized progress, though as Christina Kiaer has shown, in his advertising collaborations with Mayakovsky, Aleksandr Rodchenko was able to incorporate Benjaminian wish images of the past. See Kiaer, *Imagine No Possessions*, 175–82.

72. Buck-Morss, *Dialectics of Seeing*, 242. Buck-Morss here refers to the secular Jewish messianism lurking in Benjamin's thought, something I discuss in chapter 4. Pog-

gioli acknowledges the avant-garde's attraction to prehistory but argues that this in fact serves "avant-garde antitraditionalism, precisely because the avant-garde can evaluate archaic traditions better than official art and conservative criticism can" (*The Theory of the Avant-Garde*, 55). That is, for Poggioli, the avant-garde can rebel against immediate traditionalism (represented by official art and conservative criticism) via archaic traditions—an arbitrary distinction that strains to preserve his notion of avant-garde antitraditionalism.

73. Benjamin, *Moscow Diary*, 104. This association becomes less far-fetched in light of Joseph Brodsky's more recent description of the Soviet flag as "a scarlet, Janissary's-cloaklike banner" combining "a star and the crescent of Islam" beside a "modified cross" (Joseph Brodsky, "Flight from Byzantium," in *Less Than One: Selected Essays* [New York: Farrar, Straus, and Giroux, 1986], 429).

74. This was particularly true during the Cold War, as I discuss in chapter 4. See Mary Dudziak, *Cold War Civil Rights: Race and the Image of American Democracy* (Princeton: Princeton University Press, 2000), 12, 15, 26–46.

75. Emerging from the notion of universal human time and progress, Fabian's "denial of coevalness" refers to the tendency of anthropologists to "place the referent(s) of anthropology in a time other than the present of the producer of anthropological discourse." "Ironically, the supposedly radical break with evolutionism propagated by Boasian and Kroeberian cultural anthropology had little or no effect on" evolutionist epistemology. "True, culturalism proclaimed 'history' a domain irreducible to natural history. It relativized human, cultural time and left universal time to biological evolution. With that the Enlightenment project was in fact ignored and relegated to the natural sciences. Practically, concentration on cultural configurations and patterns resulted in such overwhelming concern with the description of states (albeit 'dynamic' states) that the eighteenth-century élan in the search for a theory of universal human progress was all but abandoned. In sum, functionalism, culturalism, and structuralism did not solve the problem of universal human Time; they ignored it at best, and denied its significance at worst" (Fabian, *Time and the Other*, 20–21, 31). For an overview of Boas, see George W. Stocking Jr., "Basic Assumptions of Boasian Anthropology," in *The Shaping of American Anthropology, 1883-1911*, ed. George W. Stocking Jr. (New York: Basic Books, 1974), 1–20.

76. Maxwell, *New Negro, Old Left*, 164. On the assimilationism of Boas and Park, see Christopher Douglas, *A Genealogy of Literary Multiculturalism* (Ithaca: Cornell University Press, 2009), 70. David Luis-Brown presses this point by arguing that both Boas and Park embraced a version of hybridity tied to intermarriage. That is, they both took on nativism "by imagining a racially homogeneous nation," and this latent racialism was "at odds with their broader strategy of proposing a shift from race to culture in social scientific theory" (David Luis-Brown, *Waves of Decolonization: Discourses of Race and Hemispheric Citizenship in Cuba, Mexico, and the United States* [Durham: Duke University Press, 2008], 205–11). On the Chicago school's latent Orientalism, see Henry Yu, *Thinking Orientals: Migration, Contact, and Exoticism in Modern America* (New York: Oxford University Press, 2001).

77. Michael Omi and Howard Winant, *Racial Formation in the United States: From the 1960s to the 1990s* (New York: Routledge, 1994), 14–23; Rey Chow, *The Protestant Ethnic and the Spirit of Capitalism* (New York: Columbia University Press, 2002), 28–30.

78. Maxwell, *New Negro, Old Left*, 178.

79. Richard Wright, "I Tried to Be a Communist," *Atlantic Monthly* 174, no. 2 (August 1944): 67.

80. Yuri Slezkine, "The USSR as a Communal Apartment, or How a Socialist State Promoted Ethnic Particularism," *Slavic Review* 53, no. 2 (summer 1994): 439. For other overviews of Soviet nationalities policy, see Ronald Grigor Suny, *The Revenge of the Past: Nationalism, Revolution, and the Collapse of the Soviet Union* (Stanford: Stanford University Press, 1993); Terry Martin, *The Affirmative Action Empire: Nations and Nationalism in the Soviet Union, 1923-1939* (Ithaca: Cornell University Press, 2001); and Francine Hirsch, *Empire of Nations: Ethnographic Knowledge and the Making of the Soviet Union* (Ithaca: Cornell University Press, 2005).

81. See, for instance, Lawrence Levine, *The Opening of the American Mind* (Boston: Beacon Press, 1996), 118; Erika Sunada, "Revisiting Horace M. Kallen's Cultural Pluralism: A Comparative Analysis," *Journal of American and Canadian Studies* 18 (2000): 57. For considerations of Kallen that highlight the gap between his "cultural pluralism" and late twentieth-century multiculturalism, see Arthur M. Schlesinger Jr., *The Disuniting of America: Reflections on a Multicultural Society* (New York: Norton, 1998), 37; John Higham, "Multiculturalism and Universalism: A History and Critique," *American Quarterly* 45, no. 2 (June 1993), 205; David Hollinger, *Postethnic America: Beyond Multiculturalism* (New York: Basic Books, 1995), 92–94; and Nathan Glazer, *We Are All Multiculturalists Now* (Cambridge, Mass.: Harvard University Press, 1997), 87.

82. Horace Kallen, "Democracy Versus the Melting-Pot," *Nation* 100, no. 2590 (February 25, 1915): 217, 219. Further references are given parenthetically in the text.

83. Walter Benn Michaels, *Our America: Nativism, Modernism, and Pluralism* (Durham: Duke University Press, 1995), 64–65; John Higham, *Send These to Me: Jews and Other Immigrants in Urban America* (New York: Atheneum, 1975), 208; Werner Sollors, "A Critique of Pure Pluralism," in *Reconstructing American Literary History*, ed. Sacvan Bercovitch (Cambridge, Mass.: Harvard University Press, 1986), 261–62.

84. Joseph Stalin, "Marxism and the National Question," in *Marxism and the National and Colonial Question*, ed. A. Fineburg (New York: International, 1934), 5–13. Further references appear parenthetically in the text. For background on Stalin's gripe with Otto Bauer's notion of "cultural-national autonomy," see Martin, *The Affirmative Action Empire*, 32. For connections between Bolshevik and Wilsonian calls for "self-determination," see Arno J. Mayer, *Wilson vs. Lenin: Political Origins of the New Diplomacy, 1917-1918* (New Haven: Yale University Press, 1959), 342–43, 380–83. According to Mayer, Woodrow Wilson's Fourteen Points were a response to the writings of Lenin and Trotsky.

85. V. A. Tishkov, *Rekviem po etnosu* (Moscow: Nauka, 2003).

86. In both the 1915 and 1924 versions, Kallen writes that a redistribution of wealth would abolish America's "dualism if the economic dualism of rich and poor were

the fundamental one." The original article adds, "It happens merely that it isn't" (193), while the republication reads, "It happens, so far, that it doesn't seem to be" (Horace Kallen, *Culture and Democracy in the United States* [New Brunswick, N.J.: Transaction, 1998], 81).

87. Martin, *The Affirmative Action Empire*, 17–18. For a counterview, see Hirsch, *Empire of Nations*, 103.

88. As one additional, 1930 resolution on the "Negro question" elaborated, blacks constituted an "oppressed nation" and as such demanded land redistribution from white landowners to black farmers, the right of self-determination, and the "establishment of the State Unity of the Black Belt"—that is, the consolidation of "artificially split up and divided" blacks into a single governmental unit. This would make it impossible for the region's "fairly sizable white minority" to claim a majority anywhere and meant the erasure of all preexisting state and local borders; see *The 1928 and 1930 Comintern Resolutions on the Black National Question in the United States* (Washington, D.C.: Revolutionary Review, 1975), 30. The Black Belt's contours can be found in Soviet ethnographic maps that divide the United States into two main nationalities, "Americans," who fill most of the country, and "Negroes," who cover the Southeast. See *Bol'shoi sovetskii atlas mira* (Moscow: Nauchno-izdatel'skii institut, 1937). On African American participation in formulating the Black Belt thesis, see Haywood, *Black Bolshevik*, 227–34, and Maxwell, *New Negro, Old Left*, 91–93.

89. Horace Kallen, *Frontiers of Hope* (New York: Liveright, 1929), 446. Further references are given parenthetically in the text. See Yuri Slezkine, *The Jewish Century* (Princeton: Princeton University Press, 2004).

90. For more on Jewish overrepresentation among the Bolsheviks, see Slezkine, *The Jewish Century*, 175. However, Slezkine goes on to suggest that many Jewish Bolsheviks were drawn to revolution precisely as a means of breaking from their roots.

91. Hirsch, *Empire of Nations*, 14.

92. Langston Hughes, *A Negro Looks at Soviet Central Asia* (Moscow: Co-operative Publishing Society of Foreign Workers in the U.S.S.R., 1934), 40; Olivier Roy, *The New Central Asia: The Creation of Nations* (New York: New York University Press, 2000), 119–21; Adeeb Khalid, *Islam After Communism: Religion and Politics in Central Asia* (Berkeley: University of California Press, 2007), 61–62.

93. Hirsch, *Empire of Nations*, 9, 273–308.

94. This is not to say that Wright and Kallen were naive. In addition to expressing his admiration for Soviet nationalities policy, Wright's 1944 essay also described his beating at the hands of white communists and decision to leave the party. By then he was well attuned to the "horror" that accompanied the "glory" of Soviet-inflected communism. See Richard Wright, "I Tried to Be a Communist," *Atlantic Monthly* 174, no. 3 (September 1944): 54. See also Michael Denning, *Culture in the Age of Three Worlds* (New York: Verso, 2004), 52. Kallen himself became a fierce critic of Stalinism and in 1937 cosponsored the pro-Trotsky Commission of Inquiry into the Truth of the Moscow Trials; see Sidney Hook, "Memories of the Moscow Trials," *Commentary* 77 (March 1984): 58. On the Jewish Autonomous Region, see Robert Weinberg,

Stalin's Forgotten Zion: Birobidzhan and the Making of a Soviet Jewish Homeland; An Illustrated History, 1928-1996, ed. Bradley Burman (Berkeley: University of California Press, 1998). On the Soviet Korean deportation, see Michael Gelb, "An Early Soviet Ethnic Deportation: The Far-Eastern Koreans," *Russian Review* 54, no. 3 (July 1995): 389–412.

95. Yuri Slezkine, "N. Ia. Marr and the National Origins of Soviet Ethnogenetics," *Slavic Review* 55, no. 4 (winter 1996): 834.

96. See ibid., passim; Clark, *Petersburg*, 212–23; and Mika Lähteenmäki, "Nikolai Marr and the Idea of a Unified Language," *Language and Communication* 26, no. 3 (2006): 285–95; N. Ia. Marr, "Iafeticheskii Kavkaz i tretii etnicheskii element v sozidanii sredizemnomorskoi kul'tury," in *Izbrannye raboty, tom 1*, ed. V. B. Aptekar' (Leningrad: GAIMK, 1933), 120–21, quoted in Slezkine, "N. Ia. Marr," 838, and in Lawrence Thomas, *The Linguistic Theories of N. Ja. Marr* (Berkeley: University of California Press, 1957), 53.

97. N. Ia. Marr, "Chem zhivet iafeticheskoe iazykoznanie?" in *Izbrannye raboty, tom 1*, ed. V. B. Aptekar' (Leningrad: GAIMK, 1933), 177, quoted in Slezkine, "N. Ia. Marr," 832. Of course, Dipesh Chakrabarty's notion of "provincializing Europe" involves not simply decentering the West but also an expansion of the Marxist tradition: enfolding historical slippages and disruptions (e.g., the persistent belief in gods and spirits) into the universal history of abstract labor. As will be seen, Marr's Japhetic theory turned "New Theory of Language" does just this.

98. N. Ia. Marr, "Iazyk i myshlenie," in *Izbrannye raboty, tom 3*, ed. V. B. Aptekar' (Leningrad: GAIMK, 1934), 111–12, quoted (with a slightly different translation) in Slezkine, "N. Ia. Marr," 843. The emphasis here on manual language is important, since, according to Marr, before the advent of class differentiation, "people spoke with their hands during the course of many tens of thousands of years." Oral speech was originally the provenance of ruling-class shamans, and Marr seemed to envision his unified socialist language as a return to speechless, manual language. See Thomas, *The Linguistic Theories of N. Ja. Marr*, 99, and Yuri Slezkine, "The Fall of Soviet Ethnography, 1928-38," *Current Anthropology* 32, no. 4 (1991): 478. On the problematic alignment of Marrism and Marxism, see Slezkine, "N. Ia. Marr," 841–44; Lähteenmäki, "Nikolai Marr," 286–89; and Clark, *Petersburg*, 217–20.

99. N. Ia. Marr, "Znachenie i rol' izucheniia natsmen'shinstva v kraevedenii," in *Izbrannye raboty, tom 1*, ed. V. B. Aptekar' (Leningrad: GAIMK, 1933), 235–36. After noting the shared aims of the October Revolution and Japhetic theory, Marr here advises archaeologists and linguists to "assist Soviet power in its task of preserving cultural treasures of past epochs and distributing them between nations from all stages of development—Soviet power's task of carefully transplanting these treasures into a new economic-cultural construction" (247–48).

100. Soviet ethnographers shared Boas's hostility to biological racism and, as Hirsch has shown, defined themselves against German racial science and in dialogue with Soviet nationalities policy (*Empire of Nations*, 266). However, they took issue precisely with Boas's purported emphasis on the simultaneity of cultures. According to a

(largely favorable) review of his *Mind of Primitive Man* (1911, translated into Russian in 1926), "Boas's objection against the view of ethnologist-evolutionists hits a bit off the mark: maintaining, as a counterweight to unilinear evolution, the convergence of cultures, that is, the development of similar forms along different paths, the author does not note that, with this, he does not refute that which he wants to refute—that some peoples advance more along the path of cultural development, and others less so. The quantitative unevenness of the cultural progress of different peoples nevertheless remains a fact" (S. Tokarev, review of *Um pervobytnogo cheloveka*, by Franz Boas, trans. A. M. Voden, *Etnografiia* 1 [1928]: 133). Tokarev here anticipates Fabian's criticism of culturalism, namely, its failure to address the problem of time (see note 75).

101. Marr, "Iafeticheskii Kavkaz," 101, quoted (with a slightly different translation) in Slezkine, "N. Ia. Marr," 839. Accordingly, Hirsch notes that in response to Soviet nationalities policy's blend of primordialism and evolutionism, "Soviet ethnographers conceived of *natsional'nosti* [nationalities] as ethnohistorical groups whose origins could be traced back to the 'prehistoric era'—but whose members were united in the present through a shared cast of mind" (*Empire of Nations*, 295).

102. Vera Tolz, *Russia's Own Orient: The Politics of Identity and Oriental Studies in the Late Imperial and Early Soviet Periods* (New York: Oxford University Press, 2011), 153.

103. For an intimate portrait of Marr as both generous and domineering, brilliant and tautological, see Ol'ga Mikhailovna Freidenberg, "Vospominaniia o N. Ia. Marre," *Vostok-Zapad* 3 (1988): 181–204.

104. Tolz, *Russia's Own Orient*, 127. See also Clark, *Petersburg*, 215.

105. Tolz makes this provocative claim by noting that one of Said's mentors, the Egyptian scholar Anwar Abdel-Malek, studied in the Soviet Union in the 1950s. See Tolz, *Russia's Own Orient*, 57, 91, 100–101, 114–18, 142, 171. Interestingly, Fabian concludes his *Time and the Other* by asserting the Other's coevalness, by refusing the opposition of tradition and modernity—similar to Marr, though Fabian (equipped with a more sophisticated brand of Marxism) would likely disagree with Marr's evolutionism. "What are opposed, in conflict, in fact, locked in antagonistic struggle, are not the same societies at different stages of development, but different societies facing each other at the same Time . . . the 'savage and the proletarian' are in equivalent positions vis-à-vis domination." Still, at one point, Fabian wonders if world revolution and, in particular, Soviet ethnography might "construe a different Other than the capitalist world market." Marr's theories, coupled with Tolz's study, suggests that this was indeed the case. See Fabian, *Time and the Other*, 155, 156, 159.

106. Walter Benjamin, "Problems in the Sociology of Language," in *Walter Benjamin: Selected Writings, Volume 3, 1935-1938*, ed. Michael W. Jennings and Howard Eiland (Cambridge, Mass.: Belknap Press of Harvard University Press, 2006), 73–75, 85–86. See also Clark, *Moscow*, 201–2.

107. Clark, *Petersburg*, 217, 221. Tolz, *Russia's Own Orient*, 62. Nataliia Azarova, "Khlebnikovskaia teoriia zaumi i politika edinogo iazyka," *Russian Literature* 67 (2010): 273–89. For the persistence of these visions, note the resonance of both Marr and

Khlebnikov in the work of the contemporary Kazakh writer and politician Olzhas Suleimenov. See Harsha Ram, "Imagining Eurasia: The Poetics and Ideology of Olzhas Suleimenov's *AZ i IA*," *Slavic Review* 60, no. 2 (summer 2001): 289–311.

108. Buck-Morss, *Dreamworld and Catastrophe*, 42–60. Again, Boris Groys has influentially contested the widespread notion that avant-gardism was antithetical to Stalinist culture (see note 26). Even recognizing the possible continuity between the two, however, few would dispute that the iconoclastic cultural experimentation of the 1920s was sharply curtailed by the 1930s.

109. Tolz, *Russia's Own Orient*, 165–67. Stalin's postwar turn is discussed in chapter 4. "Promethean linguistics"—language as "the ultimate vehicle for the transformation sought by revolution"—comes from Clark, *Petersburg*, 208.

1. Translating the Ethnic Avant-Garde

1. Dante, *De vulgari eloquentia*, ed. and trans. Steven Botterill (Cambridge: Cambridge University Press, 1996), 10–17. Many thanks to Scott Millspaugh for this tip.

2. F. T. Marinetti, "The Founding and Manifesto of Futurism," trans. R. W. Flint, http://www.italianfuturism.org/manifestos/foundingmanifesto (accessed July 4, 2014). David Burliuk et al., "A Slap in the Face of Public Taste," in *Russian Futurism Through Its Manifestos, 1912–1928*, ed. Anna Lawton, 51–52 (Ithaca: Cornell University Press, 1988).

3. Marjorie Perloff, *The Futurist Moment: Avant-Garde, Avant Guerre, and the Language of Rupture* (Chicago: University of Chicago Press, 1986). On the connections and distinctions between Italian and Russian futurism—the first more "Europeanizing and urban," the second more "primitivist and anti-imperialist"—see Harsha Ram, "Futurist Geographies: Uneven Modernities and the Struggle for Aesthetic Autonomy; Paris, Italy, Russia, 1909–1914," in *The Oxford Handbook of Global Modernisms*, ed. Mark Wollaeger and Matt Eatough, 313–40 (New York: Oxford University Press, 2012).

4. Perloff, *The Futurist Moment*, 23.

5. Ibid., 19.

6. Ibid., 10, 35–36.

7. Marinetti, "The Founding and Manifesto of Futurism"; Anna Lawton, introduction to *Russian Futurism Through Its Manifestos*, 12. The Hylaeans used archaism and primitivism to distinguish themselves from the Italian futurists (18), much as Goncharova and the neoprimitivists used Asia to distinguish themselves from Western painters. The Hylaeans, who renamed themselves cubo-futurists in 1913, were thus natural allies of the neoprimitivists, and the two groups overlapped and frequently collaborated with each other (14).

8. Vel, "Khlebnikov—osnovatel' budetlian," *Kniga i revoliutsiia*, no. 9-10 (1922): 25, quoted in Vladimir Markov, *Russian Futurism: A History* (Berkeley: University of California Press, 1968), 28.

9. Velimir Khlebnikov, "The Trumpet of the Martians" (1916), in Lawton, *Russian Futurism Through Its Manifestos*, 103–6. Emphasis in original.

10. Marinetti, "The Founding and Manifesto of Futurism."

11. Markov, *Russian Futurism*, 152, 182. See also Perloff, *The Futurist Moment*, 153.

12. Kiaer writes that Mayakovsky "invokes Africa in typically colonialist terms as an uncivilized Eden that is powerless to resist the encroaching bourgeois civilization," namely, the drinking of tea. However, she adds that the poet's implicit tie between the revolution and Africa (both subject to bourgeois corruption) "indicates that for him, 'primitive' Africa is a positive term" (Christina Kiaer, *Imagine No Possessions: The Socialist Objects of Russian Constructivism* [Cambridge, Mass.: MIT Press, 2005], 155). The possibility of a positive primitivism is explored further below.

13. Roman Jakobson, *My Futurist Years*, ed. Bengt Jangfelt, trans. Stephen Rudy (New York: Marsilio, 1997), 225–30.

14. These recollections were likely written during Rivera's 1956 return to Moscow. See David Elliott, ed., *Mayakovsky: Twenty Years of Work; An Exhibition from the State Museum of Literature, Moscow* (Oxford: Museum of Modern Art, 1982), 71. Similar recollections by Rivera are quoted and cited in S. Kemrad, *Maiakovskii v Amerike* (Moscow: Sovetskii pisatel', 1970), 62. For the logistics of Mayakovsky's time in Mexico, see William Harrison Richardson, *Mexico Through Russian Eyes, 1806–1940* (Pittsburgh: University of Pittsburgh Press, 1988), 129–30.

15. Paul Mariani, *William Carlos Williams: A New World Naked* (New York: Norton, 1990), 247. Many thanks to James Smethurst for this tip.

16. Lawton, introduction to *Russian Futurism Through Its Manifestos*, 13. Accordingly, as Perloff notes, one of Mayakovsky's credos from 1913 was that "the word, its outline and its phonic aspect determine the flourishing of poetry" (*The Futurist Moment*, 157).

17. To be fair, four years after the New York reading, Williams was able to summarize the basic gist of Mayakovsky's "Black and White." See Mariani, *William Carlos Williams*, 247.

18. As Markov writes, Mayakovsky's postrevolutionary writings were all connected to his prerevolutionary development, "when his poetic system took shape. When a certain simplicity of syntax and diction came later, during the Soviet time, it was not really a change, but an inevitable ripening of what had already grown to fruition" (*Russian Futurism*, 315–16). See also Jakobson, *My Futurist Years*, 236–37.

19. Wiktor Woroszylski, *The Life of Mayakovsky*, trans. Boleslaw Taborski (New York: Orion, 1970), 399.

20. V. V. Mayakovsky, "Nashemu iunoshestvu," in *Polnoe sobranie sochinenii, tom 8* (Moscow: Gos. izdat. khudozh. lit., 1958), 15. This, the epigraph's, and the following translations are my own, except where otherwise noted.

21. Mayakovsky both drew inspiration from the American poet and regarded him as a competitor. For a comparison of these poets' outsized bodies in relation to, respectively, American democracy and revolutionary Russia, see Clare Cavanagh, "Whitman, Mayakovsky, and the Body Politic," in *Rereading Russian Poetry*, ed. Stephanie Sandler, 202–22 (New Haven: Yale University Press, 1999).

22. Mayakovsky, "Nashemu iunoshestvu," 16.

23. Dm. Moldavskii, *Maiakovskii i poeziia narodov SSSR* (Leningrad: Sovetskii pisatel', 1951), 24. A 1983 volume similarly praised Mayakovsky's "spirit of international unity and brotherhood" and interpreted "To Our Youth" as showing how the Russian language could advance "all-national [*obshchenatsional'noi*] Soviet pride" (K. V. Aivazian, ed., *Maiakovskii i literatura narodov sovetskogo soiuza* [Yerevan: Izdatel'stvo Erevanskogo universiteta, 1983], 5, 16).

24. Edward Brown, *Mayakovsky: A Poet in the Revolution* (New York: Paragon, 1988), 205. Lawton, Introduction to *Russian Futurism Through Its Manifestos*, 46. On the many competing factions of Soviet writers and artists in the 1920s and 1930s, see Sheila Fitzpatrick, *The Cultural Front: Power and Culture in Revolutionary Russia* (Ithaca: Cornell University Press, 1992), and Clark, *Petersburg*.

25. Vladimir Mayakovsky, *My Discovery of America*, trans. Neil Cornwell (London: Hesperus, 2005), 64, 74, 76. Further references are inserted parenthetically in the text. The "Mac" hypothesis comes from Cornwell's introduction to his translation (xv).

26. Greenblatt, of course, defines wonder as that which is "apart and yet utterly compelling," as "all that cannot be understood, that can scarcely be believed." In early discourses surrounding the New World, the wonderful typically gives way to—but is never completely overshadowed by—the marvelous, which suggests apprehension and possession. See Stephen Greenblatt, *Marvelous Possessions: The Wonder of the New World* (Chicago: University of Chicago Press, 1991).

27. V. V. Mayakovsky, "Meksika," in *Polnoe sobranie sochinenii, tom 7* (Moscow: Gos. Izdat. Khudozh. Lit., 1957), 42; for the Chekhov connection, see 477n.

28. Mayakovsky, "Meksika," 43. William Carlos Williams, *In the American Grain* (New York: New Directions, 1956), 27–38. Many thanks to Mark Goble for this tip.

29. Mayakovsky, "Meksika," 45.

30. Ibid., 45, 48. For more on "Mexico," see Brown, *Mayakovsky*, 276.

31. Mayakovsky would have thus disputed notions that Rivera contradicted himself in his combinations of the modern and premodern—for instance, in his Detroit Industry murals (1932–1933), the automobile stamping press resembling the Aztec goddess Coatlicue; see Rubén Gallo, *Mexican Modernity: The Avant-Garde and the Technological Revolution* (Cambridge, Mass.: MIT Press, 2005), 15–17.

32. This reading of Mayakovsky's anti-imperialist exoticism draws from David Luis-Brown's recuperation of primitivism in his study of African American and Latin American writing. According to him, primitivism (in its "alternative" rather than "residual" or "dominant" forms) can upset "the terms of racialist discourses by calling for the forging of alliances among workers and people of color from different nations" (David Luis-Brown, *Waves of Decolonization: Discourses of Race and Hemispheric Citizenship in Cuba, Mexico, and the United States* [Durham: Duke University Press, 2008], 149–50, 170, 175).

33. V. V. Mayakovsky, "Bruklinskii most," in *Polnoe sobranie sochinenii, tom 7* (Moscow: Gos. izdat. khudozh. lit., 1957), 85, 87. For more on Mayakovsky's mixed views of the United States, as well as his conciliatory take on "the relics of olden days," see Charles A. Moser, "Mayakovsky's Unsentimental Journeys," *American Slavic and East European Review* 19, no. 1 (February 1960): 86.

34. Dovid Katz, "The Days of Proletpen in American Yiddish Poetry," introduction to *Proletpen: American Rebel Yiddish Poets*, ed. Amelia Glaser and David Weintraub, trans. Amelia Glaser (Madison: University of Wisconsin Press, 2005), 20; Ruth Wisse, *A Little Love in Big Manhattan* (Cambridge, Mass.: Harvard University Press, 1988), 117, 130; Moser, "Mayakovsky's Unsentimental Journeys," 92.

35. The *Frayhayt* interview is collected in Woroszylski, *The Life of Mayakovsky*, 374–75. *Frayhayt* editor Shakhno Epstein's 1930 account of Mayakovsky at "Nit Gedaige" is quoted in Vasilii A. Katanian, *Maiakovskii: Khronika zhizni i deiatel'nosti* (Moscow: Sovetskii pisatel', 1985), 312; V. V. Mayakovsky, "Kemp 'Nit gedaige,'" in *Polnoe sobranie sochinenii, tom 7* (Moscow: Gos. izdat. khudozh. lit., 1957), 88–91. Underscoring his immersion into immigrant New York, Mayakovsky also had an affair with a Russian émigré (the daughter of Mennonites who had fled the revolution), which, after his departure, resulted in the birth of a daughter.

36. R. M. Iangirov, "Marginal'nye temy v tvorcheskoi praktike LEFa," in *Tynianovskii sbornik: Piatye Tynianovskie chteniia*, ed. Marietta Chudakova, 223–48 (Riga: Zinatne, 1994); Gennady Estraikh, *In Harness: Yiddish Writers' Romance with Communism* (Syracuse: Syracuse University Press, 2005), 75.

37. Vladimir Mayakovsky, "How I Made Her Laugh," in *My Discovery of America*, 109–10.

38. More specifically, *Spartak/Spartacus* was published by the group Rezets (Chisel), which the journal proclaimed as "the sole group in America of Russian proletarian writers." Of course, in Moscow, "proletarian writers" referred to the protosocialist realist opponents of LEF, but as one Rezets member later admitted, the group "knew very little about the Soviet literary landscape. In their vocabulary 'proletarian' meant generically Soviet." Estraikh, *In Harness*, 74.

39. Katz, "The Days of Proletpen," 20; Kemrad, *Maiakovskii v Amerike*, 203–7.

40. V. V. Mayakovsky, "Amerikanskie russkie," in *Polnoe sobranie sochinenii, tom 7* (Moscow: Gos. izdat. khudozh. lit., 1957), 80–82. In a subsequent reading of the poem back in the Soviet Union, "the word *tudoi* came out especially funny: for a few seconds [Mayakovsky] stretched the final 'oy' and even pronounced it with a light howl [*zavyvanie*]" (P. I. Lavut, *Maiakovskii edet po soiuzu* [Moscow: Sovetskaia Rossiia, 1978], 16). This manic emphasis ("tud-OY!"), which brings to mind Jerry Lewis, suggests that Mayakovsky was mimicking and perhaps mocking Yiddish-accented Russian.

41. Mayakovsky, "Amerikanskie russkie," 82.

42. Mayakovsky, "How I Made Her Laugh," 110–13.

43. V. V. Mayakovsky, "Domoi!" in *Polnoe sobranie sochinenii, tom 7* (Moscow: Gos. izdat. khudozh. lit., 1957), 489n.

44. Lavut, *Maiakovskii edet po soiuzu*, 17; Iangirov, "Marginal'nye temy ," 299.

45. Mayakovsky, "Domoi!" 488–89n. On the poem's redaction as part of a tendentious turn, see Brown, *Mayakovsky*, 302.

46. William Harrison Richardson, "The Dilemmas of a Communist Artist: Diego Rivera in Moscow, 1927–1928," *Mexican Studies/Estudios Mexicanos* 3, no. 1 (winter 1987): 55, 58–62.

47. Lawrence Venuti, "Translation, Community, Utopia," in *The Translation Studies Reader*, ed. Lawrence Venuti (New York: Routledge, 2000), 477, 485–86.

48. Walter Benjamin, "The Task of the Translator," in *Walter Benjamin: Selected Writings, Volume 1, 1913-1926*, ed. Marcus Bullock and Michael W. Jennings (Cambridge, Mass.: Belknap Press of Harvard University Press, 1996), 259.

49. Lawrence Venuti, "Local Contingencies: Translation and National Identities," in *Nation, Language, and the Ethics of Translation*, ed. Sandra Bermann and Michael Wood, 177–202 (Princeton: Princeton University Press, 2005). See also Emily Apter, *The Translation Zone: A New Comparative Literature* (Princeton: Princeton University Press, 2005).

50. I draw here from Brent Hayes Edwards's own use of translation gaps—specifically between Tiemoko Garan Kouyaté's French and George Padmore's English renderings of a 1933 "Negro World Unity" manifesto—to articulate "an ideological 'language' of black internationalism." I do something similar with Mayakovsky and Hughes—though using this encounter to shore up a Moscow-centered ethnic avant-garde rather than a Paris-centered black internationalism. See Brent Hayes Edwards, *The Practice of Diaspora: Literature, Translation, and the Rise of Black Internationalism* (Cambridge, Mass.: Harvard University Press, 2003), 281–82.

51. V. V. Mayakovsky, "Blek end uait," in *Polnoe sobranie sochinenii, tom 7* (Moscow: Gos. izdat. khudozh. lit., 1957), 20.

52. Lydia Filatova, "Langston Hughes: American Writer," *International Literature*, no. 2 (1933): 106–7.

53. In his own work on Hughes and Mayakovsky, Ryan James Kernan dismisses Filatova on precisely these grounds. However, though Kernan discusses in favorable terms Mayakovsky's possible influence on Hughes, he notes only in passing Filatova's recommendation that Hughes look to Mayakovsky as a model. The fact that she made this recommendation suggests that she was not simply toeing the line of the Comintern or Soviet state, despite her reference to the "national form, socialist content" formula. Indeed, Mayakovsky was not officially enshrined by the state until 1935. Beyond this quibble, Kernan's reading of Hughes's translations culminates with the last lines of "Syphilis," the original of which reads as follows: "Odni govoriat— / 'tsivilizatsiia,' / drugie— / 'kolonial'naia politika.' " Hughes translates this with hardly any changes: "Some call it— / civilization. / Others— / colonial policy." Kernan asserts that Hughes reverses the original order of "civilization" and "colonial policy," which is not the case. See Ryan James Kernan, "Lost and Found in Black Translation" (PhD diss., University of California, Los Angeles, 2007), 166–72, 191–92; and Ryan James Kernan, "The *Coup* of Langston Hughes's Picasso Period: Excavating Mayakovsky in Langston Hughes's Verse," *Comparative Literature* 66, no. 2 (spring 2014): 229, 233.

54. V. V. Mayakovsky, "Sifilis," in *Polnoe sobranie sochinenii, tom 7* (Moscow: Gos. izdat. khudozh. lit., 1957), 26, 27–28, 29.

55. Langston Hughes, "Syphilis" [1933], folder 66, box 5, Langston Hughes Collection, John Hope and Aurelia E. Franklin Library, Special Collections, Fisk University, Nashville.

56. Mayakovsky, "Blek end uait," 22.

57. Ibid., 21.

58. Ibid., 23.

59. Langston Hughes, "Black and White" [1933], folder 66, box 5, Langston Hughes Collection, John Hope and Aurelia E. Franklin Library, Special Collections, Fisk University, Nashville.

60. Vladimir Mayakovsky, "Black and White," trans. Ettiene Karnot and O. Polenova, *New Masses*, February 1933, 21.

61. Kernan, "Lost and Found in Black Translation," 489.

62. John Patrick Leary, "Havana Reads the Harlem Renaissance: Langston Hughes, Nicolás Guillén, and the Dialectics of Transnational American Literature," *Comparative Literature Studies* 47, no. 2 (2010): 137–38, 139, 143; Edwards, *The Practice of Diaspora*, 11, 13–15.

63. Accordingly, David Luis-Brown notes that Hughes's writings on Africa and Mexico are marked by the "romanticization of nonwhite cultures" but one that "produces transnational affinities between groups who would otherwise tend not to view each other as part of a shared political project" (*Waves of Decolonization*, 163).

64. Hughes, "Black and White."

65. Leary, "Havana Reads the Harlem Renaissance," 138.

66. There is no indication that Hughes had anything but admiration for Mayakovsky, as well as for his critic and cotranslator Filatova. In his autobiography, he remembers her as "a very bright young woman . . . who wrote brilliant critical articles" and "spoke English very well." She was on the train station platform when he departed Moscow for China. See Langston Hughes, *I Wonder as I Wander: An Autobiographical Journey* (New York: Hill and Wang, 1956), 197, 230.

67. Edwards, *The Practice of Diaspora*, 282. See also Dipesh Chakrabarty's endorsement of one-to-one translations (e.g., between Hindus and Muslims via poetry and fiction) in which "codes are switched locally, without going through a universal set of rules" (*Provincializing Europe: Postcolonial Thought and Historical Difference* [Princeton: Princeton University Press, 2000], 85–86).

68. Benjamin, "The Task of the Translator," 261. Further references are inserted parenthetically in the text.

69. Langston Hughes, "Cubes," in *The Collected Poems of Langston Hughes*, ed. Arnold Rampersad and David Roessel, 175–76 (New York: Random House, 1994). Many thanks to Paula Rabinowitz for bringing "Cubes" to my attention. For a reading of the poem as both a critique and embrace of European modernism, see Seth Moglen, "Modernism in the Black Diaspora: Langston Hughes and the Broken Cubes of Picasso," *Callaloo* 25, no. 4 (fall 2002): 1189–1205. Similarly, Kernan provides a wonderful, focused reading of "Cubes" vis-à-vis the French avant-garde and, in particular, Mallarmé. See Kernan, "Lost and Found in Black Translation," 209–25.

70. Langston Hughes, *A Negro Looks at Soviet Central Asia* (Moscow: Co-operative Publishing Society of Foreign Workers in the U.S.S.R., 1934), 27.

71. Ibid., 6.

72. Hughes, *I Wonder as I Wander*, 174–80. The descendants of one of these settlers include the prominent Russian Africanist Lily Golden and her daughter, the Russian television personality Yelena Khanga. See their autobiographies, Lily Golden, *My Long Journey Home* (Chicago: Third World, 2002), and Yelena Khanga and Susan Jacoby, *Soul to Soul: A Black Russian American Family, 1865–1992* (New York: Norton, 1992).

73. Kate Baldwin, *Beyond the Color Line and the Iron Curtain: Reading Encounters Between Black and Red, 1922–1963* (Durham: Duke University Press, 2002), 93–94, 134–36.

74. Eisenstein quoted in Anne Nesbet, *Savage Junctures: Sergei Eisenstein and the Shape of Thinking* (London: Tauris, 2003), 122. As Nesbet elaborates, "Central characteristics of Eisenstein's Mexico were the coexistence of all things and times on a single plane, the punctuation of this plane by the savage thrills of bullfighting and other sacrifices and the ecstatic opening up of individual interiors into all surface" (122). Masha Salazkina elaborates further: in Mexico Eisenstein sought "a dialectical pattern involving a synthesis of all present stages of development." This synthesis, in turn, led to a philosophy of history that rejected "linear evolutionary development" in favor of "continuing shifts backward and forward" (Masha Salazkina, *In Excess: Sergei Eisenstein's Mexico* [Chicago: University of Chicago Press, 2009], 73, 150–63).

75. Eisenstein quoted in Salazkina, *In Excess*, 143.

76. As Salazkina notes, Eisenstein associated sexual experimentation with both proletarian revolution and "prelogical primitive structures" (*In Excess*, 128–35). This crossing of time and sexuality suggests that Eisenstein strove for what José Esteban Muñoz has identified as "queer futurity," a desire-laden, alternative temporality emerging from "a perception of past and future affective worlds" (José Esteban Muñoz, *Cruising Utopia: The Then and There of Queer Futurity* [New York: New York University Press, 2009], 25–28). Salazkina additionally dispels avant-garde masculinism by noting *¡Que viva México!*'s clear references to the works of Tina Modotti and Frida Kahlo (*In Excess*, 74–80).

2. The Avant-Garde's Asia

1. Vladimir Markov, *Russian Futurism: A History* (Berkeley: University of California Press, 1968), 111–13; Katerina Clark, *Moscow, the Fourth Rome: Stalinism, Cosmopolitanism, and the Evolution of Soviet Culture, 1931–1941* (Cambridge, Mass.: Harvard University Press, 2011), 37–38. Joseph Stalin quoted in Tsuyoshi Hasegawa, *Racing the Enemy: Stalin, Truman, and the Surrender of Japan* (Cambridge, Mass.: Harvard University Press, 2005), 7.

2. One frequently cited exception to this is the Filipino American author Carlos Bulosan. On the fraught history of Asian America and pre-1960s leftism, see Him Mark Lai, "Historical Survey of the Chinese Left in America," in *Counterpoint: Perspectives on Asian America*, ed. Emma Gee (Los Angeles: UCLA Asian American Studies Center, 1976), 63–80; Renqiu Yu, *To Save China, to Save Ourselves: The Chinese Hand Laundry*

Alliance of New York (Philadelphia: Temple University Press, 1992); Josephine Fowler, *Japanese and Chinese Immigrant Activists: Organizing in American and International Communist Movements, 1919-1933* (New Brunswick, N.J.: Rutgers University Press, 2007); and Alexander Saxton, *The Indispensable Enemy: Labor and the Anti-Chinese Movement in California* (Berkeley: University of California Press, 1971).

3. Sergei Tret'iakov, "Happy New Year! Happy *New Left*!" in *Russian Futurism Through Its Manifestos*, ed. Anna Lawton (Ithaca: Cornell University Press, 1988), 267.

4. On Tret'iakov as a Soviet cultural ambassador—traveling both East and West and combining cosmopolitanism and patriotism—see Clark, *Moscow*, 30–41.

5. Robert J. C. Young, *Postcolonialism: An Historical Introduction* (Oxford: Blackwell, 2001), 150–51; Jonathan D. Spence, *The Search for Modern China* (New York: Norton, 1999), 334–41; Michael Löwy, *The Politics of Combined and Uneven Development: The Theory of Permanent Revolution* (New York: Verso, 1981), 75–85. For Trotsky's criticism of Stalinist policy on China, see his *Problems of the Chinese Revolution*, ed. and trans. Max Shachtman (New York: Pioneer, 1932).

6. Anne Nesbet, *Savage Junctures: Sergei Eisenstein and the Shape of Thinking* (London: Tauris, 2003), 117.

7. Sergei Eisenstein, *Film Form: Essays in Film Theory*, ed. and trans. Jay Leyda (New York: Harcourt, 1949), 28–32. Sergei Eisenstein, "To the Magician of the Pear Orchard," in *S. M. Eisenstein: Selected Works, Volume III*, ed. Richard Taylor, trans. William Powell (London: British Film Institute, 1996), 67, quoted in Clark, *Moscow*, 201.

8. Sergei Tret'iakov, *Roar China* (New York: International, 1931), 8. Further references appear parenthetically in the text.

9. Devin Fore, introduction to *October* 118 (fall 2006): 4–5; Sergei Tret'iakov, "O p'ese 'Rychi, Kitai!'" in *Slyshish', Moskva?!*, ed. G. Mokrusheva (Moscow: Iskusstvo, 1965), 159, quoted (with a slightly different translation) in Natasha Kolchevska, "From Agitation to Factography: The Plays of Sergej Tret'jakov," *SEEJ* 31, no. 3 (autumn 1987): 395; Peter Bürger, *Theory of the Avant-Garde*, trans. Michael Shaw (Minneapolis: University of Minnesota Press, 2002), 69, 81.

10. Walter Benjamin, "The Author as Producer," in *Reflections: Essays, Aphorisms, Autobiographical Writings*, ed. Peter Demetz (New York: Schocken Books), 223, 229–31, 233, 234–235. For more on the Tret'iakov-Brecht connection, see Clark, *Moscow*, 50–67.

11. Maria Gough, "Paris, Capital of the Soviet Avant-Garde," *October* 101 (summer 2002): 64.

12. Hal Foster thus criticizes the belatedness of Benjamin's lecture, since 1934 spelled (quite literally, as will be seen) the death knell of avant-garde projects like Tret'iakov's. See Hal Foster, *The Return of the Real* (Cambridge, Mass.: MIT Press, 1996), 275n4. However, Gough responds that Benjamin was perfectly aware of this and that the lecture can be read as his protest against socialist realism; as an expression of his enduring hope for "an alternative, operativist model of left cultural production and materialist criticism—the path not taken by the Soviet Union but one that could nevertheless, he might have hoped, anticipate a worthier future" (Gough, "Paris," 83).

13. Benjamin H. D. Buchloh, "From Faktura to Factography," *October* 30 (fall 1984): 93–94.

14. Sergei Tret'iakov, "Happy New Year!" 267.

15. Leah Dickerman, "The Fact and the Photograph," *October* 118 (fall 2006): 137–38. For more on the cultural and political landscape of the late 1920s, particularly the avant-gardists' struggle for relevance and official support, see Sheila Fitzpatrick, "The 'Soft' Line on Culture and Its Enemies: Soviet Cultural Policy, 1922–1927," *Slavic Review* 33, no. 2 (June 1974): 267–87.

16. Buchloh, "From Faktura to Factography," 103. For more on the factographers' gradual embrace of iconic and documentary representation, see also pp. 95–99.

17. Sergei Tret'iakov, "What's New," in *Russian Futurism Through Its Manifestos*, ed. Anna Lawton (Ithaca: Cornell University Press, 1988), 270.

18. Ibid., 271.

19. Sergei Tret'iakov, "Biografiia veshchi," in *Literatura fakta*, ed. N. F. Chuzhak (Moscow: Federatsiia, 1929), 70.

20. Kolchevska, "From Agitation to Factography," 390–91.

21. Sergei Tret'iakov, "Ot fotoserii k dlitel'nomu fotonabliudeniiu," *Proletarskoe foto* 4 (1931): 20, quoted in Buchloh, "From Faktura to Factography," 108.

22. Dickerman, "The Fact and the Photograph," 144.

23. Ibid., 134; Maria Gough, "Radical Tourism: Sergei Tret'iakov at the Communist Lighthouse," *October* 118 (fall 2006): 176–78.

24. Sergei Tret'iakov, *Rychi, Kitai!* (Moscow: Ogonek, 1926), 3.

25. Ibid., 3–4. This and the following translation are my own and, as far as I can tell, are the first translations of "Roar, China!" the poem.

26. Ibid., 5.

27. Accordingly, another of Tret'iakov's Chinese works, *Den Shi-khua*, was what he called a bio-interview—a biography of one of his Chinese students but told from the student's point of view. Speaking with MoMA founder Alfred Barr in Moscow in 1927, he described it as "the most realistic and most intimate account of life in China." See Dickerman, "The Fact and the Photograph," 141.

28. Tret'iakov, "What's New," 269–70.

29. Tret'iakov's inclusion of Chinese corpses suggests his alignment with what Joseph Entin has identified (in his study of 1930s American writing and photography) as "sensational modernism." This refers to the use of "arresting and frequently disorienting images of bodily harm, sexual aggression, or racial prejudice to make palpable the unacknowledged forms of discrimination that give shape to conventional modes of seeing and representing the dispossessed." As Entin specifies, sensational modernism "departs from conventional social documentary" by subverting "the possibility of sentimentalizing and simplifying the socially inferior figures" it depicts. Tret'iakov forwards precisely this aim through his negative portrayals of the Westerners seeking corpse photos. Accordingly, though his strictly American focus does not reveal this, several of Entin's "sensational modernists"—e.g., Richard Wright, members of the New York Photo League—looked to Moscow for inspira-

tion. See Joseph Entin, *Sensational Modernism* (Chapel Hill: University of North Carolina Press, 2007), 27, 36.

30. Xiaobing Tang, *Origins of the Chinese Avant-Garde* (Berkeley: University of California Press, 2008), 223.

31. Walter J. Meserve and Ruth I. Meserve, "The Stage History of *Roar China!*: Documentary Drama as Propaganda," *Theatre Survey* 21 (1980): 4. Apparently Walter Benjamin did not see the play, but he reports in his diary seeing a model of its set at Meyerhold. See Walter Benjamin, *Moscow Diary*, ed. Gary Smith, trans. Richard Sieburth (Cambridge, Mass.: Harvard University Press, 1986), 57.

32. Konstantin Rudnitsky, *Russian and Soviet Theatre: Tradition and the Avant-Garde* (London: Thames and Hudson, 1988), 198.

33. Ibid., 197–98; Tret'iakov, *Roar China*, 10. In their capacity as official visitors to the USSR, these Chinese students were apparently off-limits as potential actors.

34. Tret'iakov, *Roar China*, 10.

35. Tret'iakov, "O p'ese 'Rychi, Kitai!' " 157.

36. Ibid., 158–59.

37. Scholars have recently traced and debated Tret'iakov's various phases as an artist through the 1920s—from agitation to literature of fact to operativism—but central to all of them is this effort to transform reality. Elizabeth Astrid Papazian suggests that, given its overt political thrust, *Roar China* the play should not be considered an example of the literature of fact, but that it instead emerges from Tret'iakov's earlier, agitational phase. However, she herself notes continuities between Tret'iakov's agitational and literature-of-fact phases—the latter, according to her, beginning the year before *Roar China*'s Meyerhold debut. See Elizabeth Astrid Papazian, *Manufacturing Truth: The Documentary Moment in Early Soviet Culture* (DeKalb: Northern Illinois University Press, 2009), 23–37. According to Papazian and Maria Gough, Tret'iakov's interest in the literature of fact later gave way to operativism, which involved the active participation of artists in the communities they depicted (e.g., Tret'iakov at the *kolkhoz*). Gough writes, "The operativist transcended the factographer's earlier valorization of the 'little report' over the belles lettrist . . . moving on instead to differentiate between two different kinds of reporters—the merely informative journalist on the one hand, and the operative writer on the other, who participates directly in the 'life of the material' in an organizational capacity: 'To invent an important theme is novelistic belles letters,' [Tret'iakov] explained, 'to discover an important theme is reportage,' but 'to contribute constructively to an important theme is operativism' " (Gough, "Radical Tourism," 168). However, Fore contends that operativism was in fact central to, rather than a departure from, factography. He defines "operativity" as factography's "claim not to vertically reflect reality . . . but to actively transform reality" (Fore, introduction to *October*, 3–4).

38. Kolchevska, "From Agitation to Factography," 395.

39. On factography and montage, see Papazian, *Manufacturing Truth*, 39–40. *Potemkin* and *Roar China* debuted within four days of each other in Moscow in January 1926. For more on the connections between the film and play, including structural and

thematic similarities, see Lars Kelberg, "Eisenstein's *Potemkin* and Tret'iakov's *Ry-chi, Kitai!*" *Scando-Slavica Tomus* 23 (1977): 29–37.

40. "A Director's Way with 'Roar China!' " *New York Times*, November 2, 1930, X2.

41. Kolchevska, "From Agitation to Factography," 395–96; Alaina Lemon, "Sympathy for the Weary State? Cold War Chronotopes and Moscow Others," *Comparative Studies in Society and History* 51, no. 4 (2009): 838. For more on the play's contrasting character depictions, see B. Rostotskii, "Dramaturg-agitator," in Tret'iakov, *Slyshish', Moskva?!*, 230–32. After praising the satirical, sarcastic takes on the Westerners, this essay notes that "nevertheless, Tret'iakov's foremost success consists of the rich, authentic dramatic effect in portraying the oppressed world" (231). As Rostotskii elaborates, these portrayals managed to present the Chinese as a unified mass without dissolving individual identities.

42. Similarly, Robert Crane notes that the naturalistic presentation of the Chinese "left many old stereotypes unchanged" and "underlined the perceived difference in the historical progress of the Soviet and Chinese nations" (Robert Crane, "Between Factography and Ethnography," *Text and Presentation, 2010*, ed. Kiki Gounaridou [Jefferson, N.C.: McFarland, 2010], 50.)

43. Accordingly, Bertolt Brecht's pro-Soviet play *Measures Taken* (1930) featured European characters agitating in China while wearing masks to pass as Chinese. As Katerina Clark writes, the mask here functions to downplay race and forward a "transnational identity": "At the point when the agitators put on their masks, they do not so much become Chinese as opt for *total* commitment to the Soviet model" (Clark, *Moscow*, 57). In Clark's book we also find a nice counterpoint to the naturalistic acting in *Roar China*—the 1935 Moscow performances of the Chinese actor Mei Lanfang, which helped inspire Brecht's "first published formulation of his theory of alienation" (192).

44. Colleen Lye, *America's Asia: Racial Form and American Literature, 1893-1945* (Princeton: Princeton University Press, 2005), 86–95. For instance, Lye notes how authors like Jack London and Frank Norris linked leftist criticisms of monopoly capitalism to the exclusion and, indeed, evisceration, of Asian populations.

45. Fritz Blockl, "Chinese Roar on Broadway," *Chicago American*, November 1, 1930, X2; *Roar China* program, "Silver" box 19 (13th season, 1930–1931), Theatre Guild Collection, Beinecke Library, Yale University. "Bequest of Langston Hughes" is stamped inside the first program, dated November 3, 1930.

46. Lynn Mally, "The Americanization of the Soviet Living Newspaper," *Carl Beck Papers in Russian and East European Studies* 1903 (February 2008): 30–40. "Cultural Front" comes from Michael Denning's seminal volume by the same name. To be sure, one of Denning's arguments is that Popular Front culture was not bound to the Soviet Union, though he himself acknowledges Meyerhold's influence on the American Living Newspaper. See Michael Denning, *The Cultural Front* (New York: Verso, 1997), 368–69. The fears of red-baiting having long passed, it seems safe now to delve deeper into such influences, as I'm doing here with *Roar China*.

47. Lawrence Langer, *The Magic Curtain* (New York: Dutton, 1951), 248–49. For more on Biberman, see James Lorence, *The Suppression of "Salt of the Earth": How Hollywood, Big Labor, and Politicians Blacklisted a Movie in Cold War America* (Albuquerque: University of New Mexico Press, 1999), 47–50.

48. Meserve and Meserve, "The Stage History of *Roar China!*" 8. The actor numbers have been counted from *Theatre Guild Program: Roar China* (New York: National Program Publishers, 1930), 8, 10.

49. "Making China Roar," *New York Times*, October 19, 1930, 116; Herbert Biberman to Ol'ga Tret'iakova, May 20, 1962, in Tret'iakov, *Slyshish', Moskva?!*, 166. *Roar China* "not only enabled Tsiang to earn fifty dollars a week, but also introduced him to the possibility of using drama as a vehicle to motivate political action" (Floyd Cheung, introduction to *And China Has Hands*, by H. T. Tsiang [New York: Ironweed, 2003], 10).

50. Leon Dennen, "'Roar China' and the Critics," *New Masses*, December 1930, 16; Myra Page, "'Roar China'—A Stirring Anti-Imperialist Play," *Daily Worker*, November 15, 1930, 4.

51. Biberman to Tret'iakova, May 20, 1962, 167.

52. "New Plays in Manhattan," *Time*, November 10, 1930; J. Brooks Atkinson, "The Play," *New York Times*, October 28, 1930, 31.

53. "Roar China!" script, 1–6, Theatre Guild Collection, Beinecke Library.

54. As Crane suggests, the Moscow production's use of "butchered Russian" arguably had the effect of "relegating the Chinese characters to the stereotyped speech used to represent Asians for years" ("Between Factography and Ethnography," 48–50).

55. Gilbert W. Gabriel, "Roar China," *New York American*, October 28, 1930. He adds that, nonetheless, the Asian actors "are fine to watch and wonder about" and that their roles are "interestingly acted." There is some indication that Biberman tried to get the actors to speak unaccented English. One reporter, sitting in on a rehearsal, objects to Biberman's demand that the Asian actors "express emotions in the accent and cadence—or lack of accent and cadence—that we use, emphasizing the words that we emphasize." See Louis Sherwin, "Stage Art of Occident, Orient Fused in Chinese Play Here," *New York Evening Post*, October 15, 1930.

56. Gilbert Swan, "Roar China," NEA Syndicate, November 1930. Biberman to Tret'iakova, May 20, 1962, 167. For instance, as Anne Cheng has shown in her discussion of *Flower Drum Song*'s film adaptation, the Rodgers and Hammerstein musical forwards an Americanism that is "at once reproduced and disturbed by the racialized bodies solicited to articulate its desires." That is, Asian American performance in the film has an unmasking effect; it "reveals Americanism to be a performative phenomenon" (Anne Anlin Cheng, *The Melancholy of Race: Psychoanalysis, Assimilation, and Hidden Grief* [New York: Oxford University Press, 2000], 59). The Asian American performances in *Roar China* apparently lacked such nuance, geared as they were to portraying China and condemning imperialism rather than the more subtle task of engaging American assimilationism. Unfortunately, it remains unclear whether many Asian Americans were in the audience as well as on stage. I have found one glowing review in *The*

Chinese Students' Monthly: "Not once in my life have I experienced so much anguish in a theater as I did in attending this play last night," wrote the anonymous reviewer, who described the execution scene as such: "It was tremendously pathetic and was so human and real. I felt it—and it hurted [*sic*] me badly" ("Roar China," *Chinese Students' Monthly* 26, no. 1:126–27).

57. Biberman to Tret'iakova, May 20, 1962, 170.

58. "A Director's Way," X2.

59. J. Brooks Atkinson, "When the Guild Is Good," *New York Times*, November 9, 1930, X1; "New Plays in Manhattan," *Time*, November 10, 1930.

60. Page, "Roar China," 4; "A Director's Way," X2.

61. Biberman to Tret'iakova, May 20, 1962, 168.

62. George Lipsitz, "Herbert Biberman and the Art of Subjectivity," *Telos* 32 (1977): 180.

63. Foster, *The Return of the Real*, 172–74.

64. Meserve and Meserve, "The Stage History of *Roar China!*" 4, 6, 8, 9.

65. Ibid., 6.

66. Tang, *Origins of the Chinese Avant-Garde*, 225.

67. Ibid., 219.

68. Ibid., 226.

69. Meserve and Meserve, "The Stage History of *Roar China!*" 10.

70. Langston Hughes, "Roar, China!" *Volunteer for Liberty* 1 (September 6, 1937): 3.

71. Langston Hughes, *I Wonder as I Wander: An Autobiographical Journey* (New York: Hill and Wang, 1956), 206.

72. Hughes, "Roar, China!" 3.

73. For documentation of Tret'iakov's execution by firing squad, see V. F. Koliazin, ed., *"Vernite mne svobodu!": Deiateli literatury i iskusstva Rossii i Germanii—zhertvy stalinskogo terrora* (Moscow: Medium, 1997), 46–68.

74. Ellen Schrecker, *Many Are the Crimes: McCarthyism in America* (Princeton: Princeton University Press, 1998), 332–34. See also Lorence, *The Suppression of "Salt of the Earth,"* 65–147.

75. Paul Jarrico and Herbert Biberman, "Breaking Ground," in *Salt of the Earth*, ed. Deborah Silverton Rosenfelt (New York: Feminist Press, 1978), 169–70.

76. Masha Salazkina, "Moscow-Rome-Havana: A Film-Theory Road Map," *October* 139 (winter 2011): 97–116. As Salazkina points out, neorealism's emphasis on transforming reality "recapitulates almost exactly the Soviet factographic notion of realism" (108).

77. Lipsitz, "Herbert Biberman and the Art of Subjectivity," 178; Lorence, *The Suppression of "Salt of the Earth,"* 197–98.

78. Deborah Silverton Rosenfelt, "Commentary," in *Salt of the Earth*, ed. Deborah Silverton Rosenfelt (New York: Feminist Press, 1978), 148.

79. Ibid., 153. Further emphasizing *Salt of the Earth*'s avant-gardist credentials, David E. James notes its Brechtian didactic structure, which "finally differentiates the film from classic realism." For instance, "each stage of its progressive unfolding of a vision of sexual equality is a little dramatic lesson that the men must learn before go-

ing on to the next stage, like Brecht's idea of the *Lehrstücke*, a 'learning play,' whose 'task is to show the world as it changes (and also how it may be changed)'" (David E. James, *The Most Typical Avant-Garde: History and Geography of Minor Cinemas in Los Angeles* [Berkeley: University of California Press, 2005], 124). As noted, Tret'iakov was Brecht's Russian translator and collaborator, opening the possibility that this didactic structure was not only Brechtian but Tret'iakovian as well.

80. Rosenfelt, "Commentary," 147.

81. Herbert Biberman, *Salt of the Earth: The Story of a Film* (Boston: Beacon Press, 1965), 44–46.

82. Benjamin Buchloh traces factography's demise to 1931, the year that one of Tret'iakov's colleagues, Aleksandr Rodchenko, photographed the construction of the White Sea Canal. This was one of Stalin's most ambitious and inhumane undertakings, with over 100,000 losing their lives because of poor working conditions. However, Rodchenko chose to emphasize monumentality rather than fragments and limited perspectives, and, as a result, his photos portrayed working conditions only as ideal. Buchloh writes, "While it is undoubtedly clear that at this time Rodchenko did not have any other choice than to comply with the interest of the State Publishing House if he wanted to maintain his role as an artist who participated actively in the construction of the new Soviet society (and we have no reason to doubt this as his primary motive), we have to say at least that by 1931 the goals of factography had clearly been abandoned" (Buchloh, "From Faktura to Factography," 117). The implication here is that a faithful adherence to factography would have revealed the horrors of the canal's construction.

83. Jonathan Flatley, *Affective Mapping: Melancholia and the Politics of Modernism* (Cambridge, Mass.: Harvard University Press, 2008), 68–75.

84. Lipsitz, "Herbert Biberman and the Art of Subjectivity," 175. To add insult to injury and despite several key victories, the union depicted in *Salt of the Earth* faced endless legal battles and merged with a rival, anticommunist union in 1967. See Schrecker, *Many Are the Crimes*, 355–58.

85. Biberman to Tret'iakova, May 20, 1962, 172–73.

3. From Avant-Garde to Authentic

1. Arnold Rampersad, *The Life of Langston Hughes* (New York: Oxford University Press, 2002), 1:259; David Chioni Moore, "Local Color, Global 'Color': Langston Hughes, the Black Atlantic, and Soviet Central Asia, 1932," *Research in African Literatures* 27, no. 4 (winter 1996): 61.

2. Langston Hughes, *I Wonder as I Wander: An Autobiographical Journey* (New York: Hill and Wang, 1956), 113–21; Arthur Koestler, *The Invisible Writing* (New York: Vintage, 2005), 137–41. Further references to both works are inserted parenthetically in the text. See also David Chioni Moore, "Colored Dispatches from the Uzbek Border," *Callaloo* 25, no. 4 (fall 2002): 1115–1135.

3. Arguably Koestler here deploys the rhetoric of colonialism—the Soviet Union as "backward," "Asiatic," and unfit for Marxist revolution. See Kate Baldwin, *Beyond the Color Line and the Iron Curtain: Reading Encounters Between Black and Red, 1922-1963* (Durham: Duke University Press, 2002), 110–16; William Pietz, "The 'Post-Colonialism' of Cold War Discourse," *Social Text*, no. 19/20 (autumn 1988): 62–65; and Jodi Kim, *Ends of Empire: Asian American Critique and the Cold War* (Minneapolis: University of Minnesota Press, 2010), 40–48. However, as noted in the introduction, notions of "backwardness" and "Asianness" were also used to further the revolution, albeit more so in the 1920s than in the 1930s.

4. Co-Operating Committee for Production of a Soviet Film on Negro Life, Project Summary, n.d., box 12, folder 6, item 11; W. A. Domingo, Bon Voyage Invitation, 31 May 1932, box 12, folder 3, item 8, Louise Thompson Patterson Papers, Manuscript, Archives, and Rare Book Library, Emory University.

5. "On Way to Soviet Union to Make a Photoplay," *Liberator*, July 1, 1932, 6.

6. Rampersad, *The Life of Langston Hughes*, 1:248, 251. Statement by McNairy Lewis et al., 22 August 1932, box 2, item 2, Louise Thompson Patterson Papers; "Say Race Bias Here Halted Soviet Film," *New York Times*, October 5, 1932. The accuracy of these rumors is discussed later in the chapter.

7. Langston Hughes, "A Negro Sees the Soviet Union," *Harlem Liberator*, September 16, 1933, published also as Langston Hughes, "Moscow and Me: A Noted American Writer Relates His Experiences," *International Literature*, no. 3 (July 1933): 60–66.

8. Hughes, *I Wonder as I Wander*, 76–79; emphasis in original.

9. RGALI, f. 631, op. 3, ed. khr. 2, l. 8, 77, 102–3, 113–15.

10. According to Glenda Gilmore, Hughes "conceded he had written the sparse dialogue" for this fourth version, which is written in clean American English with occasional instances of dialect. See Glenda Elizabeth Gilmore, *Defying Dixie: The Radical Roots of Civil Rights, 1919-1950* (New York: Norton, 2008), 140–41.

11. "Black and White" Script, n.d., box 2, item 3, Louise Thompson Patterson Papers, 29, 31.

12. With its lack of character development and abrupt scene transitions, the English-language version is indeed marked by "defects of the plot and continuity," unlike the more cohesive, realized Grebner version. This raises the question of why Junghans did not simply use Grebner's version, and the reason seems to be creative differences, to which Grebner refers in his notes. See RGALI, f. 631, op. 3, ed. khr. 2, l. 86, 93, 101. According to a report by Louise Thompson, on July 25, 1932, a meeting (with Hughes present) was held by Mezhrabpomfil'm to discuss the two versions, and a "large section" of the studio's officials preferred Grebner's. The report adds that this version was "full of inaccuracies regarding American life" without elaborating what they were. I do so in the following. See Report on Film Cancellation, n.d., box 2, item 4, Louise Thompson Patterson Papers.

13. I draw here from Svetlana Boym's distinction between "reflective" and "restorative" nostalgia in her *The Future of Nostalgia* (New York: Basic Books, 2001).

14. RGALI, f. 631, op. 3, ed. khr. 2, l. 22–23.

15. RGALI, f. 2014, op. 1, ed. khr. 61, l. 4.
16. Hughes, *I Wonder as I Wander*, 76; RGALI, f. 631, op. 3, ed. khr. 2, l. 6, 26, 73, 115; RGALI, f. 2014, op. 1, ed. khr. 61, l. 3, 4. Emphasis in original. Grebner apparently maintained his commitment to accuracy throughout his career. A 1966 Soviet film encyclopedia hails him for his "careful selection of facts" as well as his "efforts to achieve artistic completeness through the maintenance of historic truth" (*Kinoslovar' v dvukh tomakh* [Moscow: Sovetskaia entsiklopediia, 1966], 382). On the substantial printed materials about Africans and African Americans available in Moscow at the time, see Ani Mukherji, "The Anticolonial Imagination" (Ph.D. diss., Brown University, 2011), 111–12.
17. Grebner adds, "What remains unchanged is just the curly hair and characteristic 'Negro' facial constitution (in the end, not so rare even among representatives of the Caucasian race)." Interestingly, Grebner here exchanges one biological essentialism for another but also suggests that African physical characteristics need not be seen as exclusive. By "Caucasian," Grebner refers to Soviet nationalities located in the Caucasus, such as Armenians, Chechens, and Georgians. See RGALI, f. 2014, op. 1, ed. khr. 61, l. 4. For tensions between African Americans and Soviet essentialism—for instance, Moscow's tendency to use individuals like Claude McKay and Paul Robeson to represent blacks worldwide—see Baldwin, *Beyond the Color Line*, 48, 208–11, 242–51.
18. RGALI, f. 631, op. 3, ed. khr. 2, l. 1–6. As Joseph Entin has shown, this combination of avant-gardist shock and social concern appeared in interwar America in the form of "sensational modernism," as seen, for instance, in the work of the New York Photo League's 1930s photos of Harlem. See Joseph Entin, *Sensational Modernism* (Chapel Hill: University of North Carolina Press, 2007), 107–40. When *Black and White* was canceled, the (predominantly Jewish) League released a statement in support of Mezhrabpom, with which it was affiliated. See "Apropos Soviet Negro Film," *New Masses*, November 1932, 28.
19. RGALI, f. 631, op. 3, ed. khr. 2, l. 7, 87, 111, 115.
20. Robin D. G. Kelley, *Hammer and Hoe: Alabama Communists During the Great Depression* (Chapel Hill: University of North Carolina Press, 1990), 17.
21. RGALI, f. 631, op. 3, ed. khr. 2, l. 37. On the international reception of the Scottsboro case, see James Miller et al., "Mother Ada Wright and the International Campaign to Free the Scottsboro Boys," *American Historical Review* 106, no. 2 (April 2001): 387–430.
22. Kelley, *Hammer and Hoe*, 17, 28, 101–2. See also Gilmore, *Defying Dixie*, 67–154, and Mark Solomon, *The Cry Was Unity: Communists and African Americans, 1917–1936* (Jackson: University Press of Mississippi, 1998), 112–46.
23. RGALI, f. 631, op. 3, ed. khr. 2, l. 115.
24. Shelley Fisher Fishkin, "Interrogating 'Whiteness,' Complicating 'Blackness': Remapping American Culture," *American Quarterly* 47, no. 3 (September 1995): 428.
25. RGALI, f. 631, op. 3, ed. khr. 2, l. 70.
26. Michael North, *The Dialect of Modernism: Race, Language, and Twentieth-Century Literature* (New York: Oxford University Press, 1998), 3–34.

27. W. E. B. Du Bois, "Criteria of Negro Art," in *African American Literary Theory: A Reader*, ed. Winston Napier (New York: New York University Press, 2000), 22–23; W. E. B. Du Bois, *The Souls of Black Folk*, ed. David W. Blight and Robert Gooding-Williams (Boston: Bedford Books, 1997), 188–89; Langston Hughes, "The Negro Artist and the Racial Mountain," in Napier, *African American Literary Theory*, 28, 30.

28. Robert Gooding-Williams, *In the Shadow of Du Bois: Afro-Modern Political Thought in America* (Cambridge, Mass.: Harvard University Press, 2011). On the multiple, flexible notions of black authenticity, see J. Martin Favor, *Authentic Blackness: The Folk in the New Negro Renaissance* (Durham: Duke University Press, 1999), 1–23. For a more radical, Benjaminian reading of Du Bois's sorrow songs chapter, see Jonathan Flatley, *Affective Mapping: Melancholia and the Politics of Modernism* (Cambridge, Mass.: Harvard University Press, 2008), 131–57. According to Flatley—and arguably in line with various theories of the avant-garde—Du Bois's treatment of the songs resists the notion of autonomous culture and also points to instances of the past redeemed in the present.

29. Richard Wright, "Blueprint for Negro Writing," in Napier, *African American Literary Theory*, 51.

30. See the discussions of Soviet Orientology (Tolz) and nationalities policy (Hirsch) in the introduction. For more on Wright's "movement from fear to relative faith on the subject of African-American folk culture, movement fueled mainly by Communism," see William Maxwell, *New Negro, Old Left: African-American Writing and Communism Between the Wars* (New York: Columbia University Press, 1999), 164–65, 170–78.

31. A key dissenting voice is Andreas Huyssen, who defines avant-gardism as eliminating the division between high art and mass culture. Accordingly, both Mayakovsky and Tret'iakov sought (and, in Mayakovsky's case, attained) mass appeal; they weren't opposed to mass culture per se but to mass culture tainted by market forces. See Andreas Huyssen, *After the Great Divide: Modernism, Mass Culture, Postmodernism* (Bloomington: Indiana University Press, 1986).

32. James Smethurst, *The New Red Negro: The Literary Left and African American Poetry, 1930–1946* (New York: Oxford University Press, 1999), 29–30.

33. Ibid., 60–82.

34. Michael Gold, "Notes of the Month," *New Masses*, February 1930, 3, quoted in Maxwell, *New Negro, Old Left*, 107.

35. Ibid.; Barbara Foley, *Radical Representations: Politics and Form in U.S. Proletarian Fiction, 1929–1941* (Durham: Duke University Press, 1993), 185. For another variation of "Gimme That Old Time Religion," with lyrics about the Scottsboro trial, see Kelley, *Hammer and Hoe*, 105. Gold could also embrace jazz as long as it "belong[ed] to the Negro race" and not Tin Pan Alley. See Maxwell, *New Negro, Old Left*, 110.

36. Lawrence Gellert, "Negro Songs of Protest," *New Masses*, May 1933, 15.

37. Du Bois, *The Souls of Black Folk*, 38.

38. Du Bois anticipates his own turn to the left when he writes, "Such a double life, with double duties, and double social classes, must give rise to double words and double ideals, and tempt the mind to pretence or to revolt, to hypocrisy or to radi-

calism." However, at this point he was not ready to abandon religion, detecting a "deep religious feeling of the real Negro heart" (ibid., 156, 158).

39. L. Filatova, "Negritianskaia literatura," in *Literaturnaia entsiklopediia, tom 7*, ed. A. V. Lunacharsky (Moscow: Sovetskaia entsiklopediia, 1934), 662–65. Filatova detects and celebrates a connection between Paul Laurence Dunbar's use of dialect and that used by Hughes and Brown (652–54).

40. Arnold Rampersad, "Langston Hughes and His Critics on the Left," *Langston Hughes Review* 5, no. 2 (fall 1986): 38.

41. RGALI, f. 631, op. 3, ed. khr. 2, l. 25, 52, 87. Providing support to Grebner's depiction and choice of music, Gellert writes in April 1931, "The Negro preacher differs little from the white one. He is a pompous, fat-headed, blow-hard parasite, prating meaningless platitudes about 'de Lawd an' his By an' By Kingdom.'" Gellert then provides what he calls "the Negro's version of Joe Hill's 'Pie in the Sky,'" though the two are similar only in their riffs against religion. See Lawrence Gellert, "Negro Songs of Protest," *New Masses*, April 1931, 6.

42. RGALI, f. 631, op. 3, ed. khr. 2, l. 88.

43. Ibid., l. 21, 24, 25. Emphasis in original.

44. Ibid., l. 55. This and subsequent translations are my own.

45. Ibid., l. 56.

46. Ibid., l. 101–2.

47. Ibid., l. 101.

48. Ibid., l. 103.

49. Ibid., l. 103, 106.

50. At one point, Vorbi likens Brooker's case to the 1913 Beilis trial, in which a Jewish man was accused of murdering a Christian boy in Kiev. According to Vorbi, the persecution of Brooker for violating "the honor of a lady" is akin to the pogromist accusation of "blood libel," only on an "American scale [*masshtabe*]" (ibid., l. 37).

51. Likewise (though not nearly as innovative as the Vertov), the hit 1936 film musical *Tsirk*—in which a white American woman with a half-black baby finds refuge as a Soviet circus performer—concludes with a Russian lullaby that is sung in the multiple languages of the USSR to the accompaniment of national embellishments. For instance, a Jewish man singing in Yiddish is accompanied by a klezmer stylization, and a black man singing in American-accented Russian is accompanied by a blues horn. Interestingly, the half-black baby was played by the child of Lloyd Patterson, a member of the *Black and White* group who stayed behind in Moscow to work as a set designer, marrying a Russian woman. See Karen Kossie-Chernyshev, "Reclaiming 'Д. Паттерсон' (J. Patterson), Child Star in Grigori Alexandrov's *Circus*: A Reconstructive History," *Sound Historian* 8, no. 2 (2002): 61–72. On the careers of actor Wayland Rudd and writer Homer Smith, two other members of the *Black and White* group who remained in Moscow, see Mukherji, "The Anticolonial Imagination," 166–91.

52. RGALI, f. 631, op. 3, ed. khr. 2, l. 101.

53. Francine Hirsch, *Empire of Nations: Ethnographic Knowledge and the Making of the Soviet Union* (Ithaca: Cornell University Press, 2005), 9. However, Katerina Clark has shown

that even amid Stalinist centralization, Moscow remained "a center for a trans-national intellectual milieu," with, for instance, the African American icon Paul Robeson giving Marcel Granet's *La pensée chinoise* to Sergei Eisenstein as a birthday gift in 1935. Ultimately, however, Clark traces Moscow's failure to remain a nexus of world culture in the face of state terror, even as she deftly blurs the boundaries between Stalinism and Western modernism. See Katerina Clark, *Moscow, the Fourth Rome: Stalinism, Cosmopolitanism, and the Evolution of Soviet Culture, 1931-1941* (Cambridge, Mass.: Harvard University Press, 2011), 25.

54. Indeed, African American delegates to the 1928 Comintern Congress heatedly debated the prospects of a "Negro Soviet Republic" in the American South, the majority noting the complications posed to the Black Belt thesis by industrialization and migration. For a re-creation of this debate, marked heavily by American and Soviet party factionalism, see Solomon, *The Cry Was Unity*, 69–78.

55. Woodford McClellan, "Africans and Black Americans in the Comintern Schools, 1925-1934," *International Journal of African Historical Studies* 26, no. 2 (1993): 383–84; Solomon, *The Cry Was Unity*, 175; Gilmore, *Defying Dixie*, 146.

56. Although Cooper lobbied Vyacheslav Molotov, not Stalin. See Solomon, *The Cry Was Unity*, 175; McClellan, "Africans and Black Americans," 383. From the American side, Hughes biographer Faith Berry quotes in full an August 1932 State Department memo emphasizing Cooper's role in the film's cancellation. See Faith Berry, *Langston Hughes: Before and Beyond Harlem* (Westport, Conn.: Hill, 1983), 168–70. For the Dnieprostroi visit, see Soviet Travel Itinerary, n.d., box 1, folder 21, item 1, Louise Thompson Patterson Papers.

57. Report on Film Cancellation, n.d., box 2, item 4, Louise Thompson Patterson Papers. Presumably they read the English-language Junghans script stored among Thompson's papers.

58. Otto Katz to Louise Thompson, November 8, 1932, box 9, folder 21, item 6, Louise Thompson Patterson Papers. For other failed Mezhrabpomfil'm projects from the 1930s, see Katie Trumpener, *The Divided Screen: The Cinemas of Germany, 1930-* (Princeton: Princeton University Press, forthcoming).

59. Indeed, this very charge was leveled against Hughes after his participation in the Hollywood musical *Way Down South* (1939), which celebrates happy slaves and kind masters.

60. Rampersad, *The Life of Langston Hughes*, 2:216.

61. Ibid., 218–19.

62. Ibid., 216–17.

63. Ibid., 218–20, 260.

64. B. A. Gilenson, *Sovremennye negritianskie pisateli SShA* (Moscow: Znanie, 1981), 39–40.

65. This bibliography lists a select few Russian translations of African American authors, including works by Du Bois, Hughes, James Baldwin, and Lorraine Hansberry (ibid., 64). Wright and (more briefly) Ellison are, however, among the many more authors discussed by the Soviet critic.

66. Henry Louis Gates Jr. defines African American "signifyin(g)" as "essentially, a technique of repeating inside quotation marks in order to reverse or undermine pretended meaning, constituting an implicit parody of a subject's complicity." See Henry Louis Gates Jr., *Figures in Black: Words, Signs, and the "Racial" Self* (New York: Oxford University Press, 1989), 240, quoted in Dale E. Peterson, *Up from Bondage: The Literatures of Russian and African American Soul* (Durham: Duke University Press, 2000), 191. For connections between "signifyin(g)" and Mikhail Bakhtin's notion of "double-voiced discourse," see Henry Louis Gates Jr., *The Signifying Monkey: A Theory of Afro-American Literary Criticism* (New York: Oxford University Press, 1989), 110–13, and Peterson, *Up from Bondage*, 191–94.
67. Gilmore, *Defying Dixie*, 34–36, 43–45. On the founding of the ANLC, see Solomon, *The Cry Was Unity*, 46–49.
68. Harry Haywood, *Black Bolshevik: Autobiography of an Afro-American Communist* (Chicago: Liberator, 1978), 144–47; Gilmore, *Defying Dixie*, 47, 53.
69. Solomon, *The Cry Was Unity*, 58, 64–65. Fort-Whiteman was sensitive to black particularity, but in ways that diverged from the Soviet line. As Baldwin notes, in Moscow in 1924, he expressed surprise and dismay about the use of "caricatured faces of Negroes" in Russian ads, writing to the Comintern, "Though there be no anti-Negro feeling behind it, the results are the same." He also objected to the Comintern's very use of the term "Negro," stating that this collapsed together the "many distinct black races on the African continent." See Baldwin, *Beyond the Color Line*, 47, 65–66.
70. Louise Thompson to Mother Thompson, July 4, 1932, box 1, folder 24, item 4, Louise Thompson Patterson Papers. Later, Hughes and another invitee were advised to cable Fort-Whiteman in Moscow with questions, and a June 11 press release promoting the film listed him as a coscenarist. See Louise Thompson to Langston Hughes, March 10, 1932, box 12, folder 7, item 12, Louise Thompson Patterson Papers; Louise Thompson to Langston Hughes, May 10, 1932, box 12, folder 7, item 12, Louise Thompson Patterson Papers; Homer Smith to James Ford, April 28, 1932, box 12, folder 3, item 8, Louise Thompson Patterson Papers; Press Release to *The Amsterdam News*, June 11, 1932, box 12, folder 6, item 11, Louise Thompson Patterson Papers; RGALI, f. 631, op. 3, ed. khr. 2, l. 25. Grebner makes no other mention of Fort-Whiteman, suggesting that his involvement with the script was limited.
71. Louise Thompson to Mother Thompson, August 24, 1932, box 1, folder 24, item 4, Louise Thompson Patterson Papers. See also Gilmore, *Defying Dixie*, 144–47.
72. Harvey Klehr, Jon Earl Haynes, and Kyrill M. Anderson, *The Soviet World of American Communism* (New Haven: Yale University Press, 1998), 218–27. The firsthand account of Fort-Whiteman's Hughes criticism is taken from the disillusioned autobiography of Robert Robinson, an autoworker who lived in the Soviet Union from 1930 to 1975. See Robert Robinson, *Black on Red: My 44 Years Inside the Soviet Union* (Washington, D.C.: Acropolis, 1988), 361.
73. Gilmore, *Defying Dixie*, 140, 154. For other accounts of the Fort-Whiteman tragedy, see Maxwell, *New Negro, Old Left*, 70; Baldwin, *Beyond the Color Line*, 272–73n44; Joy

Gleason Carew, *Blacks, Reds, and Russians: Sojourners in Search of the Soviet Promise* (New Brunswick, N.J.: Rutgers University Press, 2008), 179–83; and Mukherji, "The Anticolonial Imagination," 192–94.

74. Gilmore, *Defying Dixie*, 444.

4. Cold War Pluralism

1. Indeed, Freeman is the central figure in Daniel Aaron's foundationa. study of this scene, a figure who can certainly be described as an ethnic avant-gardist. According to Aaron, "The epic films of Eisenstein, the productions of Meyerhold, the poetry of Mayakovski projected the socialist vision in images that Freeman could accept." The Soviet avant-garde convinced him that "one could be an artist and a revolutionary . . . without violating artistic integrity." As I discuss later, Alan Wald's own seminal studies on the American literary left have subsequently enfolded Jewishness into this mix of socialism and avant-gardism. See Daniel Aaron, *Writers on the Left: Episodes in American Literary Communism* (New York: Columbia University Press, 1992), 138. *New Masses* editor Michael Gold is now typically regarded as an advocate of "proletarian" and socialist realist literature, but he too was drawn to the Soviet avant-garde, for instance, the theater of Meyerhold. See William Maxwell, *New Negro, Old Left: African-American Writing and Communism Between the Wars* (New York: Columbia University Press, 1999), 112–13.

2. Based on David Bergelson's "Three Centers" article (1925); see Gennady Estraikh, *In Harness: Yiddish Writers' Romance with Communism* (Syracuse: Syracuse University Press, 2005), 78–79.

3. Ibid., 71; Ruth Wisse, *A Little Love in Big Manhattan: Two Yiddish Poets* (Cambridge, Mass.: Harvard University Press, 1988), 113–14, 155. See also Dovid Katz, "The Days of Proletpen in American Yiddish Poetry," introduction to *Proletpen: American Rebel Yiddish Poets*, ed. Amelia Glaser and David Weintraub, trans. Amelia Glaser (Madison: University of Wisconsin Press, 2005), 7–8. As Katz writes, another such publication was the literary magazine *Yung kuznye* (*Young Forge*), founded in 1924 (18–20).

4. Wisse, *A Little Love in Big Manhattan*, 130.

5. Kenneth B. Moss, *Jewish Renaissance in the Russian Revolution* (Cambridge, Mass.: Harvard University Press, 2009); Estraikh, *In Harness*, 168–74.

6. Liberal pluralism was Kallen's cultural pluralism but stripped of its essentialist "natio," territorial emphasis, and curious compatibility with Soviet nationalities policy. Added to the mix was the conviction that formal equality and cultural recognition would eliminate racism. On the other hand, socialist internationalism, which in the 1920s encompassed the Comintern's coordinated world revolution and anti-imperialist policies, quickly came to mean simply allegiance to Moscow and adherence to Soviet nationalities policy. As Slezkine puts it, within the USSR "internationalism" came to mean "close ties among Soviet nationalities." See Yuri Slezkine, "The USSR as a Communal Apartment, or How a Socialist State Promoted

Ethnic Particularism," *Slavic Review* 53, no. 2 (summer 1994): 443. Lending further credence to this liberal pluralism versus socialist internationalism divide, Perry Anderson writes that Stalin's dissolution of the Comintern in 1943 led to the post-war bifurcation of internationalism—with a capitalist variety forming in the West against a communist variety in the East. See Perry Anderson, "Internationalism: A Breviary," *New Left Review* 14 (March–April 2002): 15–16, 18. For a Western "internationalism" that has sought to sidestep state interference, see Akira Iriye, *Cultural Internationalism and World Order* (Baltimore: Johns Hopkins University Press, 1997).

7. For example, in 1947 the Soviet Union submitted to the United Nations "An Appeal to the World: A Statement on the Denial of Human Rights to Minorities in the Case of Citizens of Negro Descent in the United States of America," an NAACP petition edited by W. E. B. Du Bois. As Mary Dudziak has shown, Moscow's airing of America's dirty laundry helped win the passage of civil rights reforms. In turn, several Washington officials sought to bring the plight of Soviet Jews before the UN, and during Nikita Khrushchev's 1959 visit to the United States, Dwight Eisenhower "himself expressed the concern of American Jewry about the position of their brethren in the USSR." See Mary Dudziak, *Cold War Civil Rights: Race and the Image of American Democracy* (Princeton: Princeton University Press, 2000), 12, 15, 26–46. For more on Jim Crow as America's "Achilles' heel" on the world stage, see Penny Von Eschen, *Race Against Empire: Black Americans and Anticolonialism, 1937–1957* (Ithaca: Cornell University Press, 1997), 126. See also Yaacov Ro'i, *The Struggle for Soviet Jewish Emigration, 1948–1967* (Cambridge: Cambridge University Press, 1991), 133, 151–53.

8. For connections between African American and Jewish American liberal anticommunism, see Cheryl Lynn Greenberg, *Troubling the Waters: Black-Jewish Relations in the American Century* (Princeton: Princeton University Press, 2006), 169–204. Greenberg subsequently traces how this black-Jewish consensus fell apart, which is also the focus of Eric Sundquist, *Strangers in the Land: Blacks, Jews, Post-Holocaust America* (Cambridge, Mass.: Harvard University Press, 2005). As I demonstrate, the subjects of this chapter—unlike Greenberg's and Sundquist's—did not necessarily take liberal pluralism as a given, allowing us to revisit forgotten, discredited alternatives to this model.

9. Arnold Rampersad, *The Life of Langston Hughes* (New York: Oxford University Press, 2002), 2:216–17.

10. Ibid., 1:30; Langston Hughes, *Good Morning Revolution: Uncollected Writings of Social Protest*, ed. Faith Berry (New York: Citadel, 1973), 87.

11. Yuri Slezkine, *The Jewish Century* (Princeton: Princeton University Press, 2004), 216, 260. For other accounts of Jewish American ties to the Soviet Union, see Estraikh, *In Harness*, 70–101; Katz, "The Days of Proletpen," 4–22; and Tony Michels, *A Fire in Their Hearts: Yiddish Socialists in New York* (Cambridge, Mass.: Harvard University Press, 2005), 217–50, 256.

12. David A. Hollinger, "Rich, Powerful, and Smart: Jewish Overrepresentation Should Be Explained Instead of Avoided or Mystified," *Jewish Quarterly Review* 4, no. 4 (fall

2004): 595–602; reprinted in David A. Hollinger, *Cosmopolitanism and Solidarity: Studies in Ethnoracial, Religious, and Professional Affiliation in the United States* (Madison: University of Wisconsin Press, 2006), 154–65; quote from p. 162.

13. Slezkine, *The Jewish Century*, 175. Further references appear parenthetically in the text.

14. Alan M. Wald, *Trinity of Passion: The Literary Left and the Antifascist Crusade* (Chapel Hill: University of North Carolina Press, 2007), 180. Further references are given parenthetically in the text.

15. Karl Marx, "On the Jewish Question," in *The Marx-Engels Reader*, ed. Robert C. Tucker (New York: Norton, 1978), 52. Emphasis in original.

16. Slezkine's sweeping observation neglects, for example, the theme of familial devotion in Michael Gold's *Jews Without Money* (1930). Indeed, while Gold changed his name from Itzok Granich, in doing so he "affirmed his Jewish background" rather than broke from it, as Wald points out (*Trinity of Passion*, 184). On the other hand, one clear aim of *Jews Without Money* is to distance Jewishness from "huckstering." See Michael Gold, *Jews Without Money* (New York: Liveright, 1930).

17. In line with the "Jewish Revolution" against Jewishness, Wald also provides portraits of Jewish American communist writers who fought in the International Brigades during the Spanish Civil War, their war novels challenging "the popular idea that twentieth-century Jewish American culture primarily carries forward the 'ethic of mentshlekhkayt.'" However, Wald ultimately assigns blame for literary intragroup violence to "the bitter contradictions of the Popular Front" rather than Jewish familial strife. See Wald, *Trinity of Passion*, 22, 28, 45.

18. Slezkine, *The Jewish Century*, 264. "Avant-garde of the world" comes from Marci Shore's account of Polish Jews who embraced Soviet communism and the tragedies that ensued. See Marci Shore, *The Taste of Ashes: The Afterlife of Totalitarianism in Eastern Europe* (New York: Crown, 2013).

19. Estraikh, *In Harness*, 39, 41.

20. Haia Friedberg, "Lissitzky's *Had Gadîa*,'" *Jewish Art* 12/13 (1986–1987): 294.

21. Ruth Apter-Gabriel, "El Lissitzky's Jewish Works," in *Tradition and Revolution: The Jewish Renaissance in Russian Avant-Garde Art, 1912–1928*, ed. Ruth Apter-Gabriel (Jerusalem: Israel Museum, 1987), 104.

22. Ibid., 113. Many thanks to Dan Blanton for the Book of Daniel connection.

23. Abram Efros, "Aladdin's Lamp," in Semyon An-sky, *The Jewish Artistic Heritage: An Album*, ed. Vasilii Rakitin and Andrei Sarabianov (Moscow: RA, 1994), 10, 11, 15.

24. Walter Benjamin, "On the Concept of History," in *Walter Benjamin: Selected Writings, Volume 4, 1938–1940*, ed. Michael W. Jennings and Howard Eiland (Cambridge, Mass.: Belknap Press of Harvard University Press, 2006), 396; Walter Benjamin, "Paralipomena to 'On the Concept of History,'" in *Walter Benjamin: Selected Writings, Volume 4, 1938–1940*, ed. Michael W. Jennings and Howard Eiland (Cambridge, Mass.: Belknap Press of Harvard University Press, 2006), 403; Michael Löwy, *Fire Alarm: Reading Walter Benjamin's "On the Concept of History,"* trans. Chris Turner (New York: Verso, 2005), 67.

25. Wendy Brown, *Politics Out of History* (Princeton: Princeton University Press, 2001), 160. See also Jonathan Flatley, *Affective Mapping: Melancholia and the Politics of Modernism* (Cambridge, Mass.: Harvard University Press, 2008), 64–75.

26. Emma Goldman, *My Disillusionment in Russia* (New York: Dover, 2003), 229–30. The play was staged by Kultur-Lige, a Yiddish cultural organization that embraced political and aesthetic radicalism amid the power vacuum of the Russian Civil War. See Moss, *Jewish Renaissance in the Russian Revolution*, 52–57. Kultur-Lige members included El Lissitzky, as well as the poet Peretz Markish, who might be described as the Soviet Jewish Mayakovsky. As Amelia Glaser shows, Markish's expressionist Yiddish poetry, which drew from Russian futurism, combined religious imagery with modernist experimentation to advance a revolutionary, anticapitalist vision of the Ukrainian marketplace. See her translation and reading of his stunning *The Mound* (1921), Amelia M. Glaser, *Jews and Ukrainians in Russia's Literary Borderlands: From the Shtetl Fair to the Petersburg Bookshop* (Evanston, Ill.: Northwestern University Press, 2012), 120–27, 134–40.

27. Katz, "The Days of Proletpen," 12.

28. Slezkine, *The Jewish Century*, 275, 297. Despite his emphasis on 1948, Slezkine notes that "the campaign to cleanse the Soviet elite of ethnic Jews began as early as May 1939 when, in an apparent attempt to please Hitler, Stalin put Molotov in charge of Soviet diplomacy and ordered him to 'get rid of the Jews' in the Commissariat of External Affairs" (301).

29. "Despite all that the Bolshevik governments have done, in their better years, to combat these prejudices, enmity towards Jews was almost unabated. . . . The simple-minded communist often looked upon the Jews as the last surviving element of urban capitalism; while the anti-communist saw them as influential members of the ruling hierarchy" (Isaac Deutscher, quoted in S. Levenberg, "Soviet Jewry: Some Problems and Perspectives," in *The Jews in Soviet Russia since 1917*, ed. Lionel Kochan [London: Oxford University Press, 1972], 42).

30. "Podlye shpiony i ubiitsy pod maskoi professorov-vrachei," *Pravda*, January 13, 1953, 1.

31. Most of the JAC's leadership was executed in August 1952. See Joshua Rubenstein and Vladimir P. Naumov, eds., *Stalin's Secret Pogrom: The Postwar Inquisition of the Jewish Anti-Fascist Committee*, trans. Laura Esther Wolfson (New Haven: Yale University Press, 2001).

32. "Further Arrests Expected in 'Plot' of Soviet Doctors," *New York Times*, January 14, 1953, 1.

33. Peter Meyer, "Soviet Anti-Semitism in High Gear," *Commentary* 15 (February 1953): 120. Hannah Arendt's *The Origins of Totalitarianism* (New York: Harcourt, 1951), in which anti-Semitism figures centrally, apparently lends credence to the Stalin-Hitler connection. However, Arendt does not at all anticipate Soviet anti-Semitism, faulting the USSR for its "arbitrariness of terror," "not even limited by racial differentiation" (6).

34. Louis Rapoport, *Stalin's War Against the Jews: The Doctors' Plot and the Soviet Solution* (New York: Free Press, 1990), 176–91.

35. Slezkine, *The Jewish Century*, 330.

36. This applied even to Jewish Americans serving Soviet intelligence: from 1948 to 1953, "the Soviet espionage network had to be completely revamped because most of the agents (including the highly successful atomic spy Semyon Semenov, who had 'controlled' both the Cohens and the Rosenbergs) were Jews" (ibid., 304).

37. See, for instance, the anticommunist pamphlet by Arthur Schweriner, *How Far Shall We Go?* (New York: Veritas, 1935), which discourages young Jews from embracing the USSR. The war somewhat reversed such anti-Soviet sentiment among Jewish Americans owing to the Soviet-American alliance as well as the JAC's outreach efforts.

38. The best available explanation of Soviet anti-Semitism came from Solomon M. Schwarz, a Vilna-born Menshevik who left Russia in 1921 and settled in New York in 1940. His *The Jews in the Soviet Union* (Syracuse: Syracuse University Press, 1951) draws from Soviet periodicals (in both Russian and Yiddish), as well as Lenin's and Stalin's writings on "the national question" to conclude that the Bolsheviks had always sought Jewish assimilation. Schwarz briefly discusses anticosmopolitanism as the culmination of this assimilation project. The shortcomings of this framework are made evident in the following, although, to its credit, this still-cited book anticipated the worst of Soviet anti-Semitism by a year.

39. Irving Howe, *A Margin of Hope: An Intellectual Autobiography* (San Diego: Harcourt, 1982), 173, quoted in Nathan Abrams, "A Profoundly Hegemonic Moment: De-Mythologizing the Cold War New York Jewish Intellectuals," *SHOFAR* 21, no. 3 (spring 2003): 68; Irving Howe, "New York in the Thirties: Some Fragments of Memory," *Dissent* 8 (summer 1961): 248.

40. Slezkine, *The Jewish Century*, 265; Irving Howe, *Steady Work: Essays in the Politics of Democratic Radicalism, 1953–1966* (New York: Harcourt, 1966), 118.

41. Lionel Abel, "New York City: A Remembrance," *Dissent* 8 (summer 1961): 255, quoted in Joseph Dorman, *Arguing the World: The New York Intellectuals in Their Own Words* (New York: Free Press, 2000), 57.

42. Leon Trotsky, *Literature and Revolution*, ed. William Keach, trans. Rose Strunsky (Chicago: Haymarket, 2005), 126–47.

43. Clement Greenberg, "Avant-Garde and Kitsch" *Partisan Review* 6 (1939): 34–39. Greenberg's separation of avant-gardism and socialist realism has been forcefully contested by Boris Groys in *The Total Art of Stalinism: Avant-Garde, Aesthetic Dictatorship, and Beyond*, trans. Charles Rougle (Princeton: Princeton University Press, 1992). While the avant-garde advanced an experimentalism missing in socialist realism, the two (at least in their interwar Soviet iterations) undoubtedly shared transformative political aims. For a comprehensive account of the New York Intellectuals and their politics, see Alan M. Wald, *The New York Intellectuals: The Rise and Decline of the Anti-Stalinist Left from the 1930s to the 1980s* (Chapel Hill: University of North Carolina Press, 1987).

44. Many of the Jewish American communist writers discussed by Alan Wald remained Soviet defenders even after the Doctors' Plot and, as a result, became increasingly

marginal. Note the CPUSA-sponsored journal *Jewish Life*, which, in the wake of 1956, lost three-quarters of its readers. It was reborn in 1958 as *Jewish Currents* but continued to follow a pro-Soviet course until 1967. In New York's Yiddish-speaking world, *Frayhayt* (the parent of *Jewish Life* and *Jewish Currents*) also maintained a pro-Soviet bent through the 1950s, suffering many defections to *Forverts* after 1956. Editors of these publications would later admit to their naïveté regarding the Soviet Union. See Joseph Berger, "Jewish Currents Magazine and a Longtime Adversary Decide to Merge," *New York Times*, April 13, 2006; Wald, *Trinity of Passion*, 205–8; Katz, "The Days of Proletpen," 12.

45. Daniel Bell, "Reflections on Jewish Identity," in *The Winding Passage* (Cambridge, Mass.: Abt, 1980), 321.
46. Jewish American writers to the left of the New York Intellectuals underwent a similar turn. See, for instance, Amelia Glaser, "From Jewish Jesus to Black Christ: Race Violence in Leftist Yiddish Poetry," *Studies in American Jewish Literature* 34, no. 1 (spring 2015). On the other hand, for a survey of leftist Jewish American writing struggling to grasp the perceived failures of radicalism and to resist the postwar order, see Alan M. Wald, *American Night: The Literary Left in the Era of the Cold War* (Chapel Hill: University of North Carolina Press, 2012), 216–49.
47. Irving Howe, "The Lost Young Intellectual: A Marginal Man, Twice Alienated," *Commentary* 2 (October 1946): 361, 363.
48. Ibid., 367.
49. Subsequent parts were published in *Commentary* in 1948. The entire essay was then published as *Anti-Semite and Jew*, trans. George J. Becker (New York: Schocken Books, 1948).
50. Sartre, *Anti-Semite and Jew*, 26–27. Further references appear parenthetically in the text.
51. More recent calls for a "new cosmopolitanism" have effectively defended Sartre's blend of internationalism and French nationalism, with David Hollinger asserting, "The human need for solidarities smaller than the species . . . is primal" (David A. Hollinger, "Not Universalists, Not Pluralists: The New Cosmopolitans Find Their Own Way," *Constellations* 8, no. 2 [June 2001]: 238).
52. Slezkine, *The Jewish Century*, 293–94.
53. Howe, *A Margin of Hope*, 256.
54. Harold Rosenberg, "Does the Jew Exist? Sartre's Morality Play About Anti-Semitism," *Commentary* 7 (January 1949): 12; emphasis in original. Further references appear parenthetically in the text.
55. Sidney Hook, "Reflections on the Jewish Question," *Partisan Review* 16 (May 1949): 477–78. Further references are given parenthetically in the text.
56. As Slezkine puts it, "in the Mecca of rootless cosmopolitanism"—that is, the United States—"the existence of secondary loyalties is a constituent part of the political arrangement. . . . To become good Americans, Jews were to become the Chosen People again" (*The Jewish Century*, 322–23).
57. Sartre, *Anti-Semite and Jew*, 35.

58. Hook, "Reflections on the Jewish Question," 464. Rapoport, *Stalin's War Against the Jews*, 173.

59. Slezkine, *The Jewish Century*, 298.

60. Irving Howe and Eliezer Greenberg, eds., *A Treasury of Yiddish Stories* (New York: Viking, 1954), 66. Recent scholarship has affirmed this date as the cutoff for the Soviet Jewish avant-garde; see Estraikh, *In Harness*, 60–63. Moss places the cutoff even earlier—the Soviet state's takeover of Kultur-Lige in 1921 (*Jewish Renaissance in the Russian Revolution*, 269–79).

61. Elias Schulman, *The Fate of Soviet Jewry: The Jews in the Soviet Union; Soviet-Yiddish Literature, 1918-1948* (New York: Jewish Labor Committee, 1958), 19.

62. Isaac Bashevis Singer, "A New Use for Yiddish," *Commentary* 33 (March 1962): 267.

63. Howe and Greenberg, *A Treasury of Yiddish Stories*, 67. Schulman criticizes Feffer more directly, noting his "book of petty attacks against Yiddish literature abroad" (*The Fate of Soviet Jewry*, 26).

64. Estraikh, *In Harness*, 111–12.

65. Note, for instance, condemnation of Stalin's chief propagandist Il'ia Erenburg, now lauded for coediting (with Vasilii Grossman) *The Black Book*, a comprehensive account of the Holocaust commissioned by the JAC. See H. Leivick, "Who Are the Guilty?" in *A Decade of Destruction: Jewish Culture in the USSR, 1948-1958* (New York: Congress for Jewish Culture, 1958), 27, and Schulman, *The Fate of Soviet Jewry*, 32. A concerted Jewish American effort to rescue Soviet Jews began in 1964, with the first meeting of the American Jewish Conference on Soviet Jewry, precursor to the extant (though recently renamed) National Conference on Soviet Jewry. See William W. Orbach, *The American Movement to Aid Soviet Jews* (Amherst: University of Massachusetts Press, 1979).

66. For similar downward spirals, see Marci Shore's moving accounts of Polish Jewish communist poets, *The Taste of Ashes* and *Ashes and Caviar: A Warsaw Generation's Life and Death in Marxism, 1918-1968* (New Haven: Yale University Press, 2006).

67. Lionel Trilling, "Reality in America" [1940, 1946], in *The Liberal Imagination: Essays on Literature and Society* (New York: Viking, 1950), 7.

68. On the moral and political underpinnings of *The Liberal Imagination*, see R. P. Blackmur, "The Politics of Human Power," in *The Lion and the Honeycomb: Essays in Solicitude and Critique*, 32–42 (New York: Harcourt, 1955). Interestingly, Trilling's outlook on culture is not only liberal; it bears some affinity to Trotsky's writings on literature, for instance the latter's critique of the Soviet bureaucracy's heavy-handed literary preferences: "[The bureaucracy] prints books according to its own choice. It sells them also by compulsion, offering no choice to the reader. In the last analysis the whole affair comes down in its eyes to taking care that art assimilates its interests, and finds such forms for them as will make the bureaucracy attractive to the popular masses" (Leon Trotsky, *The Revolution Betrayed: What Is the Soviet Union and Where Is It Going?* trans. Max Eastman [New York: Pioneer, 1945], 185). Trilling went on to author an extended meditation on authenticity—according to him, a unity of being, as opposed to sincerity, which rests on the divide between the internal self

and external self—and its shifting presence in nineteenth- and twentieth-century literature. In light of the geopolitical implications that I am attaching to the term, it seems fitting that, at one point, he notes its Greek roots ("*authenteo*: to have full power over; also, to commit a murder") and suggests that these violent, forgotten denotations "bear upon the nature and intention of the artistic culture of the period we call Modern" (Lionel Trilling, *Sincerity and Authenticity* [Cambridge, Mass.: Harvard University Press, 1971], 131).

69. Sidney Hook, "Messages," in *A Decade of Destruction*, 37.

70. For more on the Congress for Cultural Freedom, see Christopher Lasch, "The Cultural Cold War: A Short History of the Congress for Cultural Freedom," in *Towards a New Past: Dissenting Essays in American History*, ed. Barton Bernstein (New York: Pantheon, 1968); Frank Ninkovich, *The Diplomacy of Ideas: U.S. Foreign Policy and Cultural Relations, 1938-1950* (New York: Cambridge University Press, 1981); Frances Stonor Saunders, *Who Paid the Piper? The CIA and the Cultural Cold War* (London: Granta, 1999); and Giles Scott-Smith, *The Politics of Apolitical Culture: The Congress for Cultural Freedom, the CIA, and Postwar American Hegemony* (New York: Routledge, 2002).

71. U.S. House of Representatives Select Committee on Communist Aggression, *Special Report No. 2: Treatment of the Jews Under Communism* (Washington, D.C.: GPO, 1954), v.

72. Ibid., 33.

73. "Russian Accuses West of Racism," *New York Times*, January 21, 1954, 9.

74. Lionel Trilling, "The Forbidden Dialectic," in *Isaac Babel's Selected Writings*, ed. Gregory Freidin, trans. Peter Constantine (New York: Norton, 2010).

75. This tie between the United States and liberal pluralism was later spelled out in *Beyond the Melting Pot: The Negroes, Puerto Ricans, Jews, Italians, and Irish of New York City* (Cambridge, Mass.: MIT Press, 1963), a sociological study by New York Intellectual Nathan Glazer and future U.S. senator Daniel Patrick Moynihan. For connections between this work and Glazer's neoconservative turn, see Matthew Frye Jacobson, *Roots Too: White Ethnic Revival in Post-Civil Rights America* (Cambridge, Mass.: Harvard University Press, 2006), 177–80.

76. Yuri Slezkine, *Arctic Mirrors: Russia and the Small Peoples of the North* (Ithaca: Cornell University Press, 1994), 310. Along similar lines, two years later Stalin published an article in *Pravda* explicitly debunking Nikolai Marr's "New Theory of Language" (discussed in the introduction). Against Marr's utopian quest for a unified socialist language, Stalin asserted that language was irreducible to class and instead bound to nationality—which, he asserted, existed "incomparably longer than any base or any superstructure." See Yuri Slezkine, "N. Ia. Marr and the National Origins of Soviet Ethnogenetics," *Slavic Review* 55, no. 4 (winter 1996): 858–59.

77. Slezkine, "The USSR as a Communal Apartment," 448–49.

78. The Jewish Autonomous Region of Birobidzhan in the Russian Far East had only retained around 18,000 Jews by World War II. See Robert Weinberg, *Stalin's Forgotten Zion: Birobidzhan and the Making of a Soviet Jewish Homeland; An Illustrated History, 1928-1996*, ed. Bradley Burman (Berkeley: University of California Press, 1998), 69.

79. Slezkine presents Soviet anti-Semitism as this catch-22: "Those who claimed a separate Yiddish culture were 'bourgeois nationalists'; those who identified with Russian culture were 'rootless cosmopolitans'" (*The Jewish Century*, 298). From this latter perspective, the fact that so many "cosmopolitans" had assumed Russian or revolutionary surnames only underscored their perfidy. See, for instance, Schwarz, *The Jews in the Soviet Union*, 358. These "Russians of Jewish descent or, as far as the Party's Agitprop was concerned, Jews who claimed to be Russians in order to appear Soviet" were the primary targets of Soviet anti-Semitism (Slezkine, *The Jewish Century*, 300–301). However, one could be guilty of both nationalism and cosmopolitanism when expressions of Jewish difference gestured to non-Soviet branches of the Diaspora. For example, see E. Koval'chik, "Bezrodnye kosmopolity," *Literaturnaia gazeta*, February 12, 1949, which attacks an encyclopedia entry on Jewish literature that "lists Soviet writers side by side with the arch contemporary businessmen of America, Palestine, and other countries." Cited in Schwarz, *The Jews in the Soviet Union*, 217n41.

80. Harrison Salisbury, "Jewish Writers in Soviet Active," *New York Times*, July 26, 1956, 5; Harry Schwartz, "Yiddish Writer Hailed in Russia," *New York Times*, March 8, 1959, 12. See also Sholom Aleichem, *Istorii dlia detei* (Moscow: Gos. izdat. detskoi lit., 1956); Sholom Aleichem, *Zakoldovannyi portnoi* (Moscow: Gos. izdat. khudozh. lit., 1956); Sholom Aleichem, *Schast'e privalilo!* (Moscow: Gos. izdat. khudozh. lit., 1959); and Sholom Aleichem, *Sobranie sochinenii v shesti tomakh* (Moscow: Gos. izdat. khudozh. lit., 1959).

81. Maurice Samuel, *The World of Sholom Aleichem* (New York: Knopf, 1947), 184–85, quoted in I. A. Serebrianyi, *Sholom-Aleikhem i narodnoe tvorchestvo* (Moscow: Sovetskii pisatel', 1959), 9.

82. Serebrianyi, *Sholom-Aleikhem*, 7–9.

83. For a far more balanced view of Sholem Aleichem (via Gogol and Gorky), see Glaser, *Jews and Ukrainians in Russia's Literary Borderlands*, 106–9.

84. Seth L. Wolitz, "The Americanization of Tevye or Boarding the Jewish *Mayflower*," *American Quarterly* 40, no. 4 (December 1988): 527.

85. Ibid., 519.

86. Irving Howe, "Tevye on Broadway," *Commentary* 38 (November 1964): 74.

87. Ibid.

88. Irving Howe, *A World More Attractive: A View of Modern Literature and Politics* (New York: Horizon, 1963), 211.

89. Ibid., 214.

90. Akin to Howe's revolutionary take on Sholem Aleichem, *World of Our Fathers* makes socialism central to Jewish American immigrant life. For the consequent marginalization of this work in Jewish American studies, see Tony Michels, "Socialism and the Writing of American Jewish History: *World of Our Fathers* Revisited," *American Jewish History* 88, no. 4 (December 2000): 521–46. Howe's *Politics and the Novel* (New York: Horizon, 1957) and "The Culture of Modernism" (1970) present a Trotskyite approach to literature—literature as hostile to ideology but also

as emerging from socioeconomic base. Note, for instance, Howe's and Trotsky's identical dismissals of symbolist poetry. See Irving Howe, "The Culture of Modernism," in *Decline of the New* (New York: Harcourt, 1970), 18–20; Trotsky, *Literature and Revolution*, 234–36.

91. Howe, *A World More Attractive*, 108.

92. Ibid., 109; emphasis in original.

93. Howe, *A Margin of Hope*, 257. On Howe, Baldwin, and Ellison, see John Murray Cuddihy, *The Ordeal of Civility: Freud, Marx, Lévi-Strauss, and the Jewish Struggle with Modernity* (New York: Basic Books, 1974), 203–24, and Emily Miller Budick, *Blacks and Jews in Literary Conversation* (New York: Cambridge University Press, 1998).

94. David Brandenberger, *National Bolshevism: Stalinist Mass Culture and the Formation of Modern Russian National Identity, 1931–1956* (Cambridge, Mass.: Harvard University Press, 2002), 43; Slezkine, *The Jewish Century*, 278.

95. The New York Intellectuals' allegiance to Washington was basically announced in the 1952 *Partisan Review* symposium "Our Country and Our Culture," with Irving Howe declaring, "Between the inadequate democracy of the capitalist world and the total repression of the Stalinist world there is the difference between life, however afflicted, and death" (Irving Howe, "Our Country and Our Culture," *Partisan Review* 19 [September–October 1952]: 577).

96. Jonathan Karp, "Performing Black-Jewish Symbiosis: The 'Hasidic Chant' of Paul Robeson," *American Jewish History* 91, no. 3 (March 2003): 76. On Robeson's 1935 visit to Moscow (organized by Sergei Eisenstein), see Katerina Clark, *Moscow, the Fourth Rome: Stalinism, Cosmopolitanism, and the Evolution of Soviet Culture, 1931–1941* (Cambridge, Mass.: Harvard University Press, 2011), 191–92.

97. Paul Robeson Jr., "How My Father Last Met Itzik Feffer," *Jewish Currents* 35 (November 1981): 5; cited in Rapoport, *Stalin's War Against the Jews*, 115–16.

98. Karp, "Performing Black-Jewish Symbiosis," 77.

99. Quoted in Robeson, "How My Father Last Met Itzik Feffer," 4.

Afterword

1. Arthur Schlesinger Jr., whose *Vital Center* (1949) had helped articulate the postwar liberal consensus, ominously painted the new world order: "The fading away of the cold war has brought an era of ideological conflict to an end. But it has not, as forecast, brought an end to history. One set of hatreds gives way to the next. Lifting the lid of ideological repression in eastern Europe releases ethnic antagonisms deeply rooted in experience and in memory. The disappearance of ideological competition in the third world removes superpower restraints on national and tribal confrontations. As the era of ideological conflict subsides, humanity enters—or, more precisely, re-enters—a possibly more dangerous era of ethnic and racial animosity." For Schlesinger, the takeaway was that America had to overcome its own ethnic and racial divides and unite as a nation. See Arthur M. Schlesinger Jr., *The Disuniting of*

America: Reflections on a Multicultural Society (New York: Norton, 1991), 11–12. See also Samuel Huntington, *The Clash of Civilizations and the Remaking of World Order* (New York: Simon and Schuster, 1996).

2. Accordingly, while David Hollinger shared Schlesinger's view on the need for national unity, he rejected the notion of post-Soviet nationalism as the result of primordial antagonism. Aware of Moscow's promotion of ethnic particularism, he concluded that "when the extravagantly universalist Soviet polity itself—the instrument, ostensibly, for all humankind's eventual liberation—weakened at the end of the 1980s, the only cultural adhesives strong enough to mobilize collective action were ethnic." Hollinger drew from the Soviet collapse the lesson that, in order to survive, the United States should not set expectations so high but promote a "democratic polity with universalist and egalitarian aspirations less extravagant than those of the Soviet state." See David Hollinger, *Postethnic America: Beyond Multiculturalism* (New York: Basic Books, 1995), 138–39.

3. Quoted in Schlesinger, *The Disuniting of America*, 151.

4. Charles Taylor, "The Politics of Recognition," in *Multiculturalism: Examining the Politics of Recognition*, ed. Amy Gutmann (Princeton: Princeton University Press, 1994), 36–39.

5. Nathan Glazer, *We Are All Multiculturalists Now* (Cambridge, Mass.: Harvard University Press, 1997), 7–8, 85–88.

6. See the discussion of Kallen in the introduction. For the debate surrounding him and Bourne, see Glazer, *We Are All Multiculturalists Now*, 87; Schlesinger, *The Disuniting of America*, 37; Hollinger, *Postethnic America*, 92–94; John Higham, "Multiculturalism and Universalism: A History and Critique," *American Quarterly* 45, no. 2 (June 1993): 205; Lawrence Levine, *The Opening of the American Mind* (Boston: Beacon Press, 1996), 118; and Werner Sollors, "A Critique of Pure Pluralism," in *Reconstructing American Literary History*, ed. Sacvan Bercovitch (Cambridge, Mass.: Harvard University Press, 1986), 265. See also David Hollinger, "Ethnic Diversity, Cosmopolitanism and the Emergence of the American Liberal Intelligentsia," *American Quarterly* 27, no. 2 (May 1975): 142.

7. According to Kymlicka, U.S. multiculturalism, with its emphasis on civic as opposed to minority nationalism, provided an excuse "to strip national minorities of their separate public institutions and rights of self-government. We see this trend in Slovakia, Romania, Serbia, and Russia." However, as Kymlicka himself acknowledges, he refers here to a specific kind of multiculturalism, which he derives from Hollinger—"cosmopolitan multiculturalism" ("based on individual rights"), as opposed to "pluralist multiculturalism" (based on "permanent and enduring" groups). See Will Kymlicka, "American Multiculturalism in the International Arena," *Dissent* 45 (fall 1998): 74, 79.

8. Pierre Bourdieu and Loïc Wacquant, "On the Cunning of Imperialist Reason," *Theory, Culture and Society* 16, no. 1 (1999): 41–58.

9. Slavoj Žižek, "Multiculturalism, or, the Cultural Logic of Multinational Capitalism," *New Left Review* 225 (September–October 1997): 44.

10. Nikhil Pal Singh, "Cold War Redux: On the 'New Totalitarianism,'" *Radical History Review* 85 (winter 2003): 177.

11. I draw here from John Roberts's use of "revolutionary pathos" to refer to the "cultural memory of loss and defeat" associated with the historical avant-garde and the subsequent subordination of art as a vehicle for social and political change. For Roberts, this pathos enables the contemporary avant-garde (specifically the Russian art–activist collective Chto Delat'?) to resist "the opposing routes of 'social effectivity' and aesthetic sublimity" and to instead articulate "the possibilities of new forms of life (yet) to come." See John Roberts, "Revolutionary Pathos, Negation, and the Suspensive Avant-Garde," *New Literary History* 41, no. 4 (autumn 2010): 724, 728, 729. It should be noted that, in Russian, "pathos" (*pafos*) holds both positive and negative connotations: it can be used to describe both passionate enthusiasm and false sentimentalism.

12. Fredric Jameson, "Periodizing the 60s," *Social Text*, no. 9/10 (spring–summer 1984): 188; Max Elbaum, *Revolution in the Air: Sixties Radicals Turn to Lenin, Mao and Che* (New York: Verso, 2002), 45; Christopher Leigh Connery, "The World Sixties," in *The Worlding Project: Doing Cultural Studies in the Era of Globalization*, ed. Christopher Leigh Connery and Rob Wilson (Berkeley: North Atlantic, 2007), 97; Robin D. G. Kelley and Betty Esch, "Black Like Mao: Red China and Black Revolution," *Souls* 1, no. 4 (fall 1999): 24.

13. Christopher Leigh Connery, "The End of the Sixties," *boundary 2* 36, no. 1 (spring 2009): 187.

14. Jameson, "Periodizing the 60s," 188–89. See, for example, Elaine Brown, *A Taste of Power: A Black Woman's Story* (New York: Pantheon, 1992), 304. Such reports are complicated in the following. Of course, gender inequality persisted and continues to persist long after 1949. See Delia Davin, "Gendered Mao: Mao, Maoism, and Women," in *A Critical Introduction to Mao*, ed. Timothy Cheek, 196–218 (New York: Cambridge University Press, 2010).

15. Mao Tse-Tung, "On Contradiction," https://www.marxists.org/reference/archive/mao/selected-works/volume-1/mswv1_17.htm (accessed July 4, 2014).

16. Richard Wolin describes "Contradiction and Overdetermination" as an "extended commentary" on the Mao piece. See Richard Wolin, *The Wind from the East: May '68, French Intellectuals, and the Chinese Cultural Revolution* (Princeton: Princeton University Press, 2010), 122. For more on the similarities between the two essays, see Jameson, "Periodizing the 60s," 191–92, and Guo Jian, "Resisting Modernity in Contemporary China: The Cultural Revolution and Postmodernism," *Modern China* 25, no. 3 (July 1999): 346–47. It should be noted that the Althusser piece does not reference Mao but can readily be seen as an effort to complement "On Contradiction." For instance, whereas Mao relies on readings of Lenin and Stalin, Althusser goes back to Marx and Engels themselves to critique economic determinism.

17. As Connery writes, the concept of contradiction, "widely thought to be the most important component of Maoism and to be the essence of Mao's original contribution to Marxist thought, is essential to a praxis-oriented project." While recognizing the dominant view that Maoism ultimately undermined the global left, Connery

also asserts the allure of Chinese revolutionary practice as offering a "powerful language of world-making. One could begin from nowhere, from a situation, like Mao's peasants, that was 'poor and blank,' and reconstruct humanity again, from anew. That sense of beginning was powerfully felt in Detroit, the Sierra Maestre, in Guinea, and in the ghetto of Oakland" (Connery, "The World Sixties," 97–98, 102).

18. Grace Lee and James Boggs offered a more nuanced application of the Cultural Revolution to the Black Power struggle, one critical of the Panthers. See Bill Mullen, *Afro-Orientalism* (Minneapolis: University of Minnesota Press, 2004), 140–42, and Grace Lee Boggs, *Living for Change: An Autobiography* (Minneapolis: University of Minnesota Press, 1998), 194–95.

19. Kelley and Esch, "Black Like Mao," 8, 21–26, 31–37; Mullen, *Afro-Orientalism*, 94–98; Mao Tse-Tung, *Talks at the Yenan Forum on Literature and Art* (Beijing: Foreign Languages Press, 1967), 8–12, 33, 52.

20. Fred Ho, "The Inspiration of Mao and the Chinese Revolution on the Black Liberation Movement and the Asian Movement on the East Coast," in *Afro Asia: Revolutionary Political and Cultural Connections between African Americans and Asian Americans*, ed. Fred Ho and Bill V. Mullen (Durham: Duke University Press, 2008), 160. See also Daryl J. Maeda, *Chains of Babylon: The Rise of Asian America* (Minneapolis: University of Minnesota Press, 2009). On the persecution and decline of Asian American leftism in the 1950s, see Him Mark Lai, "Historical Survey of the Chinese Left in America," in *Counterpoint: Perspectives on Asian America*, ed. Emma Gee (Los Angeles: UCLA Asian American Studies Center, 1976), 72–75; and Renqiu Yu, *To Save China, to Save Ourselves: The Chinese Hand Laundry Alliance of New York* (Philadelphia: Temple University Press, 1992), 179–97. For an example of continuity between generations of Chinese American communists, see Gordon H. Chang, "The Many Sides of Happy Lim: Aka Hom Ah Wing, Lin Jian Fu, Happy Lum, Lin Chien Fu, Hom Yen Chuck, Lam Kin Foo, Lum Kin Foo, Hom, Lim Goon Wing, Lim Gin Foo, Gin Foo Lin, Koon Wing Lim, Henry Chin, Lim Ying Chuck, Lim Ah Wing, et al.," *Journal of Transnational American Studies* 2, no. 1 (2010): 70–98.

21. Fred Ho and Steve Yip, "Alex Hing, Former Minister for the Red Guard Party and Founding Member of I Wor Kuen," in *Legacy to Liberation: Politics and Culture of Revolutionary Asian Pacific America*, ed. Fred Ho, Carolyn Antonio, Diane Fujino, and Steve Yip (San Francisco: Big Red Media and AK Press, 2000), 289.

22. Lisa Lowe, *Critical Terrains: French and British Orientalisms* (Ithaca: Cornell University Press, 1991), 142–48, 162. As Lowe notes, Julia Kristeva viewed the Chinese language as "a system of codes within which one can read about an earlier, tonal, pre-oedipal society" (149). Here we find echoes of Nikolai Marr as well as Sergei Eisenstein. As discussed in the introduction and chapters 1 and 2, however, the difference is that Marr and Eisenstein did not simply romanticize the past but sought to harness non-Western cultures and languages for historical arrest and world revolution—all the while eschewing the West's "denial of coevalness."

23. The first quote comes from W. E. B. Du Bois's poem "I Sing to China" (written on the occasion of his 1959 visit), which Mullen presents as an example of "Afro-Oriental-

ism" (*Afro-Orientalism*, 41). The second quote comes from Elaine Brown's memoir, specifically, her account of Huey Newton's impressions during their 1971 visit to China (*A Taste of Power*, 302).

24. Jeremi Suri, *Power and Protest: Global Revolution and the Rise of Detente* (Cambridge, Mass.: Harvard University Press, 2003), 210–11; Connery, "The World Sixties," 101; Elbaum, *Revolution in the Air*, 140–41. Elbaum notes the inconsistencies of Maoism within China, which hindered its ability to consolidate Third World movements. Accordingly, as Fred Ho recounts, the most prominent Asian American radical group, I Wor Kwen (which in 1978 transformed into the League of Revolutionary Struggle) "had immense admiration and took much inspiration from China." However, "we didn't follow it blindly and actually had certain differences and disagreements with the CCP, including around nuclear energy, the prohibition of trade unions and other positions" (Fred Ho, "Fists for Revolution," in *Legacy to Liberation: Politics and Culture of Revolutionary Asian Pacific America*, ed. Fred Ho, Carolyn Antonio, Diane Fujino, and Steve Yip [San Francisco: Big Red Media and AK Press, 2000], 11).

25. Frank Chin et al., "An Introduction to Chinese- and Japanese-American Literature," in *Aiiieeeee! An Anthology of Asian-American Writers*, ed. by Frank Chin et al. (Washington, D.C.: Howard University Press, 1974), xxv.

26. Maxine Hong Kingston, *China Men* (New York: Knopf, 1980), 87.

27. For a reading of Kingston that emphasizes U.S. imperialism and anticommunism, see Jodi Kim, *Ends of Empire: Asian American Critique and the Cold War* (Minneapolis: University of Minnesota Press, 2010), 63–64, 92.

28. Richard Wright, "I Tried to Be a Communist," *Atlantic Monthly* 174, no. 3 (September 1944): 54.

29. As Cheng elaborates, the root cause of racial melancholia is the formation of a dominant white identity in relation to the simultaneously avowed and disavowed racial subject. She illustrates this through another example from Kingston, namely, the hypochondriac narrator in *The Woman Warrior*. See Anne Anlin Cheng, *The Melancholy of Race: Psychoanalysis, Assimilation, and Hidden Grief* (New York: Oxford University Press, 2000), 3–20, 65–102. See also David L. Eng, *Racial Castration: Managing Masculinity in Asian America* (Durham: Duke University Press, 2001).

30. In addition to the distinction between the two words, I prefer "revolutionary pathos" over, say, "revolutionary melancholy" because of the latter's evocation of what Walter Benjamin called left-wing melancholy—a term he used to criticize leftist poets whose seemingly anticapitalist verses in fact served to transpose "revolutionary reflexes" into "objects of distraction, of amusement, which can be supplied for consumption." As Wendy Brown elaborates, "left melancholy is Benjamin's unambivalent epithet for the revolutionary hack who is, finally, attached more to a particular political analysis or ideal—even to the failure of that ideal— than to seizing possibilities for radical change in the present." However, as both

Brown and Jonathan Flatley note, Benjamin was not opposed to melancholy per se, so long as it connected past losses to present politics. See Walter Benjamin, "Left-Wing Melancholy," *Screen* 15, no. 2 (summer 1974): 29; Wendy Brown, "Resisting Left Melancholy," *boundary 2* 26, no. 3 (fall 1999): 20; Jonathan Flatley, *Affective Mapping: Melancholia and the Politics of Modernism* (Cambridge, Mass.: Harvard University Press, 2008), 64–65. Alan Wald identifies something akin to revolutionary pathos in his recent study of Cold War–era "Communist literary modernism." Combining psychoanalysis, existentialism, and Theodor Adorno's "negative dialectics," Wald traces a postwar modernism defined not by formalism but by "contentism"—that is, the experiences and perceptions emerging "in the liminal space between devotion and disillusion." Wald describes this content as a "felt texture" made up of the communist past's "unquiet dead." See Alan M. Wald, *American Night: The Literary Left in the Era of the Cold War* (Chapel Hill: University of North Carolina Press, 2012), 303–4.

31. For a recent effort to reveal these undercurrents, see Colleen Lye, "Asian American 1960s," in *The Routledge Companion to Asian American and Pacific Islander Literature*, ed. Rachel C. Lee, 213–23 (London: Routledge, 2014). See also Wen Jin, *Pluralist Universalism: An Asian Americanist Critique of U.S. and Chinese Multiculturalisms* (Columbus: Ohio State University Press, 2012).

32. Likewise, Fredric Jameson describes Maoism as the "shadowy but central presence" behind his influential periodization of the 1960s ("Periodizing the 60s," 188).

33. Karen Tei Yamashita, *I Hotel* (Minneapolis: Coffee House Press, 2010), 25–26. Further references appear parenthetically in the text.

34. See Estella Habal, *San Francisco's International Hotel: Mobilizing the Filipino American Community in the Anti-Eviction Movement* (Philadelphia: Temple University Press, 2007).

35. Elbaum, *Revolution in the Air*, 207–26.

36. Seth Rosenfeld, "Man Who Armed Black Panthers Was FBI Informant, Records Show," *Center for Investigative Reporting*, August 20, 2012, http://cironline.org/reports/man-who-armed-black-panthers-was-fbi-informant-records-show-3753 (accessed July 4, 2014).

37. Slavoj Žižek, *In Defense of Lost Causes* (New York: Verso, 2008), 58–59.

38. Connery, "The End of the Sixties," 206.

39. Žižek, *In Defense of Lost Causes*, 207.

Bibliography

Manuscript Collections

Board of the Union of Soviet Writers of the USSR Papers. Russian State Archive of Literature and Art (RGALI), Moscow, Russian Federation.

Georgii Eduardovich Grebner Papers. Russian State Archive of Literature and Art (RGALI), Moscow, Russian Federation.

Langston Hughes Collection. John Hope and Aurelia E. Franklin Library, Special Collections, Fisk University, Nashville, Tennessee.

Louise Thompson Patterson Papers. Manuscripts, Archives, and Rare Book Library, Emory University, Atlanta, Georgia.

Theatre Guild Collection. Beinecke Rare Book and Manuscript Library, Yale University, New Haven, Connecticut.

Selected Published Works

Aaron, Daniel. *Writers on the Left: Episodes in American Literary Communism.* New York: Columbia University Press, 1992.

Abel, Lionel. "New York City: A Remembrance." *Dissent* 8 (summer 1961): 251–59.

Abrams, Nathan. "A Profoundly Hegemonic Moment: De-Mythologizing the Cold War New York Jewish Intellectuals." *SHOFAR* 21, no. 3 (spring 2003): 64–82.

Aivazian, K. V., ed. *Maiakovskii i literatura narodov sovetskogo soiuza.* Yerevan: Izdatel'stvo Erevanskogo universiteta, 1983.

Aleichem, Sholom. *Istorii dlia detei.* Moscow: Gos. izdat. detskoi lit., 1956.

——. *Schast'e privalilo!* Moscow: Gos. izdat. khudozh. lit., 1959.

——. *Sobranie sochinenii v shesti tomakh.* Moscow: Gos. izdat. khudozh. lit., 1959.

——. *Zakoldovannyi portnoi.* Moscow: Gos. izdat. khudozh. lit., 1956.

Alexander, Edward. "Irving Howe and Secular Jewishness: An Elegy." *Judaism: A Quarterly Journal of Jewish Life and Thought* 45, no. 1 (winter 1996): 101–18.

Anderson, Perry. "Internationalism: A Breviary." *New Left Review* 14 (March–April 2002): 5–25.

——. "Modernity and Revolution." *New Left Review* 144 (March–April 1984): 96–113.

Antle, Martine. "Surrealism and the Orient." *Yale French Studies* 109 (July 2006): 4–16.

Apter, Emily. *The Translation Zone: A New Comparative Literature.* Princeton: Princeton University Press, 2005.

Apter-Gabriel, Ruth. "El Lissitzky's Jewish Works." In *Tradition and Revolution: The Jewish Renaissance in Russian Avant-Garde Art, 1912-1928*, edited by Ruth Apter-Gabriel, 101–24. Jerusalem: Israel Museum, 1987.

Arendt, Hannah. *On Revolution.* New York: Viking, 1965.

——. *The Origins of Totalitarianism.* New York: Harcourt, 1951.

Azarova, Nataliia. "Khlebnikovskaia teoriia zaumi i politika edinogo iazyka." *Russian Literature* 67 (2010): 278–89.

Babel, Isaac. *Isaac Babel's Selected Writings.* Edited by Gregory Freidin. Translated by Peter Constantine. New York: Norton, 2010.

Baldwin, Kate. *Beyond the Color Line and the Iron Curtain: Reading Encounters Between Black and Red, 1922-1963.* Durham: Duke University Press, 2002.

Bell, Daniel. "Reflections on Jewish Identity." In *The Winding Passage.* Cambridge, Mass.: Abt, 1980.

Benjamin, Walter. "The Author as Producer." In *Reflections: Essays, Aphorisms, Autobiographical Writings*, edited by Peter Demetz, 220–38. New York: Schocken Books, 1986.

——. *Illuminations.* Translated by Harry Zohn. New York: Harcourt, 1968.

——. "Johann Jakob Bachofen." In *Walter Benjamin: Selected Writings, Volume 3, 1935-1938*, edited by Michael W. Jennings and Howard Eiland, 11–25. Cambridge, Mass.: Belknap Press of Harvard University Press, 2006.

——. "Left-Wing Melancholy." *Screen* 15, no. 2 (summer 1974): 28–32.

——. "Moscow." In *Walter Benjamin: Selected Writings, Volume 2, Part 1, 1927-1930*, edited by Michael W. Jennings, Howard Eiland, and Gary Smith, 22–46. Cambridge, Mass.: Belknap Press of Harvard University Press, 2005.

——. *Moscow Diary.* Edited by Gary Smith. Translated by Richard Sieburth. Cambridge, Mass.: Harvard University Press, 1986.

——. "On the Concept of History." In *Walter Benjamin: Selected Writings, Volume 4, 1938-1940*, edited by Michael W. Jennings and Howard Eiland, 389–400. Cambridge, Mass.: Belknap Press of Harvard University Press, 2006.

——. "Paralipomena to 'On the Concept of History.'" In *Walter Benjamin: Selected Writings, Volume 4, 1938-1940*, edited by Michael W. Jennings and Howard Eiland, 401–11. Cambridge, Mass.: Belknap Press of Harvard University Press, 2006.

——. "Paris—Capital of the Nineteenth Century." *New Left Review* 48 (March–April 1968): 77–88.

——. "Problems in the Sociology of Language." In *Walter Benjamin: Selected Writings, Volume 3, 1935-1938*, edited by Michael W. Jennings and Howard Eiland, 68–93. Cambridge, Mass.: Belknap Press of Harvard University Press, 2006.

——. "Surrealism." In *Walter Benjamin: Selected Writings, Volume 2, Part 1, 1927-1930*, edited by Michael W. Jennings, Howard Eiland, and Gary Smith, 207–21. Cambridge, Mass.: Belknap Press of Harvard University Press, 2005.

——. "The Task of the Translator." In *Walter Benjamin: Selected Writings, Volume 1, 1913-1926*, edited by Marcus Bullock and Michael W. Jennings, 253–63. Cambridge, Mass.: Belknap Press of Harvard University Press, 1996.

Berman, Jessica. *Modernist Commitments: Ethics, Politics, and Transnational Modernism*. New York: Columbia University Press, 2011.

Bernstein, Michael André. *Foregone Conclusions: Against Apocalyptic History*. Berkeley: University of California Press, 1994.

Berry, Faith. *Langston Hughes: Before and Beyond Harlem*. Westport, Conn.: Hill, 1983.

Bethea, David M. *The Shape of Apocalypse in Modern Russian Fiction*. Princeton: Princeton University Press, 1989.

Biberman, Herbert. *Salt of the Earth: The Story of a Film*. Boston: Beacon Press, 1965.

Blackmur, R. P. "The Politics of Human Power." In *The Lion and the Honeycomb: Essays in Solicitude and Critique*, 32–42. New York: Harcourt, 1955.

Bloch, Ernst. "Nonsynchronism and the Obligation to Its Dialectics." *New German Critique* 11 (spring 1977): 22–38.

Blok, Aleksandr. *Rossiia i intelligentsia*. Berlin: Skify, 1920.

——. "Skify." In *Sobranie sochinenii v shesti tomakh*, edited by S. A. Nebol'sin, 3: 244–46. Moscow: Pravda, 1971.

Boggs, Grace Lee. *Living for Change: An Autobiography*. Minneapolis: University of Minnesota Press: 1998.

Bourdieu, Pierre, and Loïc Wacquant. "On the Cunning of Imperialist Reason." *Theory, Culture and Society* 16, no. 1 (1999): 41–58.

Boym, Svetlana. *Another Freedom: The Alternative History of an Idea*. Chicago: University of Chicago Press, 2010.

——. *The Future of Nostalgia*. New York: Basic Books, 2001.

Brandenberger, David. *National Bolshevism: Stalinist Mass Culture and the Formation of Modern Russian National Identity, 1931-1956*. Cambridge, Mass.: Harvard University Press, 2002.

Brodsky, Joseph. "Flight from Byzantium." In *Less Than One: Selected Essays*, 393–446. New York: Farrar, Straus, and Giroux, 1986.

Brown, Edward. *Mayakovsky: A Poet in the Revolution*. New York: Paragon, 1988.

Brown, Elaine. *A Taste of Power: A Black Woman's Story*. New York: Pantheon, 1992.

Brown, Wendy. *Politics Out of History*. Princeton: Princeton University Press, 2001.

——. "Resisting Left Melancholy." *boundary 2* 26, no. 3 (fall 1999): 19–27.

Buchloh, Benjamin H. D. "From Faktura to Factography." *October* 30 (fall 1984): 76–113.

Buck-Morss, Susan. *The Dialectics of Seeing: Walter Benjamin and the Arcades Project.* Cambridge, Mass.: MIT Press, 1991.

———. *Dreamworld and Catastrophe: The Passing of Mass Utopia in East and West.* Cambridge, Mass.: MIT Press, 2000.

Budick, Emily Miller. *Blacks and Jews in Literary Conversation.* New York: Cambridge University Press, 1998.

Bürger, Peter. *Theory of the Avant-Garde.* Translated by Michael Shaw. Minneapolis: University of Minnesota Press, 2002.

Burliuk, David, Alexei Kruchenykh, Vladimir Mayakovsky, and Victor [Velimir] Khlebnikov. "A Slap in the Face of Public Taste." In *Russian Futurism Through Its Manifestos, 1912-1928,* edited by Anna Lawton, 51-52. Ithaca: Cornell University Press, 1988.

Carew, Joy Gleason. *Blacks, Reds, and Russians: Sojourners in Search of the Soviet Promise.* New Brunswick, N.J.: Rutgers University Press, 2008.

Casanova, Pascale. *The World Republic of Letters.* Cambridge, Mass.: Harvard University Press, 2005.

Cavanagh, Clare. "Whitman, Mayakovsky, and the Body Politic." In *Rereading Russian Poetry,* edited by Stephanie Sandler, 202-22. New Haven: Yale University Press, 1999.

Chakrabarty, Dipesh. *Provincializing Europe: Postcolonial Thought and Historical Difference.* Princeton: Princeton University Press, 2000.

Chang, Gordon H. "The Many Sides of Happy Lim: Aka Hom Ah Wing, Lin Jian Fu, Happy Lum, Lin Chien Fu, Hom Yen Chuck, Lam Kin Foo, Lum Kin Foo, Hom, Lim Goon Wing, Lim Gin Foo, Gin Foo Lin, Koon Wing Lim, Henry Chin, Lim Ying Chuck, Lim Ah Wing, et al." *Journal of Transnational American Studies* 2, no. 1 (2010): 70-98.

Cheng, Anne Anlin. *The Melancholy of Race: Psychoanalysis, Assimilation, and Hidden Grief.* New York: Oxford University Press, 2000.

———. *Second Skin: Josephine Baker and the Modern Surface.* New York: Oxford University Press, 2011.

Cheung, Floyd. Introduction to *And China Has Hands,* by H. T. Tsiang, 7-15. New York: Ironweed, 2003.

Chin, Frank, and Jeffery Chan, Lawson Inada, Shawn Wong. "An Introduction to Chinese- and Japanese-American Literature." In *Aiiieeeee! An Anthology of Asian-American Writers,* edited by Frank Chin, Jeffrey Chan, Lawson Inada, and Shawn Wong, xxi-xlviii. Washington, D.C.: Howard University Press, 1974.

Chow, Rey. *The Protestant Ethnic and the Spirit of Capitalism.* New York: Columbia University Press, 2002.

Clark, Katerina. *Moscow, the Fourth Rome: Stalinism, Cosmopolitanism, and the Evolution of Soviet Culture, 1931-1941.* Cambridge, Mass.: Harvard University Press, 2011.

———. *Petersburg: Crucible of Cultural Revolution.* Cambridge, Mass.: Harvard University Press, 1995.

Clifford, James. *The Predicament of Culture: Twentieth-Century Ethnography, Literature, and Art.* Cambridge, Mass.: Harvard University Press, 1988.

Connery, Christopher Leigh. "The End of the Sixties." *boundary 2* 36, no. 1 (spring 2009): 183-210.

——. "The World Sixties." In *The Worlding Project: Doing Cultural Studies in the Era of Globalization*, edited by Christopher Leigh Connery and Rob Wilson, 77–107. Berkeley: North Atlantic, 2007.

Crane, Robert. "Between Factography and Ethnography." In *Text and Presentation, 2010*, edited by Kiki Gounaridou, 41–53. Jefferson, N.C.: McFarland, 2010.

Cruse, Harold. *The Crisis of the Negro Intellectual*. New York: Morrow, 1967.

Cuddihy, John Murray. *The Ordeal of Civility: Freud, Marx, Lévi-Strauss, and the Jewish Struggle with Modernity*. New York: Basic Books, 1974.

Dante. *De vulgari eloquentia*. Edited and translated by Steven Botterill. Cambridge: Cambridge University Press, 1996.

Davin, Delia. "Gendered Mao: Mao, Maoism, and Women." In *A Critical Introduction to Mao*, edited by Timothy Cheek, 196–218. New York: Cambridge University Press, 2010.

Denning, Michael. *The Cultural Front*. New York: Verso, 1997.

——. *Culture in the Age of Three Worlds*. New York: Verso, 2004.

Derrida, Jacques. "Back from Moscow, in the USSR." In *Politics, Theory, and Contemporary Culture*, edited by Mark Poster, 197–236. New York: Columbia University Press, 1993.

Dickerman, Leah. "The Fact and the Photograph." *October* 118 (fall 2006): 132–52.

Dorman, Joseph. *Arguing the World: The New York Intellectuals in Their Own Words*. New York: Free Press, 2000.

Douglas, Christopher. *A Genealogy of Literary Multiculturalism*. Ithaca: Cornell University Press, 2009.

Du Bois, W. E. B. "Criteria of Negro Art." In *African American Literary Theory: A Reader*, edited by Winston Napier, 17–23. New York: New York University Press, 2000.

——. *The Souls of Black Folk*. Edited by David W. Blight and Robert Gooding-Williams. Boston: Bedford Books, 1997.

Dudziak, Mary. *Cold War Civil Rights: Race and the Image of American Democracy*. Princeton: Princeton University Press, 2000.

Edwards, Brent Hayes. *The Practice of Diaspora: Literature, Translation, and the Rise of Black Internationalism*. Cambridge, Mass.: Harvard University Press, 2003.

Efros, Abram. "Aladdin's Lamp." In Semyon An-sky, *The Jewish Artistic Heritage: An Album*, edited by Vasilii Rakitin and Andrei Sarabianov, 7–15. Moscow: RA, 1994.

Eisenstein, Sergei. *Film Form: Essays in Film Theory*. Edited and translated by Jay Leyda. New York: Harcourt, 1949.

——. "To the Magician of the Pear Orchard." In *S. M. Eisenstein: Selected Works, Volume III*, edited by Richard Taylor, translated by William Powell, 56–67. London: British Film Institute, 1996.

Elbaum, Max. *Revolution in the Air: Sixties Radicals Turn to Lenin, Mao and Che*. New York: Verso, 2002

Elliott, David, ed. *Mayakovsky: Twenty Years of Work; An Exhibition from the State Museum of Literature, Moscow*. Oxford: Museum of Modern Art, 1982.

Eng, David L. *Racial Castration: Managing Masculinity in Asian America*. Durham: Duke University Press, 2001.

Entin, Joseph. *Sensational Modernism*. Chapel Hill: University of North Carolina Press, 2007.

Estraikh, Gennady. *In Harness: Yiddish Writers' Romance with Communism*. Syracuse: Syracuse University Press, 2005.

Fabian, Johannes. *Time and the Other: How Anthropology Makes Its Object*. New York: Columbia University Press, 2002.

Favor, J. Martin. *Authentic Blackness: The Folk in the New Negro Renaissance*. Durham: Duke University Press, 1999.

Filatova, Lydia. "Langston Hughes: American Writer." *International Literature*, no. 2 (1933): 99–107.

——. "Negritianskaia literatura." In *Literaturnaia entsiklopediia, tom 7*, edited by A. V. Lunacharsky, 649–69. Moscow: Sovetskaia entsiklopediia, 1934.

Fishkin, Shelley Fisher. "Interrogating 'Whiteness,' Complicating 'Blackness': Remapping American Culture." *American Quarterly* 47, no. 3 (September 1995): 428–66.

Fitzpatrick, Sheila. *The Cultural Front: Power and Culture in Revolutionary Russia*. Ithaca: Cornell University Press, 1992.

——. "The 'Soft' Line on Culture and Its Enemies: Soviet Cultural Policy, 1922–1927." *Slavic Review* 33, no. 2 (June 1974): 267–87.

Flatley, Jonathan. *Affective Mapping: Melancholia and the Politics of Modernism*. Cambridge, Mass.: Harvard University Press, 2008.

——. "Moscow and Melancholia." *Social Text* 19, no. 1 (spring 2001): 75–102.

Foley, Barbara. *Radical Representations: Politics and Form in U.S. Proletarian Fiction, 1929–1941*. Durham: Duke University Press, 1993.

Fore, Devin. Introduction to *October* 118 (fall 2006): 3–10.

Foster, Hal. *The Return of the Real*. Cambridge, Mass.: MIT Press, 1996.

Fowler, Josephine. *Japanese and Chinese Immigrant Activists: Organizing in American and International Communist Movements, 1919–1933*. New Brunswick, N.J.: Rutgers University Press, 2007.

Freidenberg, Ol'ga Mikhailovna. "Vospominaniia o N. Ia. Marre." *Vostok-Zapad* 3 (1988): 181–204.

Friedberg, Haia. "Lissitzky's *Had Gadîa'*." *Jewish Art* 12/13 (1986–1987): 292–303.

Friedlander, Eli. "The Measure of the Contingent: Walter Benjamin's Dialectical Image." *boundary 2* 35, no. 3 (2008): 1–26.

Gallo, Rubén. *Mexican Modernity: The Avant-Garde and the Technological Revolution*. Cambridge, Mass.: MIT Press, 2005.

Gates, Henry Louis, Jr. *Figures in Black: Words, Signs, and the "Racial" Self*. New York: Oxford University Press, 1989.

——. *The Signifying Monkey: A Theory of Afro-American Literary Criticism*. New York: Oxford University Press, 1989.

Gelb, Michael. "An Early Soviet Ethnic Deportation: The Far-Eastern Koreans." *Russian Review* 54, no. 3 (July 1995): 389–412.

Gilenson, B. A. *Sovremennye negritianskie pisateli SShA*. Moscow: Znanie, 1981.

Gilmore, Glenda Elizabeth. *Defying Dixie: The Radical Roots of Civil Rights, 1919–1950*. New York: Norton, 2008.

Gilroy, Paul. *The Black Atlantic: Modernity and Double-Consciousness*. Cambridge, Mass.: Harvard University Press, 1993.

Glaser, Amelia M. "From Jewish Jesus to Black Christ: Race Violence in Leftist Yiddish Poetry." *Studies in American Jewish Literature* 34, no. 1 (spring 2015).

———. *Jews and Ukrainians in Russia's Literary Borderlands: From the Shtetl Fair to the Petersburg Bookshop*. Evanston, Ill.: Northwestern University Press, 2012.

Glazer, Nathan. *We Are All Multiculturalists Now*. Cambridge, Mass.: Harvard University Press, 1997.

Glazer, Nathan, and Daniel Patrick Moynihan. *Beyond the Melting Pot: The Negroes, Puerto Ricans, Jews, Italians, and Irish of New York City*. Cambridge, Mass.: MIT Press, 1963.

Gold, Michael. *Jews Without Money*. New York: Liveright, 1930.

Golden, Lily. *My Long Journey Home*. Chicago: Third World, 2002.

Goldman, Emma. *My Disillusionment in Russia*. New York: Dover, 2003.

Goncharova, Natal'ia. "Preface to Catalogue of One-Man Exhibition, 1913." In *Russian Art of the Avant-Garde: Theory and Criticism, 1902-1934*, edited and translated by John E. Bowlt, 54–60. New York: Viking, 1988.

Gooding-Williams, Robert. *In the Shadow of Du Bois: Afro-Modern Political Thought in America*. Cambridge, Mass.: Harvard University Press, 2011.

Gough, Maria. *The Artist as Producer: Russian Constructivism in Revolution*. Berkeley: University of California Press, 2005.

———. "Paris, Capital of the Soviet Avant-Garde." *October* 101 (summer 2002): 53–83.

———. "Radical Tourism: Sergei Tret'iakov at the Communist Lighthouse." *October* 118 (fall 2006): 159–78.

Greenberg, Cheryl Lynn. *Troubling the Waters: Black-Jewish Relations in the American Century*. Princeton: Princeton University Press, 2006.

Greenberg, Clement. "Avant-Garde and Kitsch." *Partisan Review* 6 (1939): 34–39.

Greenblatt, Stephen. *Marvelous Possessions: The Wonder of the New World*. Chicago: University of Chicago Press, 1991.

Groys, Boris. "Rossiia kak podsoznanie Zapada." In *Utopiia i obmen*, 245–59. Moscow: Znak, 1993.

———. "Russia and the West: The Quest for Russian National Identity." *Studies in Soviet Thought* 43 (1992): 185–98.

———. *The Total Art of Stalinism: Avant-Garde, Aesthetic Dictatorship, and Beyond*. Translated by Charles Rougle. Princeton: Princeton University Press, 1992.

Guo Jian. "Resisting Modernity in Contemporary China: The Cultural Revolution and Postmodernism." *Modern China* 25, no. 3 (July 1999): 343–76.

Habal, Estella. *San Francisco's International Hotel: Mobilizing the Filipino American Community in the Anti-Eviction Movement*. Philadelphia: Temple University Press, 2007.

Hasegawa, Tsuyoshi. *Racing the Enemy: Stalin, Truman, and the Surrender of Japan*. Cambridge, Mass.: Harvard University Press, 2005.

Hauner, Milan. *What Is Asia to Us? Russia's Asian Heartland Yesterday and Today*. Boston: Unwin Hyman, 1990.

Haywood, Harry. *Black Bolshevik: Autobiography of an Afro-American Communist*. Chicago: Liberator, 1978.

Higham, John. "Multiculturalism and Universalism: A History and Critique." *American Quarterly* 45, no. 2 (June 1993): 105–219.

——. *Send These to Me: Jews and Other Immigrants in Urban America*. New York: Atheneum, 1975.

Hirsch, Francine. *Empire of Nations: Ethnographic Knowledge and the Making of the Soviet Union*. Ithaca: Cornell University Press, 2005.

Ho, Fred. "Fists for Revolution." In *Legacy to Liberation: Politics and Culture of Revolutionary Asian Pacific America*, edited by Fred Ho, Carolyn Antonio, Diane Fujino, and Steve Yip, 3–13. San Francisco: Big Red Media and AK Press, 2000.

——. "The Inspiration of Mao and the Chinese Revolution on the Black Liberation Movement and the Asian Movement on the East Coast." In *Afro Asia: Revolutionary Political and Cultural Connections between African Americans and Asian Americans*, edited by Fred Ho and Bill V. Mullen, 155–64. Durham: Duke University Press, 2008.

Ho, Fred, and Steve Yip. "Alex Hing, Former Minister for the Red Guard Party and Founding Member of I Wor Kuen." In *Legacy to Liberation: Politics and Culture of Revolutionary Asian Pacific America*, edited by Fred Ho, Carolyn Antonio, Diane Fujino, and Steve Yip, 279–96. San Francisco: Big Red Media and AK Press, 2000.

Holcomb, Gary Edward. *Claude McKay, Code Name Sasha: Queer Black Marxism and the Harlem Renaissance*. Gainesville: University Press of Florida, 2007.

Hollinger, David A. *Cosmopolitanism and Solidarity: Studies in Ethnoracial, Religious, and Professional Affiliation in the United States*. Madison: University of Wisconsin Press, 2006.

——. "Ethnic Diversity, Cosmopolitanism and the Emergence of the American Liberal Intelligentsia." *American Quarterly* 27, no. 2 (May 1975): 133–51.

——. "Not Universalists, Not Pluralists: The New Cosmopolitans Find Their Own Way." *Constellations* 8, no. 2 (June 2001): 236–48.

——. *Postethnic America: Beyond Multiculturalism*. New York: Basic Books, 1995.

——. "Rich, Powerful, and Smart: Jewish Overrepresentation Should Be Explained Instead of Avoided or Mystified." *Jewish Quarterly Review* 94, no. 4 (fall 2004): 595–602.

Hook, Sidney. "Memories of the Moscow Trials." *Commentary* 77 (March 1984): 57–63.

——. "Messages." In *A Decade of Destruction: Jewish Culture in the USSR, 1948-1958*, 37. New York: Congress for Jewish Culture, 1958.

——. "Reflections on the Jewish Question." *Partisan Review* 16 (May 1949): 477–78.

Howe, Irving. *Decline of the New*. New York: Harcourt, 1970.

——. "The Lost Young Intellectual: A Marginal Man, Twice Alienated." *Commentary* 2 (October 1946): 361–67.

——. *A Margin of Hope: An Intellectual Autobiography*. San Diego: Harcourt, 1982.

——. "New York in the Thirties: Some Fragments of Memory." *Dissent* 8 (summer 1961): 241–50.

——. "Our Country and Our Culture." *Partisan Review* 19 (September–October 1952): 575–81.

——. *Politics and the Novel*. New York: Horizon, 1957.

———. *Steady Work: Essays in the Politics of Democratic Radicalism, 1953–1966.* New York: Harcourt, 1966.

———. "Tevye on Broadway." *Commentary* 38 (November 1964): 73–75.

———. *A World More Attractive: A View of Modern Literature and Politics.* New York: Horizon, 1963.

Howe, Irving, and Eliezer Greenberg, eds. *A Treasury of Yiddish Stories.* New York: Viking, 1954.

Hughes, Langston. "Cubes." In *The Collected Poems of Langston Hughes*, edited by Arnold Rampersad and David Roessel, 175–76. New York: Random House, 1994.

———. *Good Morning Revolution: Uncollected Writings of Social Protest.* Edited by Faith Berry. New York: Citadel, 1973.

———. *I Wonder as I Wander: An Autobiographical Journey.* New York: Hill and Wang, 1956.

———. "Moscow and Me: A Noted American Writer Relates His Experiences." *International Literature*, no. 3 (July 1933): 60–66.

———. "The Negro Artist and the Racial Mountain." In *African American Literary Theory: A Reader*, edited by Winston Napier, 27–30. New York: New York University Press, 2000.

———. *A Negro Looks at Soviet Central Asia.* Moscow: Co-operative Publishing Society of Foreign Workers in the U.S.S.R., 1934.

———. "Roar, China!" *Volunteer for Liberty* 1 (September 6, 1937): 3.

———. "The Soviet Union and Jews." In *Good Morning Revolution: Uncollected Writings of Social Protest*. Edited by Faith Berry, 86–88. New York: Citadel, 1973.

Huntington, Samuel. *The Clash of Civilizations and the Remaking of World Order.* New York: Simon and Schuster, 1996.

Hutchinson, George. *The Harlem Renaissance in Black and White.* Cambridge, Mass.: Harvard University Press, 1995.

Huyssen, Andreas. *After the Great Divide: Modernism, Mass Culture, Postmodernism.* Bloomington: Indiana University Press, 1986.

Iangirov, R. M. "Marginal'nye temy v tvorcheskoi praktike LEFa." In *Tynianovskii sbornik: Piatye Tynianovskie chteniia*, edited by Marietta Chudakova, 223–48. Riga: Zinatne, 1994.

Iriye, Akira. *Cultural Internationalism and World Order.* Baltimore: Johns Hopkins University Press, 1997.

Jacobson, Matthew Frye. *Roots Too: White Ethnic Revival in Post-Civil Rights America.* Cambridge, Mass.: Harvard University Press, 2006.

Jakobson, Roman. *My Futurist Years.* Edited by Bengt Jangfelt. Translated by Stephen Rudy. New York: Marsilio, 1997.

James, David E. *The Most Typical Avant-Garde: History and Geography of Minor Cinemas in Los Angeles.* Berkeley: University of California Press, 2005.

Jameson, Fredric. "Periodizing the 60s." *Social Text*, no. 9/10 (spring–summer 1984): 178–209.

Jarrico, Paul, and Herbert Biberman. "Breaking Ground." In *Salt of the Earth*, edited by Deborah Silverton Rosenfelt, 169–74. New York: Feminist Press, 1978.

Jin, Wen. *Pluralist Universalism: An Asian Americanist Critique of U.S. and Chinese Multicultural-isms*. Columbus: Ohio State University Press, 2012.

Jolles, Adam. "The Tactile Turn: Envisioning a Postcolonial Aesthetic in France." *Yale French Studies* 109 (July 2006): 17–38.

Jones, Donna V. "The Prison House of Modernism: Colonial Spaces and the Construction of the Primitive at the 1931 Paris Colonial Exposition." *Modernism/modernity* 14, no. 1 (January 2007): 55–69.

Kachurin, Pamela. "Working (for) the State: Vladimir Tatlin's Career in Early Soviet Rus-sia and the Origins of the Monument to the Third International." *Modernism/moder-nity* 19, no. 1 (January 2012): 19–41.

Kallen, Horace M. *Culture and Democracy in the United States*. New Brunswick, N.J.: Transac-tion, 1998.

——. "Democracy Versus the Melting-Pot." *Nation* 100, no. 2590–2591 (February 18, 25, 1915): 190–94, 217–20.

——. *Frontiers of Hope*. New York: Liveright, 1929.

Karp, Jonathan. "Performing Black-Jewish Symbiosis: The 'Hasidic Chant' of Paul Robe-son." *American Jewish History* 91, no. 3 (March 2003): 53–81.

Katanian, Vasilii A. *Maiakovskii: Khronika zhizni i deiatel'nosti*. Moscow: Sovetskii pisatel', 1985.

Katz, Dovid. "The Days of Proletpen in American Yiddish Poetry." Introduction to *Pro-letpen: America's Rebel Yiddish Poets*, edited by Amelia Glaser and David Weintraub, translated by Amelia Glaser. Madison: University of Wisconsin Press, 2005.

Kelberg, Lars. "Eisenstein's *Potemkin* and Tret'iakov's *Rychi, Kitai!*" *Scando-Slavica Tomus* 23 (1977): 29–37.

Kelley, Robin D. G. *Hammer and Hoe: Alabama Communists During the Great Depression*. Chapel Hill: University of North Carolina Press, 1990.

Kelley, Robin D. G., and Betty Esch. "Black Like Mao: Red China and Black Revolution." *Souls* 1, no. 4 (fall 1999): 6–41.

Kemrad, S. *Maiakovskii v Amerike*. Moscow: Sovetskii pisatel', 1970.

Kernan, Ryan James. "The *Coup* of Langston Hughes's Picasso Period: Excavating Maya-kovsky in Langston Hughes's Verse." *Comparative Literature* 66, no. 2 (spring 2014): 227–46.

——. "Lost and Found in Black Translation: Langston Hughes's Translations of French- and Spanish-Language Poetry, His Hispanic and Francophone Translators, and the Fashioning of Radical Black Subjectivities." Ph.D. diss., University of California, Los Angeles, 2007.

Khalid, Adeeb. *Islam After Communism: Religion and Politics in Central Asia*. Berkeley: Univer-sity of California Press, 2007.

——. "Russian History and the Debate over Orientalism." *Kritika* 1, no. 4 (fall 2000): 691–99.

Khanga, Yelena, and Susan Jacoby. *Soul to Soul: A Black Russian American Family, 1865–1992*. New York: Norton, 1992.

Khlebnikov, Velimir. "The Trumpet of the Martians." In *Russian Futurism Through Its Mani-festos, 1912–1928*, edited by Anna Lawton, 103–6. Ithaca: Cornell University Press, 1988.

Kiaer, Christina. *Imagine No Possessions: The Socialist Objects of Russian Constructivism*. Cambridge, Mass.: MIT Press, 2005.

Kim, Jodi. *Ends of Empire: Asian American Critique and the Cold War*. Minneapolis: University of Minnesota Press, 2010.

Kingston, Maxine Hong. *China Men*. New York: Knopf, 1980.

Kinoslovar' v dvukh tomakh. Moscow: Sovetskaia entsiklopediia, 1966.

Klehr, Harvey, Jon Earl Haynes, and Kyrill M. Anderson. *The Soviet World of American Communism*. New Haven: Yale University Press, 1998.

Knight, Nathaniel. "On Russian Orientalism: A Response to Adeeb Khalid." *Kritika* 1, no. 4 (fall 2000): 701–15.

Koestler, Arthur. *The Invisible Writing*. New York: Vintage, 2005.

Kolchevska, Natasha. "From Agitation to Factography: The Plays of Sergej Tret'jakov." *SEEJ* 31, no. 3 (autumn 1987): 388–403.

Koliazin, V. F., ed. *"Vernite mne svobodu!": Deiateli literatury i iskusstva Rossii i Germanii—zhertvy stalinskogo terrora*. Moscow: Medium, 1997.

Koselleck, Reinhart. *Futures Past: On the Semantics of Historical Time*. Translated by Keith Tribe. New York: Columbia University Press, 2004.

Kossie-Chernyshev, Karen. "Reclaiming 'Д. Паттерсон' (J. Patterson), Child Star in Grigori Alexandrov's *Circus*: A Reconstructive History." *Sound Historian* 8, no. 2 (2002): 61–72.

Kunichika, Michael. "The Penchant for the Primitive: Archaeology, Ethnography, and the Aesthetics of Russian Modernism." Ph.D. diss., University of California, Berkeley, 2007.

Kymlicka, Will. "American Multiculturalism in the International Arena." *Dissent* 45 (fall 1998): 73–79.

Lähteenmäki, Mika. "Nikolai Marr and the Idea of a Unified Language." *Language and Communication* 26, no. 3 (2006): 285–95.

Lai, Him Mark. "Historical Survey of the Chinese Left in America." In *Counterpoint, Perspectives on Asian America*, edited by Emma Gee, 63–80. Los Angeles: UCLA Asian American Studies Center, 1976.

Langer, Lawrence. *The Magic Curtain*. New York: Dutton, 1951.

Lasch, Christopher. "The Cultural Cold War: A Short History of the Congress for Cultural Freedom." In *Towards a New Past: Dissenting Essays in American History*, edited by Barton Bernstein, 322–59. New York: Pantheon, 1968.

Lavut, P. I. *Maiakovskii edet po soiuzu*. Moscow: Sovetskaia Rossiia, 1978.

Lawton, Anna. Introduction to *Russian Futurism Through Its Manifestos, 1912–1928*, edited by Anna Lawton, 1–48. Ithaca: Cornell University Press, 1988.

Leary, John Patrick. "Havana Reads the Harlem Renaissance: Langston Hughes, Nicolás Guillén, and the Dialectics of Transnational American Literature." *Comparative Literature Studies* 47, no. 2 (2010): 133–58.

Leivick, H. "Who Are the Guilty?" In *A Decade of Destruction: Jewish Culture in the USSR, 1948–1958*, 25–27. New York: Congress for Jewish Culture, 1958.

Lemon, Alaina. "Sympathy for the Weary State? Cold War Chronotopes and Moscow Others." *Comparative Studies in Society and History* 51, no. 4 (2009): 832–64.

Lenin, V. I. "Draft Theses on National and Colonial Questions for the Second Congress of the Communist International," https://www.marxists.org/archive/lenin/works/1920/jun/05.htm (accessed July 4, 2014).

Levenberg, S. "Soviet Jewry: Some Problems and Perspectives." In *The Jews in Soviet Russia since 1917*, edited by Lionel Kochan, 30–46. London: Oxford University Press, 1972.

Levine, Lawrence. *The Opening of the American Mind*. Boston: Beacon Press, 1996.

Lewis, David Levering. *When Harlem Was in Vogue*. New York: Penguin, 1997.

Lipsitz, George. "Herbert Biberman and the Art of Subjectivity." *Telos* 32 (1977): 174–82

Locke, Alain. "The Negro Poets of the United States." In *Anthology of Magazine Verse and Yearbook of American Poetry*, edited by William Stanley Braithwaite, 143–51. Boston: Brimmer, 1926.

Lorence, James. *The Suppression of "Salt of the Earth": How Hollywood, Big Labor, and Politicians Blacklisted a Movie in Cold War America*. Albuquerque: University of New Mexico Press, 1999.

Lowe, Lisa. *Critical Terrains: French and British Orientalisms*. Ithaca: Cornell University Press, 1991.

Löwy, Michael. *Fire Alarm: Reading Walter Benjamin's "On the Concept of History."* Translated by Chris Turner. New York: Verso, 2005.

——. *The Politics of Combined and Uneven Development: The Theory of Permanent Revolution*. New York: Verso, 1981.

Luis-Brown, David. *Waves of Decolonization: Discourses of Race and Hemispheric Citizenship in Cuba, Mexico, and the United States*. Durham: Duke University Press, 2008.

Lukács, Georg. "Class Consciousness." In *History and Class Consciousness: Studies in Marxist Dialectics*. Translated by Rodney Livingston, 46–82. Cambridge, Mass.: MIT Press, 1971.

Lunacharsky, Anatoly. "The Eastern Bogey." Translated by Bessie Weissmann. *New Masses*, November 1926, 13.

Lye, Colleen. *America's Asia: Racial Form and American Literature, 1893-1945*. Princeton: Princeton University Press, 2005.

——. "Asian American 1960s." In *The Routledge Companion to Asian American and Pacific Islander Literature*, edited by Rachel C. Lee, 213–23. New York: Routledge, 2014.

Maeda, Daryl J. *Chains of Babylon: The Rise of Asian America*. Minneapolis: University of Minnesota Press, 2009.

Malia, Martin. *Russia under Western Eyes: From the Bronze Horseman to the Lenin Mausoleum*. Cambridge, Mass.: Harvard University Press, 1999.

Mally, Lynn. "The Americanization of the Soviet Living Newspaper." *Carl Beck Papers in Russian and East European Studies* 1903 (February 2008): 30–40.

Mao Tse-Tung. "On Contradiction," https://www.marxists.org/reference/archive/mao/selected-works/volume-1/mswv1_17.htm (accessed July 4, 2014).

——. *Talks at the Yenan Forum on Literature and Art*. Beijing: Foreign Languages Press, 1967.

Mariani, Paul. *William Carlos Williams: A New World Naked*. New York: Norton, 1990.

Markov, Vladimir. *Russian Futurism: A History*. Berkeley: University of California Press, 1968.

Marr, N. Ia. "Chem zhivet iafeticheskoe iazykoznanie?" In *Izbrannye raboty, tom 1*, edited by V. B. Aptekar', 158–84. Leningrad: GAIMK, 1933.

———. "Iafeticheskii Kavkaz i tretii etnicheskii element v sozidanii sredizemnomorskoi kul'tury." In *Izbrannye raboty, tom 1*, edited by V. B. Aptekar', 79–124. Leningrad: GAIMK, 1933.

———. "Iazyk i myshlenie." In *Izbrannye raboty, tom 3*, edited by V. B. Aptekar', 90–122. Leningrad: GAIMK, 1934.

———. "Znachenie i rol' izucheniia natsmen'shinstva v kraevedenii." In *Izbrannye raboty, tom 1*, edited by V. B. Aptekar', 231–48. Leningrad: GAIMK, 1933.

Martin, Terry. *The Affirmative Action Empire: Nations and Nationalism in the Soviet Union, 1923–1939*. Ithaca: Cornell University Press, 2001.

Marx, Karl. "On the Jewish Question." In *The Marx-Engels Reader*, edited by Robert C. Tucker, 26–52. New York: Norton, 1978.

Matusevich, Maxim. "Journeys of Hope: African Diaspora and the Soviet Society." *African Diaspora* 1 (2008): 53–85.

Maxwell, William J. *New Negro, Old Left: African-American Writing and Communism Between the Wars*. New York: Columbia University Press, 1999.

Mayakovsky, V. V. "Amerikanskie russkie." In *Polnoe sobranie sochinenii, tom 7*, 80–82. Moscow: Gos. izdat. khudozh. lit., 1957.

———. "Blek end uait." In *Polnoe sobranie sochinenii, tom 7*, 20–23. Moscow: Gos. izdat. khudozh. lit., 1957.

———. "Bruklinskii most." In *Polnoe sobranie sochinenii, tom 7*, 83–87. Moscow: Gos. izdat. khudozh. lit., 1957.

———. "Domoi!" In *Polnoe sobranie sochinenii, tom 7*, 92–95. Moscow: Gos. izdat. khudozh. lit., 1957.

———. "How I Made Her Laugh." In *My Discovery of America*. Translated by Neil Cornwell. London: Hesperus, 2005

———. "Kemp 'Nit gedaige.'" In *Polnoe sobranie sochinenii, tom 7*, 88–91. Moscow: Gos. izdat. khudozh. lit., 1957.

———. "Meksika." In *Polnoe sobranie sochinenii, tom 7*, 41–48. Moscow: Gos. izdat. khudozh. lit., 1957.

———. *My Discovery of America*. Translated by Neil Cornwell. London: Hesperus, 2005

———. "Sifilis." In *Polnoe sobranie sochinenii, tom 7*, 24–30. Moscow: Gos. izdat. khudozh. lit., 1957.

Mayer, Arno J. *Wilson vs. Lenin: Political Origins of the New Diplomacy, 1917–1918*. New Haven: Yale University Press, 1959.

McClellan, Woodford. "Africans and Black Americans in the Comintern Schools, 1925–1934." *International Journal of African Historical Studies* 26, no. 2 (1993): 371–90.

McKay, Claude. *A Long Way from Home*. New York: Harcourt, 1970.

Meserve, Walter J., and Ruth I. Meserve. "The Stage History of *Roar China!*: Documentary Drama as Propaganda." *Theatre Survey* 21 (1980): 1–13.

Meyer, Peter. "Soviet Anti-Semitism in High Gear." *Commentary* 15 (February 1953): 115–20.

Michaels, Walter Benn. *Our America: Nativism, Modernism, and Pluralism.* Durham: Duke University Press, 1995.

Michels, Tony. *A Fire in Their Hearts: Yiddish Socialists in New York.* Cambridge, Mass.: Harvard University Press, 2005.

——. "Socialism and the Writing of American Jewish History: *World of Our Fathers* Revisited." *American Jewish History* 88, no. 4 (December 2000): 521–46.

Miller, James, et al. "Mother Ada Wright and the International Campaign to Free the Scottsboro Boys." *American Historical Review* 106, no. 2 (April 2001): 387–430.

Milner, John. *Vladimir Tatlin and the Russian Avant-Garde.* New Haven: Yale University Press, 1983.

Moglen, Seth. "Modernism in the Black Diaspora: Langston Hughes and the Broken Cubes of Picasso." *Callaloo* 25, no. 4 (fall 2002): 1189–1205.

Moldavskii, Dm. *Maiakovskii i poeziia narodov SSSR.* Leningrad: Sovetskii pisatel', 1951.

Moore, David Chioni. "Colored Dispatches from the Uzbek Border." *Callaloo* 25, no. 4 (fall 2002): 1115–1135.

——. "Local Color, Global 'Color': Langston Hughes, the Black Atlantic, and Soviet Central Asia, 1932." *Research in African Literatures* 27, no. 4 (winter 1996): 49–70.

Moser, Charles A. "Mayakovsky's Unsentimental Journeys." *American Slavic and East European Review* 19, no. 1 (February 1960): 85–100.

Moss, Kenneth B. *Jewish Renaissance in the Russian Revolution.* Cambridge, Mass.: Harvard University Press, 2009.

Mukherji, Ani. "The Anticolonial Imagination: The Exilic Productions of American Radicalism in Interwar Moscow." Ph.D. diss., Brown University, 2011.

Mullen, Bill V. *Afro-Orientalism.* Minneapolis: University of Minnesota Press, 2004.

Muñoz, José Esteban. *Cruising Utopia: The Then and There of Queer Futurity.* New York: New York University Press, 2009.

Nadir, Moishe. *Moyde Ani.* New York: Narayev, 1944.

Nesbet, Anne. *Savage Junctures: Sergei Eisenstein and the Shape of Thinking.* London: Tauris, 2003.

The 1928 and 1930 Comintern Resolutions on the Black National Question in the United States. Washington, D.C.: Revolutionary Review, 1975.

Ninkovich, Frank. *The Diplomacy of Ideas: U.S. Foreign Policy and Cultural Relations, 1938–1950.* New York: Cambridge University Press, 1981.

North, Michael. *The Dialect of Modernism: Race, Language, and Twentieth-Century Literature.* New York: Oxford University Press, 1998.

Omi, Michael, and Howard Winant. *Racial Formation in the United States: From the 1960s to the 1990s.* New York: Routledge, 1994.

Orbach, William W. *The American Movement to Aid Soviet Jews.* Amherst: University of Massachusetts Press, 1979.

Osborne, Peter. *The Politics of Time: Modernity and Avant-Garde.* New York: Verso, 1995.

Papazian, Elizabeth Astrid. *Manufacturing Truth: The Documentary Moment in Early Soviet Culture.* DeKalb: Northern Illinois University Press, 2009.

Park, Josephine. *Apparitions of Asia: Modernist Form and Asian American Poetics.* New York: Oxford University Press, 2008.

Perloff, Marjorie. *The Futurist Moment: Avant-Garde, Avant Guerre, and the Language of Rupture*. Chicago: University of Chicago Press, 1986.

Peterson, Dale E. *Up from Bondage: The Literatures of Russian and African American Soul*. Durham: Duke University Press, 2000.

Pietz, William. "The 'Post-Colonialism' of Cold War Discourse." *Social Text*, no. 19/20 (autumn 1988): 55–75.

Poggioli, Renato. *The Theory of the Avant-Garde*. Translated by Gerald Fitzgerald. Cambridge, Mass.: Harvard University Press, 1968.

Punin, Nikolai. "O pamiatnikakh." In *O Tatline*, edited by I. N. Punina and V. I. Rakitin, 14–17. Moscow: RA, 1994.

——. *Pamiatnik III Internatsionala*. Petrograd: Otdel izobrazitel'nykh iskusstv NKP, 1920.

Ram, Harsha. "Futurist Geographies: Uneven Modernities and the Struggle for Aesthetic Autonomy; Paris, Italy, Russia, 1909–1914." In *The Oxford Handbook of Global Modernisms*, edited by Mark Wollaeger and Matt Eatough, 313–40. New York: Oxford University Press, 2012.

——. "Imagining Eurasia: The Poetics and Ideology of Olzhas Suleimenov's *AZ i IA*." *Slavic Review* 60, no. 2 (summer 2001): 289–311.

——. *The Imperial Sublime: A Russian Poetics of Empire*. Madison: University of Wisconsin Press, 2006.

——. "The Poetics of Eurasia: Velimir Khlebnikov between Empire and Revolution." In *Social Identities in Revolutionary Russia*, edited by Madhavan Palat, 209–31. New York: Palgrave, 2001.

Rampersad, Arnold. "Langston Hughes and His Critics on the Left." *Langston Hughes Review* 5, no. 2 (fall 1986): 34–40.

——. *The Life of Langston Hughes*. 2 vols. New York: Oxford University Press, 2002.

Rapoport, Louis. *Stalin's War Against the Jews: The Doctors' Plot and the Soviet Solution*. New York: Free Press, 1990.

Richardson, William Harrison. "The Dilemmas of a Communist Artist: Diego Rivera in Moscow, 1927–1928." *Mexican Studies/Estudios Mexicanos* 3, no. 1 (winter 1987): 49–69.

——. *Mexico Through Russian Eyes, 1806–1940*. Pittsburgh: University of Pittsburgh Press, 1988.

Riddell, John, ed. *To See the Dawn: Baku, 1920—First Congress of the Peoples of the East*. New York: Pathfinder, 1993.

Roberts, John. "Revolutionary Pathos, Negation, and the Suspensive Avant-Garde." *New Literary History* 41, no. 4 (autumn 2010): 717–30.

Robeson, Paul, Jr. "How My Father Last Met Itzik Feffer." *Jewish Currents* 35 (November 1981): 4–8.

Robinson, Robert. *Black on Red: My 44 Years Inside the Soviet Union*. Washington, D.C.: Acropolis, 1988.

Roediger, David R. *Colored White: Transcending the Racial Past*. Berkeley: University of California Press, 2002.

Ro'i, Yaacov. *The Struggle for Soviet Jewish Emigration, 1948–1967*. Cambridge: Cambridge University Press, 1991.

Rosenberg, Harold. "Does the Jew Exist? Sartre's Morality Play About Anti-Semitism." *Commentary* 7 (January 1949): 8–18.

Rosenfeld, Seth. "Man Who Armed Black Panthers Was FBI Informant, Records Show." *Center for Investigative Reporting*, August 20, 2012, http://cironline.org/reports/man-who-armed-black-panthers-was-fbi-informant-records-show-3753 (accessed July 4, 2014).

Rosenfelt, Deborah Silverton. "Commentary." In *Salt of the Earth*, edited by Deborah Silverton Rosenfelt, 93–168. New York: Feminist Press, 1978.

Roy, Olivier. *The New Central Asia: The Creation of Nations*. New York: New York University Press, 2000.

Rubenstein, Joshua, and Vladimir P. Naumov, eds. *Stalin's Secret Pogrom: The Postwar Inquisition of the Jewish Anti-Fascist Committee*. Translated by Laura Esther Wolfson. New Haven: Yale University Press, 2001.

Rudnitsky, Konstantin. *Russian and Soviet Theatre: Tradition and the Avant-Garde*. London: Thames and Hudson, 1988.

Salazkina, Masha. *In Excess: Sergei Eisenstein's Mexico*. Chicago: University of Chicago Press, 2009.

——. "Moscow-Rome-Havana: A Film-Theory Road Map." *October* 139 (winter 2012): 97–116.

Samuel, Maurice. *The World of Sholom Aleichem*. New York: Knopf, 1947.

Sartre, Jean-Paul. *Anti-Semite and Jew*. Translated by George J. Becker. New York: Schocken Books, 1948.

Saunders, Frances Stonor. *Who Paid the Piper? The CIA and the Cultural Cold War*. London: Granta, 1999.

Saxton, Alexander. *The Indispensable Enemy: Labor and the Anti-Chinese Movement in California*. Berkeley: University of California Press, 1971.

Schlesinger, Arthur M., Jr. *The Disuniting of America: Reflections on a Multicultural Society*. New York: Norton, 1998.

Schrecker, Ellen. *Many Are the Crimes: McCarthyism in America*. Princeton: Princeton University Press, 1998.

Schulman, Elias. *The Fate of Soviet Jewry: The Jews in the Soviet Union; Soviet-Yiddish Literature, 1918-1948*. New York: Jewish Labor Committee, 1958.

Schwarz, Solomon M. *The Jews in the Soviet Union*. Syracuse: Syracuse University Press, 1951.

Schweriner, Arthur. *How Far Shall We Go?* New York: Veritas, 1935.

Scott-Smith, Giles. *The Politics of Apolitical Culture: The Congress for Cultural Freedom, the CIA, and Postwar American Hegemony*. New York: Routledge, 2002.

Seifrid, Thomas. "Platonov, Socialist Realism, and the Avant-Garde." In *Laboratory of Dreams: The Avant-Garde and Cultural Experiment*, edited by John E. Bowlt and Olga Matich, 235–44. Stanford: Stanford University Press, 1996.

Serebrianyi, I. A. *Sholom-Aleikhem i narodnoe tvorchestvo*. Moscow: Sovetskii pisatel', 1959.

Serge, Victor. *Memoirs of a Revolutionary*. Edited and translated by Peter Sedgwick. Oxford: Oxford University Press, 1980.

Sharp, Jane Ashton. "Beyond Orientalism: Russian and Soviet Modernism on the Periphery of Empire." In *Russian Art and the West: A Century of Dialogue in Painting, Architecture, and the Decorative Arts*, edited by Rosalind Blakesley and Susan Reid. DeKalb: Northern Illinois University Press, 2007.

——. *Russian Modernism between East and West: Natal'ia Goncharova and the Moscow Avant-Garde*. New York: Cambridge University Press, 2006.

Shevchenko, Aleksandr. "Neoprimitivism: Its Theory, Its Potentials, Its Achievements." In *Russian Art of the Avant-Garde: Theory and Criticism, 1902-1934*, edited and translated by John E. Bowlt. New York: Viking, 1988.

Shklovskii, Viktor. "On *Faktura* and Counter Reliefs." In *Tatlin*, edited by Larissa Zhadova, 340–42. New York: Rizzoli, 1988.

Shore, Marci. *Ashes and Caviar: A Warsaw Generation's Life and Death in Marxism, 1918-1968*. New Haven: Yale University Press, 2006.

——. *The Taste of Ashes: The Afterlife of Totalitarianism in Eastern Europe*. New York: Crown, 2013.

Singer, Isaac Bashevis. "A New Use for Yiddish." *Commentary* 33 (March 1962): 267–69.

Singh, Nikhil Pal. "Cold War Redux: On the 'New Totalitarianism.'" *Radical History Review* 85 (winter 2003): 171–81.

——. "Retracing the Black-Red Thread." *American Literary History* 15, no. 4 (2003): 830–40.

Slezkine, Yuri. *Arctic Mirrors: Russia and the Small Peoples of the North*. Ithaca: Cornell University Press, 1994.

——. "The Fall of Soviet Ethnography, 1928-38." *Current Anthropology* 32, no. 4 (1991): 476–84.

——. *The Jewish Century*. Princeton: Princeton University Press, 2004.

——. "N. Ia. Marr and the National Origins of Soviet Ethnogenetics." *Slavic Review* 55, no. 4 (winter 1996): 826–62.

——. "The USSR as a Communal Apartment, or How a Socialist State Promoted Ethnic Particularism." *Slavic Review* 53, no. 2 (summer 1994): 414–52.

Smethurst, James. *The New Red Negro: The Literary Left and African American Poetry, 1930-1946*. New York: Oxford University Press, 1999.

Smith, Homer. *Black Man in Red Russia*. Chicago: Johnson, 1964.

Sollors, Werner. "A Critique of Pure Pluralism." In *Reconstructing American Literary History*, edited by Sacvan Bercovitch. Cambridge, Mass.: Harvard University Press, 1986.

Solomon, Mark. *The Cry Was Unity: Communists and African Americans, 1917-1936*. Jackson: University Press of Mississippi, 1998.

Spence, Jonathan D. *The Search for Modern China*. New York: Norton, 1999.

Spira, Andrew. *The Avant-Garde Icon: Russian Avant-Garde Art and the Icon Painting Tradition*. Hampshire, U.K.: Lund Humphries, 2008.

Stalin, Joseph. "Marxism and the National Question." In *Marxism and the National and Colonial Question*, edited by A. Fineburg. New York: International, 1934.

Steinberg, Mark. *Proletarian Imagination: Self, Modernity, and the Sacred in Russia, 1910-1925*. Ithaca: Cornell University Press, 2002.

Stephens, Michelle. *Black Empire: The Masculine Global Imaginary of Caribbean Intellectuals in the United States, 1914–1962.* Durham: Duke University Press, 2005.

Stocking, George W., Jr. "The Basic Assumptions of Boasian Anthropology." In *The Shaping of American Anthropology, 1883–1911,* edited by George W. Stocking Jr., 1–20. New York: Basic Books, 1974.

Sunada, Erika. "Revisiting Horace M. Kallen's Cultural Pluralism: A Comparative Analysis." *Journal of American and Canadian Studies* 18 (2000): 51–76.

Sundquist, Eric J. *Strangers in the Land: Blacks, Jews, Post-Holocaust America.* Cambridge, Mass.: Harvard University Press, 2005.

Suny, Ronald Grigor. *The Revenge of the Past: Nationalism, Revolution, and the Collapse of the Soviet Union.* Stanford: Stanford University Press, 1993.

Suri, Jeremi. *Power and Protest: Global Revolution and the Rise of Detente.* Cambridge, Mass.: Harvard University Press, 2003.

Tang, Xiaobing. *Origins of the Chinese Avant-Garde.* Berkeley: University of California Press, 2008.

Tatlin, Vladimir. "Autobiography." In *Tatlin,* edited by Larissa Zhadova, 264–66. New York: Rizzoli, 1988.

Tatlin, Vladimir, et al., "The Work Ahead of Us." In *Tatlin,* edited by Larissa Zhadova, 239–40. New York: Rizzoli, 1988.

Taylor, Charles. "The Politics of Recognition." In *Multiculturalism: Examining the Politics of Recognition,* edited by Amy Gutmann, 25–74. Princeton: Princeton University Press, 1994.

Theatre Guild Program: Roar China. New York: National Program Publishers, 1930.

Thomas, Lawrence. *The Linguistic Theories of N. Ja. Marr.* Berkeley: University of California Press, 1957.

Tishkov, V. A. *Rekviem po etnosu.* Moscow: Nauka, 2003.

Todorova, Maria. "Does Russian Orientalism Have a Russian Soul?" *Kritika* 1, no. 4 (fall 2000): 717–27.

Tokarev, S. Review of *Um pervobytnogo cheloveka,* by Franz Boas. Translated by A. M. Voden. *Etnografiia* 1 (1928): 132–33.

Tolz, Vera. *Russia's Own Orient: The Politics of Identity and Oriental Studies in the Late Imperial and Early Soviet Periods.* Oxford: Oxford University Press, 2011.

Tret'iakov, Sergei. "Biografiia veshchi." In *Literatura fakta,* edited by N. F. Chuzhak, 68–74. Moscow: Federatsiia, 1929.

——. "Happy New Year! Happy *New Left!*" In *Russian Futurism Through Its Manifestos, 1912–1928,* edited by Anna Lawton, 265–68. Ithaca: Cornell University Press, 1988.

——. "O p'ese 'Rychi, Kitai!'" In *Slyshish', Moskva?!,* edited by G. Mokrusheva, 157–60. Moscow: Iskusstvo, 1965.

——. *Roar China.* New York: International, 1931.

——. *Rychi, Kitai!* Moscow: Ogonek, 1926.

——. *Slyshish', Moskva?!* Edited by G. Mokrusheva. Moscow: Iskusstvo, 1965.

——. "The Theater of Attractions." *October* 118 (fall 2006): 19–26.

——. "What's New." In *Russian Futurism Through Its Manifestos, 1912–1928,* edited by Anna Lawton, 269–71. Ithaca: Cornell University Press, 1988.

Trilling, Lionel. "The Forbidden Dialectic." In *Isaac Babel's Selected Writings*, edited by Gregory Freidin. Translated by Peter Constantine, 469–83. New York: Norton, 2010.

———. "Reality in America." In *The Liberal Imagination: Essays on Literature and Society*, 1–19. New York: Viking, 1950.

———. *Sincerity and Authenticity*. Cambridge, Mass.: Harvard University Press, 1971.

Trotsky, Leon. *History of the Russian Revolution*. Translated by Max Eastman. Chicago: Haymarket, 2008.

———. *Literature and Revolution*. Edited by William Keach. Translated by Rose Strunsky. Chicago: Haymarket, 2005.

———. *Problems of the Chinese Revolution*. Edited and translated by Max Shachtman. New York: Pioneer, 1932.

———. *The Revolution Betrayed: What Is the Soviet Union and Where Is It Going?* Translated by Max Eastman. New York: Pioneer, 1945.

Tsiang, H. T. *And China Has Hands*. Edited by Floyd Cheung. New York: Ironweed, 2003.

U.S. Congress. House Select Committee on Communist Aggression. *Special Report No. 2: Treatment of the Jews Under Communism*. 83rd Cong., 2nd sess. Washington, D.C.: GPO, 1954.

Vel. "Khlebnikov—osnovatel' budetlian." *Kniga i revoliutsiia*, no. 9-10 (1922): 20–25.

Venuti, Lawrence. "Local Contingencies: Translation and National Identities." In *Nation, Language, and the Ethics of Translation*, edited by Sandra Bermann and Michael Wood, 177–202. Princeton: Princeton University Press, 2005.

———. "Translation, Community, Utopia." In *The Translation Studies Reader*, edited by Lawrence Venuti, 468–88. New York: Routledge, 2000.

Von Eschen, Penny. *Race Against Empire: Black Americans and Anticolonialism, 1937-1957*. Ithaca: Cornell University Press, 1997.

Wald, Alan M. *American Night: The Literary Left in the Era of the Cold War*. Chapel Hill: University of North Carolina Press, 2012.

———. *The New York Intellectuals: The Rise and Decline of the Anti-Stalinist Left from the 1930s to the 1980s*. Chapel Hill: University of North Carolina Press, 1987.

———. *Trinity of Passion: The Literary Left and the Antifascist Crusade*. Chapel Hill: University of North Carolina Press, 2007.

Weinberg, Robert. *Stalin's Forgotten Zion: Birobidzhan and the Making of a Soviet Jewish Homeland; An Illustrated History, 1928–1996*. Edited by Bradley Burman. Berkeley: University of California Press, 1998.

Williams, William Carlos. *In the American Grain*. New York: New Directions, 1956.

Wisse, Ruth. *A Little Love in Big Manhattan: Two Yiddish Poets*. Cambridge, Mass.: Harvard University Press, 1988.

Wolff, Larry. *Inventing Eastern Europe: The Map of Civilization on the Mind of the Enlightenment*. Stanford: Stanford University Press, 1994.

Wolin, Richard. *The Wind from the East: May '68, French Intellectuals, and the Chinese Cultural Revolution*. Princeton: Princeton University Press, 2010.

Wolitz, Seth L. "The Americanization of Tevye or Boarding the Jewish *Mayflower*." *American Quarterly* 40, no. 4 (December 1988): 514–36.

Woroszylski, Wiktor. *The Life of Mayakovsky*. Translated by Boleslaw Taborski. New York: Orion, 1970.

Wright, Richard. "Blueprint for Negro Writing." In *African American Literary Theory: A Reader*, edited by Winston Napier, 45–53. New York: New York University Press, 2000.

——. "I Tried to Be a Communist." *Atlantic Monthly* 174, nos. 2–3 (August–September 1944): 61–70, 48–56.

Yamashita, Karen Tei. *I Hotel*. Minneapolis: Coffee House Press, 2010.

Yao, Steven. *Foreign Accents: Chinese American Verse from Exclusion to Postethnicity*. New York: Oxford University Press, 2010.

Young, Robert J. C. *Postcolonialism: An Historical Introduction*. Oxford: Blackwell, 2001.

Yu, Henry. *Thinking Orientals: Migration, Contact, and Exoticism in Modern America*. New York: Oxford University Press, 2001.

Yu, Renqiu. *To Save China, to Save Ourselves: The Chinese Hand Laundry Alliance of New York*. Philadelphia: Temple University Press, 1992.

Yu, Timothy. *Race and the Avant-Garde: Experimental and Asian American Poetry Since 1965*. Stanford: Stanford University Press, 2009.

Žižek, Slavoj. *In Defense of Lost Causes*. New York: Verso, 2008.

——. "Multiculturalism, or, the Cultural Logic of Multinational Capitalism." *New Left Review* 225 (September–October 1997): 28–51.

Credits and Permissions

Index